Deschutes
Public Library

D0426302

ALSO BY CYNTHIA SALTZMAN

Portrait of Dr. Gachet: The Story of a Van Gogh Masterpiece,
Money, Politics, Collectors, Greed, and Loss

Old Masters, New World: America's Raid on Europe's Great Pictures

PLUNDER

PLUNDER

NAPOLEON'S
Theft of
VERONESE'S FEAST

CYNTHIA
SALTZMAN

Farrar, Straus and Giroux · *New York*

Farrar, Straus and Giroux
120 Broadway, New York 10271

Copyright © 2021 by Cynthia Saltzman
All rights reserved
Printed in the United States of America
First edition, 2021

Owing to limitations of space, illustration credits can be found on pages 313–317.

Library of Congress Cataloging-in-Publication Data
Names: Saltzman, Cynthia, author.
Title: Plunder : Napoleon's theft of Veronese's Feast / Cynthia Saltzman.
Description: First edition. | New York : Farrar, Straus and Giroux, 2021. |
 Includes bibliographical references and index. | Summary: "History of Napoleon's
 art looting of Italy and the subsequent formation of the Louvre" —Provided by publisher.
Identifiers: LCCN 2020055303 | ISBN 9780374219031 (hardcover)
Subjects: LCSH: Veronese, 1528–1588. Marriage at Cana. | Musée du Louvre—History. |
 Cultural property—Destruction and pillage—Italy—Venice. | Napoleon I, Emperor of
 the French, 1769–1821.
Classification: LCC ND623.V5 A69 2021 | DDC 759.5—dc23
LC record available at https://lccn.loc.gov/2020055303

Designed by Abby Kagan

Our books may be purchased in bulk for promotional, educational, or business use.
Please contact your local bookseller or the Macmillan Corporate and Premium Sales
Department at 1-800-221-7945, extension 5442, or by email at
MacmillanSpecialMarkets@macmillan.com.

www.fsgbooks.com
www.twitter.com/fsgbooks • www.facebook.com/fsgbooks

1 3 5 7 9 10 8 6 4 2

To Arthur
To Lily
And once again to Warren

Contents

PLUNDER

Introduction: "One of the greatest [paintings] ever made with a brush"

This is the story of Napoleon's theft of Paolo Veronese's *Wedding Feast at Cana*, a vast, sublime canvas that in 1797 the French tore from a wall of the monastery of San Giorgio Maggiore in Venice. Veronese began painting *The Wedding Feast at Cana* in June 1562. He was thirty-four and ambitious. In the sixteenth century, San Giorgio Maggiore was a wealthy and powerful Benedictine abbey, and it loomed large in Venetian life. Built of red brick, the monastery stood on the edge of an island across Saint Mark's basin from the Doge's Palace. Its entrance was set back from the lagoon by a stone quay with wide steps rising from the water to accommodate the long gondolas that on feast days brought the doge. When, two years before, the abbot Girolamo Scrocchetto had renovated the monastery's refectory, he had commissioned the architect Andrea Palladio to design it. Palladio's refectory was magnificently simple, almost austere, a monument to Renaissance confidence, humanism, order, harmony, and restraint. Palladio had stripped away all decorative detail to create a long, narrow space, with white stucco side walls, each broken by four tall windows, crowned with classical pediments—windows that filled the room with light.

It had become the custom in northern Italy for monastic orders to decorate their refectories with a large painting of a New Testament feast, placed on the end wall, so as to be the focus of the room. The biblical feast that Scrocchetto chose for Veronese to paint was the marriage celebration at Cana, in Galilee, at which Jesus performs his first miracle, by changing water into wine. A contract drawn up for Scrocchetto and Veronese specified that the painter "Paolo Caliar of Verona . . . will make a painting for us in the new refectory [that] will be as wide and high as the wall, and will cover it completely." The canvas would measure some 22.2 by 32.6 feet.

The picture's size alone spoke to the abbot's ambition to have Veronese take on Leonardo da Vinci, who between 1495 and 1498 had created the most famous of such feasts in the refectory of Santa Maria delle Grazie in Milan—*The Last Supper.*

Almost from the moment Veronese completed the canvas in 1563, news traveled that he had created an extraordinary work of art—a luminous spectacle staged by a large cast including musicians, a banquet taking place outdoors on a marble terrace in sixteenth-century Venice. Dusky reds, blues made of powdered lapis lazuli, oranges, evening yellows, greens, and whites—Veronese had lavished color on the canvas as he built the illusion of a crowd of life-sized figures (130 in all) standing, sitting, and moving about in three-dimensional space.

The canvas was one that manifested and measured the achievement of the visual arts in the Italian High Renaissance—a picture with intellectual content and an exalted argument to make, in which painted scenes appear to be "real," and two-dimensional images of the most beautiful things seem more beautiful than the things themselves.

Everywhere Veronese impresses with the virtuosity of his performance— the absolute mastery of oil paint. He conjures a sheet of paper balanced on a table, the anatomy of an arm as it lifts a jar, or, in the distance, columns and porticoes that could have been designed by Palladio. He can make a single brushstroke of white read as a ribbon, a lock of hair, the cuff of a silk sleeve, or the worn marble of a fluted column.

Across *The Wedding Feast at Cana* sweeps a scene of pleasure and delight. A long horizontal table is set in an open square and seated with myriad guests, below a stone balustrade, a second terrace, and an azure sky. Around the table, Veronese has crowded many more figures—costumed in silk and other fabrics famously manufactured in Venice and generating a share of the Republic's wealth. Along the upper terrace, above the balustrade, servants are streaming, preparing food, handing off pitchers, and carrying trays. High up, a figure in chalky pink steadies himself on a column, near a wall of silver plates, and gestures to a man with outstretched arms below. Here, on a wide canvas ground, Veronese wove together his evolving skills of visual seduction.

In the background, the artist has erected grand classical buildings of

his own invention—façades with towering columns, some made of pink marble and others of white stone. With the vertical geometry of the architecture, he anchors the horizontal crowd. At the center of the table, seated with the other guests, is Jesus, in blue and red—weightless and ethereal, an image from an icon, a divine presence, in the midst of the mortal crowd, looking straight out. By setting the miracle in the center of Venetian society, Veronese suggested that a divine revelation could happen in Venice. He seemed to ask: What does the biblical story mean in the flux of contemporary life?

Palladio had planned a ceremonial approach to the refectory. Visitors entered the building from a columned cloister, climbed twelve stone steps (one for each of the apostles), walked through a twenty-foot-high doorway into an antechamber (with two monumental red marble water basins), then up three more steps to reach a second towering door—the entrance to the room. But even from the first flight of stairs, the Veronese took charge of the view. The second twenty-foot doorway framed the figure of a handsome, dark-haired musician with a high forehead and an aquiline nose who is dressed in white and plays a viola da gamba.

No small part of Veronese's success was the way the opulent canvas worked with the spare architecture of Palladio's classical refectory. Down the side walls and across the front of the room ran dark wooden seats and paneling that rose some eight feet, like wainscoting. There, on either side of the refectory, the Benedictines sat at long narrow tables and took their meals in silence, while one of the order, standing in a pulpit high up on a side wall, read aloud from the Bible. Facing into the room, each could observe the abbot at the head table and, above him, on the wall at the level of the windows, the Veronese. The painting climbed from the dark paneling to the ceiling, and it ran horizontally all the way to the side walls, so that nothing interrupted the illusion that the refectory opened onto the terrace and the scene was in progress outside. As Veronese's expansive canvas decorated Palladio's elegant room, Palladio's architecture framed Veronese's picture.

From the rest of Italy and then from farther north, artists made their way to Venice to study Veronese's *Wedding Feast at Cana* and to paint copies. "All the sculptors come and the painters to admire it three, four,

and six times . . . and PAOLO is praised with eternal fame," wrote Benedetto Guidi, a monk at San Giorgio Maggiore who observed the traffic of viewers. Commentators tried to explain the brilliance of the picture. Annibale Carracci, a baroque master from Bologna, called it "one of the most beautiful paintings, or rather one of the greatest ever made with a brush." In his 1674 *Le ricche minere della pittura veneziana* (*The Rich Mines of Venetian Painting*), the Venetian artist, engraver, and art commentator Marco Boschini hailed Veronese: "You are that universal painter who pleases and amazes the whole universe." Earlier, about *The Wedding Feast at Cana*, he had written, "Certainly never has been seen among painters such regal pomp and circumstance, such majestic actions, such weighty and decorous manner! He is the treasurer of art and of colors. This is not painting, it is magic."

Giorgio Vasari, who in the 1568 edition of his *Lives of the Most Excellent Painters, Sculptors and Architects* championed his native Florentines and gave the Venetians short shrift, nevertheless described the Veronese—*Le Nozze di Cana Galilea*—as "a marvelous work in size, number of figures, and variety of costumes, and invention." When Annibale Carracci annotated his copy of the *Lives*, he called Vasari "this fool," because he "passes over him [Veronese] in four lines. And just because he was not Florentine."

As the fame of the painting spread, so too did the number of artists and connoisseurs traveling to see it. By 1705, the monks at San Giorgio Maggiore began to restrict access to the refectory and demanded that the artists who wanted to visit find influential individuals to introduce them.

Among the greatest admirers of *The Wedding Feast at Cana* were the French. The critic Roger de Piles expressed the consensus of the Royal Academy of Painting and Sculpture and captured the picture's mood when in 1715 he declared "not only is it the triumph of Paolo Veronese, it is all but the triumph of painting itself."

Already by then, Jean-Baptiste Colbert, Louis XIV's minister of finance, and a collector, had forced his way to the front of the line of princes wanting to buy the Veronese. But even hard cash offered by Europe's most powerful monarch through Pierre de Bonsy, his ambassador on the ground in Venice, failed to persuade the Benedictine monks to sell. Veronese had painted four feasts in Venice's monastic refectories.

Finally, when the French ambassador, working for Colbert, settled on a lesser feast—the *Feast in the House of Simon*, painted by Veronese for the Servite monastery—Venetian officials refused to allow its sale. But then, suddenly, a diplomatic crisis compelled Venice to present the Servites' Veronese as a gift to Louis XIV. The French thought it a victory and hung the painting in a stateroom at Versailles.

Even in the eighteenth century, once a taste for Greek and Roman antiquities had swept Europe, French enthusiasm for the Veronese hardly waned. Denis Diderot, in his *Encyclopédie*, said of Veronese that "one especially values his banquets and his pilgrims of Emmaus, but the wedding feast at Cana represented in the refectory of San Giorgio Maggiore . . . ranks as one of the most beautiful pieces in the world."

Two years after Veronese completed *The Wedding Feast at Cana*, San Giorgio Maggiore's new abbot, Andrea of Asola, commissioned Palladio to rebuild the monastery's church. Palladio created a Renaissance structure, with a dome and a white stone façade of overlapping classical temple fronts. The façade was beautifully proportioned and ordered in its composition of columns, capitals, pediments, niches, and statues, and it immediately became a Venetian landmark.

Napoleon Bonaparte was a plunderer of art, one of history's most accomplished. He forced his enemies to pay an aesthetic price for defeat by giving up statues and paintings. He paraded the spoils and trumpeted his thefts. In a modern and republican twist, he took the art for the French nation and displayed it in a public museum—the Louvre. He filled the former palace of the French kings with his acquisitions, and Europe flocked to Paris and hailed the Louvre as the greatest museum in the world—the Musée Napoléon. Did he take it for himself? Or for France? Or for the world at large?

Bonaparte started plundering early—in the spring of 1796, when France was at war with the Austrian Empire in Italy and, as commander of the French army in Italy, he led his first campaign. Beginning in April, he swept across Piedmont and Lombardy, driving the Austrians east. With a series of rapid-fire victories, he reversed the course of France's war

against the Habsburgs and catapulted himself to international fame as a
hero of the new French Republic. He was twenty-six.

Only weeks into this 1796 Italian campaign, a Venetian envoy, who in
a brief meeting with Bonaparte tried to gauge the threat he posed to Ven-
ice, noticed that he "is determined in his operations and loves glory and
praise." Already, Bonaparte was calculating how to impose himself on
France. For the first time, he tasted political power.

Wildly ambitious, Bonaparte used his conquests to operate on his
own, negotiating treaties himself and setting terms for peace without first
checking with the Directory, the five-man executive running the Republic
in Paris. He thought of himself in terms of history and set his leadership
of the Italian campaign in the context of Roman generals and French
kings. Later, in 1804, after foiling a royalist assassination plot, he charac-
teristically cast the incident as being of historic significance: "They seek to
destroy the Revolution by attacking my person. I will defend it, for I am
the Revolution."

The looting of art reflected the best and the worst of Napoleon's
character: his desire for greatness, which he pursued by carrying forward
the finest parts of civilization, as with his legal code; and his ruthless-
ness in getting whatever he sought, advancing his mythmaking plans, and
seizing power. Long before he crowned himself emperor of the French in
1804, the author and intellectual Germaine de Staël called him "Robes-
pierre on horseback," linking him to the Jacobin who let loose the Terror.
Whatever lethal methods it took to defeat his enemies and to capture
glory for France, Napoleon employed them—no matter the cost, a cost
that often tainted the glory.

If the French government launched the policy of seizing art from its
defeated enemies, Napoleon made it his own. He insisted that artistic in-
demnities go into the terms of peace. He forced his foes to agree to hand
over paintings and sculpture as part of the reparations of war. In legaliz-
ing the expropriation of art, Bonaparte revealed his desire to keep what he
took and, if the tide of war turned, to have no questions asked. Later, the
French would point to official documents to claim that the art pried from
Italy's fingers was transferred by diplomatic agreement.

Bonaparte didn't think of himself as a plunderer. Anything but. In the

Italian campaign, he saw himself as a soldier, a commander, a victorious general in chief—a citizen of the Republic of France carrying the Revolution abroad, and already a statesman, a diplomat who told the people of Lombardy he was freeing them from the despotic Austrian regime. He also wanted to prove himself an intellectual and a scientist, who talked of chemistry with Claude-Louis Berthollet and of mathematics with Gaspard Monge. Both celebrated French scientists traveled to Italy on the research commission assigned to help choose works of art they believed "worthy of entering" the museum in Paris.

When seizing art, Bonaparte wanted nothing less than masterpieces—paintings and sculpture deemed by artists, connoisseurs, and advisers as the most brilliant and beautiful ever made. By acquiring records of genius, he could link the names of the greatest High Renaissance artists—Leonardo, Michelangelo, Raphael, Titian, and Veronese—to the Republic of France and to his own.

1

"Send me a list of the pictures, statues, *cabinets* and curiosities"

Jealous of all glory, [Bonaparte] wanted to surround himself with the brilliance of the arts and sciences.

—Duchess of Abrantès

Almost from the start of the 1796 French campaign against the Austrians in Italy, art was on Napoleon Bonaparte's mind.

"Above all, send me a list of the pictures, statues, *cabinets* and curiosities at Milan, Parma, Piacenza, Modena and Bologna," he demanded on May 1 in a letter to Guillaume Faipoult, the French envoy in Genoa. The cities he named were famous for their paintings—stockpiles built in the sixteenth and seventeenth centuries by some of the most extravagant patrons of Renaissance art—the Viscontis, the Sforzas, the Farneses, the Estes, and the popes.

Bonaparte was aiming for collections of the highest quality—art that he imagined would enhance the prestige of the new museum in Paris at the Louvre. The Louvre had opened as the Musée Français only three years before, on August 10, 1793, during the Terror, when France's most celebrated painter, Jacques-Louis David, and the Committee of Public Safety transformed the palace of the Bourbons into a public gallery of art, granting French citizens access to the royal collections of antiquities, paintings, sculpture, and decorative arts that now, in theory, were theirs.

At that point, Bonaparte was in Turin, still far from the places he hoped to plunder. But he was advancing east. He had been in Italy only a month. Earlier, on March 2, in Paris, he had officially taken command of France's Army of Italy. A week later, he married Josephine de Beauharnais. Within two days, he had left for Nice, where he met the French troops.

As commander of the Army of Italy, Bonaparte was charged with driving the Austrians from the Duchy of Milan, which covered most of Lombardy and had been ruled by the Habsburgs for nearly a century. France was also fighting Austria in the Rhineland, so the Directory had dismissed Italy as the less important of the two fronts. At best, they hoped Bonaparte (with some forty-nine thousand troops) would divert Austria's allied forces (of some eighty thousand) away from the fighting in the north.

Bonaparte had come to the Italian campaign well prepared. The previous year he had worked at the Topographical Department of the Committee of Public Safety, the war ministry's strategic planning office in Paris, formulating the offensive to defeat the Austrians in Italy. He had articulated these agendas to the war minister Louis-Gustave Doulcet de Pontécoulant, who recalled how they "gushed out of him like a volcano sends up the lava it has held back."

To reach the Austrians in Milan, Bonaparte had first to dispense with Piedmont-Sardinia, a kingdom in the northwest of Italy that was ruled by the vacillating Austrian ally Victor Amadeus III. Bonaparte also had to contend with other Italian states—the Duchies of Parma, Modena, and Tuscany; the Republics of Genoa and Venice; and the Papal States—a collection of provinces that covered much of northern and central Italy.

Bonaparte won his first victory against the Austrians on April 12, at Montenotte, a village on the steep slopes of the Apennines, twelve miles from the Ligurian Sea. "Everything tells us that today and tomorrow will leave their marks on history," Bonaparte assured General André Masséna the night before the battle.

From the start, the French army had progressed at a fast pace. "We do not march, we fly," wrote one of the officers. With this sudden acceleration, Bonaparte imposed his method of warfare on what had been a slow-moving, undecided four-year campaign.

France's war with Austria was a conflict set off by the Revolution, and the response of Europe's monarchs to the fate of the French king. On June 20, 1791, Louis XVI had fled Paris with Marie-Antoinette and their children, hoping to reach Vienna and take refuge with the queen's brother, the Austrian emperor Leopold II. At Varennes, close to the border of the Austrian Netherlands (now Belgium), the king was arrested,

and he was soon taken back to the French capital. He continued to reside in the Tuileries Palace, under effective house arrest. In August, Emperor Leopold and Frederick William II of Prussia warned (in the Declaration of Pillnitz) that the French king's situation was of "common interest" to the European monarchs. Stirred up by fears that the Austrians now threatened France's constitutional monarchy, the Legislative Assembly and Louis XVI (who secretly hoped France would lose) launched the war against Austria in April 1792.

Four months later, on August 10, in Paris, armed political militants stormed the Tuileries and massacred some six hundred Swiss Guards. That day, Louis XVI was taken prisoner and the French monarchy collapsed. Bonaparte, then an artillery captain of twenty-two, happened to be in Paris and "ventured into" the Tuileries Gardens. "Never since has any of my battlefields struck me by the number of dead bodies as did the mass of the Swiss," he would recall. In December, France's newly elected National Convention, which had established a republic, put Louis XVI on trial for treason, found him guilty, and voted to condemn him to death.

On January 21, 1793, Louis XVI was taken by carriage to the Place de la Révolution, formerly the Place Louis XV (and later the Place de la Concorde), where he was guillotined. An artist ran off an edition of prints that shows the executioner holding the king's head above the crowd.

The French king's execution that January only raised the stakes for the Austrian emperor and the Prussian king, who soon added allies—Britain, Spain, the Dutch Republic, the Holy Roman Empire, Piedmont, and the Kingdom of the Two Sicilies—to build the First Coalition against the French. Already, in November 1792, the National Convention had voted to take the Revolution abroad, by assisting all peoples seeking to "recover their liberty." In August 1793, a French levée en masse, or conscription, aimed to raise an army of three hundred thousand men.

Bonaparte envisioned that he would quickly defeat the Austrians in northern Italy, and advance toward Vienna. "I march tomorrow against Beaulieu," he told the Directory on April 28, referring to the Austrian general Jean-Pierre de Beaulieu. "I will oblige him to cross the Po, I will pass it immediately after him, I will take all of Lombardy, and, in less than a month, I hope to be in the mountains of the Tyrol, to find the

Army of the Rhine, and with it carry the war into Bavaria." The directors had mentioned nothing about heading to Austria, but only weeks after taking charge, Bonaparte alerted them to what he intended to do whether they approved or not.

In Italy, the Directory would soon give Bonaparte another charge—to plunder it. "The resources which you will procure are to be dispatched towards France," they wrote on May 16, 1796. "Leave nothing in Italy which our political situation will permit you to carry away, and which may be useful to us." The French Republic needed funds, and its Army of Italy required equipment. "Everything is lacking and especially transport," Cristoforo Saliceti, the French government's commissioner, had written to Lazare Carnot, a director in charge of the military, in February from Nice. "No preparations have been made to enter on campaign." The commanders "say they cannot march because they need mules and supplies, either in fodder, for the transport and the cavalry, or medical supplies." Saliceti then proposed that the army exploit the resources they found in Italy: "Would it not be more useful and more correct to procure them [supplies] from the enemy, to attack in providing for the needs of the moment?"

Bonaparte took no time in turning the army's situation around. "Misery has led to indiscipline," he wrote. "And without discipline there can be no victory." He asked Faipoult to secure a loan of three million francs from bankers in Genoa. With that, Saliceti bought mules, wheat, clothes, and shoes.

After Bonaparte's victory at Montenotte, others followed within days. On April 13 and 14, at Millesimo and Dego, the French again defeated the Austrians. Austria's 5,700 casualties from the three battles were more than triple the 1,500 suffered by France. Within a week, at Ceva, and then at Mondovì, Bonaparte took on Piedmont and triumphed again. Afterward, he forced Mondovì to provide sixteen thousand rations of meat and eight thousand bottles of wine. From nearby Acqui, he ordered clothing and boots. "Napoleon did nothing drastic strategically or tactically," argues the historian Steven Englund. "But under his hand the army and its divisional commanders performed the familiar routines of march and countermarch, attack and fallback, feint and envelopment, so well and so swiftly that they struck with the force of the new."

On April 23, the Piedmont commander requested a cease-fire. Napoleon brushed him off: fighting would continue until he handed over three forts—Coni, Tortona, and Alexandria—to the French. Within five days, the Piedmont king had agreed. On April 28, in Cherasco, some thirty miles south of Turin, Bonaparte signed an armistice.

Bonaparte was "always cold, polished and laconic," wrote Joseph-Henri Costa de Beauregard, who negotiated the peace terms for Piedmont. Afterward, they had supper. Bonaparte "rested his elbows upon the balcony of a window to watch the day break," recalled Beauregard. They had talked for over an hour. "The intellect was dazzled by the superiority of his talents, but the heart remained oppressed."

Few had ever encountered the rapid-fire pace set by Bonaparte, who did many things at once. In the first nine days of the offensive, he sent off fifty-four letters to his generals. On April 20, he wrote six letters, and after midnight, three more. This barrage of words continued, and by the end of the year he would send some eight hundred pieces of correspondence—letters and dispatches.

That spring in Italy, the French army's early momentum never slackened. On April 30, the French started in Acqui, not far from Genoa; on June 3, they would arrive in Verona—150 miles to the east. Later, before the battle of Castiglione, General Pierre-François Augereau would drive his troops 50 miles in 36 hours, or at close to twice the average speed of the enemy. Bonaparte himself was always on the move. In one three-day period, he ran his horses at a pace that left five dead.

On May 6, Bonaparte had asked the Directory to send him "three or four known artists to choose what is fitting to take to send to Paris." The Directory had been thinking along the same lines. The day after Bonaparte wrote, but before receiving his letter, Lazare Carnot and two other directors, Louis-Marie de La Révellière-Lépeaux and Étienne-François Letourneur, "invited" him to appoint "one or several artists to research, collect, and ship to Paris the objects of this sort that are the most precious."

They repeated the revolutionary theme that the French Republic was the rightful heir to genius: "The Executive Directory is convinced, Citizen General, that you see the glory of the Fine Arts as attached to that of the army you command. Italy owes to them [the Fine Arts] a great part of its

riches and its fame; but the time has come when their reign must pass to France to solidify and embellish that of liberty."

The directors emphasized that the purpose of Napoleon's art appropriations in Italy was to strengthen the contents of the new gallery at the Louvre: "The National Museum should hold the most famous monuments of all the arts, and you will not neglect enriching it with those pieces for which it waits from the present conquests of the Army of Italy and those that are still to come."

In their orders to plunder, the directors followed a policy carried out in the Austrian Netherlands under Maximilien Robespierre and the Terror. On June 26, 1794, after the French had defeated the Austrians at Fleurus, they emptied the cathedral in Antwerp of its altarpieces by Peter Paul Rubens, *The Descent from the Cross* and *The Raising of the Cross*, and hauled them by cart, along with cannons and other artillery, back to Paris. On September 23, some of the 150 pictures chosen in the Austrian Netherlands arrived in the French capital. Five days later, the Rubens paintings went on view at the Louvre. The French justified these thefts less as a consequence of victory than as the right of the new republic—as acts of liberation, not plunder. On September 24, Luc Barbier, an artist and hussar lieutenant who had accompanied the Belgian pictures to France, spoke to the National Convention, invoking the revolutionary ideology with which the French recast their seizing of art in political terms: "The fruits of genius are the patrimony of liberty. . . . For too long these masterpieces have been soiled by the gaze of servitude. . . . The immortal works of Rubens, Van Dyck and the other founders of the Flemish school are no longer on alien soil. . . . They are today delivered to the home of the arts and of genius, the land of liberty and equality, the French Republic."

Already, the directors were looking south to Rome, then the unquestioned art capital of Europe. In a letter to Bonaparte dated May 7, they emphasized the artistic wealth he would find in the papal city: "Some of its beautiful monuments, its statues, its paintings, its medals, its libraries, its bronzes, its Madonnas of silver, and even its bells would compensate for the costs of the visit you will make."

Two years before, Abbé Henri Grégoire, who had advised the French

on the confiscations from the Austrian Netherlands, envisioned the art that the French might acquire if they expanded the war as far as Rome. He had addressed the Convention: "Certainly, if our victorious armies penetrate into Italy, the removal of the Apollo Belvedere and of the Farnese Hercules would be the most brilliant conquest."

As the Directory was ordering Bonaparte to lay claim to the masterpieces of Italy, he struggled to control looting by his soldiers, and he dispensed severe punishment to stop it. After the victory in Mondovì, the French soldiers had ravaged the town. "In every village, in every country house, in every hamlet, everything is pillaged and devastated," a French officer reported to Bonaparte. "Bed linen, shirts, old clothes, shoes, everything, is taken from the unfortunate inhabitants of a cottage. . . . If he does not hand over his money, he is beaten senseless. . . . Everywhere inhabitants flee."

On April 22, in his order of the day, Bonaparte congratulated his soldiers for their hard work but denounced the "frightful pillaging." He protested that when he arrived, the army "was under the influence of disaffected agitators, without bread, without discipline and without order. I made some examples. I took every step I could to reorganize the commissariat; and victory did the rest." Later, Bonaparte insisted to the troops that he would "not tolerate brigands to soil our laurels. Looters will be shot mercilessly; several have been already."

As he moved east, Bonaparte led the Austrians to believe he would ford the Po close to Milan. Instead, he crossed the river at Piacenza on May 7 and invaded the Duchy of Parma. In Parma, he met little resistance. Following the Directory's instructions, Bonaparte insisted that the war in Italy pay for itself, that his defeated enemies cough up supplies for the troops and cash, some of which he would dispatch to the impoverished government in Paris. In a treaty signed on May 9, he forced the Duke of Parma to surrender to the French large quantities of wheat (1,100 tons) and oats (550 tons), as well as currency amounting to 2 million francs and 1,700 horses. To this, he added "twenty pictures, among those currently residing in the duchy."

Art stood apart from the other indemnities. One work of art is not like another, in character and quality, in aesthetic or monetary value. By

the late eighteenth century, paintings and sculpture were tradable assets, which could be sold to dealers in London or Paris. Bonaparte made clear he understood the game and claimed he knew what he wanted; the twenty pictures would be "at the choice of the General-in-Chief."

On the day he signed the treaty, Bonaparte informed the directors that he had gotten hold of Parma's finest works of art: "As soon as possible, I will send you the most beautiful pictures of Correggio, among others, a *Saint Jerome*, which is said to be his masterpiece." He then seemed to joke about the tribulations the Revolution had caused the French Catholic church: "I must say this saint has chosen a bad time to arrive in Paris; I hope you will give him a place of honor in the Museum." He repeated his "request for a few known artists to take charge of the choice and transport of the fine things we shall see fit to send to Paris."

Bonaparte emphasized that "the celebrated painting of *Saint Jerome* is highly esteemed in this country," and that the Duke of Parma had "offered a million to buy it back." He recognized that no small part of the public fascination with masterpieces came from their financial worth.

Correggio was one of the most renowned of Parma's painters, and the French artist Charles-Nicolas Cochin, in his 1758 guidebook *Voyage d'Italie*, had called the *Madonna of Saint Jerome* "one of the most beautiful & most esteemed [paintings] in Italy." In this picture, painted between 1523 and 1530, an angel, who turns the pages of Saint Jerome's Bible, and an elegant Mary Magdalene crowd around the Madonna and Child, bringing their spiritual realm down to a courtly earth.

France's Jacques-Louis David and the Americans Benjamin West and John Singleton Copley were among the artists who in the eighteenth century traveled to Parma to study Correggio's paintings. Earlier, according to a contemporary guidebook, the Duke of Parma had fended off attempts by the kings of Portugal and Prussia to purchase the *Madonna of Saint Jerome*. As Correggio painted mostly frescoes, his canvases were rare and expensive. In 1746, Augustus III, Elector of Saxony and King of Poland, had paid the Duke of Modena 6,500 pounds for Correggio's *Reclining Magdalene*, spending a sum that could have bought close to one thousand horses on a picture measuring only slightly more than one square foot.

A contemporary drawing shows a dozen French soldiers at work in the Duke of Parma's gallery, the pictures already stripped from its walls. Large crates lie open on the floor. Three soldiers are hauling the Correggio to a box marked "St Jérôme du Corrège." Statues have been lined up, ready to be packed.

"I cannot express the pain that such a loss [of the Correggio] has caused his Royal Highness and all the citizens of the town," wrote Cesare Ventura, the Duke of Parma's minister, to Ignacio Lopez de Ulloa, a Spanish envoy, on May 2. Through two delegates in Paris, the duke would spend seven futile months trying to strike the works of art from Bonaparte's treaty.

The defeat of Parma opened a path for the French army to move toward Milan. In prying paintings from the Duke of Parma, Bonaparte knew that he was stripping the duchy of assets of incalculable value, property tied to its history, its culture and identity. Their loss delivered a sharp blow to a neutral state, which he had declared to be his enemy. In this way, Bonaparte used art as a weapon of war.

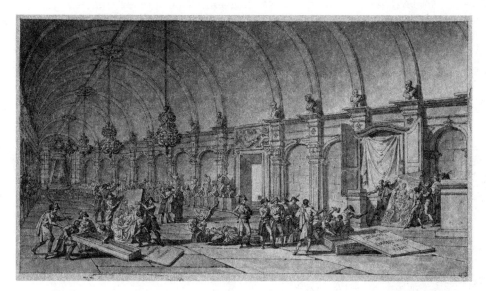

Attributed to Charles Meynier, *The Correggio Madonna of Saint Jerome Is Taken from the Academy of Parma and Delivered to the French Commissioners (May 1796),* ca. 1802–1814. On the right, three men are moving the famous Correggio to a crate on the floor.

"Fire must be concentrated on a single point, and as soon as the breach is made the equilibrium is broken and the rest is nothing," stated a document probably composed by Bonaparte outlining a strategy to beat the Austrians in Italy. He was speaking of battle. But plundering art was also designed to tip a balance, to rattle foes, to leave a wound close to their hearts, and to make something permanent of military defeat. The appropriation of art put requisitions into a metaphysical dimension. To suddenly take possession of Parma's Renaissance masterpieces gave what otherwise would be a relatively insignificant conquest the weight of history and contributed to Napoleon's sense of imperial destiny. A master of tactics and strategy, Bonaparte also grasped that intangibles—drive, courage, inspiration—dictated success in warfare. "Moral force rather than numbers decides victory," he wrote. "The moral is to the physical as three is to one."

Bonaparte also understood that by seizing works of art, the victor could transform the glory of conquest into tangible form. He used the spoils of the Italian campaign to play to the Paris public. On June 8, 1796, the armistice with Parma was published in the journal *La Décade philosophique*. And on July 2, *L'Historien* printed the list of paintings chosen for the Louvre.

With the Parma treaty, Bonaparte was again operating outside the chain of command. The Directory could hardly object. Oddly, when they informed him that they approved the terms of the armistice, they referred to the art levies, seemingly without irony, as "the gift that the prince wants to make us of several beautiful paintings to adorn the national museum."

In Paris, on May 17, Charles Delacroix, the foreign minister (and the father of the artist Eugène Delacroix), congratulated Bonaparte on putting the art indemnities (the right to "choose twenty paintings from all those in this duchy") into the armistice documents, observing that the "new treaty distinguishes you." He added: "You have conquered like Memmius another Corinth; but you don't ignore as he did the prize of treasures which it contains."

2

Venice need not "fear that the French Armies would not fully respect its neutrality"

Venetian: Have you noticed that in Venice there are more paintings than in all the rest of Italy?

Foreigner: It is right and proper that you, being the richest men in Italy, should also have more beautiful things than the others, because craftsmen go where the money flows.

—Francesco Sansovino, 1561

Even before Napoleon Bonaparte crossed into Italy, the Venetians had kept track of the French army's movements. As early as March 19, Alvise Querini, the Venetian envoy to Piedmont, stationed in Turin, took stock of the French troops, who were then quartered in Nice. Querini reassured his government that the army gave little cause for alarm: "The continuous reports from the Riviera regarding the sad condition of the enemy army, its small number, and its lack of stores and provisions each day calm the fears originally felt by this [Piedmont] court." From Genoa, the Venetian consul Gaetano Gervasoni corroborated. The French army was "always lacking the bare necessities," he wrote on April 9.

But, within the next six days, Bonaparte won his first three battles, and Gervasoni's perspective began to change. By April 30, he reported that "the French Commander Buonaparte" had been able to "remove [the Piedmont general] Baron Colli from the position he had taken after the retreat from Ceva," and "to take control of Mondovi." He understood that Napoleon had "strong backing [in Paris] which would cause one to presume his superiority" over Guillaume Faipoult, France's envoy in Genoa. Gervasoni had not yet met the French general but described him as a "very ambitious man, puffed up by his victory."

These reports on Napoleon had their origins in the long tradition of Venetian diplomacy. As early as the sixteenth century, the Venetians had developed a diplomatic corps. As opposed to sending ambassadors abroad only on specific assignments, as was the custom throughout Europe, the Venetians established permanent posts for their envoys and dispatched them to foreign cities to live. When, in 1792, war had broken out between France and Austria, the Venetians had resolved to stay out of the crossfire and declared their neutrality. But, as Bonaparte swept across northern Italy and approached Milan, the Venetians had reason to be wary.

From the city of Venice on the Adriatic, the Venetian Republic stretched west for 140 miles to the Duchy of Milan. Its *domini di terraferma*, or mainland domains, covered the Veneto and eastern Lombardy. If Bonaparte captured Milan, he would be *at* the Venetian border. If he pursued the Austrians to their fortress in Mantua or all the way to Vienna, he would have to march his armies across Venetian territory.

When Bonaparte had asked Faipoult to "send [him] a list of the pictures, statues, *cabinets* and curiosities" in the cities of northern Italy, he omitted Venice. But any quest to obtain Italy's finest works of art would have to take in the Venetian Republic's pictures. The fragile, floating city was famous for its beauty—the beauty of its architecture and of its Renaissance paintings, including those by Gentile Bellini, Giovanni Bellini, Vittore Carpaccio, Giorgione, and the sixteenth-century titans: Titian, Tintoretto, and Veronese.

These Venetians had expanded the possibilities of two-dimensional illusion with their experiments in oil paint. In the early Renaissance, artists in Italy had painted in tempera on wooden panels and also in fresco, a process by which they applied water-based colors to wet plaster, animating walls of churches, monasteries, and palaces, and fixing images to a particular place. Then, in the early fifteenth century, artists in northern Europe, including Jan van Eyck and Rogier van der Weyden, began working with pigments mixed with linseed and other drying oils. Gradually, Giovanni Bellini and other Venetians adopted the technique, which brought many practical advantages. Fresco was ill suited to the humid saltwater climate of Venice, and it also demanded speed in execution, because the paint had to be put down before the plaster dried. As they turned to oils, artists also

shifted from painting on wood to painting on canvas, stretched across a wooden frame. Canvas was less expensive than wood, and much lighter, and it could easily accommodate artists who wanted to paint on a large scale. In Venice, where commerce had long depended upon ships powered by sails, painters found canvas in abundant supply.

Painting in oil on canvas, the Venetians discovered that not only could they layer colors in thin, transparent glazes but they could also build up paint and exploit brushwork to new effects. They could draw out deep browns and rich blacks, plunging part of a picture into shadow yet not losing vivid tone. They could describe the shades and textures of fabrics and flesh, evoke the atmospheric conditions of a landscape and the intangible sense of light and air, adding naturalism to anatomically convincing figures and to space defined with linear perspective. They could exploit a kaleidoscopic range of chromatic effects. The handling of color (*colorito*), Vasari first observed, was the foundation upon which the Venetians composed their canvases. In contrast, Raphael and the Florentines based their pictures on "drawing" or "design" (*disegno*).

Among the Venetian colorists, Veronese was second to none. He had been born in 1528, in Verona, the city from which he proudly took his name. He had waited until 1555, when he was almost thirty, and already established, before he moved to Venice, then the most competitive field for painters in Italy, with many skilled artists vying for commissions.

In Venice, Titian was the towering figure. Then over sixty, he had secured his prominent place among Venetian painters in 1518 with *The Assumption of the Virgin*, for Santa Maria Gloriosa dei Frari. The painting climbed twenty-two feet and was set high above the main altar, so it drew all eyes, even from the door of the church. The Virgin is larger than life but appears to be flesh and blood and to possess the athletic energy of the classical huntress Diana. She stands on a cloud and, turning, reaches out her arms toward the image of God. Her flowing red and blue robes are set off by the yellow of a flaming sky.

Titian's first rival was Jacopo Robusti, known as Tintoretto because his father worked as a *tintore*, a dyer of cloth. Tintoretto made his reputation in 1548 with the dark, alluring *Miracle of the Slave*, painted for the Scuola Grande di San Marco—one of six *scuole grandi* (large confraternities)

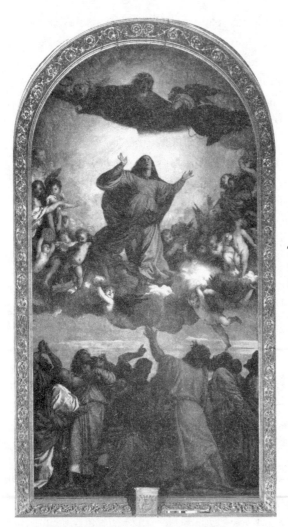

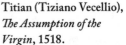

Titian (Tiziano Vecellio),
*The Assumption of the
Virgin*, 1518.

dedicated to charitable work whose ambitions to create magnificent chap-
ter houses had made them major patrons of Venetian art. In Tintoretto's
canvas, Saint Mark is sweeping down from the sky to rescue a slave—
his mostly nude body prostrate on the ground—who has been beaten for
refusing to renounce his Christianity. With radical foreshortening, Tin-
toretto charged the tightly packed scene with drama. He wanted "to make
himself known as the most daring painter in the world," the painter and
critic Carlo Ridolfi wrote in 1642. When Tintoretto won the commission

to paint *The Last Judgment* and *The Making of the Golden Calf* for the apse of the church of the Madonna dell'Orto, he made certain that these two pictures would be the tallest in Venice, canvases rising some forty-eight feet. To secure the assignment, Tintoretto also offered to accept payment only for the cost of his materials. On the wall of his studio, the artist had written the laws of his practice: "The *disegno* of Michelangelo, the *colorito* of Titian."

But competing against Titian and Tintoretto, Veronese proved himself more than prepared to take on increasingly difficult assignments and to match these rivals in originality and scale. For several years, he had gone back and forth between Verona and Venice, drilling himself on complicated compositions, scenes with multiple figures, gesturing and moving, dressed in fabrics of all kinds, and framed by architecture.

In 1553, Veronese was hired (along with Giovanni Battista Zelotti) to assist Giovanni Battista Ponchino in painting canvases to be set into an elaborately carved and gilded framework on the ceiling of the Room of the Council of Ten in the Doge's Palace, the government seat, where the Venetian Senate and other councils met. The Council of Ten oversaw state security, and the allegorical subject Veronese was to paint for the

Tintoretto (Jacopo Robusti), *The Miracle of the Slave*, 1548.

ceiling—*Jupiter Expelling the Vices*—referred indirectly to the council's work. In an eighteen-foot-long oval canvas, Veronese proved his ability to create the illusion that the ceiling opens to the sky and to make it appear with tricks of foreshortening that male and female nudes are falling head-first, from heaven, thrown out by the angry god. Thunderbolts gripped in his hand, Jupiter sails above, beside an eagle spreading its dark wings. The artist characteristically played this violent scene in a lush, daylight key—setting off the rose and chalky terra-cotta tones of flying drapery against an aquamarine sky.

The Venetian obsession with color had sources in Venice itself, in the lagoon and the canals—in the instability of the water's visual effects. The sea intensified the light, and the stone buildings reappeared in reflections on the surface of the tide. These reflections shifted with the water, its currents and waves. The exceptional state of the light had inspired art and architecture that reveled in color. The façade of Saint Mark's Basilica was constructed of polychrome stone—its doors framed by variegated columns of pale gray Istrian limestone and salmon-toned marble, which had been brought from Verona. Inside the basilica, the upper part of the walls and the huge dome glimmered with gold mosaics.

In Venice, canvases—both freestanding paintings and paintings mounted on walls or on ceilings—were often bordered in gold, the frames and moldings carved out of wood and covered with gold leaf. These gilded frames not only set off the painted colors but suggested the high aesthetic and monetary value that the Venetians assigned to their pictures.

The demand for fine colors by Venetian painters was so great that by the sixteenth century, Venice had become a center for the manufacture and supply of pigments. Painters mixed their own paints, and in Venice they found a market with an array of rare and expensive pigments, mostly imported—from northern Europe and South America, as well as the Near and Far East. Venice was the only city in Europe where pigments were sold not by apothecaries but by *vendecolori* (color merchants), who also often stocked painting supplies—canvas, resins, gums, and solvents. For each color, painters could select from various hues and levels of quality. Some of the richest pigments were produced from minerals—including

orpiment, a yellow, and realgar, an orange-red. Realgar was so rarely seen in sixteenth-century pictures painted elsewhere in Europe that its presence was taken as evidence that a canvas was Venetian. Among reds, Venetian painters also had a choice of vermilion and other pigments (made from dyes) called lakes, including kermes and madder. The Venetians themselves produced both lead white and smalt, a dark blue pigment made from grinding up cobalt glass manufactured on the island of Murano. Verdigris came from the Netherlands. The best azurite, a greenish blue made from copper, was mined in Germany and Hungary. Crimson lake (carmine or cochineal) was shipped by the Spanish from South America and brought to Venice through Antwerp. Indigo came from Greece, and also from India.

Venice's infatuation with oil on canvas had far-reaching implications for patronage and collecting. Abandoning fresco gave painters new freedom that they desired. To carry out major commissions, they no longer had to paint on-site, under the eye of patrons, but could work on their own, in their studios.

Even a large canvas mounted on a stretcher is relatively light. When a canvas is framed, the frame generally contains most of the picture's weight. If taken out of their frames and off their stretchers, pictures painted on canvas could be rolled up and reduced to a fraction of their size; they were transportable. When Philip II of Spain commissioned Titian to paint a series of scenes inspired by Ovid, the artist finished the canvases (each over six feet) in Venice, then had them detached from their stretchers, rolled, and packed in crates, which were delivered to the king in Madrid. Most probably two large allegories that Veronese painted in Venice, *Wisdom and Strength* and *The Choice Between Virtue and Vice*, were also rolled and encased to reach the Habsburg court in Prague. There they appear in a 1621 inventory of the imperial collections; they seem to have been acquired by Maximilian II, from the dealer Jacopo Strada, who had also offered the canvases to Albrecht V of Bavaria. By painting on canvas, the Venetians competed for commissions throughout Europe and built reputations on the international stage.

Mobility became a primary attribute of European painting. Pictures were no longer fixed assets. They were portable and subject to trade. Even a canvas painted for the high altar of a church, intended to remain at that site for eternity, had the potential to go somewhere else. But canvases

are also fragile, easily punctured, torn, or abraded, and this vulnerability enhances the sense of their rarity and value. By the end of the sixteenth century, oil on canvas in the Venetian tradition had become the form European pictures would take.

Bonaparte's battlefield success in Piedmont startled the Venetians, and soon they feared that his advance across Italy spelled doom for their ancient republic. Venice's heyday had come three centuries before, in the 1400s, when the maritime power had been one of the richest states in Europe. Its mainland territory then extended west to Milan, but also east to colonies in Istria and Dalmatia, on the opposite shore of the Adriatic, and, until 1571, south to Cyprus. Venice had built its wealth upon trade between Europe and the Middle East and upon the manufacture of luxury goods, especially textiles and glass. Its ships sailed the Mediterranean— west to Gibraltar and east to Alexandria and Beirut, across the Aegean to Constantinople and the Black Sea. Its navy protected its trading vessels, and all these ships were constructed by Venetians in their fortified ship-building complex, the Arsenal.

The Venetians called their republic La Serenissima Repubblica di San Marco, the Most Serene Republic of Saint Mark, and the rest of the world accepted the tribute and the name. "Serenity" spoke to the appearance of the stone city afloat on the lagoon, as well as to the longevity and stability of the republic, which had maintained its independence since the ninth century—for almost a thousand years. Venice was "rich in fame," wrote Petrarch in 1364. It was "mighty in her resources but mightier in virtue, solidly built on marble but standing more solid on a foundation of civic concord, ringed by salt waters but more secure with the salt of good counsel." He praised Venice as "the one home today of liberty, peace and justice, the one refuge of honorable men."

It was the Venetians themselves who in the Renaissance had spun what became known as the "myth of Venice," the portrayal of the Venetian Republic as an ideal state, advanced by divine favor and governed by a self-sacrificing elite. Venice "outshines in her nobility, magnificence, riches, palaces, churches, pious foundations, virtues, councils, empire,

fame and glory, any other city that there ever was," declared the poet Pietro Aretino in 1530.

The Venetian "republic" was an oligarchy, run by patricians and headed by an elected doge. The doge who faced Bonaparte was Ludovico Manin, who had been voted in on March 9, 1789, only four months before the fall of the Bastille. The Republic's endurance depended in part upon the oligarchy's broad base and the Venetian nobility's commitment to put the state's interests ahead of their own. In 1297, with a law called the Serrata (the "Lockup"), they had attempted to secure political stability by limiting membership on the Maggior Consiglio (Great Council) to descendants of the two hundred noble families who then composed it. The names of these families were inscribed in the *Libro d'Oro* (Golden Book) in 1315. They governed and set policy, not only on the Great Council but also in the Senate and on other administrative boards. The doge was elected for life but had limited power. Ranked below the *patrizi* (patricians) were the *cittadini* (citizens)—merchants, bankers, and civil service bureaucrats. The *popolani* (commoners) consisted of artisans, shopkeepers, and workers. Wealth, long concentrated among the nobility, was by the eighteenth century generated mostly by the merchants and bankers, who still lacked political power.

The Myth of Venice took shape also in the visual arts. Pictures in the Doge's Palace show the Venetian Republic personified as a goddess and queen. When Veronese was commissioned to decorate the ceiling of the Great Council Hall, *The Apotheosis of Venice* was the subject he was assigned to paint. He depicted Venice as a beautiful young woman, in flowing robes, seated on a throne, which floats on a bank of clouds. A winged figure of Victory reaches down to place a crown on Venice's head.

Venice had long depended not on fortifications and walls, but on the sea. "Venice is a very beautiful city with many inhabitants," wrote Arnold von Harff, a nobleman from Cologne, in 1497. "It lies in the middle of the salt sea, without walls, and with many tidal canals flowing from the sea, so that in almost every street or house there is water flowing behind or in front, so that it is necessary to have little boats, called gondolas, in order to go from one house, from one street, or from one church to another, and I was told as a fact that the gondolas at Venice number more than fifty thousand."

The city wielded its beauty as a shield, fashioning its wealth into magnificent art and architecture—objects and buildings that armored it with the appearance of affluence, stability, and strength. In the late fifteenth century, the French ambassador Philippe de Commines described Venice as "the most triumphant city that I have ever seen." The Grand Canal was "the fairest and best-built street, I think, in the world," he wrote. It was "so wide that galleys frequently cross one another; indeed, I have seen vessels of four hundred tons or more ride at anchor just by the houses."

At the center of the city, at the eastern end of the Piazza San Marco, rose the Basilica of Saint Mark—the doge's chapel—a Byzantine-Gothic structure with five domes and five doorways. Beside the great domed basilica stood the Doge's Palace, a white and salmon-toned stone structure resting on two tiers of elegant columns. The adjacent ecclesiastical and secular buildings were emblematic of Venice's intermeshed church and state.

Above the central door of Saint Mark's, the Venetians had mounted an extraordinary row of four gilded bronze horses. Fierce and beautiful creatures, the horses flare their nostrils, raise their ears, shake their heads, advancing as they step. These life-sized bronzes had been part of a larger sculpture and attached to a Roman chariot—a *quadriga*—driven by a triumphant warrior or a figure of victory. The four horses of Saint Mark's were long attributed to the Greek sculptor Lysippus, but their ancient origins are unknown.

The Venetians had torn the horses from their place (possibly the gates to the hippodrome) in Constantinople, when in 1204 they sacked the Byzantine capital during the Fourth Crusade. "They stand as if alive, seeming to neigh from on high and paw with their feet," wrote Petrarch in 1364. Looking down from above the central portal of Saint Mark's, the plundered horses transformed the entrance of the church into an arch of triumph.

In the sixteenth century, Francesco Sansovino, a historian and the son of the architect and sculptor Jacopo Sansovino, had observed in a guidebook that "in Venice there are more paintings than in all the rest of Italy." He had counted seventy churches as well as fifty-nine monasteries and convents. These ecclesiastical buildings, along with the Doge's Palace, the

scuole, and the palaces of the nobility were lined with pictures. "There are countless buildings," Sansovino observed, "with ceilings of bedchambers and other rooms decorated in gold and other colors and with histories painted by celebrated artists."

The abundance of paintings in Venice reflected not only the city's wealth but also its social and political structure. Commissions came from many sources—public and private, sacred and secular institutions, run mostly by members of the nobility. These Venetian patricians dispensed contracts to painters to embellish government buildings and then sought the same artists to decorate their palaces in the city and their villas on the mainland. The scholar Daniele Barbaro, who had been the Venetian ambassador to England's court of Edward VI, used his influence to get Veronese his first state commission—to paint *Jupiter Expelling the Vices* and other pictures—for the Room of the Council of Ten. Around 1560, Barbaro and his brother Marcantonio commissioned Veronese to paint frescoes over the walls of the villa that Palladio had designed for them at Maser, some forty miles northwest of Venice. In 1556, Barbaro had collaborated with Palladio in creating an influential edition of Vitruvius's *Ten Books on Architecture*. Barbaro had translated this ancient architectural treatise into Italian, and his extensive commentary together with illustrations drawn by Palladio helped clarify the complicated classical text.

But by the end of the eighteenth century, the wealth that had funded the sixteenth-century Venetian masters as they set the pace for European painting had long since diminished. The Venetian Republic had ceased to be a world power. Even in the late fifteenth century, Venice's overseas empire had begun its gradual contraction. Vasco da Gama's rounding of the Cape of Good Hope in 1497 had undercut the predominant place of the Mediterranean in international commerce and had shifted the center of Europe's Far Eastern trade to Lisbon. With the decline in its maritime empire, Venice began to draw its wealth from manufacturing and agriculture on the mainland. Still, certain members of the Venetian nobility built up their capital and extended their landholdings. By the mid-eighteenth century, at palaces in Venice, some patricians employed more than twenty gondoliers. The end of a series of wars with the Turks in 1718 brought eighty years of peace.

In the eighteenth century, Venice's greatest artist was Giovanni Battista Tiepolo, who modeled himself on Veronese and brilliantly carried on the tradition of grand illusionist narrative scenes, theatrically staged, and shot through with color and light. Tiepolo painted for specific sites—walls and ceilings—in the city of Venice and also in the Veneto and Milan, but he had many commissions beyond Italy. In 1753, he took his virtuosic painting to an extraordinary scale in a masterpiece that extends over a 6,500-square-foot ceiling above the grand staircase of the Residenz in Würzburg. Into a vast expanse of clouds and sky, he set a handsome Apollo and many other gods, and along the ceiling's edge he depicted scores of figures performing in allegories of the four continents; dressed in blue silk, the personification of Asia rides on an elephant. Tiepolo died in 1770 in Madrid, where he had spent eight years completing commissions for the king of Spain.

But the other most celebrated eighteenth-century Venetian artists were two "view painters," Antonio Canal, known as Canaletto, and Francesco Guardi. Both chose the city of Venice as the subject of their work. Their paintings captured Venice at a distance, replicating the detached perspective of foreigners, who stopped there on the Grand Tour and who composed the market for their pictures. Canaletto painted primarily for the British, whose demand for his canvases prompted the artist to move to London for ten years. Guardi never left Venice, though some complained that his views were inaccurate. His vision of Venice was Romantic and melancholy, compared with Canaletto's. He conveyed the city's fragility and showed even the huge dome and towering façade of Santa Maria della Salute, at the entrance to the Grand Canal, dissolving in a play of light.

"My eyes are very pleased by Venice; my mind and heart are not," the political philosopher Montesquieu wrote when he visited in the late 1720s. He described the Venetians as "the best people in the world." He relished the "spectacles and pleasures." But he harshly judged the city, in which theater, opera, and gambling took center stage and Carnival lasted for months: "No more strength, commerce, riches, law; only debauchery there has the name of liberty." To the French of the Enlightenment, Venice had turned from a model of good government to a symbol of hedonism. In *The Social Contract* of 1762, Jean-Jacques Rousseau, who had worked as

secretary to the French ambassador to Venice, observed that the Republic "has long since fallen into decay."

Throughout the seventeenth and eighteenth centuries, Europe's kings, nobles, and other collectors had acquired many Venetian pictures and had them brought north—to England, the Netherlands, Germany, Austria, and France. A 1683 inventory of the paintings of Louis XIV listed twenty-two Titians, eight Tintorettos, and twenty-two Veroneses. In 1746, the elector of Saxony Augustus III had purchased ten Veroneses for the Gemäldegalerie in Dresden, through Joseph Smith, a collector and dealer who was also the British consul in Venice. Smith had pawned off on King George III a *Finding of Moses* that he called a Veronese but was in fact a recent copy painted by Sebastiano Ricci. So skilled was Ricci at these reproductions that the French painter Charles de La Fosse had advised the Venetian artist to stop bothering with his own pictures: "Believe me, sir, make only works by Paolo Veronese and none by Sebastiano Ricci."

To slow the exodus of paintings from Venice, in 1773 the Senate forbade monasteries and churches to sell works of art without obtaining government permission first. That year, the Senate appointed Anton Maria Zanetti, the librarian at the Biblioteca Marciana, inspector of public pictures and assigned him to draw up a catalogue of paintings held by religious institutions.

But despite the losses, Venice still possessed some of its greatest pictures, and they persisted in dazzling Grand Tour connoisseurs. In 1715, Pierre Crozat, a French financier and collector and the patron of Antoine Watteau, had visited Venice for the first time and found its pictures unsurpassed. "I have seen very beautiful paintings in Florence, chez M. le Grand Duc, and I find them here still more superb," he wrote. "Frankly this city is the triumph of painting, and Rome—proud as she is—must cede [preeminence] to it." Crozat summed it up: "Rome had a Raphael, but Venice has had Giorgione, Titian, Paolo Veronese, Tintoretto, Palma Vecchio and Bassano, [and] any one of the six is comparable to Raphael." In his Paris *hôtel*, in the rue de Richelieu, Crozat hung nine Veroneses. In homage to the artist and to demonstrate his own erudition, Crozat placed a copy by Sebastiano Bombelli of Veronese's *Les Noces de Cana*, as he would have called it, in a room near the building's front entrance.

By not choosing sides in the war between France and Austria, the Venetians infuriated both. In 1793, the Austrians had invited the Venetians to join the First Coalition against the French and they had refused. But neither had they wanted an alliance with France.

The Venetians had looked skeptically on the French Revolution, recognizing that the preaching of equality and representative government threatened their ancient patrician oligarchy. In 1792, the Venetian ambassador to France, Alvise Pisani, had raised the alarm from Paris after he, like Napoleon, had observed firsthand the insurrection on August 10, when extremists had murdered the Swiss Guards at the Tuileries and the king had fled the palace: "Never in my life shall I witness such a scene of horror, bloodshed and fear," he wrote. Pisani had retreated to his residence, about a mile from the Tuileries near the Porte-Saint-Martin. He soon found a mob outside his door, shouting: "Ambassador, you are sheltering the King in your house; we want him." Pisani remained cool and managed to persuade the agitators to retreat. Not long after, he fled to London. "Danger is everywhere," he wrote.

Warnings came too from Daniele Dolfin, the Venetian ambassador to Vienna, who was haunted by the threat posed by the citizen-soldiers of the new republic. "The arms of the French are all the more dangerous since the poison of their maxims is diffused everywhere, and by preceding their armies contributes to their success," he wrote in 1793. "The people imagine that their poverty will be relieved by such doctrines."

The Venetians recognized that preventing the French, and also the Austrians, from invading and turning their mainland into a battleground required armed forces they no longer possessed. Even in 1701, when the English writer Joseph Addison visited Venice's famous Arsenal, the shipbuilding complex struck him as something of a museum. "It contains all the Stores and Provisions for War, that are not actually employed," he wrote. The part of the Arsenal "where the arms are laid, makes a great show," he claimed. "And was indeed very extraordinary about a hundred Years ago; but at present a great part of its Furniture is grown useless." Addison observed: "There seem to be almost as many Suits of Armour as there are Guns."

Problematically for the Venetians, they had annoyed the French. In

1794, they had succumbed to Austrian pressure and allowed the Comte de Provence, brother of the late Louis XVI, to take up residence in Verona. His presence drew French émigrés and turned the Venetian mainland city into a center of the royalist cause. Venetian relations with the Republic of France further deteriorated in June 1795, when the ten-year-old dauphin, Louis-Charles, died of tuberculosis in Paris's Temple prison, and the Comte de Provence (also known as the Comte de Lille) declared himself Louis XVIII, heir to the French throne.

That November, after a French victory over the Austrians at Loano, the Directory demanded that Venice expel the pretender. Still reluctant to anger Austria, Venice ignored the French request. But by the following March, with the French about to march on Piedmont, Venice pressured the count to leave Verona, and he departed.

On May 6, 1796, Alvise Querini, who had succeeded Pisani as the Venetian ambassador in Paris, claimed that Venice need not "fear that the French Armies would not fully respect its neutrality, and that its subjects would not remain, as reason would have it, immune from all the calamities of such a disastrous war." That Querini put his reassurances in the negative suggests the great degree of uncertainty he felt. Clearly, the ambassador lacked up-to-date intelligence on the intentions of the French. On the day after, the Directory wrote to Bonaparte that Venice "has done nothing to merit our regard."

3

"Master Paolo will . . . not spare any expense for the finest ultramarine"

We, the Prelate Don Alessandro of Bergamo, Procurator, and I, Don Maurizio of Bergamo, Cellarer, with the present document declare that on this day we agreed with the painter Master Paolo Caliar of Verona, that he will make a painting for us in the new refectory. It will be as wide and high as the wall, and will cover it completely, and it will represent the story of Christ's Miracle at the Supper at Cana, Galilee; it will have as many figures as can fit comfortably and as are required by the subject; the said Master Paolo will do his work as the painter and furthermore will provide all the pigments that are necessary as well as sew the canvas and [supply] any other item he might need all at his own expense. The monastery will simply provide only the canvas and will have the stretcher made for the painting; furthermore he will fasten the canvas with nails and provide whatever else is necessary at his expense; for the said work Master Paolo will use the highest quality pigments and not spare any expense for the finest ultramarine and only the best pigments used by all the experts.

Veronese's *Wedding Feast at Cana* originated in a contract—an agreement signed on June 6, 1562, by the artist and two of San Giorgio Maggiore's Benedictines: Father Alessandro of Bergamo and Father Maurizio of Bergamo, representing the abbot, Girolamo Scrocchetto. Written out in jagged script on a translucent sheet of paper, the contract reveals the terms of collaboration between the artist and the patron, who wanted a painting that would play off the magnificently spare space designed by Andrea Palladio and, from the far wall of the refectory, seize the attention of everyone who entered, and so celebrate the

immanence of god and bring the monastery present and future glory and fame.

Scrocchetto knew that much work went into a canvas before the artist began to paint—the craft of weavers, seamstresses, carpenters, and assistants from the painter's studio. He divided the responsibilities and left the tasks that would most influence the character of the picture to Veronese. The size of the picture—22.2 by 32.6 feet—meant that Veronese would paint it not in his workshop but on-site, in the refectory, where the bare canvas would be installed on the wall.

But first the huge canvas itself would have to be constructed—pieced together from standard bolts of cloth. In the sixteenth century throughout Italy, canvas ran about a meter wide; this width was determined by the width of the hand looms on which weavers wove the fabric. While the monastery was to pay for the canvas, most probably it was Veronese who chose the type—a linen of medium weave that happened to measure slightly more than a meter, or close to four feet, wide. Possibly, the linen was supplied by the artist's brother Antonio, who worked in the textile trade as an embroiderer. To assemble the canvas, Veronese's assistants, or whoever provided the cloth, cut six strips—each more than 32.6 feet long—from the bolts of linen, then sewed these strips together horizontally. To reach a height of over twenty-two feet, they needed five strips, and only part of the width of the sixth strip, which they narrowed to two feet ten inches. So tightly would these strips have been stitched that from the front, the 724-square-foot canvas would have appeared to be a single piece of cloth. Even without priming and paint, the linen weighed more than sixty-three pounds.

According to the contract, the monastery would have carpenters construct a stretcher out of beams of wood to fit the refectory's end wall. But Veronese would supervise the process of attaching the canvas to the stretcher—pulling the fabric taut and nailing it to the stretcher's outer edge. Veronese's assistants would then prime the fabric with thin layers of gesso—a white substance made of gypsum (calcium sulfate) mixed with binders of animal glue—to build a surface strong enough to take the paint. The monastery had also agreed to erect a scaffold that would put the artist at the level of the picture, whose lower edge was some eight feet above the floor.

"As long as he is working on the painting," the abbot invited Veronese to take his meals with the Benedictines: "The monastery will cover the cost of his food . . . and he will be able to eat in the refectory at no charge." Also, Scrocchetto promised the artist a "cask of wine, delivered to Venice to be given to him when he requests it."

In choosing the subject of the picture, the abbot had decided upon the most festive of New Testament suppers—a marriage feast. This celebratory occasion fit the spirit of the order, which held to the rule of Saint

With this contract, dated June 6, 1562, the abbot of San Giorgio Maggiore commissioned Paolo Veronese to paint *The Wedding Feast of Cana*.

Benedict that "all the guests who arrive will be welcomed like Christ, since he himself would say: I was a stranger and you welcomed me." The Venetian Senate had designated San Giorgio Maggiore as the place where the Republic's distinguished visitors would stay. In 1433, one of these guests, Cosimo de' Medici, who was exiled from Florence, had founded the monastery's library, which had since expanded and made the monastery a center of humanistic scholarship.

The abbot set the painting's high level of ambition not simply in the picture's size but also in the beauty of its colors, insisting that Veronese work with only the "highest quality pigments" and the "finest ultramarine." Ground from lapis lazuli, ultramarine was the deepest, richest, most beautiful, and most expensive of blues, costing more than gold leaf. The word "ultramarine" means "beyond the sea"; the pigment was mined in Afghanistan and imported from the Levant.

Scrocchetto understood that what set Veronese and the Venetian artists apart were their colors and their free handling of paint. Later, in the 1990s, conservators analyzed paint samples from *The Wedding Feast at Cana* and confirmed that Veronese had followed the contract and painted the sky in ultramarine. Veronese generally used fine materials, but he was practical and, like most painters of the sixteenth century, wasted almost nothing and would forgo an expensive color if a less expensive one would suffice. When he painted *Mars and Venus United by Love*, apparently for the dealer Jacopo Strada to show to potential patrons in Germany, to be economical he covered the sky with three different blues. He laid down a ground of greenish-blue azurite, then shaded it with the more intense, but cheaper, cobalt-glass smalt. Only sparingly did he then brush on ultramarine. Both azurite and smalt are fugitive and darken over time. By the late seventeenth century, the skies Veronese had painted in smalt had started turning from blue to brown and gray. Requiring Veronese to use only the finest paints, the abbot was thinking first of the allure of the picture, but, intentionally or not, he was directing its afterlife.

For *The Wedding Feast at Cana*, Veronese was well compensated: "And for his payment for the work we promise 324 ducats . . . to be given him from day to day, according to his need." The sum was close to one-third more than the 250 ducats Tintoretto would earn two years later for the

Crucifixion, in the Scuola Grande di San Rocco, a canvas that was almost as large as the San Giorgio Maggiore feast.

But, from the abbot's point of view, the picture was not expensive. The Veronese seems to have cost no more than a piece of Venetian silk of the same size would have cost at that time. At 324 ducats for the 724-square-foot canvas, the Benedictines spent roughly 2 ducats a square ell for the painting—in Venice a silk square ell, or *braccio*, measured 25 by 25 inches, or slightly more than 4 square feet. Early in the sixteenth century, the Paumgartner firm in Augsburg, Germany, had paid 2 ducats a square ell to buy lengths of Venetian satin. For "crimson" satin, the company would have expended more—almost 3 ducats a square ell. Scrocchetto put down an advance: "And for earnest money we have given him 50 ducats." He also set a deadline. "Master Paolo promises to finish the work by the Feast of the Madonna in September 1563." The abbot allowed Veronese fifteen months.

Scrocchetto's most important demand was that Veronese, and not his assistants, paint the picture. The abbot, who had chosen the subject, paid for the fabric, had the stretcher built, and required the best pigments, knew that his quest for an extraordinary canvas rested upon his choice of the artist, who had already proved he was capable of producing masterpieces.

By June 1562, when Scrocchetto decided that Veronese would paint San Giorgio Maggiore's feast, the artist was running a large workshop in Venice, in a building he rented near the church of Santi Apostoli; he accepted multiple commissions for complex cycles of paintings, and finished these difficult assignments on time. In Venice alone, Scrocchetto could have seen more than enough evidence of Veronese's ability to take on subjects from the Old or the New Testament, or from history or myth, to invent intricate narrative scenes to portray them, and to orchestrate these scenes in sonorous color.

Veronese was a first-draft painter. He rarely had to go over things more than once, rethink compositions, or fix mistakes. "He never put his brush in the wrong place," wrote Carlo Ridolfi, who based his 1646

biography of Veronese in part on conversations with Giuseppe Caliari, Veronese's grandson. In contrast, Titian would draw out the process, continuing to question and repaint.

Veronese painted quickly, with broken brushstrokes and dry, thick paint—paint saturated with pigment, and containing only small amounts of oil. To bring his colors to life, he superimposed coats of opaque paint and translucent glazes, which let in light, like stained glass. To describe one red jacket, he had brushed on yellow orpiment, then orange-red realgar, mixed with red lead, and, to pattern the red with clover shapes of blue, he drew them in azurite. Visible strokes of paint reveal the way he dragged his brush, leaving lines unevenly applied, varying in thickness and only incompletely covering the tone below. He favored pure colors— colors based on a single pigment. He thus would escape problems caused when combinations of pigments react and their chemicals change, leading their original tones to degrade. In this way, he ensured his colors would remain as close as possible to the way they looked when he first put them down.

Known for the force of his color, Veronese was also a brilliant draftsman. With free-flowing, lyrical lines of brown ink, he could in the most economical terms lay out complex compositions, while suggesting depth and movement, shadow and light. Before executing a painting with life-sized figures performing in three-dimensional space, he would have made many drawings in pen and ink—drawings of figures and architecture, drawings that mapped out the design. No doubt he did compositional drawings (in ink or in oil) for *The Wedding Feast at Cana* to show Scrocchetto his plans. Once the patron approved the design, the artist would have had his assistants enlarge the drawing to scale and transfer it in chalk onto the picture's white gesso ground: "He would at first place the shape of the figures in proportion to the canvas," wrote Marco Boschini. "Always aiming at placing them in a spacious field, richly covered with majestic architecture." In certain Veronese canvases, traces of charcoal underdrawings can be seen with infrared photography, but even in those paintings without visible charcoal fragments, conservators assume that drawings had been made and then had disappeared beneath the paint.

In 1562, Veronese, the son of a stonecutter, Gabriele Bazaro, was

thirty-four and had lived in Venice for seven years. Already, he had trans-
formed himself into a Venetian painter—one whose pictures would define
the image of the city and its public. By 1555, the artist was calling himself
Paolo Caliari, taking the name from his mother, Caterina Caliari, and his
grandfather Antonio Caliari—a nobleman with whom Caterina's mother,
Maddalena Dragina, had had an affair. The Caliaris' aristocratic connec-
tions no doubt helped the young artist gain the confidence of patrons in
the stratified society first of Verona and then of Venice, but the patrician
part the artist sought to play was also one that came naturally to him. He
"unit[ed] in his person the decorum and the nobility of painting," as Titian
put it. Veronese proved generous and steadfast. He was "always very honest
in his business," Ridolfi wrote. "He always observed his promises, and in
every action, he obtained praise."

One of the first patrons to recognize Veronese's talent and character
was the architect Michele Sanmicheli, who knew the artist when he was
still a boy and working as a stone carver for his father in Verona. Ac-
cording to Vasari, Sanmicheli treated Veronese and the painter Giovanni
Battista Zelotti "as if they were his own sons." In 1551, Sanmicheli helped
them (and Anselmo Canera) win a commission—to paint a cycle of fres-
coes (which have survived only in fragments) on the walls of a villa that
the architect designed for the Soranzo family near Castelfranco, a fortified
town between Venice and Verona.

Verona had been a Roman town, built along the Adige River at the
foothills of the Alps. One of the largest cities in northern Italy, Verona
was known for its antiquities, "for the outstanding arches and theaters,
imitators of the noblest buildings in Rome," as a seventeenth-century
commentator wrote. When Bonaparte later visited Verona, he was im-
pressed by the Roman amphitheater, where "100,000 spectators could sit
down and hear easily all that an orator said." He "could not help feeling
humiliated at the shabbiness of our Champ de Mars." Thus, from an early
age Veronese was surrounded by examples of the ancient Roman ar-
chitecture and sculpture admired in the Renaissance—architecture that
Sanmicheli was reinterpreting on the façades of the monumental stone
palaces he was building for Verona's nobility. Veronese's experience carv-
ing statues and architectural decoration is suggested by the way he later

constructed his compositions, building them upon figures of weight and dimension, who express themselves with gestures, actions, and countless variations of pose. By the time Veronese was thirteen, it was decided (probably by his father) that he should be trained as a painter. He was apprenticed first to Antonio Badile, whose daughter Elena he would later marry. He then worked in the studio of Giovanni Battista Caroto, another of Verona's leading painters.

In 1551, at age twenty-three, Veronese won his first assignment in Venice—from Lorenzo and Antonio Giustinian, brothers from a patrician family—to paint an altarpiece of the *Madonna and Child with Saint Catherine and Saint Anthony Abbot* for a chapel in San Francesco della Vigna. Diplomat that he was, Veronese addressed the problem of Titian's dominance by following his example. He placed the Madonna high on a flight of steps and off-center, as Titian had radically positioned her in his sixteen-foot Pesaro altarpiece in Santa Maria Gloriosa dei Frari.

Veronese was completing *Jupiter Expelling the Vices*—the *sotto in su* (seen from below) tour de force with its figures falling from the sky—in the Doge's Palace, when Bernardo Torlioni, the prior of San Sebastiano, commissioned the artist to paint canvases for the ceiling of the sacristy of that monastery's church. Torlioni came from Verona and would certainly have known of Veronese's work there.

Veronese finished the sacristy pictures—a *Coronation of the Virgin* and images of the four evangelists—on November 23, 1555. Only a week later, on December 1, he signed a contract to paint "the three main canvases" and eight others to surround them for the ceiling of San Sebastiano's nave. These paintings depicted the biblical queen Esther and again demonstrated Veronese's ability to build dramatic narratives with multiple protagonists, to be viewed from below, and here complicated by figures (in billowing robes) ascending or descending flights of steps. Two spirited horses seem about to leap down into the space of the church. He finished the ceiling of the nave by October 30, 1556—in less than eleven months. Veronese went on to cover the nave's side walls with two tiers of frescoes representing scenes from the life of Saint Sebastian. He also designed and painted the organ shutters. When, around 1565, he completed *The Martyrdom of Saint Sebastian* for the high altar, he had

lined the church of San Sebastiano with his paintings—transforming the simple structure into a museum of his art—in a decade, while carrying on other projects.

Veronese would accomplish something of the same sort in a secular setting when in the early 1560s he covered the walls of Daniele and Marcantonio Barbaro's villa at Maser with frescoes. At Villa Barbaro, Veronese played with trompe l'oeil and conjured sculpture, architecture, and landscape—with paint. With his brush, he seemed to set statues into niches and to place pediments over doors, but he also turned solid walls into walls with illusionistic windows through which can be seen painted

Veronese, *Hunter*, ca. 1560. The hunter entering the room with his dogs is one of the illusionistic figures Veronese painted on the walls of the Villa Barbaro, at Maser.

vistas of fields—the same vistas visible from the villa's actual windows. Members of the Barbaro family appear in the hallway—a small girl in a green dress peeks out from behind a curtain, and others greet us. A young hunter seems to step through a door while hounds swirl at his feet. Here, it is as though Veronese is saying, "In paint, I can create anything—I can create it all."

High up on a wall at the center of the house, the artist painted a woman dressed in blue with pearls circling her neck. Giustiniana Barbaro, Marcantonio's wife, seems to stand on a balcony that runs across the room, her hands resting on a balustrade on which a brown and white dog and a green parrot have perched. Nearby on the balcony, a dark-haired boy (her son) looks expectantly up at her face. Above these portraits, the frescoed wall climbs to a ceiling that Veronese has opened to the sky and filled with Olympian gods and other figures who play parts in an allegorical program composed by Daniele Barbaro to show his Venetian family as tied to the land they harvest and living in harmony with the cosmos above.

Veronese won official recognition for his work from the government of Venice in 1557, when the procurators of Saint Mark's commissioned seven artists to paint twenty-one canvas roundels to run across the ceiling of the reading room of the Biblioteca Marciana. Titian and the architect Jacopo Sansovino, who had designed the building, chose Veronese's *Allegory of Music* as the finest of these paintings and awarded him a gold chain.

In Verona, the year before, Veronese had been commissioned by the Benedictine monastery of Santi Nazaro e Celso to paint his first feast, *The Feast in the House of Simon*. In this fifteen-foot-wide canvas, Mary Magdalene is washing the feet of Christ—among thirty figures, arranged along the foreground as though in a frieze. There are "portraits from life and the most extraordinary perspectives," Vasari wrote. "And under the table there are two dogs so beautiful that they seem alive and natural." Also, in 1556, Titian began the very first feast to be painted in Venice—a *Last Supper* for the refectory of Santi Giovanni e Paolo, a Dominican convent whose towering church was famous for containing the tombs of many of the doges. Veronese's success with *The Feast in the House of Simon* in Santi Nazaro e Celso no doubt also helped him win another Benedictine

commission—to paint a feast for the order's far richer and more influential monastery of San Giorgio Maggiore in Venice.

The "supper" or "miracle" at Cana is told in the Gospel according to Saint John (2:1–11). Jesus, his mother Mary, and eight of the apostles attend a wedding celebration in Cana in Galilee. In the course of the meal, the hosts run out of wine. When Mary alerts Jesus to this, he hesitates and asks what he is supposed to do, adding, "mine hour is not yet come." He then instructs the servants to fill six stone waterpots "with water," then draw the water and take it to the steward of the feast. When the steward drinks, he is astonished to taste not water but wine, and while he doesn't know where it comes from, the servants who "drew the water" at Jesus's command know. "This beginning of miracles did Jesus in Cana of Galilee," the gospel concludes. "[It] manifested forth his glory; and his disciples believed on him."

In interpreting the New Testament story, Veronese looked to a nearby source—Pietro Aretino, the poet who was also a friend of Titian's. Aretino had been born in Arezzo but had spent close to thirty years in Venice and had died there in 1556. In his *Humanity of Christ*, Aretino envisioned the supper at Cana as an aristocratic affair. "Here in real splendor, the most solemn, the most noble and the most comely people in the city gathered," he wrote. "The tables were set up and decorated vases of gold and pure silver were placed on them." At first, Christ "rapt in his own humility, had taken a seat beside his Mother, in the lowliest place." But then "having been implored with great vehemence by the Lord of the house," he had moved with his mother "and sat in the most honored place."

Veronese followed Scrocchetto's contract and spread *The Wedding Feast at Cana* across the refectory wall—creating a banqueting scene with life-sized figures and an illusion of reality so convincing that the feast appeared to be taking place in the open air just beyond the end of Palladio's room.

Veronese seated some twenty-five figures—the bride and groom and their guests—at a long table covered with a white cloth, running horizontally almost the length of the canvas. He arranged the sitting figures—Christ

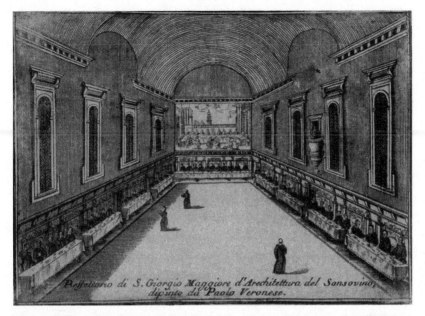

Vincenzo Maria Coronelli, *The Refectory of San Giorgio Maggiore*, 1709. This print shows Veronese's *Wedding Feast at Cana* on the end wall, above the abbot's table. (The inscription misstates the refectory's architect as "Sansovino," when in fact it was Andrea Palladio.)

and his mother beside him, the apostles, and Venetians—along the table's far side. At each end, the table turns at a right angle and comes forward, opening space in the center, as a stage where the artist could multiply the figures and deepen the crowd.

Almost directly below the central figure of Jesus is the handsome dark-haired musician in white playing the viola da gamba, which he holds like a guitar—one of a quartet. In 1674, Marco Boschini claimed that the violist was a self-portrait of Veronese and that the other musicians were Venetian artists—Jacopo Bassano on the flute, Tintoretto on the violin, and Titian, dressed in red robes, on the double bass. "He who can better arrange musical harmonies in painting, let him step forward with his instrument," Boschini wrote. Possibly Veronese put his own portrait and also Titian's into the picture, but, nonetheless, with these four musicians, Veronese claimed for the life of Venice the central place of music, and in a wider sense, the central place of art.

It is a scene charged with celebration. The principal figures are in motion and interlocked, and everywhere servants are dashing with plates and pitchers. Veronese captures the pleasure of eating, drinking, and conversing with friends, the pleasure of listening to music, but above all the pleasure of looking at beautiful objects—or the two-dimensional illusion of beautiful objects created in paint—pearls glinting in a headdress, gold arabesques woven into green silk, the elegant profile of a stone jar, and the light raking its sculpted surface.

Just as the artist directs the glances of the players, he directs the viewer's gaze. Above Jesus, Veronese silhouettes a man raising a knife in the air, poised to chop a piece of meat, the "lamb," that signifies the sacrifice the Son of God will make. Below, on the table between the musicians is an hourglass, recalling the words "mine hour is not yet come."

Veronese stops the action at the moment when the young steward, in a robe of blue, black, gold, and white, raises his glass to study its contents and sees that it is filled not with water but with red wine. Others also notice that the glasses being passed about contain wine, and they pause and seem to puzzle over the miracle. At the front, kneeling on a floor with a geometric pattern of black, gray, white, and yellow—a painted version of the refectory's own stone floor—two servants with the bodies of Roman gods pour wine from jars into pitchers. A boy holds a glass out to the groom. Beside the groom, the bride, resplendent in white, embroidered in blue and gold thread, looks out, as though to catch the viewer's eye. She is one of four elaborately costumed Venetian women with jewels in their blond hair, lined up on the picture's left side. On the right, in the shadow of a building, among the splendidly garbed men are two dressed in black—presumably Benedictines, brethren of those who would be seated at the tables running down the sides of the room.

Almost stealing the show with the humor and assurance of everyday life are two handsome, white whippet-like dogs. They are part of the company, their collars tied together by a single leash. One lies on the stone floor, biting a bone. The other, in profile, strains toward a cat on its back, taunting him, as its paws bat the spout of the jug that is a source of the startling wine.

Far up, at the top of a portico, another dog pokes its nose through a

gap in a balustrade. Nearby, crowning a pediment, is a stone statue of a woman who bends her head and holds out a hand, as though in benediction. Across the way, boisterous figures crane their necks to observe the plates on the table and the finery of the guests. One of them has just tossed a rose in the air.

The painting demands attention with the seductive extravagance of an opera at the moment when the chorus flows onto the stage and the audience doesn't know where to look: colors, fabrics, and faces shift before your eyes.

Veronese built his composition upon figures caught in medias res, protagonists engaged in action, gesturing, talking, doing things—their bodies as beautiful or handsome as classical sculptures. Drapery seems to have weight and to fall over the figures' knees. This layered frieze of linked figures defined a novel approach to composition, with which Veronese reinvented the telling of religious narratives.

So gorgeous were Veronese's paintings—the arrangement and variety of figures, the faces, the slashed sleeves, the cascades of drapery—that beginning with Marco Boschini, who in his 1660 poem "La carta del navegar pitoresco" ("The Map of Painting's Journey") called him "the painter of beautiful things," Veronese has often been dismissed as a producer of "decoration." But in fact, Veronese had plotted out intellectual programs upon which to structure the visual splendor.

In *The Wedding Feast at Cana*, Veronese captured the material wealth and cosmopolitan life of Venice, long dependent on commerce and trade, and shaped by its tradition of fine workmanship. He showed the wealth in aesthetic form—in silver and gold plates, glass goblets, musical instruments, and ravishing clothes, made of Venetian silk: fabric woven in Venice, from threads spun and dyed in Venice.

Upon silk Veronese let loose his illusionism, evoking the play of light on white damask. Boschini singled out Veronese's pictures for the sheer variety of the "Costumes, solemn or extravagant in style," and the fabrics—"Cloth of gold or silver, satins and twills array'd / With patterns of damask and velvet pile," and "Colors of shot silks without end." Boschini was the first to observe that Veronese invented some of his painted textiles: in "real and fantastic clothes of different shapes," he dressed the Venetians

in costumes more elaborate and magnificent than those they had actually worn.

Attiring the wedding guests in garments that signified rank and achievement, Veronese created a portrait of an ideal Venice—Venice as he imagined it, Venice as it should be. He also made the case for the Republic as an earthly paradise, its spiritual and worldly spheres in harmony. The subject that Scrocchetto had selected for the refectory's wall— the miraculous changing of water into wine—became a metaphor for the painter's transformation of life into art.

The masterpiece Veronese created at San Giorgio Maggiore brought immediate demands from other monastic orders in Venice to have the artist paint feasts for their refectories. In 1568, Bernardo Torlioni contracted Veronese to paint *The Feast in the House of Simon* for the refectory of San Sebastiano, the monastery whose church the artist had already filled with pictures. Two years later, for Santa Maria dei Servi, the Servite monastery in the *sestiere* (district) of Cannaregio, Veronese began another *Feast in the House of Simon*, the picture Venice would later give to Louis XIV.

By then, Veronese had married Elena Badile, on April 17, 1566, in Verona. They would have four sons, Gabriele (born in 1568), Carlo (born in 1570), Orazio (born in 1571), and Camillo (born in 1579, he died only weeks later), as well as a daughter, Vittoria (born in 1572). From the early 1580s, Gabriele and Carlo would work, along with the artist's brother Benedetto, in Veronese's studio.

Veronese's success as a painter would make him rich, but Ridolfi emphasized that he "lived away from luxury; and he was careful in expenditure, so that he was able to buy many farms and accumulate wealth and furnishings worthy of any knight." In Venice, he continued to live modestly—moving in around 1566 to a four-story house with a plain façade on Salizada San Samuele. There he would remain.

In 1573, the Dominican convent of Santi Giovanni e Paolo commissioned Veronese to paint a large *Last Supper* for its refectory. The picture was to replace the *Last Supper* by Titian, which had burned in a fire in July two years before. At forty-two feet, Veronese's *Last Supper* was even wider than *The Wedding Feast at Cana*. Again, Veronese painted a feast of extraordinary beauty, mixing the religious and the secular and setting

the biblical scene in Venice—a stately gathering with about fifty figures, richly robed in red, lime green, black, and gold. Three towering classical arches rise from a marble terrace and open onto the portico that shelters the crowd. Veronese has narrowed the focus of the sacred supper by cutting back on the number of figures and stripping away details around the figure of Christ, who sits at the center framed by the white of the tablecloth before him and the blue of the sky behind. Again, Veronese scattered figures from Venice among the crowd, including a small girl up front, on a flight of stairs, with her hand outstretched and her fingers splayed against a marble balustrade. A child who could be from any place or any era, she collapses the distance between the viewer and the artist's sixteenth-century Venetians.

Veronese signed the canvas on April 20, 1573. Then oddly, three months later, on July 18, the Dominicans, who had accepted the finished painting, summoned the artist back to Santi Giovanni e Paolo to defend himself before the Inquisition on a charge of heresy. The tribunal included the papal nuncio Giovanni Battista Castagna (the future Pope Urban VII) but was dominated by Venetians, among them the Patriarch of Venice, Giovanni Trevisan. These inquisitors rarely if ever had dealt with the problems posed by a work of art. They addressed violations of church rules: "apostasy, necromancy, the eating of prohibited food, witchcraft, the abuse of the sacrament, iconoclasm, atheism, . . . Judaising, Moslemising, Grecianising [promoting the east-west schism]," as well as "Lutheranism, heretical conversations, the trafficking in prohibited books, [and] polygamy."

They began by asking Veronese his profession. In his own voice, the painter defended his art before this tribunal, answering with humility and respect, but also with the confidence appropriate to a Renaissance master, someone who believes he should have the freedom to paint as he wants without interference from any authority.

"I paint and compose figures," he replied.

By identifying himself as a figure painter, Veronese distinguished himself from the gilders, sign painters, illuminators, designers of textiles and playing cards, and other craftsmen, who were also members of the Arte dei Depentori, the Venetian painters' guild.

The inquisitors wanted to know if the artist had painted "other Suppers," and he named the three feasts he had painted in Venice. When they questioned the meaning of a figure with a bleeding nose and the "armed men dressed as Germans, each with a halberd in his hand," Veronese seized the chance to defend the artist's privilege to answer only to himself, replying, "We painters take the same license the poets and the jesters take."

Veronese here echoes the Roman poet Horace, who in *On the Art of Poetry* wrote that "painters and poets have always enjoyed the right to take liberties of almost any kind." But Veronese also explained the rationale for including the "armed men": "I have represented these two halberdiers, one drinking and the other eating, nearby on the stairs. They are placed there so that they might be of service, because it seemed to me fitting, according to what I have been told that the master of the house, who was great and rich, should have such servants."

The inquisitors then asked about "a man dressed as a buffoon with a parrot on his wrist." Veronese responded that he was "for ornament, as is customary." Still, who did Veronese "really believe was present at that [Last] Supper?" He told them, "One would find Christ with His Apostles." Then he added: "But if in a picture there is some space to spare, I enrich it with figures according to the stories." He explained, "I received the commission to decorate the picture as I saw fit. It is large and, it seemed to me, it could hold many figures."

They continued to press him. "Does it seem fitting at the Last Supper . . . to paint buffoons, drunkards, Germans [i.e., Protestants] . . . and similar vulgarities?" He answered no, but later argued that he did "not intend to confuse anyone, the more so as those figures of buffoons are outside of the place in a picture where Our Lord is represented."

But by then the inquisitors had already gotten to the point: Did the artist "not know that in Germany and in other places infected with [the Reformation's] heresy . . . it is customary with various pictures full of scurrilousness and similar inventions to mock, vituperate, and scorn the things of the Holy Catholic Church in order to teach bad doctrines to foolish and ignorant people?"

"Yes, that is wrong," Veronese admitted. However, seizing upon an

example that could undercut the inquisitors' objections, he then pointed out that when Michelangelo portrayed the Last Judgment in the Sistine Chapel, he "painted Our Lord, Jesus Christ, His Mother," and others "in the nude—even the Virgin Mary—and in different poses with little reverence," and the pope had permitted it.

In the end, the inquisitors demanded Veronese "improve and change his painting" at his own expense and gave him three months to do it. But Veronese had powerful patrons in Venice. The only change the artist made to the *Last Supper* in Santi Giovanni e Paolo was to its title (and so to its subject as well). From then on, the painting was to be called *The Feast in the House of Levi*—a dinner Jesus had with tax collectors, mentioned only briefly in the Bible. Also, in the foreground of the canvas, Veronese added what appears to be lettering, carved in the marble balustrades, that quotes the biblical source—Saint Luke—in Latin:

FECIT D[OMINVS]. CO [N] VI [VIVM]. MAGNV[M]. LEVI/LVCAE CAP[VT]. V.

(LEVI MADE HIM A GREAT FEAST IN HIS OWN HOUSE.)

In his will, drafted in 1591, Veronese's brother Benedetto would write a wrenching tribute to the artist: "We loved him as a father, and as the one favored by God he had a better destiny than me. And I truly saw myself as his son and brother for the benefits that over time I received, possibly over forty years of my life." Three years earlier, on April 19, 1588, in his house on Salizada San Samuele, at age fifty-nine or sixty, Veronese had died.

4

"He is rich in plans"

His height is less than medium, his face lean and pale, his eyes lively and his body slender. He is self-composed and very reflective. He gives such clear and precise orders to the subordinate Generals that they have little or nothing left to add. He knows the strength of his army in its different positions so well that he can order their movements by heart and in an instant, without seeking any help. He is rich in plans and is able to take them to completion in a straightforward manner.

Thus, on May 29, 1796, Leonardo Salimbeni, a Venetian army captain, described Napoleon, alerting his government to exactly what made the French general a threat. Salimbeni had been sent to deliver a letter to Bonaparte and had met with him in Brescia, one hundred miles west of Venice, three days before.

Always on the move, stopping sometimes only for a matter of hours, Bonaparte was hard to track down. As he darted from place to place, the Venetians sent envoys to meet him. They wanted to argue the rights of the Republic, to demand that the French respect Venice's official state of neutrality, to gauge his intentions, and to assess his power.

The meetings were brief. Bonaparte boasted that he never wasted time. He certainly had little time for Venice and treated the ancient republic with contempt—a contempt reflecting the judgment of the French, who over the past century decried the demise of Venice as a maritime empire.

These Venetian diplomats were among the very first outside France to deal directly with Napoleon. Trained to gather intelligence on Venice's enemies and its allies, they proved astute observers and analysts of Bonaparte's character, and they took exact measure of the unlikely French general.

At that point, those who met Bonaparte had no preconceived image. His portrait had yet to be painted.

The victorious commander didn't look the part. In one of the first drawings ever made of Napoleon, the French artist Antoine-Jean Gros shows a gaunt face, a profile with an aquiline nose, wide eyes, and a penetrating gaze, at odds with the disordered look of the locks falling over his high collar. He was "a young man, of pale and yellowish complexion, grave and bent over, looking sickly and frail," wrote the French war minister the Comte de Pontécoulant, himself only thirty.

Bonaparte gave no better first impression in June 1796 to André-François Miot de Melito, the French envoy to Tuscany. The general "was

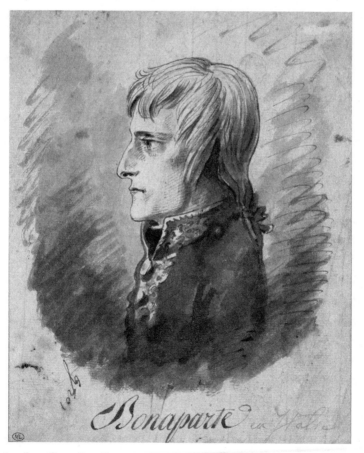

Antoine-Jean Gros, *Bust Portrait of Bonaparte*, 1796–1797.

anything but good looking." He was "below common height and very thin. His hair, powdered and cut square below his ears, fell on his shoulders. He was dressed in a tight tunic buttoned to the top, with narrow gold facings; and he had a tricolor feather in his hat." Miot concluded, "But his strong features, keen questioning look and quick decisive gestures revealed a flame-like spirit."

Yet looking the part was beside the point. Bonaparte had worked his way up through the republican army on intelligence, talent, and luck, bringing a new level of competence and professionalism to the officer corps, whose ranks had been decimated by the flight of the aristocracy from France.

Bonaparte knew he had to inspire his officers and his troops by the force of his personality, by convincing those who met him that he possessed the attributes required for a commander in chief. His enemies and others who distrusted him delivered some of the most astute judgments of his character. He was "to be feared as troublesome, of ardent republican spirit, of vast knowledge in things military, of great activity and great courage," wrote an Austrian minister in 1796.

Restless and intense, he astonished those who met him with his energy, as well as his ability to analyze information and to formulate and execute the logistics necessary to provision his army. He drilled his subordinates for facts. A quick study, he kept track of many things at once, writing as many as fifteen letters a day and, in those letters, leaping among subjects, both trivial and important. "A singular thing about me is my memory," he noted. "As a boy, I knew the logarithms of thirty or forty numbers."

But Piero Mocenigo, the Venetian governor of Brescia, rightly found the logician and planner to be mercurial. Bonaparte was a cultivated "individual," he wrote in a dispatch to the Senate on May 27. "A young man of 28, he feels the passions of pride to the highest degree; resolute in his decisions, he believes everything dependent upon his [own] will to be limitless." Mocenigo warned Venice:

> Every situation—even an innocent one—in which he believes he can perceive some opposition to his intentions in a flash makes him turn to ferocity and threats. Everything is overstated, indescribable presumptions,

continuous suspicions [. . .] and should a wish of his not be supported, his ill-humor immediately takes over and creates some delicate circumstances. . . . [Take him on] . . . with care and with adroit threads appropriate for a vain man who believes he is superhuman.

The French military's velocity and energy also alarmed Mocenigo. "The churning of ideas among the commanders of the French army is incalculable; courage, weapons, writings, songs, seduction and praise are all present in these new men," he wrote.

Bonaparte mostly kept his volcanic feelings in check, but they propelled the pragmatism of a strategist whom a twentieth-century historian called "a pure eighteenth-century rationalist." Claire-Élisabeth de Rémusat, who would work as a lady-in-waiting to Josephine, saw him differently. "Was he not a completely eccentric person, always alone on one side, with the world on the other?" she asked. "This view of the world is what makes his politics."

Bonaparte revealed a romantic imagination in his writings—well-crafted orders of the day sound like trumpet calls. Certain proclamations and dispatches recount the campaign with the flourish of epic poetry. On May 6, 1796, he commended the troops: "You have won battles without cannon, crossed rivers without bridges, undertaken forced marches without boots, bivouacked without liquor and often without bread." Rarely did Napoleon waste the chance to cast his situation in dramatic, historic, or cosmic terms. This streak of romanticism not only infused his visions of his destiny but also, at this moment, served to attract others longing for such inspiration.

Bonaparte had been born on August 15, 1769, into the minor nobility of Corsica, just one year after France had bought the rights to the island from the Republic of Genoa. Once Corsica had become a territory of France, Napoleon's father took advantage of a policy put into effect by Louis XV that awarded academic scholarships at twelve French military schools to boys from impoverished noble families. Napoleon won one of these six hundred scholarships and on January 1, 1779, entered a school in Autun, in Burgundy. He spent only three months there but learned enough French to transfer in May 1779 to the military school in

Brienne-le-Château, near Troyes, in Champagne. At Brienne, he studied Latin, Roman history (Caesar's *Commentaries* and Cicero), some French literature, and mathematics, a subject in which "he has throughout distinguished himself by his steady work." "To be a good general, you must know mathematics," Bonaparte would later write. "It serves to direct your thinking in a thousand circumstances."

From Brienne, in October 1784, he went on to the École Militaire in Paris. There he took the courses he preferred—mathematics, geography, and history, as well as French, German, and drawing. In 1785, he placed forty-second out of fifty-eight on the final exam.

As an artillery commander, Bonaparte first proved himself in 1793, when he helped drive the British from the harbor of Toulon and demonstrated an ability to plan, consider outcomes and possibilities, then work backward and calculate the arms and the men he needed to achieve his objectives. He had arrived at the port city to find only four cannons and two mortars in the battery put under his command. Within weeks, he had obtained one hundred guns and had them firing twenty hours a day. To build up supplies of gunpowder, cannonballs, muskets, and shells, he scouted out a foundry and hired workers to manufacture what he needed. Brimming with confidence, he took a lead role in directing the attack against the British on December 17 and was injured by a bayonet piercing his thigh. Five days later, he was promoted to brigadier general.

In Toulon, Bonaparte met Augustin Robespierre, a National Convention deputy, who recommended him to his brother Maximilien, an influential member of the Committee of Public Safety, which was running the government when terror was made "the order of the day." Augustin wrote, "I would add to the list of patriots the name of citizen Buonaparte, general in chief of the artillery, an officer of transcendent merit."

On July 27, 1794 (9 Thermidor, Year II, in the new revolutionary calendar), a coup toppled Maximilien Robespierre and his allies, and the following day he was executed. Almost two weeks later, on August 9, with the new "Thermidorian" regime in place, Bonaparte's ties to Robespierre led to his arrest in Nice and he was detained. On August 20, he was freed, and soon General Pierre-Jadart Dumerbion, then commander of France's Army of Italy, requested he submit plans for the campaign there. That fall,

Bonaparte went to Italy twice with the army and developed strategies for fighting in Piedmont. In 1795, while struggling to advance—he participated in an expedition to recapture Corsica, which was foiled by the British, and then avoided being sent to repress the insurgency in the Vendée—he was hired by Pontécoulant for the Topographical Department in Paris.

There, on October 5, 1795 (13 Vendémiaire, Year IV), a royalist rebellion broke out, and Paul Barras, head of the Army of the Interior, recruited Bonaparte to stop it. In the center of Paris, close to the Tuileries, where the National Convention met, Bonaparte brought cannons and in a matter of hours his five thousand troops suppressed the largely unarmed insurgency of thirty thousand, gunning down three hundred of the rebels on the rue Saint-Honoré, outside the church of Saint Roch. Soon, Barras named Bonaparte to succeed him as commander of the Army of the Interior. "Promote this man," Barras wrote, "or he will promote himself."

Bonaparte made the same impression in Nice, at the start of the 1796 Italian campaign, when he first met with his generals, including Pierre Augereau, Louis-Alexandre Berthier, and André Masséna. Masséna later told the government commissioner Saliceti that at first he and the others "formed a pretty poor opinion" of Napoleon. Bonaparte's "few inches and weak physique were not impressive." They imagined "from the way he carried about his wife's portrait and showed it to everyone, and still more from his extreme youth, that he owed his appointment to yet another bit of intrigue." But, Masséna added, in only a "minute or two," they changed their minds. "He asked us where our divisions were stationed, how they were equipped, what was the spirit and fighting value of each corps; he gave us our marching orders, and announced that tomorrow he would inspect the whole army, and the day after tomorrow it would march and deliver battle against the enemy. He spoke with such dignity, preciseness and competence that his generals retired with the conviction that at last they had a real leader." Bonaparte's authoritative manner assured them he had earned his way to his post.

The portrait that Bonaparte "showed to everyone" was of Josephine de Beauharnais. From the start, their partnership was driven by passion,

sometimes on one side, sometimes on the other, but mostly by the recognition of the advantage of the joint enterprise, which drew both parties into the spotlight.

Marie-Josèphe-Rose Tascher de la Pagerie de Beauharnais was thirty-two (six years older than Bonaparte) and a vicomtesse. She was the widow of Alexandre de Beauharnais, who had served as president of the National Assembly and general in chief of the Army of the Rhine. When Louis XVI fled Paris in June 1791, Beauharnais was the one who had sent troops to intercept him, and he had interrogated the king on his return.

Pierre-Paul Prud'hon, *Empress Josephine*, 1805. Prud'hon portrayed Josephine in a wooded landscape on the property of the Bonapartes' Château de Malmaison the year after Napoleon became emperor of the French.

Bonaparte met Josephine in October 1795, probably through Paul Barras (she'd been his mistress), when she was living in Paris with her fourteen-year-old son, Eugène, and twelve-year-old daughter, Hortense. In the sophisticated, shifting social politics of Paris, she had experience, and Bonaparte fell in love with her.

Josephine had grown up in Martinique, the daughter of Joseph-Gaspard Tascher de la Pagerie. She had arrived in France in 1779, at the age of sixteen, already engaged to Beauharnais. They had not been happily married. She had responded to her husband's liaisons by becoming the mistress of General Lazare Hoche.

In 1794, Beauharnais was arrested and imprisoned. In an attempt to have him freed, Josephine was thrown in prison herself. They were held in the vault beneath the church of Saint-Joseph-des-Carmes, in rue de Vaugirard, a prison where 115 priests had been slaughtered nineteen months before. "The walls and even the wooden chairs were still stained with the blood and the brains of the priests," wrote Grace Elliott, the Duc d'Orléans's mistress, who had also been incarcerated there. Beauharnais was executed on July 23, 1794. Five days later, Robespierre went to the guillotine. Josephine was freed the same day.

Some scholars credit the time in prison to explain Josephine's extravagance and appetite for pleasure. Later, when she became empress of France, she would have a large allowance, but rarely keep within it. Her annual spending would run on average to some nine hundred thousand francs, and the bills from her dressmaker (she owned more than nine hundred dresses) would also exceed those of Marie-Antoinette. Josephine's contemporaries found her vivacious and attractive. Charles-Maurice de Talleyrand-Périgord dismissed her as lacking intelligence but granted that "no one ever managed so brilliantly without it."

An aristocrat and a keen observer, Talleyrand would negotiate his way through France's political upheavals and ally himself with Napoleon early on. Prevented by an injured foot from following his father into the military, he had entered the priesthood, becoming bishop of Autun at age thirty-four and representing the church in the Estates-General. But he supported the Revolution and turned to subjugating the church to France and confiscating its lands—acts for which Pope Pius VI excommunicated

him. Talleyrand escaped the Terror by fleeing to the United States; he returned to France in 1796 when Bonaparte was fighting in Italy.

To Bonaparte, Josephine represented upward mobility. That his Corsican heritage came through in accented French no doubt only fueled his ambition to find acceptance in Paris. In a letter to his brother Joseph in July 1795, Napoleon conveyed the appeal the French capital held for him in the general euphoria that followed the Terror. "Here in Paris, luxury, enjoyment, and the arts are resuming their sway in surprising fashion," he wrote. And "who," he asked, "could be a pessimist in this mental workshop, this whirlwind of activity?":

Smart carriages and fashionably dressed people are once more in the streets; they have the air of waking up after a long dream, and forgetting that they ever ceased to display themselves. The book shops are open again. There is a succession of lectures on history, chemistry, botany, astronomy and so forth. The place is crammed with everything that can distract, and make life agreeable. No one is given time to think. . . . Women are everywhere—applauding the plays, reading in the book shops, walking in the Park. . . . Paris is the only place in the world where they deserve to steer the ship of state: the men are mad about them, think of nothing else, only live by them and for them. Give a woman six months in Paris, and she knows where her empire is, and what is her due.

It was three months later, in October 1795, that Bonaparte was introduced to Josephine. Their marriage and his departure for the Italian campaign took place in early March 1796; she would visit him in Italy, arriving in Milan that July.

5

"This museum must demonstrate the nation's great riches"

Let us show the world what a sovereign people can do; and that
the completion of the Louvre becomes a brilliant testimony to the
superiority of the new regime over the regime of old.
—Armand-Guy Kersaint, *Discours sur les monuments publics*

What did Napoleon know of art? He knew that in France the visual arts were inextricably linked to political power, that Louis XIV and other French kings had few rivals in their extravagant collecting and patronage of painting and sculpture, and in exploiting art to aggrandize their reigns. Napoleon also knew that in plundering the art of Italy, the Louvre would be his collaborator. The Paris museum would distract eyes from the bloodshed and casualty counts, disguising his ruthlessness with the brilliance of its collections and transmuting that ruthlessness into glory.

As a public museum of art in the former palace of the Bourbon kings, the Louvre was complicated and contradictory, royalist and republican, born of the ideology and violence of the Revolution, but in its magnificent Renaissance architecture proclaiming its origins as the seat of the absolute monarchs of France. From the start, the Louvre had lined its galleries with art brought to its doors by means of seizure and appropriation—art taken from the various royal residences, but also from the churches, monasteries, and convents, shuttered in November 1789 with the abolition of the French Catholic church, and from the palaces of the nobles who had fled France. This same method of collecting paintings and sculpture for the Paris museum Napoleon now applied abroad.

France's revolutionary government had chosen August 10, 1793, to open the Musée Français in the Louvre. The date marked the one-year anniversary of the fall of the French monarchy: on August 10, 1792, one

Jean Marot, *West Façade of the Cour Carrée of the Louvre*, seventeenth century. The beautifully proportioned, richly ornamented façade to the left of the tower, designed in 1546 by the architect Pierre Lescot and the sculptor Jean Goujon, would inspire the architecture of the Louvre's later wings.

of the bloodiest days of the Revolution, Louis XVI had been put under arrest and imprisoned.

Only nine days after the king's overthrow, deputies of the National Assembly announced their intent to create a gallery in the Louvre. They declared "the importance of bringing together at the museum the paintings and other works of art that are at present to be found dispersed in many locations." They added: "There is urgency." The urgency reflected the fear of Jean-Marie Roland, the minister of the interior, and others that the royal collections of art were at risk of destruction from radicals wanting to eliminate all traces of the ancien régime.

In the Place de la Révolution, Jacobins had torn down Edmé Bouchardon's equestrian statue of Louis XV and had the bronze cut up and melted, to use in the manufacturing of armaments. On the façade of Notre-Dame, the heads of twenty-eight gothic statues, each ten feet tall and carved in the thirteenth century, had been hacked off. The Paris council that ordered the destruction of the twenty-eight "Kings" of Notre-Dame seemed unaware that the statues represented the kings of ancient Judah, and not the medieval kings of France.

The urgency to preserve the king's collection was all the greater in light of the sudden loss to Paris of the stupendous collection of the Duc d'Orléans—a stockpile of some five hundred Italian, Dutch, and Flemish paintings that rivaled (and some said surpassed) the collection of the duke's

cousin, the French king. The Orléans collection had been amassed primarily by Philippe II; the rich and dissolute nephew of Louis XIV was regent to his cousin Louis XV when the five-year-old boy inherited the throne in 1715. Philippe II bought art in bulk. In 1714, he had sent Pierre Crozat to Rome to negotiate the purchase of the collection of the late Queen Christina of Sweden. Christina had acquired many of her finest pictures from the collections assembled by Rudolf II, Holy Roman Emperor, when, in 1648, her army had plundered Prague. By 1727, the Orléans collection (including 123 of Christina's pictures) was on public view at the Palais Royal, the Orléans palace, built by Cardinal Richelieu, across from the Louvre. In his Paris guidebook, Joachim Nemeitz, a Strasbourg-born author, declared the "new gallery with various rooms embellished by rare paintings . . . the most remarkable part of the palace." There were twenty-seven Raphaels, twenty-nine Titians, and nineteen Veroneses.

The Orléans collection was a casualty of the Revolution. In 1791 and 1792, Louis-Philippe-Joseph, the great-grandson of Philippe II, had sold his family's pictures in a complicated series of transactions that delivered them to collectors in England. The duke, who called himself Philippe Égalité, was forced to raise funds to pay off debts run up from his gambling and his financing of the Revolution. First, he let go of the Dutch and Flemish pictures. Then, the Italian, French, and Spanish were purchased by a Brussels banker, who sold them to Count François Laborde de Méréville. By 1792, Méréville had shipped more than three hundred of the Orléans paintings to London, where they were purchased by three British nobles: Francis Egerton, the third Duke of Bridgewater; his nephew, George Granville Leveson-Gower, Earl of Gower; and Frederick Howard, the fifth Earl of Carlisle, Gower's brother-in-law. This syndicate kept about one hundred pictures and had auctioned the rest.

The Orléans sales effectively slashed the quantity of old masters in Paris by one-third. That England benefited from the dispersal made it all the more galling to France. When the Orléans pictures went on display in London, the essayist and critic William Hazlitt wrote of being "staggered" by seeing "Titian, Raphael, Guido [Reni], Domenichino, the Carracci . . . face to face." The influx of pictures to England began to compensate for the paintings lost after the execution of Charles I, in

1649, when Oliver Cromwell's revolutionary government had auctioned the king's collection, one of the greatest in Europe.

On September 17, 1792, less than a month after the National Assembly's decision to establish the Paris museum at the Louvre, Interior Minister Roland ordered 125 of the finest paintings owned by Louis XVI removed from Versailles and delivered to the "Old Louvre." Among the king's pictures transferred to Paris were Titian's *Man with a Glove* and *Supper at Emmaus* and Leonardo da Vinci's *La Belle Ferronnière* and *Virgin and Child with Saint John the Baptist and an Angel*, known as the *Virgin of the Rocks*. The *Mona Lisa* would arrive on August 12, 1797, five years later.

The Leonardo portrait of Lisa Gherardini, commissioned in Florence in 1503 by her husband, the silk merchant Francesco del Giocondo, had been acquired from the artist in 1518 by Francis I. Like Napoleon, Francis fought the Habsburgs in Italy, and in 1515 conquered the Duchy of Milan. There, he saw Leonardo's *Last Supper* and had invited the artist to come to France. In 1516, Leonardo moved to the Château du Cloux (Clos Lucé), in Amboise, on the Loire, where as "First Painter, Engineer, and Architect to the King," he spent the last three years of his life.

More than a century later, Louis XIV had also added to the royal painting reserves, thanks in part to Cardinals Richelieu and Mazarin and the banker Eberhard Jabach, many of whose pictures ended up at Versailles. Both Mazarin and Jabach had taken advantage of the sale of Charles I's collection. They had joined kings and princes who, the Duke of Clarendon wrote, "made haste . . . that they might get shares in the spoils of a murdered monarch." At his death in 1715, Louis XIV had 1,478 paintings in his possession; 903 of them were French and 369 were Italian, including Titian's *Supper at Emmaus*, once owned by Charles I, then bought by Jabach, who bequeathed it to the French king.

The collecting of paintings and sculpture was part of Louis XIV's extravagant project to have France take the lead in the fine and decorative arts. Wanting French tapestries to compete with those of Flanders, Jean-Baptiste Colbert, Louis XIV's finance minister, took over the Hôtel des Gobelins, in the Faubourg Saint-Marcel, and there he consolidated workshops from all over Paris. To the staff of weavers and dyers, he added cabinetmakers, founders, sculptors, engravers, and gilders, expanding the factory's capacity

so it was capable of manufacturing all the types of decorative arts required to embellish the palaces and other buildings owned by the crown.

In the late eighteenth century, despite their political troubles, Louis XVI and Marie-Antoinette also kept France's craftsmen at full employment. Like his predecessors, Louis XVI sought to have his collections enhance the splendor of his court and shore up his authority. But the Enlightenment had brought the idea that the kings and princes of Europe should open their private galleries and allow their paintings and sculpture to be seen by a wide audience. In 1750, Louis XV had put 110 of his paintings (half of them Italian) on view two days a week (winter mornings and summer afternoons) at the Luxembourg Palace. Following suit, Louis XVI had instructed Charles-Claude Flahaut de la Billarderie, the Comte d'Angiviller, his director general of royal buildings, to draw up plans to turn the Louvre's Grande Galerie into a museum in which he would exhibit some of the royal collections. However, disputes between architects over the design and the lighting stalled the project, and the Revolution intervened. Not long after the fall of the Bastille, the Comte d'Angiviller fled France.

At the Louvre, the revolutionaries sought to exploit the royal collections for their own political purposes. The new art gallery, with the king's extraordinary holdings transferred to the public and open to all, became a symbol of French democracy and the aspirations of the modern state. "This museum must demonstrate the nation's great riches. . . . France must extend its glory through the ages and to all peoples: the national museum will embrace knowledge in all its manifold beauty," Roland wrote to the painter Jacques-Louis David on October 17, 1792. "By embodying these grand ideas, worthy of a free people . . . the museum . . . will become among the most powerful illustrations of the French Republic."

The new museum was intended to appeal not simply to artists and connoisseurs—those who studied art or who possessed it—but to a broad public; it was expected to instruct and to educate. "The museum is not supposed to be a vain assemblage of frivolous luxury objects that serve only to satisfy idle curiosity," David declared in 1794. "What it must be is an imposing school." The Louvre's most important pupils, in David's view, were the artists of France. He had been instrumental in closing down the

French Royal Academy of Painting and Sculpture, on August 8, 1793, after denouncing it in a speech as "the last refuge of all aristocracies." Instead, he wanted French painters and sculptors to have the freedom to choose their teachers and to learn by studying the masterpieces in the Louvre.

Hailed for over a decade as the greatest artist in France, David understood as few others the political potential of art. He had first made his name at the 1785 Paris Salon with his smoldering but austere *Oath of the Horatii*, a "history painting" commissioned by Louis XVI, but whose patriotic call was later seen to have prefigured the Revolution. David took the story of the Horatii, brothers who swear to fight to their deaths for the Republic of Rome, from the Roman historian Livy, and he exhibited the painting in Rome before unveiling it in Paris. He showed the three young warriors in a row reaching toward three swords held high by their father as they make their suicidal pledge. David intensified the drama by muting the colors and delineating the players in sharp contours. What was radical was the seamless mixing of the ideal and the real; the Roman soldiers seem to be made of flesh and blood, but in their flawless figures they resemble the gods and heroes of ancient sculpture. Denis Diderot, who had demanded that French artists reject the frivolity and whimsy of the rococo, praised David for depicting the "severity, rigor and discipline of Sparta." Soon David's neoclassicism caught fire not only in Paris but throughout Europe.

As a student, David had been brilliant and temperamental. "We are dealing with a man who is open, honest, but at the same time excitable enough to need careful handling," wrote the artist Jean-Baptiste-Marie Pierre, First Painter to the King. Later, when David failed to be appointed head of the French Academy in Rome, the Comte d'Angiviller suggested that he wasn't ready: "In six years' time, he will be less of a hothead."

That intensity drove the artist to enter politics during the Revolution's most radical phase. In September 1792, he was elected to the National Convention as a deputy representing the Louvre section of Paris—the district surrounding the palace. Like other prominent artists, David had been given rooms in the Louvre by the government to use as a studio and an apartment. In January 1793, David was one of the delegates to vote for the death of the king and allied himself with Maximilien Robespierre. A

member of the Committee of General Security, David signed some four hundred warrants of arrest.

David's Jacobin politics shifted the direction of his art away from ancient history. When he won the commission to paint *The Oath of the Tennis Court*, he declared: "I shall not need to invoke the gods of fable to excite my genius. Nation of France it is your glory that I wish to promote." That glory he gave in the summer of 1793 to Jean-Paul Marat in one of his greatest paintings—*The Death of Marat*—a hot-off-the-press record of political assassination and an image of a revolutionary martyr whose pathos recalled Michelangelo's *Pietà*.

Marat was the publisher of an inflammatory populist journal, *L'Ami du Peuple*. He had gained such influence that his denunciations of his opponents sometimes led to their deaths. Germaine de Staël summed up his malevolent power: "Posterity will perhaps remember [Marat] in order to attach to one man the crimes of an epoch."

But David's portrait forced history to see Marat differently. The painter shows the revolutionary moments after he had been stabbed (on July 13, 1793) by Charlotte Corday. The top half of the five-foot painting is empty and dark. His turbaned head is slumped back, his eyes are closed, his well-made right arm has fallen slack, and his fingers still hold a quill pen. The painting's nightmarish beauty is derived from the sharpness of the details: a sheet of paper, with eight lines of script in Marat's left hand, the glint of the bloody knife blade, a note of paper currency—the revolutionary government's *assignat*.

"The drama is there, alive in all its pitiful horror . . . ," the French poet and critic Charles Baudelaire would write. "Where now is that famous ugliness which holy Death has so swiftly wiped away with the tip of his wing? Henceforth Marat can challenge Apollo." David exhibited *The Death of Marat* in a pavilion in the courtyard of the Louvre, before hanging the picture in the Salle du Manège, the former royal riding academy in the Tuileries Gardens, where the National Convention met.

At this brutal moment, some looked to the Louvre to counterbalance the guillotine, which stood in front of the Tuileries, and to restore faith at home and abroad in the character and reputation of France. The museum must "prove to both the enemies as well as the friends of our young

Jacques-Louis David, *The Death of Marat*, 1793.

Republic," argued Dominique-Joseph Garat on July 4, 1793, "that the liberty we seek, founded on philosophic principles and a belief in progress, is not that of savages and barbarians." Garat had become the minister of the interior five months before, replacing the more moderate Roland, who, as an aristocrat, had taken flight from Paris. The latter's wife, the writer Marie-Jeanne Roland, had stayed in the capital. She was arrested and imprisoned, and on November 10, she was tried and executed. When, days later, in Rouen, Roland learned of her death, he committed suicide. By then, the guillotine had been moved to the other side of the Tuileries Gardens and set up in the Place de la Révolution—distanced from the Louvre.

6

"Draw as much as you can from Venetian territory"

The contradictions that emerge between the actual conduct and
the words of the French leave room for hope. . . . The state finances
will have to be subjected to a grave sacrifice. [But] . . . public tran-
quility will not be compromised.
— Francesco Battagia and Nicolò I Andrea Erizzo
to the Venetian Senate, June 5, 1796

On May 11, 1796, only five days after Alvise Querini, the Venetian ambassador to France, had reassured his government that the French army would "respect [Venetian] neutrality" and spare Venice "the calamities of such a disastrous war," he was proved wrong. That day, General Berthier, Bonaparte's chief of staff, and some two thousand French troops crossed from the Duchy of Milan into the Republic of Venice, reaching the fortified Venetian town of Crema. Berthier immediately issued the demand the Venetians had feared: that Venice, being "a friend to the French and neutral in the present war" should allow his army "to enter and pass through this territory." Only the day before, the French had charged a bridge across the Adda River, at Lodi, forcing the Austrians to retreat east toward their stronghold in Mantua and clearing Napoleon's way to the city of Milan.

Berthier delivered his order to Crema's governor, Zan Battista Contarini. Before responding, Contarini explained to the Venetian government that he would have no choice but to acquiesce to the French. He possessed only an "extremely weak garrison of infantry and cavalry" and was "completely without gunpowder and ammunition."

Only two days before, Contarini had received the same orders from the Austrians and had failed to prevent their troops from invading his Venetian province. Contarini came from a low-level patrician family,

neither rich nor politically well connected. He would tell Berthier that he was "trusting in the good relations that exist between the two republics, [and] he was convinced that [Berthier] would not in any way disrupt the state of neutrality which the Venetian government enjoys and which its subjects hope will spare them any damage."

On May 12, Bonaparte himself reached Crema. He immediately arranged to see Contarini, and for the first time the Venetians encountered the French general face-to-face. Bonaparte had many questions to ask. Why had the Venetians allowed the Austrian general to march his troops through Crema? Why hadn't they granted the same to the French? Bonaparte was accompanied by the French government commissioner, Cristoforo Saliceti.

Bonaparte but "especially" Saliceti expressed "a rather angry tone filled with dissatisfaction for the Serenissima Venetian Republic," Contarini reported. Saliceti had "sprawled with contemptuous disregard in the armchair." He had spelled out the French complaints: Venice had "kept at its breast" the Comte de Provence, had tolerated the presence of French émigrés, and had permitted Austrian soldiers to cross Venetian land. However, Bonaparte was polite: "Given either a natural taciturnity or an intentional demonstration of ill-humour, and perhaps also due to the fatigue from the hardships suffered, [he] remained serious and pensive."

Bonaparte focused on logistics: he wanted "a topographical map of the *terraferma* of the Venetian State," and to know how long it would take for a messenger to ride from Crema to Venice—a distance of some 140 miles. These questions may have alarmed Contarini, but Bonaparte left claiming to be "much obliged for the attention and kindness shown him." Contarini was struck by Bonaparte's look of exhaustion, and he asked whether he was tired. The French general answered, "Yes, I am very tired." Contarini came away thinking Venice would be spared.

On May 15, Bonaparte entered the city of Milan, accompanied by his generals, five hundred cavalry, and a thousand foot soldiers. Crowds greeted him, but not in the numbers or with the enthusiasm that he would later describe. Nevertheless, the entrance into Milan contributed to the legend of France's Italian campaign, constructed in art and literature. An 1804 print by the French artist Carle Vernet shows Bonaparte, on

a spirited horse, approaching a triumphal arch, amid a tumult of supporters, some of whom have climbed to the top of the monument. Famously, Stendhal used Napoleon's appearance in Milan to begin his 1839 novel *The Charterhouse of Parma*: "On 15 May 1796, General Bonaparte entered Milan at the head of that young army which had lately crossed the Lodi bridge and taught the world that after so many centuries Caesar and Alexander had a successor."

In Milan, Bonaparte issued a proclamation from the Republic of France. He pledged "fraternity" to the citizens of Lombardy and declared "hatred to the tyrants." On May 19, he announced the founding of a Lombard republic. But he demanded a high price for Milan's "independence": twenty million francs, more than five thousand horses, and works of art, once again to be chosen by the general in chief. "Milan is ours, and the Republican flag flies over all of Lombardy," he told his soldiers on May 20.

Three days before, he had reminded the Directory of the art he had seized from Parma: "Tomorrow, Citizen Directors, there leave for Paris twenty superb pictures, chief of which is the famous Saint Jerome of Correggio, which I am assured was sold for twenty thousand francs. Tomorrow, I will have about as many again sent from Milan, including those by Michelangelo."

Bonaparte's capture of Milan also delivered the Duchy of Modena. In an armistice signed on May 17, Bonaparte forced Duke Ercole III d'Este to make cash payments to the French, to supply firearms and gunpowder, and to hand over twenty paintings from "his gallery or his states."

The duke had inherited the remains of the legendary collection built up by his predecessors, the Este dukes, including the Renaissance patron Alfonso I, who commissioned works from Giovanni Bellini and Titian, and Francesco I, who in the seventeenth century acquired paintings by Albrecht Dürer, Hans Holbein, Giulio Romano, and Correggio. Also, from Venice, Francesco I had obtained a brilliant cycle of four pictures (each at least thirteen feet wide) painted by Veronese for Alvise Cuccina and his two brothers—wealthy merchants and friends of the artist—for their palace on the Grand Canal. But the Este collection had lost these Veroneses and its other finest pictures in 1746 when Ercole's father, Francesco III d'Este, sold one hundred paintings to Elector Augustus III of Saxony, who hung them in the Gemäldegalerie in Dresden. The twenty paintings

Napoleon now wanted from the Duke of Modena would be "taken . . . at the choice of the commissioners."

Bonaparte had asked the Directory on May 6 to send "three or four known artists" to choose paintings and sculpture for Paris, but he was too impatient to wait for them to arrive. On May 19, he named his own commissioner: Jacques-Pierre Tinet, a forty-three-year-old painter who was already in Milan. Once a student of Jacques-Louis David, Tinet had helped select art for the Louvre after France's victories in Belgium. The day he was appointed, Tinet asked Berthier to order the Biblioteca Ambrosiana—built in Milan in the seventeenth century by Cardinal Federico Borromeo to house his fifteen thousand manuscripts and thirty thousand books—to turn over the pieces he wanted to take. He identified paintings by Rubens, Giorgione, and Leonardo, as well as three of the library's rarest works: a fourteenth-century edition of Virgil, annotated by Petrarch and illuminated by Simone Martini; Leonardo's *Codex Atlanticus*; and a Raphael cartoon of *The School of Athens*, the fresco depicting Greek philosophers and scientists painted for Pope Julius II in the Vatican's Stanza della Segnatura. The Raphael was a full-scale, twenty-five-foot-wide working drawing with pinpricks in the paper so the outlines of the composition could be transferred to a wet plaster wall—one of the only such drawings to have survived from the sixteenth century.

Once the Venetian Resident Zuanne Vincenti Foscarini met with Napoleon in Milan on May 17, the Venetians had a second chance to assess his intentions and plans. Surprisingly, Foscarini reported to his government that he had been impressed by Bonaparte's handling of rebellions in Binasco, Pavia, and other cities on the Venetian mainland. Bonaparte showed "not only unambiguous displays of promptness and talent, but also a praiseworthy sense of rightful justice and humanity, possibly preventing greater evils."

But in Venice, Francesco Lippomano disagreed. The fifty-one-year-old senator had served at the Venetian government's highest levels, and he took a cynical view of France. After reviewing the accounts of Bonaparte's encounters with the Venetian representatives in Crema and in Milan, he despaired that the French would cause "melancholy for the Venetian state." They "continue to advance in Italy," Lippomano warned Ambassador

Querini, who was his son-in-law. Lippomano dismissed Bonaparte's promises as amounting to nothing: "The Venetian State is about to become the theater of war," he wrote. "For four days, the troops passed. The City [Crema] was unharmed, [but], the Territory was roughed up. Promises of payment, but instead devastation ensued and the French plundered Houses and violated Churches." Ten days later, he found the situation worse. "I assure you that I do not know how the Savi [the cabinet that ran the Venetian government] are keeping their heads," Lippomano told Querini. "Letters, Express letters, Memoranda come in all the time and the new developments are distressing, require attention and counsel." His conclusion: soon Venice would be "inundated, oppressed and sacrificed."

Indeed, on May 17, Bonaparte ordered Jean-Baptiste Lallement, France's ambassador in Venice, to send "spies to Trento, Mantua, and the route to the Tyrol." Napoleon sought tactical information. "Spare neither money nor pains," he wrote. "Send me an accurate and very detailed map of the Venetian states."

Meanwhile, the Venetian Senate attempted to mount a defense. They appointed Nicolò Foscarini—a member of a leading Venetian noble family—as the administrator-general of the Venetian mainland domains. Operating out of Verona, Foscarini was to negotiate with the armies of Austria and France, and to hold them off. His orders were "to ascertain the state of public opinion, to preserve tranquility and to give to the subjects of Venice that consolation and reassurance to which they are accustomed." He was also to keep "the Senate constantly informed of developments and carry out its orders."

On May 24, only days after Foscarini took his post in Verona, French troops occupied Crema, and Napoleon and Saliceti presented the administrator-general with a new demand: Venice must provide supplies for ten thousand troops. If these provisions weren't immediately delivered, the French threatened "to abandon the country to the free will of the soldiers." On the twenty-sixth, the Austrians captured the fortress at Peschiera, a Venetian town eighteen miles from Verona, at the south end of Lake Garda. From there, they sought to control the passage to the Tyrol and to Austria.

That day, Foscarini drafted a letter to Bonaparte, objecting to the presence of French forces in the Veneto, complaining of their "violent

ways," and demanding they withdraw. To deliver the letter, he dispatched Captain Leonardo Salimbeni and Colonel Giovanni Francesco Avesani. By then, Napoleon had advanced east and they met him in Brescia.

Bonaparte immediately expressed his anger that the Venetians hadn't stopped the Austrians from capturing Peschiera and insisted that they expel them. Salimbeni replied that the Venetian government could do little about the takeover of Peschiera, confessing that Venice "did not have forces with which to oppose" Austria. Later, Bonaparte would acknowledge to the Directory that the Austrians had tricked the Venetians. "The truth about the Peschiera affair is that Beaulieu [the Austrian commander] basely deceived them; he requested passage for fifty men, then seized the town."

Bonaparte refused to reply in writing to Foscarini's letter. Three days later, he informed the government of Venice that "the French army, in its pursuit of the Austrians . . . is advancing into territory of the Venetian Republic." Still, he offered conciliatory words to Venice: "But it [France] will not forget that the two republics are united by a long-standing friendship. Religion, government, customs, and property will be respected."

In Verona, Foscarini had still heard nothing from Bonaparte, and he lost his patience. On May 30, in a second letter, the administrator-general repeated his demand that the French vacate Venetian territory. Also, he insisted to Napoleon that the French army compensate Venice for the destruction caused when its troops overran Crema. Foscarini assigned his aide-de-camp, Lieutenant Colonel Giacomo Giusti, to carry the letter.

Giusti reached Bonaparte on May 31, in Valeggio, fifteen miles southwest of Verona. Bonaparte began to read Foscarini's letter, then stopped, threw it down on the table, and reiterated the French complaints: granting asylum to the late king's brother and handing Peschiera to Austria gave France "two strong motives for treating Venice as an enemy." In his report to the Venetian government, Giusti claimed he had "tried to dissuade Bonaparte from taking Verona in every possible way," and for a moment he thought "he had appeased the French general." Then Bonaparte demanded he hear these justifications from Foscarini himself and insisted they meet that night in Peschiera, which the Austrians had abandoned to the French.

The prospect of a summit with "the young general . . . drunk with

ambition and glory" unnerved Foscarini. When they met, Bonaparte treated him with "the greatest contempt." Napoleon threatened that unless Venice let him occupy Verona, the French would burn the city.

The next day, June 1, the Venetians surrendered Verona to the French. "After Verona, what will be left of our *terraferma*?" the Venetian senator Francesco Lippomano lamented to his son-in-law in Paris on June 2. He asked Querini to go to the Directory and plead Venice's cause. "We are reduced to living day to day, in fact moment to moment," Lippomano wrote. "The French have betrayed us, they want to break it [neutrality] with all their strength. . . . The pain, the confusion, the burden and the terror are everywhere and on everyone's face. I never expected such extreme and excessive bad faith. At any moment now I expect a Liberty Tree [a symbol of the Revolution] will be planted in some city." Lippomano's fears were well founded. Over the next eleven months, in Verona alone, French requisitions would cost the Venetian Senate 1.7 million silver ducats.

To the Directory, Bonaparte suggested he would persist in exploiting Venice's weakness and pressure the Republic into giving up its neutrality and joining the French cause. "I have purposely engineered this quarrel, in case you wish to get five or six millions out of Venice," he wrote on June 4. "If you have more decided intentions, I think it will be in our interest to continue the *brouillerie*, just let me know what you wish to do, and we will await the favorable moment." Six days later, Bonaparte made clear again how he planned to subjugate Venice, in an order to one of his generals: "You must draw as much as you can from Venetian territory, paying for nothing."

7

"The Pope will deliver ... one hundred paintings, busts, vases or statues"

It is no longer blood that the Frenchman demands! He desires only to have his rights recognized and his government respected. It is not slaves, nor even kings that he wants to chain to the chariot of victory; it is the glorious spoils of arts and industry of which he wants to decorate his triumphs.

— *Le Moniteur universel*, 18 Prairial, Year IV (June 6, 1796)

Even as the theater of war shifted onto Venetian territory, Bonaparte turned his attention to Rome. In early May 1796, the directors had reminded him of the city's "beautiful monuments" and had urged him to go there. On June 19, following their orders, Bonaparte invaded the Papal States at Bologna. Four days later, Pius VI, lacking forces to withstand the French, signed an armistice. Represented by Chevalier José Nicolás de Azara, the Spanish ambassador to the Vatican, the pope agreed to surrender to Napoleon control of the Adriatic port of Ancona and twenty-one million francs. The fate of the Vatican collections was sealed in the treaty's article 8:

> The Pope will deliver to the French Republic one hundred paintings, busts, vases or statues, at the choice of the commissioners who will be sent to Rome, among these objects will be notably a bronze bust of Junius Brutus and one in marble of Marcus Brutus, both set in the Capitol, and five hundred manuscripts, at the choice of the aforementioned commissioners.

Napoleon's demand for one hundred works of art—five times the number he had seized from either Parma or Milan—matched in its ambition the scale and quality of the papal collections. The Vatican trove

had been assembled by worldly popes who, starting with Julius II, rivaled European monarchs in their extravagant outlays on Renaissance and baroque paintings and on ancient sculpture. For two hundred years, excavations in and around the Eternal City had unearthed countless antiquities, and the pontiffs rarely let anyone else have them. When Cardinal Giovanni Angelo Braschi was elected Pius VI in 1775, the Vatican possessed some twelve hundred antiquities. The popes and their families (the Farnese, the della Rovere, the Medici) had also patronized many of the leading fifteenth-, sixteenth-, and seventeenth-century artists: Sandro Botticelli, Pietro Perugino, Domenico Ghirlandaio, Michelangelo, Raphael, Caravaggio, Annibale Carracci, Guido Reni, and Guercino. Around 1509, Raphael began painting frescoes—including *The School of Athens*—in the apartments of Julius II (Giuliano della Rovere). At the same time, for the same pope, and only a few corridors away, Michelangelo was painting some three hundred figures across the six-thousand-square-foot ceiling of the Sistine Chapel.

Rome was the place where the French plunderers wanted most to go, its aesthetic authority based, above all, on the ancient Greek and Roman marbles in the papal collections—the *Laocoön*, the *Antinous*, the *Tiber*, the *Cleopatra*, and the *Apollo Belvedere*. In 1764, the German art historian

Vincenzo Feoli, *Right Side of the Portico in the Courtyard of the Museo Pio Clementino*, ca. 1790–1827. The Belvedere statue court as it looked at the end of the eighteenth century, with the *Apollo Belvedere* (left) and the *Laocoön* (center).

Johann Joachim Winckelmann declared the *Apollo* "the highest ideal of art," and in the eyes of the eighteenth century, the statue was second to none.

The *Apollo* had first captured attention in 1512, when Julius II, who had acquired the sculpture when he was a cardinal, put it on display in a garden with fountains and orange trees within the Villa Belvedere, a summer retreat set on a hill above the Vatican's main palace. He announced that he wanted to possess "all the most wondrous and beautiful antiquities in order to place them in his garden." Julius went on to buy the *Laocoön*—a chilling depiction of a man and his sons struggling to break from the grip of snakes—as well as *Commodus as Hercules*, the *Cleopatra*, and the *Tiber*. As intended, he installed these sculptures in the Belvedere's interior garden, transforming it into what would become the legendary Statue Court.

In the eighteenth century, ancient Greek and Roman sculptures reigned over the visual arts—celebrated and revered by artists and connoisseurs as works that set the standards, works that had never been surpassed. They had the sort of fame that certain van Goghs would have in the twenty-first century, but they also wielded authority as models and examples to be studied and copied by every ambitious student of art. These antique marbles depicted the human figure with bodies that artists had idealized and made beautiful, their proportions elegant, their limbs long and slender, their features evened out. Classical gods and goddesses, heroes and heroines of ancient myths, they look these parts. Their eyes are large and wide, their lips full, their noses straight, extending the line of their foreheads in strong profile.

The eighteenth century's passion for Greek and Roman art was largely fired by Winckelmann, a cobbler's son who had worked his way to becoming secretary to the great collector Cardinal Alessandro Albani, in Rome, and in 1763 the commissioner of antiquities at the Vatican. There, in 1764, Winckelmann produced the first comprehensive chronology of Greek and Roman art, the *History of the Art of Antiquity*, which was translated into French two years later, then into English and Italian. Earlier, in his 1755 *Thoughts on the Imitation of Greek Works in Painting and Sculpture*, Winckelmann had famously praised Greek sculptures for their "noble simplicity and calm grandeur." He had declared that "the only way for us to become

great, and, if indeed it is possible, inimitable, is through the imitation of the ancients."

The French obsession with Rome and its antiquities had begun early in the sixteenth century with Francis I, who sent his court artist Francesco Primaticcio to Italy to have full-scale bronze copies made of the *Apollo* and other Vatican sculptures for Fontainebleau, the château he was constructing out of a royal hunting lodge, in the forest of Bière, forty miles southeast of Paris. When Vasari learned about the French king's collection, he hailed Fontainebleau as "almost a new Rome." In a portrait by Jean Clouet, Francis appears as the Renaissance prince he sought to be, armed in a gold silk doublet, assessing the viewer with his skeptical gaze.

When, in 1661, Louis XIV began to transform Versailles—again, a hunting lodge—into the grandest palace in Europe, he sent agents to Rome to acquire antiquities. According to ledgers at Versailles, in 1679 he had 303 boxes of marbles shipped there from Rome. Ten years earlier, the French financial minister Colbert had written the king, "We must ensure that we have in France everything of beauty in Italy."

In addition, in 1665, Louis XIV invited Gian Lorenzo Bernini, the Roman sculptor and architect, to Paris to redesign a wing of the Louvre. In Paris, Bernini told Colbert that to compete with the painters and sculptors of Italy, French artists would have to travel to Rome and study "all the most beautiful statues, bas reliefs and busts from antiquity." In response, Louis XIV opened an outpost of the French Royal Academy of Painting and Sculpture in Rome's Palazzo Capranica. Soon after, the king established a prize to be awarded to promising French artists to fund a stay of at least three years at the French Academy in Rome.

At the end of the eighteenth century, the French passion for the art of ancient Rome only intensified when Jacques-Louis David, who had won the Prix de Rome in 1774, exhibited *The Oath of the Horatii* at the 1785 Salon.

Almost immediately after Bonaparte signed the treaty with the Papal States at Bologna, François Cacault, the French ambassador to the Holy See, warned that the French should expect resistance: "The article of the armistice with Rome, which stipulates that the hundred most beautiful works of painting and sculpture be delivered to us [the French], strikes to the heart of the Roman people and of all Italy, where they are very

attached to these monuments." The Romans, he predicted, would try to change the terms of peace. "Italy would easily watch without regret if the Pope were to cede all the provinces belonging to the Apostolic Church . . . in exchange for the monuments."

Among the Romans most likely to thwart the execution of the treaty would be the pope himself. The French mocked the papacy as benighted, but Pius VI, like his predecessor Clement XIV, had proved to be among the most progressive of Europe's collectors by creating a public gallery in the Villa Belvedere, and he would not want to see the French empty it. At the Pio Clementino Museum (named after the two founders), the popes had underlined the significance of their collection of ancient sculpture by framing it in opulence. Visitors ascended a grand marble staircase banked with red columns and crowned by a barrel vault. The stairs doubled back on either side, and switched again, to reach the second floor. From the top of these stairs, visitors could see through a series of galleries, each decorated with vaulted and frescoed ceilings and marble floors patterned in red, yellow, and gray. "Never were the divinities of Greece and Rome honored with nobler temples," an English visitor wrote. "Never did they stand on richer pedestals; never were more glorious domes spread over their heads. Or brighter pavements extended at their feet."

On July 2, 1796, Cacault raised the level of alarm: "The commissioners sent to choose [works of art] certainly risk assassination." He had reason to fear. In 1793, a mob, angered over remarks made by a French diplomat slandering the pope, had ransacked the French Academy, then housed in the Palazzo Mancini, and soon after it was closed. Doubting that he could protect the commissioners, Cacault suggested that they were superfluous. "Rome's most beautiful works are so well-known that there is hardly any need for Commissioners to select them." The choices, he observed, "could be made in Paris."

Cacault had a point. In choosing art for the Louvre, the commissioners would seem to have relied on standard guidebooks of Italy, especially the bestselling *A Frenchman's Voyage in Italy*, by Joseph-Jérôme Lalande, an astronomer and the director of the Paris Observatory. Lalande praised the Vatican museum and "admit[ted] without difficulty the superiority that this museum has already over all those that exist."

About the Belvedere Statue Court he went further: it was "the most remarkable site for the arts in all of Italy, even the entire universe, since it is here that the most perfect Greek statues that remain to us are preserved: the Laocoön, Apollo, Antinous, and the [Belvedere] Torso." Lalande's assessment of the "ancient and famous" courtyard within the museum echoed the eighteenth century's accepted opinion.

The French came to Italy, carrying the revolutionary doctrines of their new republic, but the art they desired for the Louvre was conventional— long admired by the Royal Academy of Painting and Sculpture and by the religious and political absolutists they had deposed. Their taste for antique sculpture, as well as the paintings of Raphael and the baroque artists of Rome and Bologna, was a taste they inherited directly and without protest from the despised ancien régime. The paintings and sculpture the French coveted from Italy were sights sought out on the Grand Tour. On July 25, Angelo Petracchi and Serafino Casella, two "Roman citizens," would warn the foreign minister Charles Delacroix, "You will have to answer to posterity should harm or loss befall these masterpieces [that have won] the admiration of the entire world."

Within a week of Napoleon's May 6 request to send him "three or four known artists," the director Lazare Carnot had recruited six "men of merit." He made clear the urgency of the mission, by demanding they decide immediately "if [they will] accept or refuse this assignment." If they agreed to go, he told them, "Appear tomorrow morning [at the office of the secretary general in Paris] between nine and ten to collect your passport."

Carnot, who was a mathematician and an engineer, also expanded the scope of French plunder to include "masterpieces" of natural history as well as of art—the range spelled out in the delegation's bureaucratic name: the Government Commissioners for Research on Objects of Science and Art.

In Italy, art would be the focus of French plundering, but nevertheless Carnot had weighted this research commission in favor of science. It consisted of two artists, the painter Jean-Simon Berthélemy and the sculptor Jean-Guillaume Moitte; two botanists, Jacques-Julien de Labillardière

and André Thouin, head of the Jardin des Plantes; and the chemist Claude-Louis Berthollet and the mathematician Gaspard Monge, two of the greatest scientists in France.

Berthollet, forty-eight, and Monge, fifty, were "natural philosophers," whose discoveries in chemistry and physics had put France at the forefront of experimental science. For decades, they had corresponded and exchanged papers with researchers in England, Germany, Italy, and other countries, part of a circle who validated one another's experiments and constituted the international order of eighteenth-century science, an order they proudly insisted transcended national interests. Writing to Labillardière on June 9, 1796, the British botanist Joseph Banks made the point: "The science of two Nations may be at Peace while their Politics are at war."

The presence of Berthollet and Monge endowed the research commission with intellectual weight and credibility. With the scientist and the mathematician, the Directory hoped to persuade the rest of Europe that France was justified in looting Italy's art, to portray this quest as sanctioned by the philosophes, and to link it to the aims of the French Enlightenment. While French plans for gathering masterpieces in an encyclopedic museum took inspiration from Denis Diderot and Jean d'Alembert's *Encyclopédie*, the theft of cultural property by conquering armies was no longer the norm.

To Bonaparte, the directors acknowledged they were walking a fine line. They were following a policy of expropriation and plunder set in motion by the Terror, and they feared it would come under fire. "You should advise each of them [the commissioners] to extract only those objects which are truly beautiful and good," they wrote. "Taking without taste, without choice, is ignorance and near vandalism."

At the same time, the directors expected the Army of Italy to finance the "upkeep and spending of their [art-plundering] mission" out of "contributions raised in the country." As the director Louis-Marie de La Revellière-Lépeaux cynically explained to the government commissioner Saliceti: "You make a hundred times more money with your bayonets than we can raise with every financial law imaginable. That's always been our stumbling block."

Both Berthollet and Monge were extraordinarily prolific, writing treatises, delivering papers, and contributing to both basic and applied science. They were members of the prestigious National Institute of Sciences and Arts (which had replaced the royal academies) and founders of the École Polytechnique, where they served on the faculty. At various times, they had been drafted by the government to ready the nation for war—by attempting to increase the production of iron, steel, cannons, and armaments; to improve the reliability of hot-air balloons; and to boost the explosive power of gunpowder.

Berthollet and his European colleagues designed experiments to disprove the entrenched idea that the natural world was composed of the four elements—earth, air, fire, and water. In 1784, the French king had appointed Berthollet the director of dyeing operations at the Gobelins tapestry works. In his Gobelins laboratory, Berthollet discovered that chlorine could be used as a bleach, and he developed a new bleaching process. Characteristically, he had no interest in exploiting the commercial potential of his discovery, and in 1786 showed his method to the Scottish chemist James Watt, who would set up a bleaching plant in Glasgow. "For him [Berthollet] gold was nothing but a metal and a means of exchange for the necessities of life," wrote a contemporary. "It had no value in his eyes except in so far as it allowed him to satisfy his love for science."

Diplomatic by nature, Berthollet had stayed out of politics. After the fall of the Bastille, he had moved some eight miles northeast of Paris to the village of Aulnay-sous-Bois. Once, when summoned by the Committee of Public Safety to confirm its suspicion that some brandy had been laced with poison, he had the courage to state that the brandy contained nothing harmful and that he would drink it to prove his point.

In contrast, Monge was a Jacobin and firebrand who jumped into the political fray. He was born in Beaune in 1746, the son of a tradesman, and educated at the Collège de la Trinité in Lyon. At eighteen, he was hired as a draftsman at the École Royale du Génie at Mézières, a military engineering school, and went on to become a teaching assistant and then a mathematics professor. He also taught physics. In 1792, Monge briefly served as France's secretary of the navy.

Berthollet and Monge often collaborated with France's leading scientist, the chemist Antoine Laurent Lavoisier. At the Paris Arsenal, Lavoisier set up the most advanced and well-equipped laboratory in Europe, and his experiments there, including the 1783 deconstruction of water (into hydrogen and oxygen), revolutionized chemistry. Berthollet and the chemists Louis-Bernard Guyton de Morveau and Antoine-François de Fourcroy had worked with Lavoisier to systematize the naming of elements and compounds. They had raced to publish their *Method of Chemical Nomenclature*, in 1787, meeting almost every day for eight months. By 1800, their new chemical language would be adopted in laboratories throughout Europe; it remains in worldwide use today.

In 1788, on the eve of the Revolution, David had painted a magnificent double portrait of Lavoisier and his wife and collaborator, Marie Anne Pierrette Paulze, in which he shows the couple (he was forty-five, she thirty) personifying the intellectual promise of the Enlightenment. The portrait was commissioned by Lavoisier, and David created a nine-foot-tall canvas—a scale ordinarily reserved for princes and kings. Lavoisier, in a black frock coat, is working at a table and turns his head to look up at Paulze. She stands beside him, resting her arm on his shoulder but staring out—a spectacular figure, in a white dress that cascades to the floor and is tied at the waist with a pale blue sash. She seems to have just walked into the room, having dropped a dark cloak on a chair and set a portfolio against its back.

In the portrait, past and future seem to converge. Paulze's fashionable clothes, her powdered hair, a red velvet cloth on the table, and Lavoisier's quill pen conjure Paris under the ancien régime. But the scientific revolution is there too—in the large glass beakers and other instruments on the table and the floor. To draw attention to Lavoisier's science, David exploited his art—creating in paint the illusion of a glass surface that reflects windows on the other side of the room.

Marie Anne Paulze had studied art, and with thirteen of her drawings she illustrated Lavoisier's *Elements of Chemistry*, a seminal text published a year after the portrait was painted. She also learned English, so that she could translate Lavoisier's works for publication in London and translate texts by Joseph Priestley, Henry Cavendish, and other British scientists into French. The couple had married when she was thirteen, introduced

Jacques-Louis David, *Antoine Laurent Lavoisier and Marie Anne Pierrette Paulze Lavoisier,* 1788.

by her father, Jacques Paulze, who, like Lavoisier, was a shareholder in the *ferme générale,* the corporation that collected certain taxes for the king.

David submitted the painting to the 1789 Salon, but before the exhibition's August 25 opening, the Comte d'Angiviller, the minister in charge of the arts, withdrew it. The month before, on July 14, a mob had stormed the Bastille, and in the volatile political climate, Lavoisier's role in the *ferme générale* and also as a director of France's gunpowder and saltpeter administration infuriated revolutionaries. Earlier, he had removed hundreds of barrels of gunpowder from the Bastille so it could be replaced with gunpowder of higher quality, but republicans misinterpreted the decision as undermining their cause and had rioted.

In naming Berthollet and Monge to the commission to choose art in Italy, the members of the Directory sought to distance themselves from the policies of Maximilien Robespierre, who had put Lavoisier on trial on May 8, 1794—for profiting from investing in the *ferme générale*. Before a politicized court, Lavoisier's guilt was a foregone conclusion; he was executed later that day. Also that day, Jacques Paulze and twenty-seven other *ferme générale* directors went to the guillotine. Shockingly, Jacques-Louis David, then Robespierre's disciple and a member of the Committee on General Security, made no move to stop Lavoisier's killing. A month after Lavoisier's death, Berthollet was assigned the sad task of visiting the chemist's house at 243, Boulevard de la Madeleine, to inventory his equipment and chemicals.

Science ranked high in Bonaparte's priorities, and the directors' choice of Berthollet and Monge could have been his own. He befriended both and later would appoint them to lead the team of scientists, engineers, and artists who accompanied his campaign in Egypt. In October 1797, he would honor Monge by entrusting him to take the treaty of Campo Formio, a peace agreement between France and Austria, to Paris. "The sciences, which have revealed so many secrets and destroyed so many prejudices, are called upon to render still greater services," Napoleon would write to the Directory. "New truths and new discoveries will contribute even more to the happiness of mankind; but it is essential that we should respect the scientists and protect science."

In the research commission's two artists, Moitte and Berthélemy, the French had more than enough expertise to select masterpieces in Italy. They had both studied in Rome and had worked their way up in the French art establishment, producing works for the ancien régime. Moitte had modeled his neoclassical sculpture on the ancient marbles that in Rome would be his prey. When he left for Italy, he was carving a statue of Jean-Jacques Rousseau and had clothed the French philosopher's figure in the robes of the ancient world. Taciturn and buttoned up, Moitte could be inventive and playful when he applied his neoclassicism to the decorative arts, interweaving snakes and flowers on the lid of a silver soup tureen. For his part, Berthélemy was a history painter whose narratives—such as *Alexander Cutting the Gordian Knot* and *The*

Liberation of Paris from the English—were derived from the Renaissance and baroque paintings that he was to track down. He claimed that carrying out Marie-Antoinette's commission to paint a fresco of *Aurora and Her Chariot* on the ceiling of the queen's rooms at Fontainebleau had turned him into a revolutionary.

In Italy, the commission's two naturalists, Thouin and Labillardière, would have their own collecting assignments: to "harvest" specimens—plants, seeds, minerals, and skeletons—for the Jardin des Plantes and the Natural History Museum in Paris. This task was less controversial than the seizing of art because the "objects of science" were not unique or irreplaceable.

Thouin had gained experience for Italy when looting the natural history collections in the Austrian Netherlands after the French victories there. He had packed up the famous cabinet of Stadtholder Wilhelm V in The Hague with its 30,000 objects—10,000 minerals, 3,872 plants, 5,000 insects, 9,800 shells, and 1,176 stuffed birds, which had required 150 crates. Earlier, as director of the Jardin des Plantes, Thouin had built an international reputation through his network of four hundred correspondents, spread across Europe, but also in India, China, and America. To Thomas Jefferson, he had sent 107 kinds of seeds cultivated in France.

Ironically, Labillardière's experience with plundering began as its victim. In 1791, he had sailed to the South Pacific on an expedition to find the ships of Jean-François de Galaup, Comte de La Pérouse, which had vanished near Australia's Botany Bay. The French found no trace of La Pérouse, but Labillardière assembled a natural history collection in Australia, only to have it captured in Java by British ships. Labillardière had appealed to Joseph Banks, who, in the summer of 1796, argued to his government that England should give up the French property, as a matter of honor: "By this her Majesty [Queen Charlotte] will lose an acquisition to her herbarium which I very much wish'd to see deposited there, but the National Character of Great Britain will certainly gain much credit for holding a conduct toward Science and Scientific men liberal in the highest degree." The British returned the collection.

The six French commissioners had left Paris on May 21, 1796. They crossed the Alps at Mt. Cenis, when snow still blanketed the pass, and

arrived in Milan by June 7. There, and in other northern Italian cities, they spent the next four weeks making lists and packing up works of art.

On July 2, Napoleon praised the commissioners. They have "conducted themselves very well and are assiduous in their task," he wrote to the Directory. He tallied the paintings already in their grasp:

> 15 paintings from Parma
> 20 paintings from Modena
> 25 paintings from Milan
> 40 paintings from Bologna
> 10 paintings from Ferrara
> Total 110

From Napoleon's vantage point, seizing one hundred works of art from the pope would nearly double the size of his trove. Characteristically, he ignored Cacault's warnings that the commissioners would be at risk in Rome, and on July 29, they arrived.

They worked fast. After only eight days, Cacault told Azara, the Spanish ambassador, that the commissioners had drawn up an inventory of fifty pieces from the papal collections—thirty-two antiquities they had seen in the Vatican museum and eighteen paintings, mainly from various churches in Rome.

At the top of the list they triumphantly placed the *Apollo Belvedere*. The *Apollo* was a lanky, young archer, carved in white marble, with a handsome face, a long, straight nose, parted lips, and curling locks of hair. "He has just discharged his Arrow at the *Python*," wrote the painter and writer Jonathan Richardson in 1722, "and has an Air, particularly in the Head, Exquisitely Great, and Awful, as well as Beautiful."

The commissioners found the *Apollo* in the Belvedere Statue Court, where Julius II had placed it almost three hundred years before. When describing the courtyard in *A Frenchman's Voyage in Italy*, Lalande had also singled out the *Laocoön*, the *Antinous*, and the *Belvedere Torso*. That these sculptures appeared on the French list as numbers 2, 3, and 4, after the *Apollo*, suggests that the commissioners consulted Lalande's guide, or

perhaps the astronomer himself, who, like Berthollet and Monge, was a member of the National Institute of the Sciences and the Arts.

From the Statue Court, the commissioners moved to a series of galleries, each filled with marble statues. From these rooms, they chose *Cleopatra, Demosthenes, Trajan,* a *Kneeling Venus, Adonis, Paris,* the *Discobolus of Myron, Sardanapalus, Augustus, Meleager, Ceres, Melpomene, Menelaus, Minerva,* the *Nile,* the *Tiber,* and a black vase, carved of basalt and ringed with masks. "We see here so many statues, so many ancient busts, it makes the head hurt every night," Monge complained to his wife, Catherine Huart, on August 3. "We will try to do our duty."

Monge felt the pressure of time. The list was not complete when on August 8, around six in the evening, Edmé Gaulle and F. Boulanger, who worked for the commission as a draftsman and a secretary, respectively, were chased down the Corso by a group of Romans, who shouted insults and threw rocks. Gaulle darted into a house, and Boulanger was escorted back to their hotel by an officer and soldiers in the pope's army.

Shaken by this incident, Cacault told Charles Delacroix that he wanted to leave Rome but would stay and make sure "everything promised us is delivered." So far, he added, the Vatican's secretary of state had done "nothing" to help.

The commissioners pushed on. To the Vatican museum sculptures, they added fourteen statues, five busts, and fourteen "tombs, altars, candelabras, vases, etc." from the galleries in the Palazzo Nuovo and the Palazzo dei Conservatori, on the Capitoline hill. Again, the French went after the most famous statues—the *Spinario* (*The Boy with the Thorn*), *Cupid and Psyche,* the *Marble Faun,* and the *Dying Gladiator.*

By August 15, the choice of the hundred objects had been made; the commissioners wanted eighty-three antique sculptures and only seventeen Renaissance and baroque paintings, which they put at the end of the list as though they were an afterthought. Yet the French had gotten their hands upon pictures revered by eighteenth-century commentators, including *The Transfiguration,* Raphael's last painting, described by Vasari as the "most glorious, the most lovely, and the most divine" work. The commissioners had found *The Transfiguration* over the main altar of San Pietro in Montorio, on the Janiculum hill, a church built in the fifteenth century to mark

the place where Peter was thought to have been crucified. High up against a blue sky, Christ appears in glory to three of his disciples, but the drama takes place below—among more than a dozen figures, including a boy, possessed by demons, who flings his arms wide and seems to cry out, as other apostles gesture in despair.

The French saw Raphael as the greatest of the High Renaissance painters and credited him for resurrecting the art of ancient Greece and Rome. Born in 1483, the son of Giovanni Santi, court painter to Federico da Montefeltro, the Duke of Urbino, Raphael was gracious, sociable, and urbane; he was seen to personify the virtues wanted in a Royal Academy painter, in contrast to Michelangelo, who was a rebel.

"Ah divine Man!" cried Jacques-Louis David. "It is to you [Raphael] that by degree raised me almost to antiquity! It is to you sublime painter! It is to you among the moderns who has arrived the closest to these inimitable models."

After Raphael, the French wanted paintings by the sixteenth- and seventeenth-century artists who worked in Bologna and were seen as Raphael's heirs—Annibale Carracci, Ludovico Carracci, Guido Reni, and Guercino. The Bolognese artists were masters of illusionism and drama who depicted Christ or martyred saints, often in the hands of their torturers. The French took only a single Caravaggio, *The Entombment* from Santa Maria in Vallicella (Chiesa Nuova). They bypassed three other Caravaggios—*The Calling of Saint Matthew*, *The Martyrdom of Saint Matthew*, and *Saint Matthew and the Angel*, no doubt because they were in a chapel at San Luigi dei Francesi, a French church.

On August 25, 1796, the commissioners told Delacroix that Vatican officials had obstructed their progress, but that "yesterday, we saw the places dedicated for the packing prepared and the majority of the statues [had been] taken off their pedestals." By then, "a packet of French gazettes" had brought the commissioners news of Paris. They learned that protests against their requisitions of ancient statues in Rome were coming from France itself: on August 15, David was one of fifty artists and architects (including Anne-Louis Girodet, Augustin Pajou, Hubert Robert, Charles Percier, and Pierre-François Fontaine) who had signed a petition objecting to Napoleon's plan to "displace from

Rome the monuments of antiquity and the masterpieces of painting and sculpture."

Driving the petition was the critic Antoine Quatremère de Quincy, a monarchist who had recently published seven short articles, titled "Letters on the Plan to Abduct the Monuments of Art from Italy" (later known as *Letters to Miranda*), in which he argued that tearing works of art away from their places of origin stripped them of meaning. Only in Rome, Quatremère claimed, with its quantities "of statues, of colossi, of temples, of obelisks, of triumphal columns, of baths, of circuses, of amphitheaters, of triumphal arches, of tombs, of stucco decoration, of frescoes, of bas-reliefs, of inscriptions, of ornamental fragments, of building materials, of furniture, of utensils, etc. etc." was it possible to comprehend the "inner connection of all these objects to each other." The city of Rome, not the Louvre, he contended, was "the true museum."

To the French protesters, Monge was defiant. "Well, I advise them to take their leave, since the *Apollo Belvedere* and Raphael's *Transfiguration* are on the list and among the number of a hundred objects named in the armistice and the armistice will be carried out," he wrote to Catherine Huart.

But at the end of July, Austria had launched a counteroffensive to take back northern Italy. Bonaparte complained to the Directory that he needed reinforcements. His "middling army" was struggling "to face all emergencies," he reported. "To hold the [Austrian] armies in check, to besiege forts, to protect our rear, to overawe Genoa, Venice, Florence, Rome and Naples, we must be in force everywhere." During August and early September, he won a series of battles, but some twenty-five thousand Austrian troops still remained in northern Italy; they were awaiting supplies in Mantua. Also, the relentless campaign had left the French army "exhausted," Bonaparte wrote. "The heroes of Lodi, Millesimo, of Castiglione and Bassano have died for their motherland or lie in hospital."

At the same time, despite his threats to Venice, Bonaparte still preferred to draw the Venetians to the French cause by means of diplomacy. On August 21, in Brescia, he proposed an alliance to the Venetians, but they declined. A month later, on September 19—following French victories at Rovereto and Bassano—Jean-Baptiste Lallement, the French

ambassador in Venice, issued a second invitation to the Venetians to ally with France. Again, the Venetians were reluctant to abandon their neutrality; they could see that Bonaparte's hold on the territories he had conquered in Italy remained tenuous.

The volatility of the war encouraged Pius VI also to resist the French. Perhaps the pope thought that Napoleon's reengagement with Austria would prevent the French from enforcing the punishing terms of the armistice and allow him to keep his legendary collections.

On September 24, Cacault informed Delacroix that the French operation in Rome had been "suspended." The commissioners, having faced delays and obfuscation, decided to wait no longer and departed from Rome empty-handed.

8

"I'm on a path a thousand times more glorious"

Others would have painted the ancient Alexander, [but I would have painted] the new one.

—Antoine-Jean Gros, November 23, 1798

In the summer of 1796, the French painter Antoine-Jean Gros was living in Genoa, struggling to make ends meet and "reduced," as he put it, to painting portraits, when he heard rumors that Josephine de Beauharnais might soon be arriving in the port city. Gros then asked Guillaume Faipoult, the French consul in Genoa, if he would introduce the artist to Bonaparte's wife, "in the sole hope of getting to do the portrait of the general." He added, "His glory and the details people have given me of his physiognomy only excited this desire."

The encounter between Napoleon and Antoine-Jean Gros was unlikely, almost accidental—the consequence of circumstances and events set off by the French Revolution, which had sent each to Italy and dealt them different hands. Their meeting would produce an iconic portrait of the French general—an outcome that in retrospect seems inevitable—born of the long collaboration between art and politics in France and of the rigorous training Gros had received at the Paris studio of Jacques-Louis David in painting scenes from classical history and in reimagining heroes from the ancient world.

Gros was twenty-five, talented, ambitious, neurotic, and charming. He had dark eyes and the face of a boy, and his brown hair fell to his shoulders. His friend the painter François Gérard portrayed him as a Romantic whose innocent expression seems to jar with the sophistication of his black jacket, ruffled white shirt, and tall black hat, which signified his republican politics. When Gros painted a *Self-Portrait* in 1795, he was foundering in Italy and he put his stricken face in shadow.

François Gérard, *Antoine-Jean Gros*, ca. 1790. Gérard painted Gros when both were apprenticed in the Paris studio of Jacques-Louis David.

Four years before, Gros had been a rising star in David's studio, on a path to become one of France's leading history painters. The artist assumed he would win the Prix de Rome, which would allow him to spend three or four years completing his education at the French Academy there.

But the fall of the French monarchy brought the art establishment down with it. Gros stood back from the politics of the Revolution, but he felt the heat of the fire. His plans to study in Italy collapsed when the French Academy was closed in January 1793. Still believing Rome to be crucial for his artistic advancement, Gros insisted on going there on his own. That February, he sailed for Genoa. Once in Italy, the young painter found himself exiled in a theater of war.

By June 1793, he moved to Florence and competed with other artists for portrait commissions from French expatriates. But Gros thought portraits a waste of his time and his talent. He was haunted by his ambitions

to reach the highest ranks of the French art establishment as a history painter, like David. In the eighteenth century, history paintings—large-scale, high-minded epics of classical, biblical, or mythological history—stood at the pinnacle of the hierarchy of painting, above landscapes, portraits, still lifes, and genre scenes. The ambition to paint history had been instilled in Gros at an early age by his father, Jean-Antoine Gros, a painter of miniatures, and then by David. Later, David would admonish his former pupil to focus on ancient Rome: "You love art too well to occupy yourself with frivolous subjects. . . . Quick, quick, my friend, turn the pages of your Plutarch."

Still in Florence the following spring, Gros was convinced that his career as a serious painter was finished. He became despondent. His father had died, and his mother, Madeleine-Cécile Durand, also a painter of miniatures, depended upon Gros for financial support. She was the artist's closest confidante, and in his letters to her he recounted his troubles in Italy. At that point, the French envoy François Cacault (who had served in Florence before he became the ambassador to Rome) urged Gros to return to France. The young painter had "found himself in the greatest distress," Cacault wrote Durand on June 13, 1794. "He was beginning to have debts and not a penny. Grief has overtaken him in a country without financial resources." Cacault advised, "Give over all of your efforts to bring him back to your side and give him the means to cultivate and perfect his art." But he cautioned, "You must speak to him gently. He is young, volatile, impressionable."

Cacault settled Gros's accounts and provided the funds he would need to reach Paris. Gros traveled north to Genoa, where he planned to book passage to France. He had written to ask the "powerful" David for help, but his letters went unanswered. In August, he learned that only days after Robespierre's execution on July 28, David had been imprisoned. "My poor master, without sense, without knowledge, without the least political talent was caught in the nets of a villain," Gros wrote on September 8. Robespierre "manipulated" David "as easily as he [the painter] positions models." Gros claimed to have "always admired and pitied him [David] for his political ambitions," but he seethed: "David has made himself detestable."

In a *Self-Portrait* he painted in prison, David wears a brown jacket and a white ruffled shirt and stares out with a look of alarm. Over a scar—the aftereffect of a fencing accident that disfigured the side of his mouth—he had painted a shadow. David was released in December, arrested again May 28, 1795, then freed on August 3. Two months later, the National Convention declared a general amnesty and the charges against David were dropped.

By the summer of 1796, Gros still hadn't left Genoa. Over the two years he had spent there, the artist made friends. He lived with a Swiss banker named Jean-Georges Meuricoffre and his wife, the mezzo-soprano Celeste Coltellini, who regularly gathered a circle of artists and musicians at their house. (In 1788, as Mozart was revising *Don Giovanni* for its opening in Vienna, Coltellini had been cast as Zerlina.)

Jacques-Louis David, *Self-Portrait*, 1794. David painted this self-portrait while imprisoned in the Hôtel des fermes for his role on the Committee of General Security and his allegiance to Maximilien Robespierre.

Still, Gros despaired that he had never reached Rome, and he described his "aspirations" to paint "history" as "laughable." The artist judged himself in his father's eyes. "I have slipped back into the class that he wanted to keep me out of, you know!" he told his mother. "I am going to be and I am, a painter/errand boy."

Meanwhile, Gros read newspaper accounts of Bonaparte's progress on the battlefields of northern Italy. In August, he wrote Durand again: "Bonaparte paused the siege of Mantua, reunited his forces, gave battle and made them feel the same way as [they had] along the river of Genoa a few months ago."

Close at hand, Gros began to realize, was a commander that the press was comparing with Hannibal and Caesar. The young artist had dismissed the painting of portraits as a degrading endeavor, but he recognized that the skills he had developed in churning out likenesses might be put to use in depicting a modern hero, reigniting his ambitions as a history painter, and getting him back to Paris. To Gros, a chance to meet the general's wife, Josephine, seemed to promise no less than salvation.

Some three months after Bonaparte had left Paris, Josephine had reluctantly followed, arriving on July 13, 1796, in Milan. She came to Italy, bringing her dog, and also Hippolyte Charles, a hussar lieutenant with whom she was having an affair. Their situation seemed to be lost on nobody but Bonaparte, who would eventually learn the truth.

On November 17, Bonaparte defeated the Austrians at Arcola, seventeen miles from Verona. Ten days later, he returned to Milan to discover that Josephine had left for Genoa. He was furious: "You run from town to town after the fêtes," he wrote. "The whole world is only too happy if it can please you, and your husband alone is very, very unhappy."

Josephine arrived in Genoa at the end of November and, as Gros had requested, Guillaume Faipoult introduced them. Not surprisingly, Josephine took immediately to the handsome painter. "She received me in the most honest manner," Gros wrote to his mother. "And began herself to say to me that she knew that my desire was to go to Milan and there take various assignments to paint some of her husband's victories." His "idea," he explained, was to do "a portrait of Bonaparte."

Josephine suggested that if Gros "did not have too much work keeping

[him] in Genoa, she would offer [him] a place in her carriage" when she returned to Milan. The next day, the artist showed her two of his recent portraits. One was "of a man with a severe physiognomy, and built like I had heard Bonaparte more or less was." It "gave her infinitely more pleasure than I had dared to hope."

"I will take you to Milan," Josephine had said. "I will take you everywhere."

Five days later, Gros left Genoa, riding with Josephine and Faipoult in her carriage. On December 5, they reached Milan. Bonaparte had moved his headquarters into the Serbelloni Palace, and Josephine invited Gros to stay with them there. The next day, Josephine took Gros to meet Napoleon, the painter excitedly reported.

"*Voilà*," Josephine said. "This is the young artist of whom I have spoken to you."

"Ah, I am charmed to see you," Bonaparte said. "You are a pupil of David?"

Bonaparte told Gros that David had already requested a drawing of "the taking of the bridge at Lodi," as he "wants to paint this." He added, "I have some good scenes in mind that I'll have sent to you."

In the margins of that day's letter to his mother, Gros scribbled, "I have begun the general's portrait."

He added, "One cannot give the name of sitting to the little time that he gives me. I cannot therefore choose my colors; I have to resign myself to only painting the nature of his physiognomy, and after that, as best I can, to give the portrait its form." However, "they are giving me courage, already satisfied with the little bit that there is on the canvas. I am rather anxious to see the head almost done."

Gros turned the pressure of time to his advantage, not bothering with the formal demeanor of a portrait, except in the black jacket trimmed with gold braid, but instead racing to get down the head and torso of the handsome officer, charging into battle, in a small (one-by-two-foot) oil sketch. He painted Bonaparte close-up. The young soldier pivots—to look back at his troops. He is boyish and elegant, serious and steely. Strength and resolve are captured in the dark sleeve thrust across the foreground and a black gloved hand (cut off by the frame) raising the pole of a flag,

billowing behind him and merging into the darkness of a sky suffused with smoke and lighted by gunfire. Bonaparte's portrait was enough of a likeness—in the long, straight nose, curved lips, and strong jaw—to be convincing, and yet it was highly idealized.

In Milan, Gros had found Napoleon "cold and severe." But, far from Paris, Gros broke from the conventions that would have had him view a commander from a distance, part of a battlefield panorama, and standing still. In the dash and the freedom of the paint, in the bold touches of gold on the edge of the jacket, Gros had caught the daring and the fire of the conqueror, who was fighting for the ideas of the Revolution and to defeat the enemies of France.

The portrait also captured the combustion of feelings set off by the painter's meeting with the young general. Gros had been seeking a "great man"—a hero—as a subject to paint. But in the pale, thin Bonaparte, he had found something more. The artist, who had lost his father and felt abandoned by David, hungered for a paternal figure to replace them and for a leader to bring order and peace to France, while recovering its place among the European powers. Such political change could resurrect the French art establishment and put Gros back on track as an artist.

Gros invested Bonaparte's portrait with the confidence he had gained as a portrait painter and the excitement of having found a stage on which to demonstrate his abilities. The portrait's sense of triumph reflects Gros's own sense of escaping the mundane for a future in which Bonaparte might pave the artist's way. It is striking that the face of Napoleon resembles the face in the *Self-Portrait* of Gros.

Gros titled the portrait *Bonaparte on the Bridge at Arcola*. One of the very first portraits painted of Napoleon, it would prove to be one of the greatest and an early icon of Romanticism.

On this first painting of Bonaparte, Gros based a larger, more detailed three-quarter-length portrait. Here, he expanded on the uniform, describing a band of elaborate gold braid running down the front of the jacket and a red and white sash. Bonaparte is holding a sword and a French flag—its blue, white, and red emerging from the smoke. When Gros exhibited this more formal version of the portrait for the first time at the Salon of 1801, a critic for *Le Moniteur universel* gave it what to Gros would have seemed

the highest form of praise: "This portrait only needs to be full-length and have some accessories in order to be a history painting."

By February 1797, Gros finished this second portrait. It took Bonaparte little time to recognize the picture's power; he asked the artist to have an engraving made and gave him five thousand francs. Over the next two years, printmakers produced six additional engravings of Gros's *Bonaparte on the Bridge at Arcola*.

Bonaparte's victory at Arcola in November 1796 had depended upon a charge made by French troops across the twenty-two-foot-long Arcola bridge. In the actual sequence of events, Bonaparte had followed General Pierre Augereau over the bridge and then withdrawn. In the confusion, he fell into a ditch and had to be pulled out by his soldiers. "Never have we fought so badly," General Barthélemy Joubert recalled. "Never have the Austrians fought so well." Nevertheless, Bonaparte rewrote the narrative to place himself leading the charge: "It was imperative, however, to cross the bridge," he wrote. "I went up myself: I asked the soldiers if they were still the victors of Lodi. My presence produced a reaction in the troops that convinced me to attempt the crossing again." It was Napoleon's version of the undaunted commander inspiring his troops that Gros translated into visual terms. In December, the artist wrote his mother, "You see that I'm on a path a thousand times more glorious than I had ever dared to hope for."

In early January 1797, Gros learned through Josephine that Napoleon wanted him to be part of the research commission. He had hesitated. "I told her I was too young to be linked" to the "famous sculptor" Moitte, the painter Berthélemy, Berthollet, and Monge, he wrote his mother. But Louis-Alexandre Berthier, Bonaparte's chief of staff, warned Gros that he had "to accept." He was then invited to lunch with Bonaparte. "I told him I regretted not deserving such kindness," Gros reported on January 9. "Why not?" Bonaparte had characteristically replied. "If you have talent."

"So, tomorrow or the day after tomorrow, I will go to Bologna," Gros wrote. "And there we will know more about our destinations."

Since the fall of 1796, Bonaparte had been struggling to repel the Austrian counteroffensive. But his victory at Rivoli on January 15 forced the Austrians finally to abandon Mantua and to retreat north toward Vienna.

On February 1, Bonaparte resumed the attack and again invaded the Papal States. With the Treaty of Tolentino, signed on February 19, he extracted thirty million francs from Pius VI and ensured that article 8 of the armistice signed the year before at Bologna, which gave the French the hundred works of art from the Vatican, would be "executed in its entirety and as quickly as possible."

Immediately, Napoleon sent the Directory an accounting of the Italian art thefts:

> The commission of experts has reaped a good harvest in Ravenna, Rimini, Pescara, Ancona, Loreto and Perugia which will be sent to Paris. That, together with what we have from Rome, will mean that we have everything that is a work of art in Italy, save for a small number of objects in Turin and Naples.

In fact, the commissioners had yet to take possession of the paintings and sculpture they had set aside from the papal collections, but Bonaparte was confident that soon they would be in French hands.

In March 1797, Antoine-Jean Gros reached Rome, the city upon which the painter had set his sights five years before. Despite the closing of the French Academy in the Palazzo Mancini, Gros and the other commissioners took up residence there. "Most of the time I am at the pope's museum from which we have skimmed the cream," Gros wrote his mother at the end of the month. "But there is still an innumerable quantity of beautiful things to study. Being in Rome for only a short time, I have a lot to do in order to see everything before I leave."

After the Treaty of Tolentino, the French faced little resistance from the Vatican, but they still grappled with logistical problems not easy to solve: "The size of the loads, the need to construct all the carts in a country stripped of the means of industry, the roads . . . steep and damaged, present obstacles that we can only overcome with time," the commissioners told Foreign Minister Delacroix on April 17. Eight days before, the first convoy, with ten carts carrying crates of sculpture and one cart crates of paintings, had left Rome for Bologna. From there, it would head to Livorno. A second convoy followed in early May; its extraordinary cargo

included Raphael's *Transfiguration*, as well as the *Apollo Belvedere*, the *Laocoön*, the *Antinous*, and the *Belvedere Torso*.

Gros complained to his mother that he had to take a "very boring but essential trip," adding "one can't be too careful with such masterpieces." On June 10, after only ten weeks in Rome, he departed with the third convoy—twelve carts—of French plunder. A month later, the fourth and final convoy began the journey to Paris.

In a sketch, Gros reveals the precariousness of the carts as they left Rome piled high with crates containing irreplaceable works of art. He drew one cart heading down a steep incline. Soldiers on horseback wield sticks as they try to control the teams of oxen, yoked both to the wagon's front and back, to prevent it from racing downhill.

On July 14, from Rome, François Cacault wrote Delacroix that all

Antoine-Jean Gros, *Scene of a Convoy in a Landscape of Hills*, 1797. Gros's freehand sketch of a cart leaving Rome loaded with paintings and sculpture seized by the French suggests the risks of transporting these works to France.

four convoys, with more than fifty carts, had survived the 225-mile trip over the Apennines and had reached Livorno.

Less than a month later, at midnight on August 11, the "paintings and statues coming from Rome set sail" for France. "The precious treasures" left Livorno "in 13 carriers . . . escorted by three small warships," Charles-Godefroy Redon de Belleville, the French consul in Livorno, wrote Talleyrand, who had replaced Delacroix as foreign minister. Redon de Belleville had wanted the ships to be "escorted by a more imposing force." Livorno is "full of English 'friends and correspondents,'" he had explained. But he had gauged the risks, had lined up the armed vessels, and was optimistic: "The wind is good, the weather is beautiful; we have no knowledge of any enemy ships in the Mediterranean strong enough to overcome the republican escort." Only five days later, Moitte and Thouin reported that the art seized in Rome by the French had arrived in the port of Marseille.

9

"The Republic of Venice will surrender ... twenty paintings"

If [the Venetian] Government does not use vigourous measures
it will be finally dissolved after an existence of near 1400 years.
—Richard Worsley, British ambassador to Venice, May 10, 1797

Within weeks of Bonaparte's victory at Arcola, he again sought an alliance with Venice. In Paris, on November 30, 1796, the director Jean-François Rewbell tried to convince Ambassador Alvise Querini that Venice should side with the French Republic. But when given a third chance to join forces with the French, the Venetians refused; the patricians were incapable of agreeing to back the revolutionaries of France.

Three months later, on March 10, Bonaparte launched his drive to Vienna from Bassano, forty miles northwest of Venice. From Klagenfurt, on March 30, he proposed "peace" to Archduke Charles, the Austrian field marshal: "Has the war not lasted six years? Have we not killed enough people and done enough to a sorrowful humanity?" But the French army continued on, and a week later, Bonaparte reached Leoben, only seventy-five miles from Vienna. His advance guard at the Semmering Pass could almost see the Austrian capital. That day, two Austrian generals requested an armistice.

Buoyed by the prospect of a cease-fire with Austria, Bonaparte threatened to wage war on Venice. On April 9, he handed General Andoche Junot an ultimatum to deliver to the doge, Ludovico Manin: "Is it to be war or peace?" Over the past month, across the Veneto—in Bergamo, Brescia, and Cremona—there had been uprisings against the French, which Bonaparte was determined to suppress. With customary hyperbole, he laid the blame on the Venetian government: "All the mainland of the Most Serene Republic is in arms. On every side, the rallying-cry of the peasants whom

you have armed is 'Death to the French!' They have already claimed as their victims several hundred soldiers of the Army of Italy."

Bonaparte set out his terms: "If you do not take immediate measures to disperse these militias, if you do not arrest and deliver up to me those responsible for the recent murders, war is declared." He gave Venice twenty-four hours to respond.

Junot arrived in Venice with Bonaparte's order on April 14, Good Friday. The next day, the Collegio (the doge's cabinet) drafted a letter, asserting Venice's peaceful intentions toward France and promising to punish the agitators in the Veneto who had attacked French troops. Ambassadors Francesco Donà and Leonardo Giustinian were to take the letter to Napoleon in Austria.

But two days later, on Easter Monday, a rebellion broke out in Verona and about four hundred French soldiers were killed. Hearing the news, Bonaparte vowed revenge. "I will take general measures for all the Venetian mainland and I will issue such extreme punishments that they won't forget," he told the Directory. By then, he had ordered the leaders of the Verona insurgency to be executed. To further penalize Verona, he extracted a steep indemnity and ordered the confiscation of "all the paintings, collections of plants, shells, etc. that belong either to the city or to individuals."

Soon after, Claude Berthollet and the Italian painter Andrea Appiani traveled to Verona to select pictures for the museum in Paris. They went straight for Verona's most celebrated works of art—Andrea Mantegna's *Madonna and Child with Saints*, created for the Basilica of San Zeno, and Veronese's *Martyrdom of Saint George*, in San Giorgio in Braida. From the Bevilacqua family's grand private palace, they chose an eleven-foot-wide Tintoretto oil sketch, titled *Paradise*, which the artist had made in preparation to decorate the vast Great Council Hall of the Doge's Palace with a canvas that would span seventy-two feet.

On April 19, at 2:00 a.m. at Eckenwald Castle near Leoben, Napoleon signed a preliminary agreement with the Austrians. They had decided that in the final treaty, to be ratified in October, Austria would give up Milan, Modena, the Austrian Netherlands, and the left bank of the Rhine, but would receive the Republic of Venice. The plan to trade away Venice

presumed that the French would have Venice to give. In these negotiations, Bonaparte proceeded without consulting the directors in Paris. He kept secret his promise to treat Venice as no more than a bargaining chip. To persuade the Directory of the Venetians' treachery, he denounced the doge's government as "the most absurd and tyrannical." Besides, Napoleon wrote, "there is no doubt it wanted to profit by the moment we were in the heart of Germany to murder us. Our Republic has no more bitter enemies."

The Venetians were clinging to the hope that Bonaparte would leave them alone, when they made a move that upended their attempts to placate the French. On April 17, they had officially closed their waters to foreign vessels. Three days later, a French ship, ironically named *Libérateur de l'Italie*, sailed into the Venetian lagoon, and the commander of the Arsenal opened fire, killing Captain Jean-Baptiste Laugier and four of the crew.

News of Laugier's death hadn't reached Bonaparte, when on April 25 Ambassadors Donà and Giustinian arrived in Graz (twenty-five miles south of Leoben) and handed him the Venetians' conciliatory letter. Still, Bonaparte was in no mood to make peace with Venice. He ignored the Collegio's overtures and again threatened war: "I will have no more Inquisition, no more Senate. . . . I shall be an Attila to the state of Venice."

Donà and Giustinian were on their way back to Venice when they encountered a courier who told them of Laugier's death and gave them instructions from the Senate to inform Bonaparte. Fearful of his response, the diplomats put the news in a letter, which they delivered to him on April 30, by which time the French commander was in Palmanova, just sixty miles from Venice.

Bonaparte responded in writing. He condemned the killing of Laugier as an event "without parallel in the annals of the nations of our time." He demanded the Venetians turn over "the admiral who gave the order to fire, the commander of the fortress and the Inquisitors who direct the police of Venice."

To the Directory he wrote: "If French blood is to be respected in Europe, if you do not want them to mock us, blood must flow, the noble Venetian admiral who presided over this assassination has to be publicly condemned." He called for France to withdraw its ambassador, Jean-Baptiste Lallement.

The shooting of Laugier gave Bonaparte the excuse he sought to attack Venice. On May 2, in Treviso—only sixteen miles north of Venice—he met with the Venetian governor, Angelo Giustinian, who later reported that Bonaparte had ordered him to leave Treviso in twenty-four hours or he would have him shot.

Giustinian remained calm. He replied that he took orders only from Venice and would stay put in Treviso until his government instructed otherwise. Bonaparte again threatened to kill Giustinian unless he immediately arranged to have ten Venetian "inquisitors" turned over to France. The Venetian refused to flinch. He spoke out in defense of Venice, drew his sword, and threw it at Napoleon's feet, declaring: "I will surrender myself as a hostage for Venice. If you must have blood, shoot me, but spare my country."

Not surprisingly, Giustinian's show of nerve impressed Bonaparte: "I shall not only spare you but when I seize the property of the nobility yours shall be left untouched." But Giustinian was not appeased: "I care to receive neither my life nor my property as a favor from you."

The following day, May 3, Bonaparte declared war on Venice. "After such horrible betrayal, I do not see any way other than to wipe the Venetian name from the face of the map," he wrote the Directory. Five days later, from Milan, he added that the Venetian Great Council had agreed to set up a democratic government and that he intended to send three or four thousand troops to Venice.

On May 9, Joseph Villetard, France's new chargé d'affaires, ordered the Venetians to allow French forces to take over the Arsenal and to establish a new democracy. They were to free all political prisoners, although, in fact, there were none.

On Friday, May 12, in the Doge's Palace, the Great Council held an emergency session. Doge Manin put forth a resolution to abolish the Venetian Republic and create a new "Provisional Municipality," under the French, with the "most high object of preserving unharmed the Religion, life and property of all these most beloved inhabitants." During the meeting, shots were heard. Fearing the French invaders and not realizing that Venice's own soldiers from Dalmatia were firing into the air as they were taking leave of the city, the councilors shouted, "Vote! Vote!" They

cast their ballots and fled, many abandoning their robes so they would not be identified outside by Venetians angry that the Great Council had capitulated so quickly. Afterward, Manin found himself almost alone in the room. The ballot's lopsided outcome was predictable: 512 had voted for abdication; 20 voted against it (5 abstained). That the vote was illegal—without a quorum of 600—made no difference to the Venetian Republic's fate. On May 16, General Louis Baraguey d'Hilliers and some seven thousand French troops entered Venice.

That same day, in Milan, Piero Mocenigo signed a treaty, dictated by Bonaparte to the Republic of Venice. According to secret articles to the treaty, Venice would pay France about three million francs and furnish "three ships of the line and two frigates in good condition, armed, and equipped with everything necessary." Article 5 covered France's demand for works of art: "Finally, the Republic of Venice will surrender to the commissioners [selected] for this purpose twenty paintings and five hundred manuscripts, to be chosen by the general in chief."

10

"In the Church of St. George ... *The Wedding Feast at Cana*"

I had already called upon the Commissioners' magnanimity ...
not to take Titian's Assumption in the Frari. I still feared for
the famous Giovanni Bellini in San Giobbe as well as the Titian
in Santa Maria Maggiore.

—Pietro Edwards, 1797

In mid-June 1797, while Gaspard Monge and the other commissioners lingered in Rome, Claude Berthollet had gone ahead to Venice. He was alone. On June 19, Jean-Baptiste Lallement, the French ambassador, informed the Venetian Provisional Municipality that a "member of the Commission of the Sciences and Arts charged by the French Government for gathering in Italy objects of this nature" had arrived in Venice. He asked the Venetian officials to "issue the orders that it judged necessary so that Citizen Berthollet can make the choice of the paintings and manuscripts."

Berthollet had no formal training in art or its history, but he was more than capable of deciding upon twenty Venetian pictures for the Louvre. As the head of dyeing operations at the Gobelins tapestry works, the chemist well knew of the Republic's preeminence in the production of dyes and in the manufacture of silks and other textiles. Six years before, he had written *Elements of the Art of Dyeing*, a book in which he surveys the history of dyeing processes and singles out the Venetians as pioneers. "For a long time, Italy and particularly Venice, possessed almost exclusively the art of dyeing, which contributed to the prosperity of their manufacture and their commerce," he wrote. And, Venice had taught the French: "But by degrees this art was introduced into France" and practiced by the Gobelins workshop in Paris.

François Seraphin Delpech, after Nicolas-Eustache Maurin, *Claude Berthollet*, 1832.

Berthollet was no stranger to Venetian painting. As a young physician in Paris, he had worked for Louis-Philippe I, the Duc d'Orléans, who had given him space to put a chemistry laboratory in the Palais Royal, the vast palace across from the Louvre that had housed the fabulous Orléans collection, with its twenty-nine Titians, ten Tintorettos, and nineteen Veroneses.

Berthollet was also well suited to handle the diplomatic challenge of persuading the Venetians to give up some of their finest works of art. He had been born in December 1748 to a French family in Talloires, a village on Lake Annecy, in what became the Haute-Savoie region of France but was at the time part of the Kingdom of Piedmont-Sardinia. He grew up speaking Italian and, in Italy, was able to translate for those commissioners who spoke only French. "Berthollet was a most amiable man," wrote Sir Humphry Davy, a British chemist. "When [he became] the friend of Napoleon even, [he was] always good, conciliatory and modest, frank and

candid. He had no airs and many graces." These qualities were evident early on. In 1772, at the age of twenty-three, Berthollet arrived in Paris, with a medical degree from Turin, and, through the Swiss Théodore Tronchin, who was the chief doctor to the Duc d'Orléans, he became the personal physician to the thirty-five-year-old Charlotte-Jeanne Bérault de la Haye, Madame de Montesson, the duke's mistress and later his wife.

In his Palais Royal laboratory, Berthollet made the most of his time. By 1780, he had defended the four theses necessary to earn a medical degree from the University of Paris, and he had presented seventeen papers at the Royal Academy of Science. In 1779, he married Marguerite-Marie Bauer, and in 1780, their son, Amédée, was born.

Chemistry also paved Berthollet's way in diplomacy. One of the Venetians to lead the new pro-French Provisional Municipality was Vincenzo Dandolo, thirty-nine, himself a chemist, who would have welcomed the illustrious Berthollet to Venice. Later, in 1804, Dandolo would pay tribute to Berthollet by translating and publishing his influential *Essay on Static Chemistry*. But already, Dandolo had brought the advances made by the French chemist and his colleagues to Italy. In 1790, Dandolo had translated Lavoisier's *Elements of Chemistry* for the first Italian edition. Three years later, Dandolo's *Foundation of the Science of Physical Chemistry* introduced Italian scientists to the new chemical nomenclature devised by Lavoisier, Berthollet, Morveau, and Fourcroy.

Dandolo was the son of Abram Uxiel, a Jewish pharmacist who had converted to Christianity and had assumed the illustrious Venetian name of Dandolo. Excelling at school, Dandolo earned a degree in chemistry under Marco Carburi, the University of Padua's first professor of chemistry. Returning to Venice in 1778, Dandolo took over his father's pharmacy, near Campo San Fantin. There, in his laboratory, he manufactured medicines, including a new type of quinine, and also held meetings for fellow Jacobins. According to a contemporary, Dandolo was handsome, vivacious, and "studious notwithstanding the distractions available in Venice."

Once the French took over, Dandolo was one of sixty members of the assembly who ran the Provisional Municipality, and he sat on its policy-setting Committee of Public Safety. At a "Festival of Liberty"

held in the Piazza San Marco, the French planted a Liberty Tree and set fire to a copy of the Golden Book, in which the names of Venice's noble families had been first recorded in the fourteenth century. In a speech, Dandolo hailed the day, June 2, as "the day of exaltation, blessed for future generations . . . the day of regeneration." No doubt, Dandolo welcomed the concrete step toward liberty taken in July, when officials of the new government tore down the gates of the Jewish ghetto and had them burned.

As Dandolo embraced the French, he seemed not to dispute their claim to Venice's art. On June 18, he wrote the Venetian "Delegation in Charge of Housing," asking them to find a "large and decent place" where Berthollet, the "Commissioner of Fine Arts," could place "the objects."

Dandolo assigned the task of advising the French to Pietro Edwards, a fifty-two-year-old artist and painting restorer who for two decades had served as inspector general of the public pictures of Venice. Edwards was a powerful figure in the Venice art world. He had played an influential

With this letter from the Committee of Public Safety of the Provisional Municipality of Venice to the Delegation in Charge of Housing, dated 30 Pratile V (June 18, 1797), Vincenzo Dandolo paved the way for "Citizen Berthollet" to choose Venetian art for Paris.

and pioneering role in the field of art conservation, studying chemistry, advancing modern practices, and insisting that whatever restoration was done to a painting must be reversible.

In late June 1797, Dandolo sent Edwards to meet Berthollet. Berthollet probably knew of the restorer from Lalande, who in the 1786 edition of *A Frenchman's Voyage in Italy* describes the "academy for the restoration of the beautiful pictures of Venice" and mentions Edwards (an "English painter") by name but spells it as it would have been pronounced in French: "M. Edoas."

On hearing from Edwards, however, Berthollet immediately put him off, explaining that the other two commissioners had not yet arrived. While the reason for Berthollet's delay was factually accurate, it was mainly tactical. The delay would give Berthollet time to inspect Venice's paintings on his own, without interference from the Venetians.

On July 23, Berthélemy, Moitte, and Tinet left Rome. They wrote that they planned to "digress a little off the route to see for themselves the state of our depot in Livorno." Monge also headed for Venice, but he stopped first in Florence and then Milan. Berthollet had six weeks alone in Venice.

Not until July 29 did Lallement announce that "Citizens Monge, Tinet and Berthleme [*sic*], of the Commission of Arts of France in Italy have arrived in this city." The French ambassador added, "They will occupy themselves unceasingly with the choice of pictures which by the peace treaty have been ceded to the Republic of France."

Only eight days later, the French choice had been made. That the commissioners completed the list quickly suggests that Berthollet had drafted it and then sought the concurrence of the others. On August 6, the commissioners sent Lallement a list of sixteen paintings. They wanted him to deliver this list to the Municipality of Venice and to ask the Venetians to find an "architect to put in charge of the removal and the transport of paintings to the Palazzo Grimani di San Luca." They aimed to get the paintings onto two French frigates leaving for Toulon in about twelve days. Within two days, Lallement passed the list and the request on to the Venetians. Again, Dandolo proposed that Pietro Edwards direct the French in moving and packing the pictures.

As Venice's chief restorer, Edwards was in effect the curator of the

Venetian government's paintings—responsible for the canvases (many of enormous size) on the walls and also the ceilings of government buildings, most importantly the Doge's Palace. He had also worked on many paintings in churches, monasteries, and *scuole* across the city. Over the course of forty-seven years, between 1770 and 1817, Edwards would supervise the restoration of some 759 pictures.

Born in 1744 in Italy to English Catholic parents, who gave him his Italian first name, Pietro Edwards had moved to Venice when he was eight. He was educated at the school of the Oratorio, and he considered himself Venetian. An aspiring painter, he apprenticed to Gaspare Diziani and started out restoring paintings in Padua. In 1771, Edwards drew the attention of Venetian officials when he claimed that the corrupt restoration practices of the Venetian painters' guild (the Collegio dei Pittori) had caused extensive damage to Venice's pictures. Seven years later, the Venetian government put Edwards in charge of its large inventory of canvases. He had set up a restoration studio in the "new" refectory of the convent of Santi Giovanni e Paolo, one of the first such laboratories in Europe.

Resolved to raise the job of restorer from a craft to a profession, Edwards applied himself with zeal to all aspects of his work. A realist, even a pessimist, Edwards often cried doom over the plight of Venice's troves of paintings—warnings that he felt went largely unheeded. He produced reams of meticulous records, inventories, and accountings. In detailed reports, Edwards analyzed the problems of pictures and documented the procedures he had performed to address them. He was a prolific author, fluent in convoluted, overwrought abstract language, designed to flatter and impress the nobles who employed him. To argue that the Venetians should take measures to halt the export of their extraordinary pictures, he wrote that "these excellent products of our celebrated brushes are . . . sought after with a transcendent profusion of gold from other nations, to which Nature did not offer the gift of a Titian or a Paolo [Veronese]."

So seriously did Edwards take the challenge of conserving Venice's paintings that he complained about the impracticalities of oil paint, the very medium with which Veronese and other Venetians had achieved their artistic breakthroughs. Edwards couldn't resist pointing out "the deep and natural imperfection of this favored liqueur," whose dazzling

effects of color had "seduced everyone." His critique reflected the experience of seeing many fifteenth- and sixteenth-century oil paintings whose tones had shifted and darkened, whose paint had dried out and cracked.

Despite his numerous records, treatises, and letters, Pietro Edwards remains an elusive figure. Nothing seems to be known about where he lived or what he looked like. The only information scholars have about his wife, Teresa Fossati, is her name. Their son, Giovanni O'Kelly Edwards, also became a restorer. The letters written to Edwards from the Government Commissioners for Research on Objects of Science and Art address him as "Citizen Edwards . . . charged by the provisional government of Venice to Supervise the execution of the Treaty concerning the Arts."

From the early eighteenth century, the Venetians had advanced art conservation in response to the problems they encountered repairing the damage to their pictures inflicted by the humid salt air of a city built on islands in a lagoon. The water that reflected and amplified the light and had inspired Venetian artists to become masters of color also saturated the atmosphere, causing both canvas supports and painted surfaces to deteriorate. Many of Venice's paintings were installed in churches and monasteries, which had no heat nor much light, and thus subjected the paintings (even without leaking roofs) to perpetual dampness, and in winter, extreme cold. Candles caused problems not unique to Venice, darkening pictures with soot and posing a constant risk of fire.

Edwards's restoration laboratory had attracted international attention. In 1782, it was visited by Paul Petrovitch, the Grand Duke of Russia (later Tsar Paul I), and his wife, Maria Feodorovna, who were traveling under the pseudonyms the Comte and Comtesse du Nord.

Eight years later, in the spring of 1790, the German writer Johann Wolfgang Goethe was looking at Titian's *Death of Saint Peter Martyr* in the church of Santi Giovanni e Paolo when a friar asked "whether [he] would not like to see" the painting restorers at work. Goethe was impressed with what he saw in the convent's refectory next door. He described Edwards's laboratory as a "large *salon*, with some adjacent spacious rooms . . . whither the damaged pictures are brought and restored." The restorers were "intimately acquainted with the diverse styles of the masters," he wrote. They "are carefully instructed on the subject of canvas, priming,

first coat of color, glazing, finishing and harmonizing." Allowing such prominent visitors to observe his operation, Edwards sought to disseminate his theories and his practice.

At the heart of the Venetian art world, Edwards also bought and sold paintings. In 1804, when the sculptor Antonio Canova sought to acquire "views" of Venice, he wrote Edwards from Rome inquiring whether the restorer knew of any Canova could buy. Edwards's reply was characteristically pessimistic: Canalettos were not to be had. Nor did he know of any views by Francesco Guardi. "There are no more view painters of quality," Edwards wrote.

What did Edwards think of the French? He was too much of a diplomat and an operator to let on. He had devoted his life to "saving" Venetian pictures, and now he was thrust into the unexpected and onerous role of assisting the French in removing those same pictures from the places for which they had been created and in packing them up and shipping them to Paris. Later, he would mourn the cultural cost the French had extracted from Venice, by the "detachment from our once celebrated walls of those precious testaments to our national greatness and genius."

It was not until August 11, after Tinet, Berthélemy, and Monge had been in Venice for almost two weeks, that Pietro Edwards was instructed to get in touch with the commissioners. That day, he met them for the first time, and they handed him the list of the sixteen paintings they had chosen for the Louvre. The list, Edwards later wrote, "caused me great pain."

Indeed, to anyone who knew Venetian painting, the "List of Paintings"—a makeshift memo written in French on three sheets of paper, with a column of numbers, between ruled lines, running down each page—was a shocking document. To the left of the numbers are the names of some of Venice's major institutions, including the Doge's Palace, the church of San Zaccaria, and the Scuola Grande di San Marco. To the right of each number is the name of a picture and the artist who painted it. The French list was signed by the two painters, Berthélemy and Tinet, and by Berthollet. (An Italian version of this list was translated from the French and composed in a free-flowing hand.)

When Edwards looked at the list, he could visualize each of the sixteen pictures selected by the French. Not every painting was outstanding,

Liste des Tableaux qui doivent être
Livrés à la République française, en Vertu
du Traité conclu entre le Général En Chef
de l'armée d'Italie, et le Gouvernement de
Venise.

Palais du
Doge

Salle des 4 Portes.

N°. 1. un Tableau de Contarini, Representant la
Vierge, quelques Saints l'environne, un Doge
dans le bas du Tableau.

même Salle.

2. un Tableau du Titien, Representant la foi,
St Marc, et divers Soldats et autres figures.

Salle de l'anticollège.

3. Un Tableau de Paul Veronese, Rep.t
L'Enlevement d'Europe.

Salle du Conseil des 10.

4. Un Plafond rep.t Jupiter foudroyant les
vices, Par Paul Veronese.

même Salle.

5. Junon répandant les tresors sur la Ville
de Venise, Plafond, Par Paul Veronese.

à l'Eglise
St Georges

Dans le refectoire des Moines.

6. Les Noces de Cana, Par Paul Veronese.

The "List of Paintings that must be removed to the French Republic, according to the Treaty Concluded Between the General in Chief of the Army of Italy and the Government of Venice." *The Wedding Feast at Cana* is no. 6.

but a Giovanni Bellini, a Tintoretto, two Titians, and four of the Veroneses were masterpieces. These were pictures created in the sixteenth century, when Venice was a maritime and cultural power and these artists were second to none—pictures that had been lauded by commentators, starting with Vasari, and engraved many times, pictures with which the Venetians had advanced the art of painting.

Despite his alarm, Edwards confessed to "feeling some satisfaction that . . . the majority of the works [the French chose] had been restored under my direction." Some of these fragile paintings, he claimed, owed their very existence to his work. "Among these were pictures saved from such heavy deterioration, that at first I had not accepted them for fear of the impossibility of restoring them and had finally done so under protest."

The French had organized the list of paintings geographically, as though Berthollet had taken Lalande's guidebook and gone back and forth across Venice not unlike a sightseer on the Grand Tour. Berthollet started with the Doge's Palace. From there, he had moved on to the churches and monasteries. He had sailed or rowed across Saint Mark's basin to the island of San Giorgio Maggiore, then crossed the water back to the monastery of San Sebastiano, in the *sestiere* of Dorsoduro, and from there headed northeast to the Scuola Grande di San Marco, on the other side of the city. He had gone on to five churches—San Zaccaria, the Madonna dell'Orto, Santi Giovanni e Paolo, Santa Maria della Carità (now part of the Galleria dell'Accademia), and Santa Maria Assunta, known as the Gesuiti, the Jesuit church. Berthollet seems to have looked to Lalande, taking seven out of the eight pictures the astronomer had highlighted in *A Frenchman's Voyage in Italy* as the most important in Venice.

From the Doge's Palace, the French had designated five pictures. They put down these canvases in the order in which they would have encountered them after climbing the steep Golden Staircase to the grand staterooms on the building's second floor. The list began quietly. The first two paintings were insignificant, if unmistakably Venetian: the *Doge Marino Grimani Adoring the Madonna with Saints Mark, Marina and Sebastian*, by Giovanni Contarini, and a minor Titian, *Doge Antonio Grimani Worshiping Faith*.

But immediately thereafter Edwards could see that the French were going after the finest paintings in the city, and judging from the next six

pictures—those numbered 3, 4, 5, 6, 7, and 8 on the list—what they sought above all else were Veroneses.

No. 3: in the Sala dell'Anticollegio, the commissioners picked *The Rape of Europa*, a sultry scene of blues and greens, in a partly wooded landscape where Veronese reinvented the Ovid myth as an idyll, anticipating the eighteenth-century *fêtes galantes* of Antoine Watteau.

No. 4: from the Room of the Council of Ten, they wanted the great oval canvas Veronese had painted for the center of the ceiling—*Jupiter Expelling the Vices*, which had launched the artist in Venice.

No. 5: they had chosen a second Veronese from the same ceiling—*Juno Showering Gifts on Venice*. The goddess floats on yellow clouds and drops gold coins and a crown to the female figure who personifies the Republic.

At the bottom of the first page, the French had written:

à l'Église St. Georges . . . dans le réfectoire des Moines
6 . . . *Les Noces de Cana par Paul Véronèse.*

(In the Church of St. George . . . in the refectory of the monks
6 . . . *The Wedding Feast at Cana by Paolo Veronese.*)

The sight of *The Wedding Feast of Cana* from San Giorgio Maggiore enraged Edwards, and he said so. He had not worked on the picture, but he knew that the canvas was too large and fragile to detach without causing damage.

His eyes moved on, to no. 7. The French weren't settling for only one Veronese feast. They were taking a second—the smaller, simpler feast from the refectory of San Sebastiano—*The Feast in the House of Simon*. But, here again, Veronese had called up costumes, colors, gesturing figures (around two tables), Palladian architecture, classical sculpture, dogs, cats, and children and directed them so as to capture the charged moment when Judas questions Jesus about the expensive oil with which Mary Magdalene is washing his feet.

No. 8: the sixth Veronese selected by the French was installed in the sacristy of the church of San Zaccaria—the *Madonna and Child with Saints*, an altarpiece painted around 1562 for the Bonaldi family chapel.

Veronese had placed the Madonna beneath a gold dome, purposefully referring to the gold dome above the Madonna in Giovanni Bellini's altarpiece painted some fifty-seven years before in the nave of the same church.

The French wanted this beautiful Bellini too—no. 9, the *Madonna and Child Enthroned with Saints Peter, Catherine of Alexandria, Lucy, and Jerome*. Rising sixteen feet, the picture was painted on a wooden panel, which was set into a stone frame, resembling a triumphal arc, built against the wall of the church. The Madonna, robed in blue, sits high on a throne. In the dome of gold above her, Bellini evokes the gold mosaic ceiling of the Basilica of Saint Mark. Pairs of saints in robes of cardinal red, ocher, olive green, and blue stand near the throne; seated on its steps, an angel plays a violin. Bellini experimented with illusion. In the painting, he places the figures in a chapel that seems to extend from the nave of the church. Gaps between the chapel's painted columns open the architecture to give glimpses of spindly trees against a blue sky. The picture is "so mild and serene, and so grandly disposed and accompanied," Henry James would later write, "that the proper attitude for even the most critical amateur, as he looks at it, strikes one as the bended knee." Edwards knew that the panel painting would be particularly difficult to get out from behind the stone frame that bordered it and was part of the wall.

For a different reason, Edwards feared also for Tintoretto's *Last Judgment*—no. 10—one of the two tall canvases the artist had painted for the choir of the Madonna dell'Orto. Forty years after Michelangelo completed the Sistine Chapel, Tintoretto had responded with a darker vision. The picture is jammed with bodies—floating, struggling, drowning— while at the bottom a flood sweeps the life-sized figures of the damned to the underworld and higher up the saved rise through paradise toward Christ.

The commissioners had seen Tintoretto's *Last Judgment* not in the church but in Edwards's studio, where he had taken the canvas to be restored. That Edwards had already pulled the painting down from the wall may have encouraged the choice of the French.

On the French list were two other Tintorettos—*Saint Agnes*, also from the Madonna dell'Orto (no. 15), and the far greater *Miracle of the Slave*

(no. 11), the picture painted for the Scuola Grande di San Marco that had proved the artist to be Titian's rival.

No. 12 was Titian's *Death of Saint Peter Martyr*—at that time the artist's most celebrated work. Painted on a wooden panel in Santi Giovanni e Paolo, it showed the struggle between the unarmed saint and a heretic. Plunging this fight into a menacing landscape of trees, Titian had up-ended the staid and heavenly worlds evoked in conventional altarpieces.

The third Titian on the list, *The Martyrdom of Saint Lawrence* (no. 16), was darker and more violent; Saint Lawrence was killed in Rome—and according to legend, he was burned to death on a gridiron. Titian com-pressed the soldiers and henchmen torturing the young saint into the foreground but set the scene in nighttime Rome—its architecture and sculpture made chilling and gorgeous with the play of light against the deep blues and blacks of the darkness, illuminated only by flames leaping from tall torches and the fire beneath the saint.

Pordenone's *San Lorenzo Giustiniani* (no. 13) and Leandro Bassano's *Raising of Lazarus* (no. 14) proved that even Venice's second-tier masters could paint well. Later, a Louvre catalogue would point out that the *Rais-ing of Lazarus* was the museum's only example of Bassano's work, suggesting the reason for the French decision to take it.

Edwards understood that all but one of the paintings on the French list had remained on the walls for which they had been painted, encased in their original architectural frames. Extracting these pictures would put them at risk of injury or even destruction. The threat to the physical life of the paintings was the only argument Edwards dared use to resist the demands of the French.

In a letter to the Venetian Committee of Public Safety, written in the late summer of 1797, Edwards spelled out the cost that the French plundering exacted from Venice. He did not depart from the formal rhet-oric in which he had been trained, but sought to set the record straight and to defend himself against the possible charge that he had made the French choice. His strategy had been to "try to meet their [the commis-sioners'] requirements with true candor, promptness and the greatest dil-igence," but not to advise or make suggestions. He avoided having any "direct influence," but instead played "a passive role with regard to these

enlightened citizens." Edwards's letter, transcribed into a book of official Venetian documents, is written out in narrow columns and runs to fourteen pages.

Edwards wrote that he had behaved with the utmost propriety when collaborating with the French, and he voiced no complaints about Berthollet and his colleagues, even if he had had them. "I found the French commissioners outwardly cultured, courteous, and uncommonly skilled in the fine arts; they showed themselves to be particularly well instructed as far as their mission was concerned."

But the embattled restorer knew that the technical expertise he offered the French had only deepened the wound to Venice, and the situation threw him into despair. "I took on this assignment with which you charged me and completed it," he wrote, "filled with a dissimulated sadness as any other loving citizen and passionate artist would have been."

Beneath the controlled prose, Edwards seethes not only at the French but also at the Venetians, who had gotten the Republic (and him) into this fix, and who had questioned his work in the past. The French choice of pictures, he argued, vindicated his sometimes controversial approach to painting conservation. "The government will now receive a consolatory and solemn testimony that removes any trepidation" about the "extreme utility of very thorough restoration." Then he snapped: "So much for the audacious slander, the envy and the malice that for so many years angrily accompanied [the] realization" of this work.

Veronese's *Wedding Feast at Cana* was one of four paintings Edwards asked the French not to take. They were in such a "dangerous state," he wrote. "I felt it my duty to warn the commissioners that without taking some extraordinary precautions there would be no hope of their arriving [in Paris] intact." The others were Bellini's *Madonna and Child Enthroned with Saints*, Titian's *Death of Saint Peter Martyr*—both painted on wooden panels—and Tintoretto's towering *Last Judgment*. The four pictures were, probably not coincidentally, among the greatest the French desired.

The French paid little attention to Edwards's warnings. "They were determined to maintain the selections they had made," he explained. Only in the case of Tintoretto's *Last Judgment* were the commissioners

"persuaded to change their minds." The Tintoretto canvas had required a lot of "extremely laborious" work, Edwards argued. And "the freshness of the recent restoration" left the picture vulnerable. "Rolling it and packing it would have put the entire painting in danger."

In this case, Edwards may have regretted he said anything at all. When the commissioners saw the Tintoretto in his restoration studio in Santi Giovanni e Paolo's new refectory, they must have looked around and walked into the monastery's old refectory as well. There they would have found another Veronese feast—*The Feast in the House of Levi*, the painting that had started out as *The Last Supper* and prompted the artist's interrogation before the Inquisition.

"Without consulting me," Edwards wrote, the French "chose as a substitute [for the Tintoretto] another painting they saw in the refectory at S. Giovanni e Paolo." This picture, he emphasized, was "our last remaining Banquet by Paolo Veronese of the four he painted" in Venice and "was not in good condition either."

The old refectory in Santi Giovanni e Paolo was a beautiful room with mahogany wainscoting, large brass chandeliers, ocher-toned walls, and long curtains of cranberry silk at its windows. We know what the commissioners saw from a dark, moody painting by Francesco Guardi from 1782 in which he describes an audience Pius VI held there that year. Some thirty Venetian officials in red robes parade down the vast space toward the pope, who is just visible at the end of the room, standing before a large throne, and beneath the Veronese feast. The Guardi had been commissioned by the Republic of Venice, and Edwards had handled the negotiations with the artist to paint four pictures documenting the papal visit.

By adding the three Veronese feasts from Venice to the *Feast in the House of Simon*, which had been acquired by Louis XIV and was hanging in Versailles, the French would own all four.

Bonaparte's treaty with Venice had stipulated that the French would appropriate twenty pictures, but the commissioners had named only sixteen. They explained nothing to the Venetians about why they delayed completing their list, but on August 4, they laid out their reasoning to Napoleon himself:

Venice possesses four horses, Greek monuments, which would be a worthy ornament for one of our squares; but constrained by the terms of the treaty, we must express our regret at leaving them behind; we propose to you a means of obtaining them. It would be to limit the choice of paintings to sixteen: that number would suffice, and the four paintings would be replaced by the horses.

The bronze horses, described by Petrarch in the fourteenth century as "standing as if alive," still reigned over the façade of Saint Mark's Basilica. To persuade Napoleon to ignore the treaty's specifics and carry off Venice's most famous sculptures, the commissioners flattered him: "The horses of Venice would make a monument worthy for Paris of the heights which have made this year so celebrated in the annals of the world." They suggested that Bonaparte "may perhaps have other means" of acquiring the horses.

Meanwhile, for the moment, the commissioners abandoned their plans to take the four bronze horses to Paris. Instead, on August 26, they gave Edwards a list of the "four remaining objects, to be added to the list of sixteen paintings which you have already received from us, amounting to the twenty in the terms of the treaty."

To decide on these four objects, the French returned to the Doge's Palace. There they chose a third Veronese ceiling painting—*Saint Mark Rewarding the Theological Virtues*. They also went back to the Scuola Grande di San Marco for a large canvas by Paris Bordone, depicting a Venetian legend, *The Fisherman Presenting a Ring to the Doge*. Then, as though to test whether the Venetians would object if they failed to comply strictly with the treaty, the commissioners substituted two sculptures from the Biblioteca Marciana—a bronze *Bust of Hadrian* and a stone bas-relief, "representing a sacrifice," installed over the building's door—for two of the twenty paintings.

If forced to accept the four new pieces, Edwards was in fact delighted. He dismissed the Veronese and the Bordone canvases as "wretchedly restored." The *Bust of Hadrian*, he claimed, was a sixteenth-century copy, and the bas-relief was broken.

On August 30, Lallement, the French ambassador, informed the

Venetian Committee of Public Safety that the commissioners had presented him with the final choice of eighteen paintings and two sculptures, and he and the Venetians had approved the list. By that same day, the French forced Edwards to vacate his studio. Two months before, the Committee of Public Safety had warned him that they planned to turn part of the convent of Santi Giovanni e Paolo into a military hospital. Edwards shot back with his own demands. To move his laboratory, he needed to find a new space with the capacity for "enormous" pictures and for his "equipment and tools," and to be given time for the "ground work and transportation, which would take about fifteen days." He also asked for money to pay for the moving expenses.

In mid-August, the French had again ordered Edwards to leave. He resisted and threw the problem of what to do with the canvases in the restoration studio back to the French. "I'll return the keys of this room," but "will not be able to take responsibility for those paintings if I don't know where they will be relocated," he wrote. He was busy now helping the commissioners pack up their chosen art. A draft of a letter, addressed to Venetian officials, reveals that he struggled to compose it—his handwriting appears rushed and uncharacteristically messy; he has crossed out lines and rephrased his points.

While stalling, Edwards made the decision to move his workshop to the Palazzo Grimani di San Luca, a sixteenth-century building designed by Michele Sanmicheli, which looms over its neighbors on the Grand Canal. The Palazzo Grimani's *piano nobile*, or second level, rises to the top of the third story of the palace beside it, and it has a tall doorway through which paintings could easily be brought in and out.

To the draft of the letter, Edwards added a sad postscript, which he titled "scattered notes . . . about the . . . sudden evacuation of everything from S. Gio e Paolo":

25 August the move begins.
30 August the laboratory has been emptied and the move completed.

11

"We . . . have received from Citizen Pietro Edwards"

As a final precaution, wooden planks were placed securely around
the containers.

—Pietro Edwards, August 1797

Once the French choice of the Venetian paintings had been made,
the unnerving part of the process began. It was one thing for the
commissioners to draw up a list of eighteen pictures they desired
for the Louvre and another to deliver them to Paris unscathed. In the-
ory the Venetian canvases were portable, but Veronese's *Wedding Feast at
Cana* was not intended to be. Veronese had painted it to Abbot Scrocchet-
to's instructions on a mural-sized canvas attached to a wall of Palladio's
refectory, and he had expected the picture to remain there as long as the
monastery of San Giorgio Maggiore was standing. To get the Veronese to
the museum, the French would have to pry the enormous canvas from its
architectural frame and off its stretcher, wrap the unwieldy painted fabric
around a cylinder, pack the roll into a crate, and load the crate onto a ship
that would cross the Mediterranean to the coast of France—risking at
best abrading the paint and at worst a total loss.

Edwards realized that it was probably impossible not to injure the Ve-
ronese when detaching it from Palladio's wall, but he hoped to minimize
the damage. Above the refectory's stone floor, Edwards constructed "an
artificial floor" onto which he could lower the canvas. He said little about
the process of dismantling the Veronese, but some of the difficulty can
be inferred from an early-twentieth-century photograph showing that to
move the picture required industrial ropes, pulleys, and more than twelve
men.

To begin the process of separating the canvas from the wall, Edwards
and the French commissioners first had to pull out the nails that ran

around the fabric's periphery, fastening it to the stretcher. They then pulled the picture down from the top. But as the canvas came away from the wall, they saw it rip suddenly along a row of nails that ran horizontally, high up, across the picture and that had been hidden beneath the paint, which splintered as each nail tore through the fabric, scattering chips to the floor. As the painting continued to fall, a second and a third row of nails tore through the paint and the canvas. Now scarring the glorious picture were three lines of holes, each half an inch in diameter. The top row punctured the blue expanse of the sky, the second followed along the balustrade, and the third cut through the crowd, dotting the costume of the master of ceremonies and the face of the violist.

Why these nails? Later, French conservators claimed that the iron nails had been driven across the bare canvas and into the stretcher's wooden crossbars by Veronese's assistants when they first put the bare linen up on the wall. They had then covered the nails with the gesso ground on which the artist spread paint. But other conservators argue that Veronese would not have agreed to these three rows of iron nails spanning the canvas and they must have come later. They hypothesize that in the damp refectory, the painting had started to sag and in a desperate measure to save it from collapsing, restorers had secured the canvas by inserting nails, which they then disguised behind touches of putty and paint.

In a draft of his letter to the Venetian Committee of Public Safety, Edwards congratulated himself on "saving" *The Wedding Feast at Cana*. As he had objected to the "strange method [the commissioners] had proposed to remove the immense canvas," he had "in this one instance" directed the painting's dismantling. "Confident in my ability I took on the responsibility as if I were working for my own benefit." The operation went well. "When the canvas was fully extended on the artificial floor that I had constructed for this purpose, the commissioner Berthélemy embraced me," Edwards wrote. "Then, I declared, 'I turn this painting over to you.'"

On a list of the Venetian paintings heading for Paris, dated September 30, the French took note of the damage: the Veronese "is pierced with nails applied on three bars that cross its entire length, two meters apart from each other." They added: "A little flaking and folds which have caused further flaking."

The commissioners wanted to act quickly to get the pictures onto ships before the onset of fall and winter. But to move many of the paintings required demolishing their architectural frames. To cut Giovanni Bellini's *Madonna and Child Enthroned with Saints* from the stone that had held the wooden panel in San Zaccaria since 1505 took ten days. Workers had to approach the picture from the back and to chisel through the twenty-six-inch-thick wall, which was attached to the wall of the building next door, Edwards explained. Then, they had to "shore up three floors of the building." Yet he claimed the Bellini had escaped without harm. "No need to shout reprimands at this crew," he wrote.

Freeing Veronese's *Feast in the House of Levi* from its frame in Santi Giovanni e Paolo's refectory also forced Edwards to have workers hammer through the stone wall behind the picture, causing him "continuous palpitations." The canvas had been cut into three sections in 1697, when a fire swept through the refectory and rescuers were quickly forced to pull it down. "Extreme diligence . . . [was required] to manage a piece composed of so many panels," Edwards explained. Also, the painting was "over one and a half centuries old . . . [and] weigh[ed] about three thousand pounds."

Originally, the commissioners had planned to use the Palazzo Grimani di San Luca—the site of Edwards's new studio—as a warehouse in which they would build wooden crates and pack the paintings for shipment to Paris. But "after much study and discussion," they rejected that plan. Instead, they decided a better place for crating the art would be the refectory of San Giorgio Maggiore, "notwithstanding the inconvenience of its distance and of the passage over water." The stone quay in front of the monastery allowed room for moving large canvases and crates. Like many Venetian buildings, the convent had a slip and a dock, accessible through an arch cut into an outer wall.

The dismantling of the sixteen Venetian paintings first chosen by the French began on August 11 and went on for three weeks. Edwards ferried back and forth across Saint Mark's basin to San Giorgio Maggiore's island four to six times a day. Fourteen of the sixteen paintings were canvases, and Edwards oversaw their removal from the Doge's Palace and seven other buildings and their transport to San Giorgio Maggiore. The two paintings on wooden panels—Bellini's *Madonna and Child Enthroned*

Canaletto (Giovanni Antonio Canal), *San Giorgio Maggiore*, 1735–1740.

with Saints at San Zaccaria and Titian's *Death of Saint Peter Martyr* at Santi Giovanni e Paolo—were difficult to move, and he left them at the two churches to be packed.

Again, Edwards claimed to have had no part in the decisions about taking down and packing the pictures: "I wanted all the methods, all the orders to come directly from the commissioners; I wanted the commissioners themselves to coordinate all the workmen; and I wanted them to witness every phase of the execution." If the French damaged the pictures before they left Venice, he sought to avoid blame. The French had ordered six wooden cases and two cylinders to be built. Edwards made certain that in fabricating the crates and in preparing the paintings for transit, the commissioners considered every issue, even as he insisted "all this was entirely their responsibility":

> The quality of wood for the rollers and large cases—the thickness, their
> form and construction, the strength of the wood, [and the] iron. And
> above all, the way to roll the Paintings [on the cylinders]—[whether] to
> use paper and glue or not, to secure and seal them in one way or another,

and finally how to pack them all with the greatest care. . . . The choice of lining for the chests, how to tar them, wrap them, tie them up with the right amount of rope.

Edwards also feared that the French would accuse him of replacing the original paintings with copies: "I wanted them to certify the identity of the objects at the very moment they were wrapped and encased." The packing of the Venetian art was completed on September 11, 1797. That day Berthollet, Tinet, and Berthélemy drew up a three-page packing list, written in elegant script and addressed to the "Museum of Art, in Paris." Three days later, they sent this list to Talleyrand.

The packing list identified the art the French had put into each crate. Improbably, into only two of the crates, fourteen of the Venetian canvases had been packed—wrapped around cylinders—face out to prevent the crushing of the paint. The list also documented the order in which they had been rolled.

The list began with *The Wedding Feast at Cana*, in crate 1. Crate 1 was a narrow box, twenty-two feet long, presumably constructed to accommodate the twenty-two-foot-high Veronese, so it could be rolled horizontally without being folded. The Veronese had been the first of five canvases to go on to the cylinder, because it was the largest.

Over *The Wedding Feast at Cana*, the commissioners wound the "middle part" of Veronese's *Feast in the House of Levi*—a "painting in three sections"—then Tintoretto's *Miracle of the Slave*, then the "left part" and the "right part," of the Veronese, Titian's *Doge Antonio Grimani Worshiping Faith*, and finally Veronese's *Jupiter Expelling the Vices*.

Into crate 2, another narrow, long (seventeen-foot) box, they placed a cylinder on which they rolled nine pictures. The first three were Veroneses—*Saint Mark Rewarding the Theological Virtues*, *The Feast in the House of Simon*, and *The Rape of Europa*. On top of these, they added Bassano's *Raising of Lazarus*, Pordenone's *San Lorenzo Giustiniani*, Contarini's *Doge Marino Grimani Adoring the Madonna with Saints Mark, Marina and Sebastian*, Tintoretto's *Saint Agnes*, Veronese's *Madonna and Child with Saints*, and his *Juno Showering Gifts on Venice*.

The third and fourth crates had each been built to hold one of the two

panel paintings. Titian's *Death of Saint Peter Martyr* went into crate 3. There, the commissioners also put Paris Bordone's canvas, *The Fisherman Presenting a Ring to the Doge*. Giovanni Bellini's *Madonna and Child Enthroned with Saints* occupied crate 4. Again, into the box with the panel painting the commissioners added a canvas, Titian's *Martyrdom of Saint Lawrence*. The two sculptures from the Biblioteca Marciana—the *Bust of Hadrian* and the bas-relief—were encased individually in the last two crates.

Earlier, in Rome, the French commissioners had explained their method of rolling and packing paintings on canvas of "large dimensions": "Between each revolution, there are sheets of white paper, which protect the paintings from contact with the canvas wrapped above it." To prevent any slippage between the pictures, "the whole thing was wrapped in canvas and well secured in the middle by a band tied in a helix . . . first in one direction, then in the other." Each cylinder was attached to its wooden box "at the two ends of its axis," so that "its surface touches nothing." The crates were then filled with straw to prevent the rolled canvases from jostling. To keep out rain, the boxes were slathered with tar and covered with waxed canvas.

The French officially took possession of the eighteen Venetian paintings and two sculptures on September 14: "We . . . have received from Citizen Pietro Edwards, charged by the Provisional Government of Venice with the delivery of the objects of art, for the Republic of France, the following." The first picture on the list, written in French, was "A Painting by Paolo Veronese, representing the Wedding at Cana." Signed again by Berthélemy, Tinet, and Berthollet, the list contained only the names of the works of art, but not the buildings from which they had been taken.

Fighting back, Edwards issued his own final list of the French thefts, written in Italian. He organized the works of art by their places of origin, starting with the Doge's Palace. Veronese's *Rape of Europa* was the first painting on Edwards's list, and Veronese's *Wedding Feast at Cana* was the last. He pointedly documented the pictures as "detached and delivered."

Finally, and paradoxically, in his long letter to the Committee of Public Safety, Edwards exploited the chance to call upon Venice to establish a museum on the model of the Louvre. This "patriotic institution" would "protect the precious, dispersed relics of our sublime masters" and display

a "concentration of all the greatness that our social equality must remove from private pomp." Suddenly switching to addressing the French capital, he wrote: "Paris, you anticipate with your vast Museum the eagerness of other peoples who too late feel remorse and envy." Remorse and envy were of course emotions roiling within him, along with pride and distress, as the expert who had advised the French, aiding and abetting the enemy and watching some of the objects of his life's work depart.

On September 17, the commissioners published a twenty-seven-page accounting of the two hundred paintings and more than one hundred works of sculpture that Bonaparte had, as they put it, "harvested in Italy." The commission was to be dissolved. Moitte and Thouin had left with the convoys from Rome and were already in Marseille; Tinet and Berthélemy were leaving for Paris. Berthollet and Monge would remain in Venice to oversee shipping arrangements for the Venetian art and complete the selection of ancient manuscripts.

To the Directory, Bonaparte lauded his commission: "These men . . . have served the Republic with a zeal, an activity, a modesty, and a selflessness without equal . . . in the delicate mission with which they were charged, they served as examples of the virtues that almost always accompany distinguished talent."

The French occupation of Venice was decisive and brief. On October 17, 1797, six months after the preliminary settlement at Leoben, Bonaparte and Austria's plenipotentiary Count Johann Ludwig Cobenzl signed the Treaty of Campo Formio, ending five years of war. Earlier, in the spring and summer of 1797, Bonaparte had established the Cisalpine Republic (assembled from the Lombard Republic and neighboring states) and the Ligurian Republic in Genoa. Both of these republics would remain in place. France would take the Austrian Netherlands and, as Bonaparte had surreptitiously arranged, the Austrians would acquire Venice. That Napoleon betrayed his promise to liberate Venice and instead turned over the ancient republic to the Habsburg Empire shocked the French public.

Bonaparte returned to Paris on December 5, 1797. He wore civilian clothes and lived with Josephine in a house they had rented at 6, rue Chantereine—renamed rue de la Victoire that December in tribute to his conquests. "All classes united to welcome him on his return to this

country," wrote the Duchess of Abrantès. "The lower orders cried, Long live General Bonaparte! Long live the victor of Italy! The peacemaker of Campo Formio! . . . The upper classes rushed with enthusiasm to acclaim a young man who in one year had gone from the battle of Montenotte to the Treaty of Leoben, from victory to victory! He may have made mistakes, even big ones, since that time, but in those days he was a pure and great giant of glory."

On December 24, to honor the conquering general, the directors gave a banquet for seven hundred in the Grande Galerie of the Louvre. The following day, Bonaparte was elected to the National Institute; his candidacy for the "science section" had been promoted by Berthollet and Monge. Bonaparte "was perhaps the first figure in modern history," notes the historian Philip Dwyer, "to foster the illusion of avoiding public acclaim, when his real goal was to attract it."

Before the French abandoned Venice, they destroyed the historic Arsenal, after commandeering ships and equipment that would be of use to the French fleet. They left nothing of value that could fall into the Austrians' hands.

Napoleon also dealt Venice a final aesthetic blow. In mid-December, he had instructed Berthier, his chief of staff, to make sure that by December 30 "the four horses," as well as "the lions, all the maps, all the papers pertaining to the Republic of Venice, which can be useful to us, be in our possession." The most famous lion designated for Paris was the winged Lion of Saint Mark, a bronze sculpture that had stood since the thirteenth century on top of the two-story column on the quay in front of the Doge's Palace. Bonaparte also wanted the French to take "all the galleys, cannon boats," and the *bucintoro*, the doge's ceremonial barge. Every year, on Ascension Day, the hundred-foot boat, elaborately carved and gilded, and powered by 168 oarsmen, ferried the doge out across the lagoon to the Adriatic; there he would drop a gold ring into the water, symbolizing the marriage of Venice to the sea. In the end, the French decided to demolish the *bucintoro*, chopping the wooden barge into pieces and setting them on fire, so they could reclaim the gold.

The French waited until December 13 to pull the horses down from Saint Mark's façade. Something of how they engineered the sculptures'

ENTREE DES FRANÇAIS À VENISE, EN FLORÉAL, AN 5.

Jean Duplessis-Bertaux, after Carle Vernet. *The Entrance of the French into Venice,* *Floréal, Year 5,* 1799–1807. Vernet reimagines French troops removing the four bronze horses from Saint Mark's Basilica in May 1797. In fact, the French took the horses in December 1797, before abandoning Venice to the Austrians.

dismantling can be seen in a print after a drawing by Carle Vernet. The great five-domed basilica looms behind a crowd filling the Piazza San Marco. Children are at play and elegant Venetians stroll about. Vernet has pushed the French troops into the background. But in the festive depiction the artist altered the facts. He titled the print *The Entry of the* *French into Venice, Floréal, Year V* to make it seem as though the French had removed the horses in May 1797, the moment they arrived in Venice, and not seven months later—the moment of betrayal—just before they handed the Republic to Austria. Up front, amid the crowd, three of the beautiful sculpted horses are standing on carts. The fourth horse dangles on a rope over the basilica's central door.

12

"The most secure way would be to send them on a frigate, with 32 cannons"

The loss of even one of these masterpieces would be irreparable and all of Europe would accuse France if they were to suffer even minimum damage.
—Gaspard Monge, Jacques-Pierre Tinet, Jean-Guillaume Moitte, Jean-Simon Berthélemy, Rome, July 1, 1797

Once off the wall of the Benedictine monastery, wrapped around a cylinder and encased in a crate, Veronese's *Wedding Feast at Cana* was in limbo. It was no longer an object of religious devotion, nor fully a work of art, but temporarily cargo, part of a shipment of goods, in transit.

On September 18, 1797, Berthollet, Tinet, and Berthélemy, who had instructed Rear Admiral Jean-Baptiste Perrée to secure a "ship adequate for the transport" of the Venetian art objects to France, asked Bonaparte to decide what type of ship they should choose.

To reply, Napoleon turned to François-Paul Brueys, the commander of French forces in the Adriatic. "The most secure way would be to send them on a frigate, with 32 cannons, a vessel of good speed, lined with copper," Brueys wrote, on September 26. "The *Sensible* appears to us to be the most fitting for your aims." The *Sensible* was a 145-foot square rigged frigate, with three masts carrying multiple tiers of sails. Seven years before, Josephine had crossed the Atlantic on the *Sensible*, when returning to France from Martinique.

Brueys reassured Bonaparte that the Venetian pictures would survive the voyage. "The paintings are encased in six crates and wrapped with care. The four largest will be placed between the forecastle and the decks, instead of a lifeboat, which the frigate will leave in the port of Venice."

They would put dinghies over the crates at the upper level and the two smallest cases would be put in steerage. He concluded, "It will be easy to keep them all sheltered from water and other ordinary accidents."

On November 2, the engineer and ship designer Pierre-Alexandre-Laurent Forfait wrote Bonaparte from Venice that "the paintings destined for transport to Paris are loaded [on to the *Sensible*] . . . and will go to Ancona under escort with the first good weather."

Some eleven weeks later, on January 22, the Venetian crates reached Toulon. There, the *Sensible*'s captain had them hauled ashore. On the voyage, rats had chewed the waxed canvas wrapping the crates, and he didn't want to risk them gnawing through the boxes and reaching the paintings rolled up inside. There were more insidious dangers, if the canvases were delayed. André Thouin had noticed that the straw packing was wet and crumbling—evidence that when crossing the Mediterranean on the ship's deck, the crates had been drenched.

The year before, the commissioners had learned that "during their long journey," the canvases seized from Milan and other states in northern Italy were exposed to rain and salt water, and that once they reached Toulon, they were held there for months. The paintings must not remain in that condition or they could be badly damaged, they warned. "Eventual losses would be irreparable, and France would be blamed by the entire world."

On February 28, 1798, in Toulon, the six crates of Venetian art were put onto a ship that sailed west along the coast more than a hundred miles to reach Arles, at the entrance to the Rhone, on March 7. In Arles, the crates from Venice met up with the crates of art from Rome, which had been stored in a church since November, stalled there because of ice floes on the river.

At the end of March, the crates from Venice and Rome were loaded onto new ships to begin the voyage first up the Rhone and then the Saône toward Paris. At Chalon, the crates were transferred to barges capable of navigating canals. Heading up the canal du Centre, they arrived on May 20 in Digoin. Then, warned that the Loire would soon flood, the captain waited there for a month. Instead of flooding, he found the river was low. At Bec d'Allier, to have the vessels draw less water, he shifted some of the crates to other boats; at La Charité, he had a channel dug in

the riverbed. From Cosne, he took the canal de Briare and the canal du Loing (built in 1723, with funds from Philippe II, Duc d'Orléans) to join the Seine east of Fontainebleau. On July 15, 1798, after ten months of travel, Veronese's *Wedding Feast at Cana* reached Paris.

At the time, Bonaparte was about to enter Cairo. He had set sail from Toulon two months before, with thirty-five thousand troops and some three hundred ships, aiming to capture Egypt, part of the Ottoman Empire. "Egypt was a province of the Roman Republic," Talleyrand had written in 1797. "It must now become a province of the French Republic." To accompany the army, Napoleon brought 160 French scientists, engineers, artists, and intellectuals, whose purpose was to gather artifacts and information, and whose leaders were Berthollet and Monge. In the end, this cultural investigation, for which the two scientists had prepared themselves in Italy, would prove the most successful aspect of the Egyptian campaign and would lay the foundations of the study of ancient Egypt.

But Napoleon's absence from Paris, on a campaign to conquer the Middle East, seemed to the directors a fine moment to trumpet his Italian victories and proclaim France heir to the Roman Empire by parading the spoils of Rome and Venice across the French capital. They staged this modern version of a Roman triumph as part of the Fête de la Liberté, a festival on July 27 organized to celebrate the fall of Robespierre and the end of the Terror. Paris "must be the center of the arts in Europe," *La Décade philosophique* had declared four years earlier, when in 1794 the Rubens altarpieces and other Belgian art plunder had appeared in the French capital. Now, the refrain of a song commissioned for the festival argued that France had more than realized that aim: "Every Hero, every Great Man / Has changed country: / Rome is no more in Rome, / It is all in Paris."

The year before, from Marseille, Commissioner André Thouin had lobbied to have the famous Vatican antiquities make a noticeable entrance into Paris. "Will we let the precious bounty from Rome arrive in Paris like charcoal barges and will we have it disembarked on the Quai du Louvre like crates of soap?" he asked Louis-Marie de La Réveillière-Lépeaux, then president of the Directory.

The festival's organizers spelled out in banners and labels the political significance they assigned to the looted art. A banner attached to a cart

ENTRÉE TRIOMPHALE DES MONUMENTS DES SCIENCES ET ARTS EN FRANCE; FÊTE À CE SUJET.
les 9 et 10 Thermidor. An 6.^{me} de la République.

Pierre-Gabriel Berthault, *Triumphal Procession of the Monuments of the Sciences and the Arts in France, 9 and 10 Thermidor, Year 6 of the Republic* [July 27, 1798], 1798.

of Vatican sculptures pronounced them proof of France's imperial destiny: "Monuments of antique sculpture. Greece gave them up. Rome lost them. Their fate has twice changed. It will not change again."

The procession began with "Natural History"—ten horse-drawn wagons carrying minerals, seeds, exotic plants, and agricultural instruments, as well as caged lions from Africa and a "bear from Bern [Switzerland]." Then, after six carts of manuscripts and rare books, came the horses of Saint Mark's, riding on a cart. The four sculptures led the train of "Fine Arts": twenty-five wagons loaded with the crates of antiquities from Rome, followed by two carts with boxes of paintings from Rome and from Venice. "The Arts seek the land where laurels grow," one banner claimed. And another called, "Artists come running! Here are your masters!"

To ensure Venice's bronze horses would be understood politically as emblems of France's ascent in the international order, they too carried labels: "Horses transported from Corinth to Rome, and from Rome

to Constantinople, from Constantinople to Venice, and from Venice to France. *They are finally in a free land.*" However, brought down from their commanding position over the doorway of Saint Mark's to a cart at eye level, the horses appeared captives of the French and anything but free—masterpieces unable to escape their historic fate as plunder.

The banner announcing the "Venetian School, Titian, Paul Veronese, etc." referred not to politics but to aesthetics: "The variation of their color embellishes their palettes." In fact, the Venetian paintings had so little obvious propaganda value that the French had left some of the crates from Venice on a dock, near the rue des Saints-Pères, on the Left Bank of the Seine. It's possible that Veronese's *Wedding Feast at Cana* never made it to the parade at all.

Not surprisingly, the Paris parade did little to convince the rest of Europe that the French Republic had any right to Italy's art. That year, Karl Heinrich Heydenreich, a professor of philosophy in Leipzig, condemned the plundering of literature and art. He could do "nothing but declare it a crime against humanity if a defeated nation is robbed of its national masterpieces of art." In this theft, Heydenreich observed, the conqueror "announces the immortality of his hatred and revenge."

13

"The seam . . . will be unstitched"

In what other part of the world can you see assembled together the Cartoon of the School of Athens, *The Transfiguration*, *The Communion of Saint Jerome?*

—*Notice des principaux tableaux recueillis en Italie, par les commissaires du gouvernement français: Seconde partie* [Musée Central des Arts,] November 8, 1798

Veronese's *Wedding Feast at Cana* arrived at the Louvre on July 31, 1798, and immediately went into storage. The Administrative Council that ran the Louvre—now called the Musée Central des Arts—felt pressure to exhibit the paintings and sculpture from Italy, but they had much work to do on the Veronese before they dared to put it on display. A casualty of war, the painting needed treatment and repair.

It's impossible to know the exact condition of *The Wedding Feast at Cana* before it left Venice. However, from the moment an artist puts down his brush, a painting begins to change. The materials composing the picture—the linen, the pigments, and the oils, as well as the gesso ground—had shifted and evolved in various ways as they aged and interacted with light and air. Veronese's craftsmanship and Scrocchetto's insistence that the artist use only fine pigments had worked to the picture's advantage and fended off the depredations of time and certain problems that plagued other sixteenth-century paintings. That Veronese worked quickly, often putting down paint saturated with pigment and containing minimal amounts of oil, meant that his colors had held their intensity. Also, with his careful technique in the application of paint, he had largely steered clear of problems produced when mixtures of pigments and oils triggered chemical interactions that caused tones to degrade. So well had Veronese constructed the picture that after it was taken off its stretcher

and rolled up for months, the paint he had applied still adhered to the ground, and the canvas had survived mostly intact. In the two hundred years the Veronese had spent in San Giorgio Maggiore's refectory, candle smoke had darkened its surface. But whatever damage had occurred to the canvas in the damp and unheated Venetian room, the French had inflicted more damage—damage that the museum administrators seemed not to have recorded or explained.

Earlier that year, on February 6, Louvre officials had unveiled the first of Napoleon's Italian spoils in the Salon Carré—eighty-six paintings from Parma, Piacenza, Milan, Modena, Cento, and Bologna. In a catalogue, the Administrative Council defended the time (as much as fifteen months) they had taken to display the plunder in response to the "impatience of the public": they had "busied themselves without interruption with the task of putting these masterpieces in a fit enough state to be shown." In Italy, they argued, the pictures had been "totally neglected" and had suffered from smoke, dirt, and old varnish; but now "the competent hands of [French] restorers [will] render them for true connoisseurs." By claiming to have found the Italian paintings close to ruin, the French tried to deflect accusations that they had injured them in transit and to prove their plunder was not simply a right of warfare but a means to conserve endangered works of art.

Others were skeptical. Wilhelm von Humboldt, the German philosopher and diplomat, saw the paintings from northern Italy at the Louvre; afterward, in a letter to Goethe, he rightly observed the difficulty of figuring out "whether, or not, the pictures which have arrived so far have suffered from the transport, the treatment here, and the restoration." Humboldt focused on Raphael's *Saint Cecilia*. The picture "was obviously dirty, but she now has a certain red coloring. All damage is thus not to be denied." But "I believe it is, by far, not as much as many claim."

On November 8, 1798, a second exhibition of Napoleon's Italian art plunder went up in the Louvre—eighty-two paintings from Rome, Venice, and other cities. There were spectacular pictures: Caravaggio's *Entombment*, from the Chiesa Nuova in Rome, Mantegna's San Zeno altarpiece—the *Madonna and Child with Saints*—from Verona, as well as nine Raphaels and twelve Veroneses—one from Mantua, five from Verona,

and six that Pietro Edwards had packed up in Venice. In a catalogue, *Notice des principaux tableaux recueillis en Italie, par les commissaires du gouvernement français*, the Louvre administrators apologized for not exhibiting certain major works, because of "their immense size or their poor condition." They named five pictures, one appropriated from the Papal States and four from Venice: Raphael's *Madonna of Foligno*, Giovanni Bellini's *Madonna and Child Enthroned with Saints*, Titian's *Death of Saint Peter Martyr*, and Veronese's *Feast in the House of Levi* and *The Wedding Feast at Cana*.

The Louvre administrators also promised soon to show all four Veronese feasts now in France and attributed the future pleasure of seeing them together to "the genius of victory." Earlier, a plaque above the entrance to the Salon Carré spelled out the debt owed to Bonaparte for the Louvre's new acquisitions: "To the Army of Italy."

At the end of November, the Administrative Council took up the problem of restoring *The Wedding Feast at Cana*, the largest painting in the Louvre. To put the canvas up on the wall, they would have to build a new stretcher, patch some 360 holes, and retouch these repairs and any other places that had been abraded or left bare. But first the council decided to stabilize the canvas: "Very quickly arose the problem of consolidating the support."

The most vulnerable part of a picture painted in oil on canvas—be it a Titian, a Degas, a van Gogh, or even a Rothko—is the textile on which it is painted. Fabrics are fragile and tend to age badly. Even the most finely spun fibers weaken over time, become brittle, and shred. From the back, painted canvases reveal their years, as the bare fabric darkens from white to brown, and the threads from which they are woven disintegrate. Veronese's *Wedding Feast at Cana* was now more than 235 years old.

By the late eighteenth century, the standard approach for preserving a painting whose canvas support had begun to fail was to line it—to reinforce the canvas by attaching new fabric to the back of the old. In France and in Italy, restorers had pioneered the lining of pictures, but the process was difficult and unpredictable, and it often injured the paint. To line a canvas of ordinary size, restorers would spread glue across the back and cover it with a new piece of canvas. To bind the two fabrics

together, they would melt or dry the glue by dragging a hot iron across the fresh canvas attached to the back or across the front of the picture, whose paint they would have protected with layers of paper or cloth. The French generally ironed canvases faceup. The lining process demanded strength and finesse. The irons weighed as much as fifty pounds and were heated on coals, so their temperature could not be regulated. Restorers had to learn to modulate the force of the iron to avoid compressing the surface of paint, but rarely did they succeed. This flattening is visible on many old master pictures. So risky was the operation that even when canvases were ironed facedown, sheets of paper were usually glued to the front so that if the lining went awry, the paint would nevertheless be held in place. The Veronese's size complicated all aspects of the lining procedure. Because no table would have been large enough to hold the canvas, it would most likely have been unrolled on the floor.

At this point, the Administrative Council made a radical decision that was recorded in the minutes of a meeting, dated November 28, 1798, and preserved in the archives of the Louvre:

> Advised of the impossibility of recanvassing Paolo Veronese's large painting representing the Wedding at Cana in a single piece and in a solid manner given its large size, [the council] decrees that the seam found across the width and under the shadow of the balustrade will be unstitched. As a consequence, the stretcher will be constructed in two parts.

Unstitched? The council had decided to cut the huge Veronese in two. They would divide the picture along the central seam, below the rail of the balustrade—a seam sewn by Veronese's assistants in 1562, when stitching together six lengths of linen to form a single piece of cloth. Once the French restorers had split the canvas, they would line the two halves and mount each on a separate stretcher. Later, the Louvre's internal correspondence would refer to *The Wedding Feast at Cana* as "a large painting on canvas in two parts."

Why this drastic step? The Administrative Council gave little explanation. On December 28, the council put "Citizen Hacquin" in charge of lining the Veronese. François-Toussaint Hacquin had succeeded his father,

Jean-Louis Hacquin, in 1784 in his post as a picture liner at the Louvre. Perhaps Hacquin argued that lining two smaller pictures was safer than lining a large one—he would find it easier to control the iron across the canvas and lessen the chance of further injuring this masterpiece. By the time he began to work on the Veronese, the new stretchers had been made.

In theory, pulling out a thread that bound the linen strips composing the canvas would be the least destructive way to divide the picture. But once Veronese had covered the canvas with paint, undoing the stitching was hardly different from severing the threads of the linen itself: Hacquin would have to slice through the now fragile sixteenth-century paint, splintering it in a line across the picture. Hacquin spent six months cutting the Veronese, lining the painting's two halves, and nailing each half to a new stretcher.

At the Louvre, the tasks involved in the restoration of old master pictures were divided. The picture liners treated the supports—canvases or wooden panels—and the restorers, who were generally trained as painters, took care of the front of the pictures, cleaning, retouching, and varnishing the paint. On June 19, 1799, the Louvre paid Hacquin 630 francs for his work, at the standard rate of "1 franc per [square] foot."

At that point, two different restorers took over. Edmé-André Michau worked on the Veronese's lower half. From July to September, he "cleaned, applied a large quantity of putty, added color and varnish four and five times." Mathias Bartholomäus Röser, a German landscape painter, "cleaned and restored" the picture's top half, "more damaged than the other by putty and old repainting." He also completed his work that September.

To have the Veronese appear to be in one piece, the restorers aligned the two canvases and locked their stretchers together with metal braces. Yet, in dividing the picture, the French restorers had destabilized it. Only a year later, starting on June 20, 1800, Michau spent three months applying putty and paint to the Veronese, presumably to cover the space where the two stretchers met. In 1802, again Michau had to "restore the junction" of the two halves. Four years later, Michau once more "varnished, puttied and put tone in the joint between the two parts of the canvas."

14

"The Revolution … is finished"

Everyone saw in Bonaparte the man who would save France and
end the Revolution.

—Auguste Bigarré, French army officer

In the fall of 1799, as Edme-André Michau and Mathias Röser were
cleaning and retouching *The Wedding Feast of Cana*, Bonaparte took
charge of the government of France. He had returned from Egypt
to a hero's welcome in October, and a month later, on November 9
(18 Brumaire, Year VIII, in the revolutionary calendar), he joined Tal-
leyrand and Emmanuel-Joseph Sieyès, a political commentator who had
written the 1789 revolutionary pamphlet *What Is the Third Estate?*, in en-
gineering a coup d'état that brought the Directory's reign to an end and
established a new provisionary government—a consulate. "Especially for
people with property, security and order had become by far the leading
political priorities," writes the historian David Bell. At first, Bonaparte
was one of three consuls, but before the end of the year, the Constitution
of the Year VIII elevated him to First Consul and put him, for the next
fifteen years, in control of France. "Frenchmen! . . . The Constitution is
founded on the true principles of representative government, on the sacred
rights of property, equality and liberty," Napoleon declared. "Citizens, the
Revolution is established on the principles which began it. It is finished."
This declaration ignored the authoritarian character of the new regime.

Napoleon was thirty. His face was still boyish and lean, and not far
from the way it appeared when artists idealized it. That the Egyptian
campaign had gone badly hardly mattered. Bonaparte had trumpeted his
victories and ignored his defeats.

Only weeks after he had arrived in Egypt, on August 1 and 2, 1798, the
British admiral Horatio Nelson had come upon the French fleet in Aboukir

Bay and attacked it, sinking two ships of the line, two frigates, and nine other ships. The catastrophic loss prevented the French from resupplying the troops in Egypt and gave the British control of the Mediterranean. Bonaparte blamed the fleet's commander, François-Paul Brueys, who the year before had advised him on shipping the Venetian pictures to France. During this battle, Brueys lost his leg in an explosion and died the same day. Later, Bonaparte purposefully stripped his correspondence of information that would have implicated his own decisions in the naval defeat.

Bonaparte secretly left Egypt a year later, on August 23, 1799, sailing from Alexandria with Berthier, as well as Berthollet and Monge. He had handed over command of the French army to Jean-Baptiste Kléber, who would be assassinated ten months later. When word of Bonaparte's return reached Paris, the politician Antoine Thibaudeau was at the Théâtre Français. It "was as though an electric shock had passed through the room," he recalled. "No one paid any attention to the show. People went from box to box, came out, entered, ran, unable to remain in one place . . . on every face, in every conversation, was written the hope of salvation and the presentiment of happiness."

Once back in Paris, Bonaparte played the part not only of the invincible general, capable of fighting off France's enemies, but also of the statesman who could free the Republic from the Directory, under which, he claimed, it had "fallen into the utmost debasement and misery."

As the First Consul, Bonaparte presented himself as a moderate, seeking to establish common ground with both radicals and royalists and to promote tolerance. "I refused to be the man of one faction," he wrote in *Le Moniteur universel*. His first order declared his desire to make the Republic "respected abroad and feared by its enemies." That fear he would try to instill in any who opposed him. On January 17, he ordered sixty of the seventy-three Paris newspapers to close. By 1811, he had cut the number of papers in Paris to only four.

Bonaparte kept an eye on the progress of the Louvre. In December 1799, he went to the museum and saw, to his displeasure, that much of the art he had brought from Italy was not yet on view. The six galleries intended for the antique sculpture of Rome, in the former apartments of Anne of Austria on the palace's ground floor, were still under construction.

Bonaparte took steps to get a promised two hundred thousand francs from the government to complete the work.

His power secured in France, Napoleon was soon to return to Italy. By the end of 1799, Austria had won back most of Lombardy and the French had retreated to Genoa. At 2:00 a.m. on May 6, 1800, Bonaparte left Paris and then surprised the Austrian commanders by crossing the Alps at the Saint Bernard Pass, the highest, shortest route. "We have hit the Austrians like a thunderbolt," Napoleon wrote his brother Joseph on May 24. He reached Milan on June 2.

Twelve days later, Bonaparte defeated the Austrians at Marengo, an unlikely victory. Bonaparte would recast Marengo as the battle that crowned his campaign against the Austrians in Italy. But General François-Étienne Kellermann would recall it differently: "Marengo [was] the one [victory] from which he obtained the greatest profit for the least personal glory. He was tormented by it; he was weak enough to want to appropriate it, all the more since it belonged to him the least. It explains the contradictory and untruthful accounts, which he told and retold again and again."

After Marengo, Napoleon did not linger in Italy. "I will arrive in Paris without warning," he told his brother Lucien. "My intention is to have neither triumphal arches nor any other kind of ceremony. I have too good an opinion of myself to have any respect for such trinkets. I know of no other triumph than public satisfaction." To win that approval, he immediately commissioned six enormous battle paintings of victories in Italy and Egypt, including Marengo and Rivoli. But the picture that captured the idea of Napoleon as the hero who would shape the future of France was Jacques-Louis David's equestrian portrait, *Bonaparte Crossing the Alps at Grand-Saint-Bernard*.

The portrait commission came not from the First Consul but from Charles IV, the king of Spain, who, after the French victory at Marengo, calculated that a portrait by David would buy influence with France's First Consul. "And so not only will we own a work by that famous artist, but we will also satisfy our hero [Bonaparte]," the Spanish secretary of state, Mariano Luis de Urquijo, wrote to Ignacio Muzquiz, the Spanish ambassador to France, on August 11, 1800.

For the Spanish king, the portrait more than served its purpose. David put Bonaparte on a wild-eyed rearing horse, poised on an Alpine peak. Napoleon's identity is clear—in the angular face, the blue jacket, the black two-cornered hat, and the high military boots—but he seems more sculpture than human being. David transformed the mundane facts into a vision of a rider who controls an untamable steed. He looks out but points to the mountains ahead. Wind whips his orange cape, which billows around his shoulders and covers the head of the horse, propelling it forward. In the background, soldiers haul a cannon up the mountain trail. David shows the name BONAPARTE, carved on a rock, above the names of the two legendary conquerors who preceded him over the Alps— KAROLUS MAGNUS (Charlemagne) in A.D. 773 and HANNIBAL in 218 B.C. The force of this mythic image depended upon the sharp-edged precision of details—gold embroidery on the collar and cuffs of Bonaparte's jacket, gold embossing on the hilt of his sword.

David painted fast, completing the portrait in January 1801, only four months after he began. To see the portrait, Bonaparte went to David's studio in the Louvre on June 5, 1801. He immediately ordered three copies—the first for the library of Les Invalides, the Paris military hospital; the second for the Cisalpine Republic's palace in Milan; and the third for the château at Saint-Cloud, a palace seven miles west of the French capital. David made a fourth copy, which he kept in his studio.

Oddly enough, José Nicolás de Azara, the new Spanish ambassador to France, was less enthusiastic. He complained to a friend, "*First*, it looks like Bonaparte about as much as it looks like you. . . . Not a single color is true, with the exception of the tricolor sash." However, realism was not the point. In fact, on the steepest parts of the Alpine pass, Napoleon had ridden a donkey. Instead, as the critic Pierre Chaussard explained, "The cloak of [Bonaparte] is thrown to make one imagine . . . the wings of a demigod gliding in the air. Furthermore, like the ancients, David has elevated the character of the hero's features to capture an ideal."

The battle of Marengo was followed by General Jean Moreau's victory at Feldkirch, near Munich, on July 13, 1800. Together, these French wins compelled the Austrians to negotiate. But the talks broke down, and war started again. In December, Austria lost to Moreau a second time. As

the French began to bear down on Vienna, the Austrians sought to work out an accord. In the Peace of Lunéville, signed on February 9, 1801, the Austrians acknowledged the French expansion to the left bank of the Rhine and to Belgium, and recognized Holland, Switzerland, and the Cisalpine and Ligurian Republics in Italy. The French took Tuscany. The Austrians kept Venice.

The peace weakened Austria's position among the European powers and caused Bonaparte's stature in France to soar. In a matter of days, the price of engravings printed with his portrait doubled and then tripled. A commentator in the *Journal des débats* captured the mood of the French: "What a magnificent peace! What a start to the century."

Bonaparte also sought to settle France's hostilities with the Catholic church. Two years before, he had exiled Pius VI from Rome to Valence, a town on the Rhone, and on August 29, 1799, the pope had died. His successor, Pius VII, was a Benedictine—Cardinal Barnaba Chiaramonti, who had been chosen by a conclave that had met in Venice at San Giorgio Maggiore. "The clergy is a power that is never quiet," Napoleon wrote. "You cannot be under obligations to it, wherefore you must be its master." In July 1801, in Paris, the Vatican secretary of state, Cardinal Ercole Consalvi, and Napoleon's brother Joseph Bonaparte hammered out a concordat that established Catholicism as the religion of the "great majority of French citizens" but also put the church partially under French government control.

At that point, Napoleon remained at war solely with Great Britain; but already in the spring of 1801, the British foreign secretary Lord Hawkesbury and the French envoy Louis-Guillaume Otto broached possible terms of peace. A year later, on March 25, 1802, the French and the British signed the Peace of Amiens, bringing to an end the war that had embroiled France for more than a decade.

With Amiens, Napoleon had concluded peace agreements with eight European nations. "One can say without the slightest exaggeration that at the time of the Peace of Amiens, France enjoyed, in foreign relations, a power, a glory, and an influence beyond any the most ambitious mind could have desired for her," declared a not unbiased Talleyrand, whom Bonaparte had named foreign minister. On April 18, Easter Sunday,

Pierre-Paul Prud'hon, *Charles-Maurice de Talleyrand-Périgord, Prince de Bénévent*, 1817.

Napoleon celebrated the peace with Britain, as well as the concordat, at Notre-Dame, with a mass and a Te Deum. Four months later, on August 2, the Senate passed a motion to make Napoleon First Consul for life, with the right to appoint his successor. He named his brother Joseph.

"A First Consul is not like kings . . . who see their states as an inheritance," Napoleon said in May 1803. "He needs brilliant deeds, and, therefore, war." But he recognized that such brilliant deeds were required even in times of peace.

To that end, Napoleon applied the relentless pace he had kept in the Italian campaign to the demands of governing—drafting the laws and building the institutions (educational, financial, religious)—on which to

ground the French state. "You think the Republic is definitively established? You seriously delude yourselves. We are in a position to do it, but we have not done it, and we shall not have it until we raise up a few great granite blocks on the sands of France," he famously told the Council of State, an advisory group of fifty that debated policy and helped write legislation. The most important of these blocks was the Napoleonic Code, which united France's 366 different legal codes, and much of which still stands. Another of Napoleon's lasting legacies was the Louvre.

15

"You enter a gallery—*such* a gallery. But *such* a gallery!!!"

The gallery of the Louvre is the great feature of Paris, which is itself a vast *bonbonniere* [sic], an immense *Académie de jeu*, and an enormous *table d'hôte*; where all nations meet, like travelers through a desert at a watering place.

—Stephen Weston, 1802

On May 21, 1801, four years after it had left Venice, Veronese's *Wedding Feast at Cana* went up in the Salon Carré (Le Grand Salon) in the Louvre.

"On ascending the staircase, itself unrivalled for elegance of construction, you enter the spacious [salon]," wrote Abraham Raimbach, an engraver from London. "Here burst upon the astonished sight the gorgeous work . . . of Paolo Veronese, the Marriage of Cana." The Salon Carré was "outstandingly beautiful," Wilhelm von Humboldt wrote to Goethe. It "gets the light from above, thus it is a heavenly illumination."

The French unveiled the Veronese in an exhibition entitled simply "The Large Pictures of Paul Veronese, Rubens, Le Brun, and Ludovico Carracci," but whose intent was to dazzle with the scale of twenty-eight Renaissance and baroque pictures, more than half of them trophies of war commandeered by Napoleon from Italy. The size of the canvases alone boasted of the feat of French plundering—the expertise and ambition, the engineering, the resources, the manpower, the ships, the crates, the livestock, and the carts required to get them to Paris. These pictures spoke to French taste and also to French power.

From Antwerp, the French armies had brought an altarpiece by Rubens; from Milan, Raphael's *School of Athens* cartoon. From Piacenza, they had delivered Ludovico Carracci's *Transporting of the Body of the Holy Virgin*, and from Rome, Guercino's *Burial of Saint Petronilla*, which,

according to the catalogue, was his greatest picture. From Venice came five Veroneses.

The Louvre council had promised in 1798 to show all four Veronese feasts at once, but even two were an extraordinary sight. Together, *The Wedding Feast of Cana* and *The Feast in the House of Levi* dominated the gallery—not simply because of their size, but because of their brilliance. They were scenes with multiple life-sized figures—evocations of the Venetian Republic close to its heyday, describing its architecture, its inhabitants, its textiles, its light. In bringing together Veronese's two finest feasts, France showed the world that it had conquered the ancient republic and taken possession of its wealth and genius, its past, present, and future.

But even as the French bragged of these Veroneses as plunder, they emphasized their place in the history of art. The five Veroneses from Venice composed an exhibition that gave a sense of the range of the artist's work. They ran from the tumultuous allegorical ceiling painting—*Jupiter Expelling the Vices*—to the tranquil *Madonna and Child with Saints* and included the mythological *Rape of Europa*, whose lush green background showed the artist's power as a landscapist. The small Veronese survey culminated in the two feasts.

Since the early eighteenth century, the Salon Carré, designed as a reception room for Louis XIV, had been the most important exhibition space in France. There, starting in 1737, the Royal Academy of Painting and Sculpture had presented the (annual and later biannual) exhibition known, because of the room, as "the Salon." At the Salon, artists (most of them French) vied for the attention of the critics and the public—their latest pictures hung floor to ceiling, and their latest sculptures set out across the room. By 1785, when David showed *The Oath of the Horatii*, as many as sixty-one thousand visitors flocked to the Salon Carré to take stock of the state of contemporary art. Public opinion, in addition to government patronage, now counted in an artist's professional fortune. It was in the Salon Carré that the Louvre administrators mounted three exhibitions of Napoleon's Italian spoils.

In the late eighteenth century, the Louvre was smaller than it would become, but the building was still vast and spectacular, composed of wings and pavilions erected over the course of four centuries. The palace had

begun as a medieval fortress, which had been torn down and replaced by Francis I and his successors with the Cour Carrée, or Square Courtyard, known as the "Old Louvre." It was from an elegant façade in the Cour Carrée, designed in 1546 by the architect Pierre Lescot and the sculptor Jean Goujon, that the rest of the royal structure would take its design. There, Lescot and Goujon had created a tableau of light and shadow out of arches, windows, pilasters, friezes, and figures, sculpted in relief, which animated the architecture.

The Salon Carré stood at one end of the Grande Galerie, the extraordinary corridor that ran thirteen hundred feet, or a quarter of a mile, along the Seine and linked the Louvre to the Tuileries. The Tuileries was a four-hundred-room palace with an eighty-eight-yard façade that stood at what would become the east end of the Tuileries Gardens. Together, the Louvre and the Tuileries constituted a royal architectural complex commanding the center of Paris. Between the two palaces, there were clusters of buildings, along streets and two courtyards, part of medieval Paris that Napoleon began to clear. Emptied in the mid-nineteenth century, this space would become the vast courtyard where in 1989 I. M. Pei would build a glass pyramid.

In 1564, Catherine de Médicis had begun building the Tuileries outside the city walls to escape the Louvre, which she found uncomfortable. (*Tuileries*, or tile factory, referred to a building that had stood there before.) In 1595, Henri IV began constructing the Grande Galerie to connect the two palaces, completing it over a decade later. "In Paris you will find my grand gallery [in the Louvre], which reaches as far as the Tuileries, finished," Henri IV wrote in 1607. Once, to amuse his son, the dauphin, the king released dogs and a fox in the Grande Galerie and staged a hunt.

Since 1682, when Louis XIV had moved the court and his art collections to Versailles, the Tuileries had served as the Paris residence of the French kings when they came into the city. (Later, in 1870, the Tuileries would be torched by the Paris Commune.) When Louis XIV vacated the Louvre, he invited the Royal Academy of Painting and Sculpture to take over the Salon Carré and neighboring rooms, which then became the center of the French art establishment.

At the moment Veronese's *Wedding Feast at Cana* appeared in the Salon

Israel Silvestre, *Tuileries Palace of Catherine de Médicis, Built in 1564, Augmented in 1600 by Henry IV Who Made the Gardens*, 1649–1651.

Pierre-Alexandre Aveline, after Jean-Michel Chevotet, *Façade of the Grande Galerie of the Louvre on the Side of the River*, 1628.

Carré, the Louvre administrators were rushing to complete the installation of the museum's painting collection in the Grande Galerie. They had hung the long, narrow corridor in stages, starting in 1799 with 649 Flemish, Dutch, and French paintings, many pilfered from Belgium. By July 14, 1801, they added 285 Italian pictures. There were twenty-three Guercinos, thirty-one Guido Renis, twenty-four Annibale Carraccis, six Caravaggios, eight Correggios, seventeen Domenichinos, and eight Raphaels, including *Saint Michael Slaying the Demon*, *Saint George Fighting the Dragon*, and *The Transfiguration*, as well as Titian's *Man with a Glove* and *Christ Crowned with Thorns*. The four Leonardos included Francis I's *Mona Lisa*.

Running down both sides of the Grande Galerie were about 950 paintings, many of them masterpieces; it was a breathtaking sequence of pictures arranged to take viewers through the history of European art—broken into various national schools: Flemish, Dutch, German, French, and Italian. Many of the Italian pictures had been brought by Napoleon from Milan, Turin, Florence, Venice, and Rome. Now in the Grande Galerie, the public could take full measure of the Renaissance and baroque appropriations made in the wake of Napoleon's victories in Italy. By mixing the new paintings into the royal collection, the French elevated Napoleon as a collector, whose acquisitions were on a level with those of the kings.

Downstairs, on the Louvre's ground floor, in the apartments of Anne of Austria, the antiquities galleries had opened the year before, on November 9, 1800, the first anniversary of the 18 Brumaire coup d'état that brought Napoleon to power. The rooms had been redesigned and ornamented with allegorical paintings and gilded stucco, to create a brilliant backdrop to the marble sculptures of Rome. Ennio Quirino Visconti, a former curator at the Vatican's Pio Clementino Museum, had been put in charge of the antiquities he had been forced to pack up in Italy. From the museum's entrance, visitors could see straight ahead through a series of five rooms to an end wall at whose center stood the famous *Laocoön*. In another room, the *Apollo Belvedere* was also dramatically staged, standing on a pedestal, in a niche, framed by tall red granite columns.

The Louvre had come to resemble what its revolutionary founders had imagined—a collection whose brilliance would draw Europe's gaze and cause Paris to be recognized as the new Rome. "The museum of art

contains at this moment the richest collection of paintings and antique sculpture in Europe," Jean-Antoine Chaptal, the interior minister, wrote in 1800. "United there are all the riches which before the Revolution were dispersed." He counted the canvases: "thirteen hundred and ninety paintings of the foreign schools, two hundred and seventy French Old Masters, and more than a thousand of the French modern school." There were also "twenty thousand drawings . . . , four thousand engraved plates and thirty thousand engravings, together with fifteen hundred antique sculptures."

A painting by Hubert Robert shows the Grande Galerie in 1800 to be a romantic and beautiful space—a public promenade with fashionable people coming and going and artists copying pictures. The long dark green corridor extends as far as the eye can see, its end wall fading into the distance, like a landscape. Along both walls, gold-framed paintings climb from the chair rail to the ceiling. They are stacked in three and sometimes four rows—the smallest hung at eye level; the largest, in theory easier to see, high up. These pictures lean forward, their top edges covering the molding at the edge of the barrel vault. Red marble columns, topped with antique busts, break up the long horizontal of the green walls.

A young man in a black top hat, seated on the gallery's floor, sketches on a drawing board that is set on his knees. Leaning over him, another young man, also in gentlemen's clothes and with a portfolio under his arm, points toward the art on the wall. Two women are also at work— copying. One of them, in a long white skirt, stands on a platform reached by a ladder, in front of a large canvas propped against an easel.

Robert's canvas reveals that the French had imposed a visual order on the Louvre's collection. They had arranged the pictures symmetrically within each bay, while leaving intervals between them, suggesting a new respect for the formal aspects of each. The walls are full, but there is a sense of grandeur, in the extent of the corridor's receding space and in the way the pictures have room to be seen.

On February 19, 1800, shortly after a plebiscite endorsed the Constitution of the Year VIII, Bonaparte followed the Bourbon kings and moved into the Tuileries Palace. As First Consul, he would now put French royal architecture to use as a brilliant setting for his administration and his plundered art. Both the Tuileries and the Louvre had proved the point

Colbert had made to Louis XIV: "Your Majesty knows that apart from striking actions in warfare, nothing is so well able to show the greatness and spirit of princes than buildings and all posterity judges them by the measure of those superb habitations which they have built during their lives." At the Tuileries, Bonaparte placed himself close to the Louvre and to the paintings and sculpture he had looted from Italy. To see these works of art, he had only to walk into the Grande Galerie, now a physical and symbolic link between art and politics, domains long seamlessly welded together by the French.

The day Napoleon and the other two consuls, Jean-Jacques-Régis de Cambacérès and Charles-François Lebrun, took up residence in the Tuileries, they rode to the palace in splendor. Their carriage was drawn by six white horses—presents from Francis II, the Holy Roman Emperor, who customarily had no more than two horses pulling his coach. Like other contemporary monarchs, the Austrian downplayed his wealth. However, "the idea that prevailed" over Napoleon "was to give the government the character of seniority that it lacked," Cambacérès wrote.

At the Tuileries, Napoleon occupied the rooms of the late French king on the second floor overlooking the Tuileries Gardens. Josephine chose the suite of Marie-Antoinette. Napoleon seemed to have put to the back of his mind his shock only seven years before, on August 10, 1792, when he had seen the corpses of the Swiss Guards, left outside the Tuileries by the mob who stormed the palace.

The grandeur of the Bonapartes' apartments in the Tuileries astonished a Swedish aristocrat, who found the "grandiose public splendor" to be "far greater than what you see in our time in most courts." Bonaparte quickly duplicated that splendor by taking over the royal palace at Saint-Cloud outside Paris as a second residence in 1802. That seventeenth-century château had been expanded by Philippe I, Duc d'Orléans; then it was acquired by Louis XVI for Marie-Antoinette, abandoned in 1792 with the king's arrest, and seized by the revolutionary government. For Bonaparte, the château had significance as the site of the Brumaire coup d'état. He hired the architects Charles Percier and Pierre Fontaine to renovate it. Earlier, Josephine had seen a house they had remodeled on the rue de la Victoire and chose them to redesign Malmaison, a small

château near the Seine nine miles west of Paris, which she had bought when Bonaparte was fighting in Egypt. Appointed as architects to the government, Percier and Fontaine would also redo sections of the Tuileries and create the gilded neoclassicism that would stamp Napoleon's reign.

Germaine de Staël perceived an authoritarian arrogance accompanying Bonaparte's royalist trappings as she observed the way he staged his arrivals: "His valet opened the carriage door and hurled down the ladder with a violence which seemed to say that even objects were insolent when they delayed for an instant the progress of their master." She also noted that "the only attitude that comes naturally to him is that of a man giving orders."

The opulence of the Tuileries also shocked the British author Mary Berry, who had come from London in 1802. She persuaded Josephine's Swiss tailor to show her around the palace. "I have formerly seen Versailles, and I have seen the Little Trianon, and I have seen many palaces in other countries, but I never saw anything surpassing the magnificence of this," she reported in her journal. In a small room with green walls and bookcases, Berry noticed Raphael's *Madonna della Sedia* but assumed mistakenly it was a copy.

In fact, Bonaparte had borrowed the Raphael from the Louvre. "We are battling incessantly with our neighbors [in the Tuileries Palace]," Bernard-Jacques Foubert, a Louvre administrator, complained to the painter Joseph-Benoît Suvée in 1801. "Every day, they [the Bonapartes] demand the most expensive paintings; it is necessary to give up something and already Raphael's *Holy Family* has left: you can imagine our regret." The Louvre's Administrative Council bristled at the way that Napoleon and Josephine both treated the French national collections and the museum's staff as their own:

> [We] are sent so often to find [in the museum] a great number of paintings to place, either in the Tuileries, in Saint-Cloud, in Malmaison or elsewhere, without concern about replacing them with others. Madame Bonaparte, who is part of that which happens in the art world, strongly expressed her displeasure that we refused her husband the paintings which she claimed that we must see as the result of his conquests, and to which, as a consequence, we must be indebted.

One piece that Bonaparte was not refused was the ancient bust of Junius Brutus that he had named when demanding sculpture from the Vatican; he had it placed in his study. For the Tuileries, Napoleon had also commissioned twenty-two stone busts that depicted warriors and leaders with whom he wanted to be identified. They ranged from Alexander the Great, Julius Caesar, Hannibal, Scipio, Cicero, and Cato to Frederick the Great, George Washington, and Honoré-Gabriel Riqueti, the Comte de Mirabeau.

Bonaparte knew that the attention of Europe was fixed on Paris, on the French general who at thirty had just taken charge of France, and, as the art historian Andrew McClellan notes, on the Louvre, with its spectacle of plundered paintings and sculpture. In the wake of Napoleon's victories in Italy, Paris was now the capital of the most powerful nation in Europe. With the *Apollo Belvedere* and the Raphaels, Correggios, Carraccis, Titians, and Veroneses grandly displayed in the galleries constructed by the French kings, Napoleon sought to persuade his enemies to see his Italian plunder as evidence of the French Republic's dominant position in Europe's new military, political, and cultural order.

Still, in a world where many had decried Napoleon's seizing of art from Italy, the French understood they could not simply stockpile these treasures in Paris and expect universal admiration to follow. Claiming to rescue masterpieces from neglect and obscurity in places reached only by those with the means to take the Grand Tour and exposing them to a broad public was essential, but not enough.

Napoleon had further to justify his Italian art looting by showing the French to be worthy possessors—not the notorious vandals of the Revolution, but collectors and connoisseurs. They would take control of masterpieces in a way that revealed the strength of their army, but, more important, their passion for knowledge, their respect for history, their discipline, rationality, and expertise in the fine arts. They wanted the museum to reflect their modernity, their support for the Enlightenment, and their enthusiasm for the classifying methods of the natural sciences. While repairing and stabilizing fragile artifacts, they had to sort, order, display, but also label, describe, and explain. By treating the paintings and sculpture Napoleon had seized as objects of beauty and genius, the Louvre would transform the spoils of war into a public good.

When the Administrative Council exhibited *The Wedding Feast at Cana* in the Louvre, they documented the sixteenth-century Venetian painting for the first time. In printed catalogues, they recorded relevant facts about the plundered pictures—titles, dates, subjects, places of origin, and provenance—and what they knew about the artists who painted them. This information would lay the foundations of the history of Western art.

But while the Veronese's journey from San Giorgio Maggiore to the Louvre brought the Renaissance picture into the modern era, it did so at a cost. When the French broke the canvas from its frame in the Benedictine refectory, the paint shards that Pietro Edwards saw fall to the floor signified the picture's break from its origins and its past.

In San Giorgio Maggiore, Veronese's *Wedding Feast at Cana* had been alone—isolated and removed from the center of the city, within a complex of monastic buildings on an island, one of many scattered across the Venetian lagoon. Palladio's contemplative white room with its tall windows had allowed the Veronese the full measure of its brilliance.

To see *The Wedding Feast at Cana*—as Berthollet and the other commissioners saw it in 1797, in Venice, on the wall on which Veronese had painted it—was to be plunged, even two hundred years later, back into the place and time in which the artist had produced such pictures. That historical context extended beyond the refectory, the monastery, and the island on which the monastery stood, to the thriving trading capital that poured funds into its appearance—its architecture and its art. In the eighteenth century, enough of these structures and pictures survived to recall the maritime empire's political and cultural heyday. The creation of the painting had depended upon Veronese's genius, but also upon the circumstances that put the finest materials within his grasp—the linen woven by Venetians who also wove canvas for the sails that powered Venetian ships and the pigments of a variety and quality that allowed him to cover the expanse of sky solely with the rarest and most costly blue: ultramarine.

In San Giorgio Maggiore, the Veronese had a double identity as an object of devotion and a work of art. Its audience consisted principally of the Benedictines, but also of eminent Venetians and foreign dignitaries, who, as the Venetian Republic's official guests, stayed at the monastery, as well

as artists, connoisseurs, and European travelers who made their way to San Giorgio Maggiore to see it. The German poet and playwright Friedrich Schiller had "lamented that a work of so high a standard . . . should be allotted no wider sphere than a monkish refectory." The Veronese, he argued, "ought to be exhibited for the gratification of the public taste." He suggested that great works of art should be accessible to all levels of society—an Enlightenment idea that, as the eighteenth century progressed, began to prevail. This case was now made by Napoleon to rationalize his seizures, as he put the Italian paintings on display in the public museum in Paris. There, in the Louvre gallery, the Veronese's religious meaning would recede and the perception of the painting would change. Enlisting the Venetian picture into a company of masterpieces, the French singled it out as an object to be looked at aesthetically.

What struck French commentators most about *The Wedding Feast at Cana* was its realism. "Next to this painting, all the others, all, without exception, look painted," declared the historian François Emmanuel Toulongeon in 1806. "This one, next to nature, doesn't appear to have been painted. It is nature fixed and rendered unchanging by an enchantment of the figures who have been seized by immobility."

But in this naturalism, the Veronese had violated the French Royal Academy's rules. In the catalogue of the Musée Napoleon, Joseph Lavallée, the father of the museum's general secretary Athanase Lavallée, faulted Veronese for setting the New Testament miracle in sixteenth-century Venice. Also, the academic conviction that drawing should take precedence over color showed through when he observed that Veronese's color was "so true" that he could sometimes forget that "the drawing has some defects." Nevertheless, Lavallée called *The Wedding Feast at Cana* a "masterpiece." He explained: "The beauty of the colors, the charm of the invention, the admirable ensemble of the composition, the variety of expressions spread over this crowd of figures, who number over a hundred, who all move, speak, go, come, without harm, without confusion, and without blocking the view; the grandeur of the formality, the magnificence of the architecture, the general harmony extend over this immense surface."

As Napoleon used the Louvre to legitimize French plunder, he could hope the museum would also confer upon him the political legitimacy he

struggled to acquire after he had conspired to overthrow the Directory with the coup d'état, abandoned the democratic principles of the Revolution, and seized power as First Consul. He embraced the Louvre as a symbol of the sovereignty he sought to establish, when he claimed, "I am the Revolution." If by amassing art he joined the line of French kings, by installing that art in the Louvre's public galleries and thus giving it to the French people, he presented himself as an Enlightenment leader, an intellectual, and a friend of the philosophes.

With the Peace of Amiens, the Louvre's audience expanded, as the British flocked to Paris. In the twelve months after the treaty was signed in March 1802, some ten thousand visitors from Great Britain crossed the Channel to France. "Paris was ever a place of general rendezvous, but now more so than at any known period," wrote the British antiquarian Stephen Weston. "And since it has drawn within its circle all the curiosities of Holland, and the Low Countries, all the treasures of Italy, all the wonders of ancient art, it is become the general magazine of Sculpture and Painting, whilst all other Museums are left naked and desolate."

As the French had hoped, many found the profusion of painting and sculpture astounding. Mary Berry arrived in Paris on Sunday, March 14, 1802. At 1:00 p.m. the next day, she went to the Louvre. "To give any idea of this gallery is quite impossible," she wrote.

> You ascend to it (at present) by a commodious plain staircase, and first enter a large square room [the Salon Carré] . . . lined with all the finest Italian pictures, very well placed as to light. Out of this room you enter a gallery [the Grande Galerie]—*such* a gallery. But *such* a gallery!!! As the world never before saw, both as to size and furniture! So long that the perspective ends almost in a point, and so furnished that at every step, tho' one feels one must go on, yet one's attention is arrested by all the finest pictures that one has seen before in every other country, besides a thousand new ones.

The British wanted to indulge in French fashion, and to see the "unequalled assemblage of antique statues and pictures by the old masters," as Abraham Raimbach wrote. British visitors included the artists Benjamin

West, J.M.W. Turner, and John Flaxman, as well as two-thirds of the House of Lords. "It would be difficult to convey an idea of the *rush* that was made to the French capital by persons of every class who had the means of transit in their power," wrote Raimbach. The engraver had left London on July 8 and arrived in Dieppe on the tenth. Three days later he was in Paris. Whereas in the past, for residents of Great Britain to see paintings and statues in various cities of Italy had required weeks of travel; now, assembled in Paris, they could be reached from London in less than a week: five to ten hours to cross the Channel to Calais, then some fifty more hours in a coach to make the 150-mile overland trip from Calais to the French capital.

The French treated their former enemies as the Louvre's most important public. Foreigners enjoyed greater access to the gallery than did the citizens of France. The Louvre's hours were ten o'clock to four, but different segments of the public came on different days. Foreigners had only to show a passport or a carte de visite to get into the museum for nine out of the ten days that composed a "week" in the revolutionary calendar. The French "general public," on the other hand, was restricted to only three (the eighth, ninth, and tenth) of the week's ten days. French artists fared better, but still not as well as the tourists. Bringing sketch pads and setting up easels, they came to study and to make copies of the paintings—copies that would sometimes take months to complete.

Some found the Grande Galerie overwhelming. "The various masters press close upon one another, and the different schools jostle each other," wrote Stephen Weston. "One moment you are in France, and the next in Flanders; whilst you are conversing with Poussin and Le Sueur, Antwerp and Rubens appear in view, from Venice to Naples is but a step, and Florence, Rome, and Bologna are all visited and gone over in a morning. Formerly it was a very different thing, and from one picture to another it was a week's journey." Sulpiz Boisserée, an architectural historian from Cologne, had a similar response: "We didn't have enough eyes." The British artist Martin Archer Shee argued he needed time to sort out the "chaos": "All is confusion and astonishment: the eye is dazzled and bewildered, wandering from side to side—from picture to picture; like a glutton at a feast."

Friedrich Schlegel, the German writer and critic, who was living in

Paris, told his brother August Wilhelm that the Louvre was eating up his days. He explained he hadn't had time to answer his letter as "I found myself, for some time, completely absorbed . . . just by the paintings and antiquities," he wrote on September 16, 1802.

However, the German diplomat and biographer Karl August Varnhagen von Ense recoiled at the museum as a "victory monument." He agreed with Goethe that "works of the mind and art are not for the mob." One of the most pointed attacks on the French was made by Friedrich Schiller, who had argued for greater access to the Veronese in Venice. In a twelve-line poem, "The Antiques at Paris," he characterized the French as pilferers, who had cut off their imaginative access to the ancient sculpture they had stolen from Rome: "What art the Greeks created . . . To the Vandal they are but stone!"

Still, most who visited the Louvre refused to let the violent provenance of its masterpieces interfere with the dizzying pleasure of the encounter with more than a thousand pictures, all together, all at once.

On July 14, 1803, Dominique-Vivant Denon, the new director general of the Louvre, wrote to Bonaparte: "There is a frieze above the entrance [to the museum] that awaits an inscription: I think the Musée Napoléon is the only one suitable." By August 15, the Louvre's name had been officially changed to the Musée Napoléon.

16

"The transparency of air ... place[s] Gros beside Tintoretto and Paul Veronese"

The life of Napoleon is the event of the century for all the arts.
—Eugène Delacroix

If *The Wedding Feast at Cana* refused to conform to the rules of French academic taste, hanging prominently in the Louvre, it could hardly be ignored. The Venetian canvas was in its way a subversive presence, to be seen and studied by its most important audience—the artists of France. "Artists come running! Here are your masters!" cried the banner on the carts that had paraded the Italian plunder across Paris. Indeed, even those artists who had condemned the French art seizures in Italy did not stay away now that these paintings and sculptures were on display at the Louvre. To French painters, the Veronese threw down the gauntlet—in its scale and magnificence. Its scale was the scale that Napoleon was now demanding as he commissioned pictures to commemorate his battles and create a visual history of his reign.

However, for artists who aspired to greatness, such painting commissions were no longer straightforward. One of the most difficult commissions Napoleon offered, in 1803, was to Antoine-Jean Gros. Napoleon has "given me a subject to treat," Gros wrote to the artist Pierre-Narcisse Guérin. "He had enjoyed describing it to me himself." The subject was to be a moment of heroism in the Egyptian campaign—a visit Bonaparte made on March 21, 1799, to a hospital set up in an Armenian monastery in Jaffa to minister to French soldiers stricken by the bubonic plague. He had stopped at Jaffa on his way north to take on Ottoman forces in Syria.

Napoleon had much riding on Gros's painting, hoping the artist would create an image to recast the problematic facts of France's 1801 defeat by the British in Egypt but also to combat reports in the British press of

Napoleon's brutality not only toward the enemy but also toward some of his own troops.

The political landscape was shifting. After only a year, the peace negotiated at Amiens had collapsed. On May 18, 1803, Great Britain had declared war on France. Already, British travelers had begun to evacuate Paris. "Flight was the order of the day," wrote Bertie Greatheed, a British playwright. "And the most judicious prepared immediately for their departure."

The approach of war had emboldened Bonaparte to expand his power. So too had threats against his life. His minister of police, Joseph Fouché, had foiled a royalist plot, financed by the British and led by Georges Cadoudal, whose treason was punished by execution. To further warn his enemies, on March 15, 1804, Bonaparte ordered French soldiers to cross the border into Baden and arrest Louis de Bourbon Condé, the Duc d'Enghien. Although he knew the duke to be innocent of plotting his execution, Bonaparte still had him brought to the Château de Vincennes, on the eastern edge of Paris, and tried before a military commission, which found him guilty and had him shot. Enghien's murder enraged the monarchs of Europe, further fueling their distrust of Napoleon. Britain's chargé d'affaires had written in 1802 that Bonaparte would be "Caesar or nothing."

For some time, Bonaparte pushed the idea of replacing the consulate with a hereditary empire, and, on May 18, 1804, the Senate took up this proposal and declared him emperor of the French. From then on, Bonaparte would use his first name, Napoleon. He would establish what the historian Steven Englund calls "*a new kind of monarchy*, democratic and representative in origin and legitimacy, Roman in style, liberal in aspiration, dictatorial in substance . . . occasioned by war but not requiring war, sustained by glory."

That May of 1804, Gros was more than halfway through the Jaffa picture. The canvas would be his largest to date—17 feet high by 23 feet across—nearly three times the size of David's *Oath of the Horatii* (at 10 by 14 feet). To paint the picture, Gros set up a studio in the Jeu de Paume at Versailles. The commission fired the artist's ambition, and he finished the large complex work in only six months. Certainly, Napoleon's visit

to the Armenian monastery in Jaffa had revealed a near reckless courage. "The general walked through the hospital and its annex, spoke to almost all the soldiers who were conscious enough to hear him, and for one and a half hours, with the greatest calm, busied himself with the details of the administration," wrote René Nicolas Desgenettes, the chief doctor on the Egyptian campaign. "Finding himself in a very cramped and very overcrowded room . . . he helped to lift . . . the hideous corpse of a soldier."

Napoleon had dared this encounter to diminish the alarm of soldiers terrified of contracting the plague, which killed 92 percent of its victims, and to prove that the disease, which he downplayed as "a fever," was not contagious. "It is one of the peculiarities of the plague that it is most dangerous to those who fear it," he would write. "Those who allowed themselves to be mastered by their own fear are almost all dead." He would argue that "the surest protection, the most efficacious remedy was a display of moral courage." Later, scientists would discover that in fact the plague was spread by fleas, and, in Jaffa, many soldiers had caught it from insect-infested uniforms they had removed from the corpses of its victims.

Two months later, on his return journey to Cairo, on May 24, 1799, Bonaparte stopped by Jaffa a second time. "Nothing could have been more horrible than the sights brought before our eyes," wrote Jean-Pierre Doguereau, an artillery officer. "The dead and dying were everywhere, begging passers-by for treatment or, fearful of being abandoned, praying to be taken on board ship." But, the ships did not have enough room for their numbers. Bonaparte decided that the sickest soldiers (as many as sixty) would be left there. Not wanting these victims to be discovered by the vengeful Turks, he ordered the doctors to give them fatal doses of laudanum. Desgenettes refused, but a pharmacist obeyed. When the British reached Jaffa, on May 30, they learned of Bonaparte's cold-bloodedness from French soldiers who had taken the poison but had survived.

Earlier, when Gros was in Milan, he regretted that Napoleon had not taken him to Egypt. But it happened that by staying in Italy, as the Austrians retook parts of Lombardy from the French, the artist experienced warfare firsthand. In the spring of 1799, Gros had accompanied the French army to Genoa. He was in Genoa in April 1800, when the Austrians laid siege to the city for two months, causing starvation, disease, and

the deaths of some four thousand French soldiers and thirty thousand civilians. Gros himself had almost died. On June 5, 1800, the day after the Austrian surrender, he boarded a British ship that carried him to the coast of France. He then spent some eight months in Marseille, convalescing, before he returned to Paris.

The painting Gros produced was no straightforward propaganda piece, but a nightmarish scene, a complicated reading of Napoleon and his war-torn reign, and one of the artist's greatest works. Bonaparte is center stage, armored by the dressy splendor of his dark uniform, with its red sash and gold braid, white pants, tight on the legs, tall brown-and-black boots, and a red plume on his black hat. He stands within a crowd of soldiers in blue uniforms, oriental archetypes in robes and turbans, and the near naked victims of the plague. Unflinching, he reaches out a hand (he has removed his glove) to touch the wound on a soldier's chest. Gros gave Bonaparte the famous pose of the *Apollo Belvedere*—which was standing in a gallery in the Louvre. The gesture also evoked the healing power of Christ and of the French kings, who, after coronation ceremonies in Reims, would walk among the crowds, promising the miraculous cure of their touch. In the distance is a city on a hill, and a flagpole on which the French flag is flying. The sky is filled with smoke, and the brightest light is an autumnal yellow.

In the shadows of the foreground are long-limbed naked bodies, and faces, gaunt and darkened by illness. The life-sized scale, once reserved in Western art for gods, kings, and heroes, amplifies the horror experienced by these French soldiers, many of whom are dead. Their sculpted bodies resemble the baroque martyrs of Guercino, yet Gros shows them not as a rhetorical exercise but as the documentary truth. He spells out the cost of war in the figure of a fair-haired young soldier in a French uniform who has collapsed to the ground, succumbing to the illness, like the man who lies facedown, across his lap. Contemporaries identified the young man as Saint-Ours, a physician, who was killed by the plague on the Egyptian campaign.

Bonaparte Visiting the Plague-Stricken in Jaffa went on exhibition at the Salon in August 1804. "The sincere admiration which this composition excited was so general that painters from all the respected schools united to carry to the oeuvre a great laurel wreath to hang above Gros's

picture," the painter Étienne-Jean Delécluze wrote. Gros had distilled his admiration for Napoleon into the image of a hero and a savior, capable of somehow rescuing not only French soldiers in Egypt but also the French nation, even if it were in a state of mayhem and destruction. It was "as if all dangers and scourges had to respect the one that the heavens destined to become shortly the restorer of France," a commentator wrote. But what also struck the critics, as the art historian Darcy Grimaldo Grigsby observes, was the painting's explicit account of "the stages of the disease— the stupor, despondency, fury, desire."

Some weeks after *Bonaparte Visiting the Plague-Stricken in Jaffa* first appeared at the Salon, the director of the Louvre, Dominique-Vivant Denon, claimed to Napoleon that in this "masterpiece," Gros had proved he could compete with the legendary painters of Venice. In his praise, Denon implied that Gros had learned much from *The Wedding Feast at Cana*: "All the heat and the transparency of air in the climate and a magic in the chiaroscuro . . . place Gros beside Tintoretto and Paul Veronese." Gros had showed contemporary French painting to be up to its task. "At this very moment," Denon wrote, "I could leave his painting with all the productions of the Venetian school."

The Wedding Feast at Cana stood as a model, in the way Veronese had taken the Benedictine monastery's commission to paint the "Miracle at the Supper at Cana," to venture far out on his own—in subject and style—subsuming the New Testament story into a canvas that invites various interpretations. The painting struck many notes and told more than one story. It was religious and secular, tragic and celebratory, biblical and contemporary, all at the same time.

In *Bonaparte Visiting the Plague-Stricken in Jaffa*, as in *Bonaparte on the Bridge at Arcola*, Gros had strayed far from the neoclassicism of David. He reveled in color loosely applied—to describe scarlet drapery, blue uniforms, the eerie tone of the sky, and to convey the dark passion of the scene, played out on a monumental scale: a drama in which Napoleon's heroism is highlighted but simultaneously undercut by the horror of the doomed men.

17

"This beautiful work reminds us of the picture by Paul Veronese"

[David] then thought that to keep a grip on a composition filled with so many portraits, he would be obliged to soften the severe style that had ensured the success of his other works, a style that has brought glory to the modern school.

—Jean-Baptiste-Marie Boutard, *Journal de l'Empire*, January 24, 1808

While Antoine-Jean Gros's *Bonaparte Visiting the Plague-Stricken in Jaffa* had its triumphant run at the 1804 Salon, the French emperor completed the plans for his coronation. It was to take place on December 2, 1804, in the Cathedral of Notre-Dame, before Pius VII and a crowd of some twenty thousand. Bonaparte based the ceremony on the "consecrations" of the Bourbons and designed it to impress the European sovereigns, who both scorned and feared him. Napoleon also commissioned Jacques-Louis David to paint the historic event. Throughout the ceremony in Notre-Dame, David and an assistant rushed out sketches—drawings the artist would later use for his painting.

David spent more than three years completing the huge descriptive tableau. To carry out the commission, he requested the use of the church of Cluny, in the Place de la Sorbonne. By the end of 1806, he had mapped the composition and was working on the costumes and the heads. Talleyrand was one of the many who came to the church and spent a few hours posing, as David drew their faces directly onto the canvas. On February 7, 1808, *The Coronation of Napoleon* went up in the Salon Carré. Days later, Nicolas Ponce, an engraver and art writer, in *Courier de l'Europe et des Spectacles* compared David's painting to *The Wedding Feast at Cana*: "This beautiful work reminds us of the picture by Paul Veronese that

we admired on the same wall a few years ago; as with that picture, the spectators get confused with the painted figures, for these seem so natural and true."

David himself made clear that Veronese's *Wedding Feast at Cana* was the painting against which he wanted to compete. "The Nuptials of Cana, by Paul Veronese" he would describe as "the greatest known picture in the world," but would claim it "is only 33 feet long and 18 high." He wrongly asserted that his "coronation" picture was larger. To make this boast, he shaved 4 feet off the height of the Veronese, which was a foot taller than his picture.

Although a disciple of Raphael and a student of Roman antiquities, David took the Veronese as a model for structuring the canvas, with more than one hundred figures, a group portrait that captures the spectacle Napoleon had staged before his family, his officers, and other members of the French elite, beneath the towering arches and muted gloom of Notre-Dame.

After protracted negotiations, Napoleon had persuaded Pius VII to come to Paris to crown him. Only twice before—in 754 to bless Pépin III, in Paris, and then, in 816 to crown Louis the Pious, in Reims—had the popes left Rome to participate in the investiture of a French king. Even Charlemagne had been forced to make his way to the Vatican. The arduous journey from Rome to Paris took Pius VII three weeks. He was accompanied by six cardinals and ten bishops. Taking the Mt. Cenis pass, they crossed the Alps in two convoys of twenty carriages and wagons, drawn by 130 horses. Napoleon pressed the architect Fontaine to complete the renovation of apartments at the Château of Fontainebleau, so the pope and his entourage could spend a few days there before proceeding to Paris.

In postrevolutionary France, the pope's presence did not sit well with either the republicans, who raged against Napoleon's desire to obtain the blessing of the Catholic church, or the royalists, who criticized the pontiff for giving that blessing to the usurper. For his part, Napoleon asserted his independence from the Vatican, even as he demanded Pius VII's participation.

The guests began to arrive at Notre-Dame at 6:00 a.m. All night snow had fallen. The pope started from the Tuileries Palace at nine and reached

the cathedral an hour and a half later. Napoleon and Josephine followed, riding in one of a procession of twenty-five coaches, and kept the pontiff waiting. Later, in the cathedral, Napoleon took the "diadem of oak and laurel leaves made of gold," a replica of Charlemagne's crown, and crowned himself. "It is the French Revolution that is being sanctioned and sanctified," the Prussian diplomat Friedrich von Gentz observed.

A preparatory drawing David made in brown ink describes the moment Napoleon held the crown above his own head. But in the painting, David backed away from Napoleon's defining gesture and showed the emperor crowning Josephine.

David's *Coronation* appeared to be an exact record of the event; its protagonists and their costumes are described in a profusion of detail, starting with Napoleon's red velvet mantle, elaborately embroidered with gold bees and eagles, as well as laurel, olive, and oak leaves. Across the canvas, David had painted more than eighty portraits—Pius VII, and Cardinal Caprara, the papal legate in Paris; Eugène de Beauharnais; the former consuls Cambacérès and Lebrun; Berthier and Talleyrand, their backs armored in capes of blue velvet, dotted with bees; Napoleon's brothers Joseph and Louis (Lucien stayed in Rome) and sisters Caroline Murat, Pauline Borghese, and Elisa Baciocchi; as well as Hortense de Beauharnais, her small son, Napoleon Charles, and Joseph's wife, Julie. Two ladies-in-waiting lean forward to hold up the empress's train.

Despite the details that anchored the scene, David also invented and idealized. Napoleon's mother, Letizia Bonaparte, had refused to attend her son's investiture, but Napoleon had insisted that David place her there. The artist seated Napoleon's mother in the second level of the gallery, the prominent place she might have occupied had she decided to take part.

Napoleon saw the canvas for the first time in David's studio in the Cluny church on January 4, 1808. "This is not a painting; one walks in this picture," the emperor said. No doubt Napoleon appreciated the display of his wealth and power—the pope (seated behind him), Napoleon's ministers in plumed hats and expensive fabrics, his brothers and sisters, attired as the royalty they had become.

Napoleon demanded David make a change. He asked the artist to repaint the right hand of the pope so it would be raised in blessing. David

altered the pose but left the pontiff, slumped in his throne, submissive before the emperor. David "in fact, reveals in the painting what had been censored in the press," the art historian Dorothy Johnson observes, "namely, that the pope was a political prisoner, an unwilling and unhappy participant in Napoleon's coronation."

In 1808, when Pius VII refused to ally himself with the French emperor against the British, Napoleon occupied the Papal States. On June 10, 1809, the pope responded by excommunicating Napoleon. A month afterward, French troops broke into the Quirinal Palace, arrested Pius, and forced him into exile in Savona. Three years later, Napoleon had the pope transferred to Fontainebleau and held under house arrest at the very château he had renovated for the pontiff's earlier stay.

In December 1804, Napoleon's coronation festivities had continued for two weeks—with fireworks and a balloon launching—but the celebration failed to persuade his enemies of his legitimacy or to gain much in the way of French public support. Neither did David's painting, for all its spectacle, convince all viewers of Napoleon's greatness. A critic who called himself "Arlequin au Muséum" argued that David's depiction of the staged ceremony was all too realistic and had captured the stultifying atmosphere of the event. "We were suffocating in the church of Notre-Dame," he wrote, suggesting that he objected less to the press of the crowd in the cathedral than to the limits Napoleon placed on individual freedoms. *"No air, no effect, no perspective."* He tells the reader, "You would have preferred M. David make in this great *machine* what Paul Veronese made" in *The Wedding Feast at Cana.* In that picture, "we see everything, we go around everything, in which the figures are clearly set off from the architecture, and from the sky." Veronese had left plenty of room for the crowd. "And in which the sky is open and appears only like empty space to the eye."

Arlequin was perceptive. The image of the emperor was far removed from the singular soldier and improvisational hero of Antoine-Jean Gros's 1796 *Bonaparte on the Bridge at Arcola* or from the allegorical commander of David's own 1801 *Bonaparte Crossing the Alps at Grand-Saint-Bernard.* Now, Napoleon was a figure among many figures—raising a crown in the air but defined by the opulence of his clothing, and much diminished.

Only months after Napoleon's coronation in Paris, he staged a second

coronation, on May 26, 1805, in the Duomo of Milan, before Cardinal Caprara and some thirty thousand onlookers. He crowned himself king of the Kingdom of Italy—this time with the Iron Crown of Lombardy, made of gold and metal from a nail of the True Cross, and worn by Frederick Barbarossa in 1155 and successive Holy Roman Emperors. "The ceremony was as good as the one in Paris, with the difference that the weather was superb," Napoleon said. "When taking the Iron Crown and putting it on my head I added these words: 'God gives it to me; woe betide any who touches it.' I hope it will be a prophecy."

The French emperor made Eugène de Beauharnais, his twenty-three-year-old stepson, viceroy of Italy on June 7. That month, France took possession of the Ligurian Republic, and Napoleon established the Principality of Lucca and Piombino, setting up his twenty-eight-year-old sister Elisa and her husband, Felice Baciocchi, as sovereigns there.

Tolstoy's *War and Peace* famously opens with Anna Pavlovna Scherer speaking to her guests in Saint Petersburg about Napoleon's takeover of Italy: "Well, my prince, Genoa and Lucca are now no more than possessions, *estates*, of the Buonaparte family."

18

"I succeeded ... in packing most of the pieces of small size and great value"

The [Louvre's] order—systematic arrangement of every genre—
[and] unlimited access . . . deserve universal admiration. This
should be the model for all such arrangements.
 —Georg von Dillis, Paris, 1806

During the brief hours that were given to me on the day of October 17 [1806] and from noon to six in the evening, I succeeded with the help of several friends and of the secretary Ahrens in packing most of the pieces of small size and great value." Thus wrote Johann Friedrich Emperius, the director of the Duke of Brunswick's collection, about his scramble to clear the gallery in the Schloss Salzdahlum of its finest works of art. Three days before, Napoleon had routed the Prussian army in battles at Jena and Auerstädt, in Saxony. Three months earlier, Frederick William III, the Prussian king who was angered by French troops marching across his territory and Napoleon's increasing sway over German politics, had resolved to attack France. He allied himself with Tsar Alexander I of Russia and in early October declared war.

In Prussia, as Emperius anticipated, Napoleon's art-plundering operation began anew, on a nearly industrial scale. In Italy, in 1796, Bonaparte had enlisted artists and scientists to choose paintings and sculpture for the French Republic, and the Directory had rationalized these thefts as acts of liberation. Now, a decade later, the French emperor sent a single scout—Dominique-Vivant Denon, the Louvre's director—the "eye" of Napoleon, as the director of Munich's Hofgartengalerie called him. Beyond the right of conquest, Denon offered no excuse. As justification for the French appropriations of German and Austrian masterpieces, the Louvre's ambition was more than enough.

The Louvre had won the respect, admiration, and envy of many in Europe. Emperius described the Paris museum as "the largest collection of the most magnificent works that had ever been assembled." But, like other German gallery directors, he had come to understand Napoleon's designs on his collection and mounted a defense before the French army arrived.

After the victories at Jena and Auerstädt, Napoleon marched north and on October 27 entered Berlin, riding a white horse through the Brandenburg Gate. Denon reached the Prussian capital that same day. Frederick William III had prepared Berlin for the French invasion: he ordered Jean Henry, the director of the royal Kunstkammer, to crate the most important paintings and accompany them to Küstrin, in Prussian Poland.

"If several works of art are made part of the contributions of war, Prussia would . . . produce only a very few things," Denon had cautioned Napoleon. Nevertheless, in Berlin and Potsdam, where Frederick the Great had built his summer palace, Sans Souci, Denon seized some sixty paintings, including twenty by Lucas Cranach, court painter to the Electors of Saxony and friend of Martin Luther.

In late November 1806, Napoleon left Berlin to continue east across Prussia, and he vanquished its armies in less than two months. Napoleon's successive victories against Frederick William III entitled the Louvre's director to prey upon galleries in other Prussian cities and in the cities of Prussia's allies. From Berlin, Denon headed 120 miles west to Brunswick. Although Emperius had sent the pictures he'd removed from the Schloss Salzdahlum to Denmark, Denon nonetheless found seventy-eight paintings in the gallery he deemed worthy of the museum in Paris.

Still, such was the authority of the Louvre that when Denon arrived in Brunswick, speaking no German and with lists of desired artworks in hand, Emperius jumped at the chance to meet him. Denon was "renowned and distinguished as an artist, as a connoisseur of works of art . . . as a traveler, as a writer," he would explain. Emperius would also confess that "had the business that led him [Denon] here not been so detestable, a closer acquaintance with him would have seemed very desirable to me." The "warm welcome reserved for Denon in Germany makes sense," argues the art historian Bénédicte Savoy, "only if one considers the spirit of self-flagellation and the feeling of inferiority still present around 1800

in the cultural relations between a Germany in search of identity and a France of hegemonic influence."

By 1806, Denon held wide-ranging power in the French art establishment. He ran not only the Louvre but the Musée des Monuments Français and the Musée de l'École Française at Versailles, as well as the Sèvres porcelain factory and the Gobelins tapestry works. He also gave out Napoleon's commissions for sculptures and paintings.

Denon had made his name in 1802 with the publication of *Travels in Upper and Lower Egypt, During the Campaign of General Napoleon*, a fast-paced account of his experiences as a draftsman accompanying the French army, illustrated with his own engravings. Denon's *Travels* became a bestseller in France and was translated into Italian, German, and English. In Egypt, Denon's energy had impressed Napoleon, and Denon's book did much to redress the news of France's Egyptian defeats.

A maverick and the author of an erotic novel, *Point de Lendemain* (*No Tomorrow*), Denon had reinvented himself several times. Born in Burgundy in 1747, Denon had studied painting and engraving in Paris with Noel Hallé, who helped him get a job as keeper of gems and medals for Louis XVI. In 1772, he was given a diplomatic post at the court of Saint Petersburg, and then worked as a French envoy in Stockholm and in Naples. On this last assignment, he gained some expertise in the antiquities discovered at Herculaneum and Pompeii. He also would publish more than five hundred prints, including black-and-white engravings of well-known paintings. In a self-portrait etching, Denon looks out from the network of dark lines and delivers a shrewd smile.

Denon flattered Napoleon: "Sire, it is those [artists] who have heard you utter an apt phrase, who have seen you take a position in a difficult situation, who have seen you act, and who, so to speak, have heard you think, who can write or paint your history."

Denon's maneuvering irked Pierre Fontaine, the architect who had to work with him on the Louvre's renovations. "This new administrator is driven by the desire to do well and, above all, the need to be seen by everyone," Fontaine wrote in his journal on February 5, 1804. Four years later, he added: "M. Denon is one of those unwelcome flies that we cannot succeed in hunting and against whom we must simply have patience." Denon perhaps

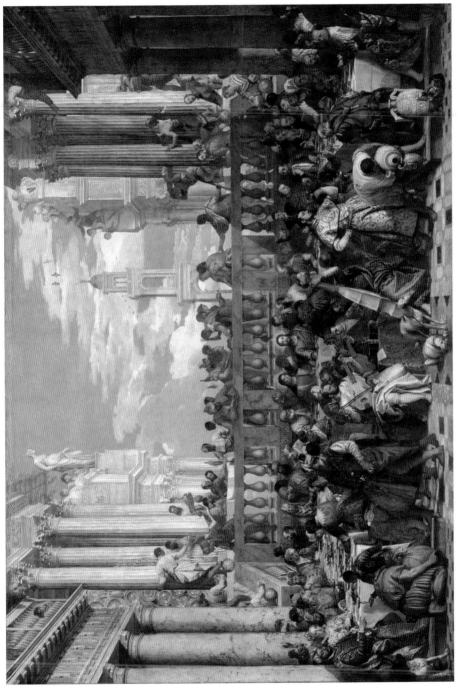

Paolo Veronese, *The Wedding Feast at Cana*, 1563.

Canaletto (Giovanni Antonio Canal), *San Giorgio Maggiore: From the Bacino di San Marco*, 1726–1730. Canaletto shows the church, designed by Andrea Palladio, and to the right, the monastery.

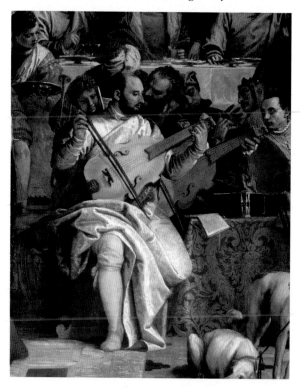

Paolo Veronese, *The Wedding Feast at Cana* (detail), 1563. In 1674, Marco Boschini claimed that the musician in white was a self-portrait of Veronese.

Antoine-Jean Gros, *Bonaparte on the Bridge of Arcola, November 17, 1796*, 1796–1797. Gros painted this iconic portrait in Milan, when the French general was leading France's campaign against Austria in Italy.

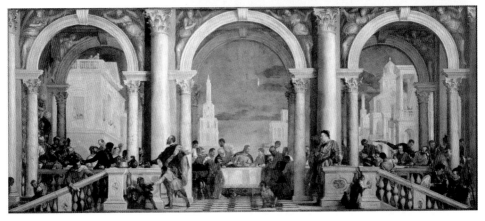

Paolo Veronese, *The Feast in the House of Levi*, 1573. Veronese painted this as a *Last Supper*; after the Inquisition demanded changes to the picture, the artist simply retitled it.

Francesco Guardi, *Pope Pius VI Descending the Throne to Take Leave of the Doge in the Hall of SS. Giovanni e Paolo, 1782*, ca. 1783. In the background, on the refectory's end wall, is Veronese's *Feast in the House of Levi*.

Giovanni Bellini, *Madonna and Child Enthroned with Saints Peter, Catherine of Alexandria, Lucy, and Jerome*, 1505. Bellini's altarpiece was set into an architectural frame in Venice's church of San Zaccaria.

Raphael, *The Transfiguration*, 1520. Raphael's last painting, this celebrated work was removed by the French from the church of San Pietro in Montorio, in Rome.

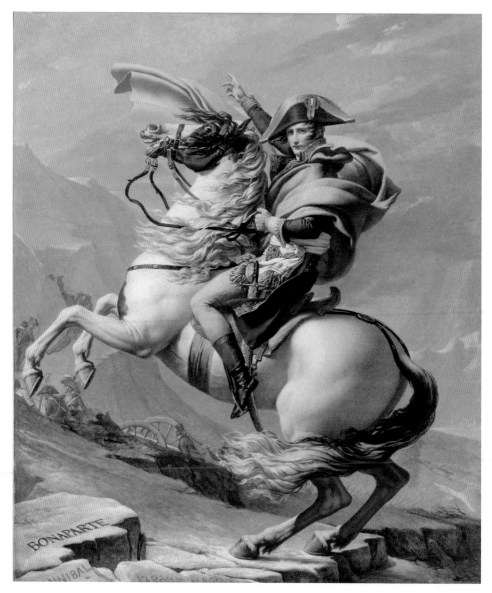

Jacques-Louis David, *Bonaparte Crossing the Alps at Grand-Saint-Bernard*, 1801. After Bonaparte's 1800 victory at Marengo, the Spanish king Charles IV deemed it politically advantageous to commission David to paint a portrait of France's First Consul.

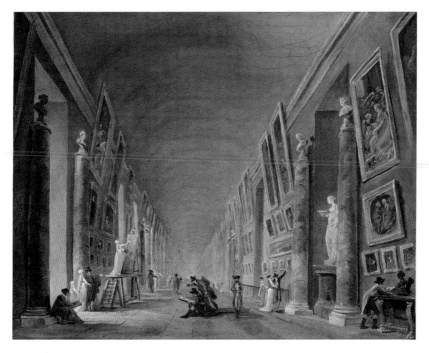

Hubert Robert, *Grande Galerie of the Louvre*, 1801–1805. The Louvre's quarter-mile-long gallery was lined with some 950 old masters, including paintings seized by Napoleon from Italy.

Antoine-Jean Gros, *Bonaparte Visiting the Plague-Stricken in Jaffa*, 1804. Gros presents a heroic Napoleon, while also depicting the mortal cost to French soldiers of the Egyptian campaign.

Jacques-Louis David, *The Coronation of the Emperor Napoleon and Josephine at Notre-Dame on December 2, 1804*, 1807. Critics compared David's painting to Veronese's *Wedding Feast at Cana*.

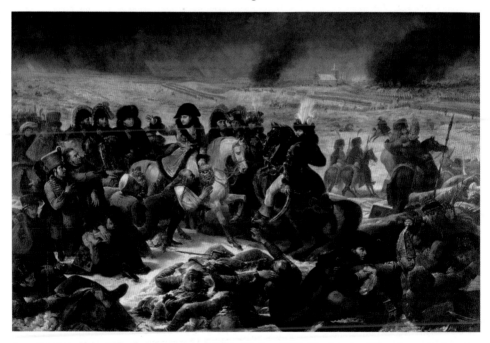

Antoine-Jean Gros, *Napoleon on the Battlefield of Eylau*, 1808. The image of Napoleon confronting dead and dying Russian soldiers after the 1807 battle in East Prussia seemed to foretell the catastrophe of France's 1812 Russian campaign.

condescended to the architect as he did to artists. In a letter to Napoleon, he praised France's artists as Europe's "most beautiful and almost the only school," while claiming he could whip them into shape. Denon proposed supervising their schedules, establishing deadlines for delivering works, and holding down the prices demanded by Gros and others for their pictures. Denon would fight their "exaggerated pretensions and bring them back to the modest simplicity of true artists the world over, who have always found glory in being highly productive and in living honorably but without pomp from the proceeds of their nightly labors and plentiful works." He wanted to pay no more than twelve thousand francs—his annual salary—for large history pictures and six thousand for an average-sized easel painting.

In January 1807, Denon traveled from Brunswick eighty miles southwest to Kassel. There, the Elector of Hesse, William I, seeking to keep the Fridericianum Museum's finest paintings out of French hands, had stashed forty-eight canvases (among them Rembrandts, a Poussin, a Raphael, and a Van Dyck) in a fourteenth-century castle that served as a royal hunting lodge, in a forest twenty miles outside the city. However, General Joseph Lagrange learned of the whereabouts of the pictures, and, much to Denon's annoyance, he had them delivered directly to Josephine, who happened to be visiting Mainz. Josephine had then sent the paintings on to Paris—not to the museum, but to Malmaison. Nevertheless, after five days at the Fridericianum, Denon selected 299 paintings for the Louvre. "In all I will have made a harvest that cannot be compared to that from Italy," Denon wrote Athanase Lavallée, the Louvre's general secretary, on January 29. "But that is well beyond what I had hoped for from Germany." Denon added, "We now find ourselves with some pieces by Albrecht Dürer, Lucas Cranach, Heemskerck, and Holbein, which we absolutely lacked."

In Kassel, the French artist Benjamin Zix made a drawing of Denon and a team of eleven in the process of stripping a gallery in the Fridericianum of its pictures. Born in Alsace, the thirty-five-year-old Zix spoke both French and German and had accompanied Denon to Germany as a draftsman and an interpreter. In the drawing, Denon kneels to examine a painting, one in a stack propped against the wall, ready for packing. Five men have climbed a ladder to a scaffold and struggle to take down a huge painting. On a pile of frames on the floor, someone has tossed a hat.

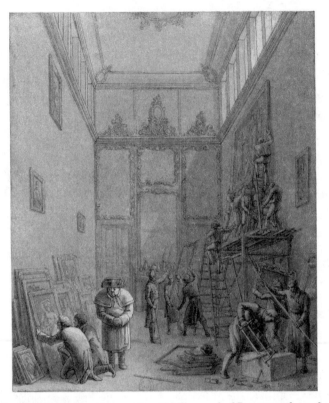

Benjamin Zix, *M. Denon Supervising the Removal of Paintings from the Picture Gallery, in Kassel,* 1807. On the left, the Louvre's director general Dominique-Vivant Denon inspects a picture.

While Denon was working through the collections in Kassel, Napoleon pursued the Russian army to East Prussia. On February 7 and 8, 1807, at Eylau, near Königsberg, in temperatures that plunged to fifteen degrees below zero, the French fought Russian troops and forced them to retreat. Although the French stood their ground, there was no decisive victory. What impressed the army surgeon Pierre-François Percy was the "horrifying butchery." He wrote that "all you could see were the cadavers of men and horses. Artillery wagons and vehicles passed over them, cutting them up further, crushing and grinding skulls and members." The casualties ran to twelve thousand (and possibly as high as thirty thousand) for the French, and at least twelve thousand dead and twelve thousand wounded for the Russians. "What a massacre! And without any result," Marshal Michel Ney observed.

After Eylau, Napoleon kept marching east, defeating the Russians again on June 14 at Friedland. At this point, Tsar Alexander wanted peace, and on June 25, he and the French emperor met on a raft on the Niemen River, near Tilsit, in East Prussia, about four hundred miles east of Berlin. They spent two weeks cementing their new alliance. Frederick William III also traveled to Tilsit, and in the treaty he signed on July 7, 1807, Napoleon reduced the Prussian king's territory by half and forced him to pay a large indemnity. In East Prussia, the French army had leveled towns and stolen crops and livestock. Food shortages led to disease, and the incidence of infant mortality in Berlin shot toward 75 percent.

From Kassel, Denon traveled to Hanover and Hamburg, then east to Schwerin, which held the Duke of Mecklenburg's collection. After returning to Berlin, he went on to Danzig (Gdańsk) and Warsaw. In the eight months—from October 1806 to June 1807—that Napoleon had spent conquering Prussia, Denon had commandeered more than one thousand paintings, as well as sculptures, medals, and objects of decorative art. Altogether, he forwarded 250 cases of Germany's art to Paris.

On October 14, 1807, Denon showed off the results of his diligence in

Benjamin Zix, *Arrival at the Louvre of Works Seized from Berlin*, 1808. To the right of the Louvre's entrance stand Johann Gottfried Schadow's bronze horses, removed by the French from Berlin's Brandenburg Gate.

an exhibition of 368 paintings and 280 sculptures from Germany, which reflected the humiliating terms that Napoleon had thrust upon the Prussian king at Tilsit. The show's title detailed Napoleon's spoils: "The Statues, Busts, Bas-Reliefs, Bronzes, and Other Antiquities, Paintings, Drawings, and Interesting Objects Conquered by the Grande Armée in the Years 1806 and 1807." The exhibition opened at the Louvre on October 14, 1807, the first anniversary of the Battle of Jena.

Startlingly, when Germans visited the Louvre and confronted works stolen from their own collections, some felt conflicted. Helmina von Chézy, a journalist from Berlin, had accompanied the brothers Ferdinand and Heinrich Olivier, painters from Dessau, to the Paris gallery, where they saw Hans Memling's *Last Judgment* from Danzig's Marienkirche. "The Olivier brothers took me to it," von Chézy wrote. "Ferdinand rejoiced with tears in his eyes, his ill-restrained tears concerning the abduction from Germany, his rejoicing the sight of the old masterpiece." Ferdinand Olivier's very presence in Paris had depended upon the French thefts. Leopold III, the Duke of Anhalt-Dessau, sent him there, to make copies of certain pictures that had left Germany with Denon.

The loss of the German pictures to the French reawakened an appreciation in Germany for the fifteenth- and sixteenth-century masters, whose paintings had recently been ignored. "It was through their sojourn in the Parisian museum that many works from German collections became known, or indeed famous, in their own country," writes Bénédicte Savoy. "And in certain cases (the old German School of painters, for example) elevated to icon status." Later, in writing about the sudden attention Memling's *Last Judgment* received in the French capital, a journalist imagined what the picture itself might observe about its removal to Paris: "I would be lying if I were to say that the journey was not of great benefit to me: firstly, I had an opportunity of measuring myself against other pictures, and I did not come off so badly; secondly, people began enquiring about me. . . . It turned into my own resurrection."

The year before Napoleon's Prussian campaign, he had fought the Austrians, who were allied with Britain, Russia, and Sweden in the Third Coalition,

and he had won. In late October 1805, he defeated the Austrian army at Ulm, in Bavaria; on November 14, he arrived in Vienna. By then, Emperor Francis, along with the empress and their children, had fled the Austrian capital and sent paintings from the Habsburgs' legendary collections in the Belvedere palace to Hungary. But not until Napoleon routed the Austrians and the Russians, on December 2, near the Czech town of Austerlitz, did Francis sue for peace. The Treaty of Pressburg, signed on December 26, 1805, cost Austria forty million francs as well as territory: Venice was transferred back to France and became part of the Kingdom of Italy.

Napoleon visited Venice only once, from November 28 to December 8, 1807, but he left the French empire's mark on the city with building projects, including a public garden near the Arsenal, a graveyard on the island of San Cristoforo, and a new palace for the imperial government: the Palazzo Reale, which ran across the western end of the Piazza San Marco. To clear the site, the French tore down a sixteenth-century church designed by Jacopo Sansovino. In 1806, the French ordered thirty-four convents and monasteries in the city of Venice to be closed. By 1811, they had stripped ecclesiastical buildings throughout the former Venetian Republic of thirteen thousand pictures—pictures they left in Venice and assigned Pietro Edwards to catalogue.

At the battle of Austerlitz, the French captured 130 Austrian and Russian cannons. Hauled to Paris, these cannons were melted down and the bronze was cast by French sculptors into 425 bas-relief plaques illustrating the progress of the 1805 campaign. These bronze plaques were to spiral up a column—modeled on Trajan's Column in Rome—to be built in the Place Vendôme in commemoration of France's triumphs against the Austrians. Denon commissioned the French sculptor Antoine-Denis Chaudet to create a bronze statue of Napoleon as a Roman emperor to stand on the top of the 137-foot column.

The Vendôme column had yet to be finished when, in the spring of 1809, the Austrian emperor, backed now by the Fifth Coalition (with Great Britain) declared war on France. "There can no longer be any question what Napoleon wants. He wants everything," the emperor's brother, Archduke Charles, wrote. In the first battle, on April 22, Napoleon defeated the Austrian army in Eckmühl, Bavaria. By May 5, most of Vienna's two

hundred thousand citizens abandoned the city. Emperor Francis and his family had escaped to Hungary. There too he had sent about 625 of his paintings. For the fourth time, Heinrich Füger, a neoclassical painter and director of the imperial collections, packed pictures from the Belvedere—Titian's *Ecce Homo*, Raphael's *Madonna and Child with John the Baptist*, and Giorgione's *Three Philosophers* among them—and shipped them in fifty-four cases to three different Hungarian cities, each at least 250 miles away. This packing and transport cost the Austrian government 1,791 florins, over three times the 500 florins it had spent each year to maintain the collection.

Napoleon rode into Vienna for the second time on May 13, 1809. He was followed on June 7 by Denon, who had set his sights on the Belvedere palace. Denon arrived there armed with an order from the French governor-general, Antoine-François Andréossy: "His Majesty the Emperor and King has instructed M. Denon, the Director-in-chief of the Museums of France, to make him a list of the objects in the Belvedere worthy of selection and sequestration." Andréossy demanded that Füger "put all the objects selected by him at his [Denon's] disposal." At the Belvedere, Denon came upon four crates of art that had been intended for Hungary but were accidentally left behind. He took what he wanted from the crates and added other pictures from the palace. In all, he chose some four hundred of Vienna's paintings for Paris. As in Prussia, Denon zeroed in on Northern Renaissance masterpieces—Jan van Eyck's 1436 portrait of *The Goldsmith Jan de Leeuw*, Hieronymus Bosch's *Temptation of Saint Anthony*, Quentin Massys's *Saint Hieronymous*, Jan Gossaert's *Saint Luke Painting the Virgin*, Jan Sanders van Hemessen's *Calling of Saint Matthew*, and Pieter Bruegel the Elder's canvases of the four seasons. But he also selected Italian pictures—by Titian, Palma Vecchio, Fra Bartolomeo, and Giorgione.

Füger sought to dissuade Denon from removing Rubens's fifteen-foot-high *Assumption of the Virgin*, painted on a wooden panel. However, Denon argued that the Rubens could be "cut into two pieces . . . to pack it, which presents no difficulties because it would be easy to fix it in Paris." Füger objected. "I tried to warn him that such an operation was uncommon in the world of painting," he told the Austrian emperor. But

"Monsieur Denon argued that he had received an order expressly to take this painting." The result, Füger wrote: "It has been sawed from each part with thin blades."

Denon was still packing up works of art in Vienna when, on July 6, Napoleon won a battle against Archduke Charles at Wagram. "My enemies are defeated, thrashed, in full rout. They are very numerous; I have crushed them," Bonaparte wrote Josephine at two in the morning after the battle.

In the Treaty of Schönbrunn, signed at the palace outside Vienna on October 14, 1809, Napoleon punished Austria, subtracting more territory—mostly southern states that had provided access to the Adriatic—and reducing the size of the Habsburg Empire by one-quarter. France also forced Austria to stop its trade with England, limit its army to 150,000 troops, and pay reparations of 200 million francs.

The piling of plunder from Germany and Austria onto the Italian spoils in the Louvre signified the expansion of the French empire and reflected Napoleon's vision of a unified Europe. "We need a European law code, a European supreme court, a single currency, the same weights and measures, the same laws," he told Joseph Fouché, his minister of police. "I must make all the peoples of Europe into a single people, and Paris, the capital of the world."

19

"The only thing to do is to burn them!"

The Museum is run at my expense, it costs me quite considerably;
this is another encouragement of the arts.
 —Napoleon to Pierre Daru, August 6, 1805

In October 1809, when the sixty-three crates of the Austrian emperor's paintings arrived in Paris from Vienna, the Louvre was closed. The architects Charles Percier and Pierre-François Fontaine were constructing a grand staircase to lead from the entrance of the museum to the Salon Carré. But, when the Louvre reopened in 1810, Denon still kept the Austrian pictures in storage. By then, Napoleon wanted nothing to embarrass the Austrian princess Marie-Louise, whom he had decided to marry in a ceremony he intended to hold at the Louvre.

Napoleon had divorced Josephine on December 16, 1809. For some time, he resisted the arguments of his advisers that he should end his marriage and choose a wife from one of Europe's ruling families, who would provide an heir and ensure the future of the Bonaparte dynasty. Josephine was forty-six and had failed to bear children with Napoleon. In the settlement, Josephine came away with the title of empress, the Élysée Palace, and Malmaison—the house and one hundred acres—as well as three million francs a year for the rest of her life, a sum financed by the government of France. As empress, she had spent a third as much every year on clothes alone. By August 1810, when David's *Distribution of the Eagles*, which depicted one of Napoleon's coronation ceremonies, appeared at the Salon, the artist had painted the figure of Josephine out.

In pursuit of a bride who would put him on equal footing with Europe's kings, Napoleon had first approached Tsar Alexander I, about his sister, Grand Duchess Anna Pavlovna. Only after the tsar delayed considering the proposal did Napoleon, now forty, turn his attention to the

eighteen-year-old Marie-Louise, the eldest daughter of Francis I, a descendant of Louis XIV, and the great-niece of Marie-Antoinette, whom the French had guillotined only seventeen years before. In Austria, the marriage plan had been advanced by Prince Klemens von Metternich, the foreign minister, a pragmatist who thought Austria's future depended upon "adapting to the triumphant French system."

Napoleon now controlled most of Europe. He had dominion over some forty-four million citizens; more than thirty million others lived in allied or subsidiary states, mainly ruled by members of the Bonaparte family—the Kingdom of Italy (under Viceroy Eugène de Beauharnais), Naples (under General Joachim Murat and Caroline Bonaparte), Piombino and Lucca (under Felice and Elisa Baciocchi), Spain (under Joseph Bonaparte, who had been transferred by Napoleon from Naples), Westphalia (under Jérôme Bonaparte), and Holland (under Louis Bonaparte).

Metternich had scrutinized the French emperor close-up, during the two years he had resided in Paris as the Austrian ambassador to France. He had come to believe that Napoleon was bent on destroying the Habsburg Empire. "Napoleon and I spent years together as if at a game of chess," Metternich would later write, "carefully watching each other; I in order to checkmate him, he to crush me together with the chess figures."

An aristocrat, born in Koblenz in 1773, Metternich traced his "aversion" to Jacobin doctrines to his days as a law student in Strasbourg, when in 1798 he witnessed "the plundering of the Stadthaus perpetrated by a drunken mob, which considered itself the people." The Duchess of Abrantès observed that "his manners were courteous and easy, and precisely those of a well-bred nobleman." Friedrich von Gentz, Metternich's secretary, described his employer as "a great talent; cool, calm, imperturbable and calculator *par excellence*." Metternich was rumored to have taken Caroline Murat as one of his mistresses.

Princess Marie-Louise had grown up despising Napoleon. Twice, the invading French army drove her and her family from Vienna. "I pity the poor princess he chooses," she had written on January 10, 1810. Metternich broke the bad news to her on February 15. By then, she had accepted her fate, writing to a friend, "If ill-fortune requires it, I am ready to sacrifice my private happiness to the good of the state."

Alexandre Berthier and Metternich signed a marriage contract for the French emperor and the Austrian princess on March 9, in Vienna. Two days later, the couple were married by proxy (Archduke Charles represented his niece, and Berthier, Napoleon) in the Capuchin Chapel of the Hofburg palace. Marie-Louise left Vienna by carriage on March 13, heading for France; she crossed the Austrian border north of Salzburg, traveled for two weeks through Germany and northern France, and on March 27 reached the château of Compiègne, forty-five miles

Louis Charles Auguste Couder, *Napoleon I Visiting the Louvre, Accompanied by the Architects Charles Percier and Pierre Fontaine*, 1833. Napoleon inspects plans on the staircase the architects had built to lead to the museum's painting galleries.

north of Paris, where she met Napoleon. On April 1, at the château of Saint-Cloud, they participated in a civil ceremony, and the next morning they rode by coach to Paris, for the religious service at the Louvre.

In its vastness, age, and magnificence, the Louvre would put a façade of royal legitimacy over the lowly origins of the groom, his ascent through the ranks of the revolutionary army, and his divorce from Josephine, as well as divert attention from the thousands of Austrian casualties caused by his wars. Napoleon had decided that the wedding would take place in the Salon Carré, and he ordered the architects Percier and Fontaine to transform the Louvre gallery into a "chapel."

Napoleon had planned the route through Paris to impress the Austrian princess with his military feats, overlooking that many had come at Austria's expense. The royal couple entered the French capital through a wooden mock-up of the Arc de Triomphe, in the Place de l'Étoile, commissioned to celebrate France's victory against Austria at Austerlitz and still under construction.

In front of the Tuileries, they passed through the Arc de Triomphe du Carrousel, a smaller triumphal arch built in 1808, again to commemorate Austerlitz and modeled by Percier and Fontaine on the arch of Septimius Severus in Rome. On the Arc du Carrousel, Denon had mounted the horses of Saint Mark's. He had attached the horses to a chariot, driven by a statue of Mars, which stood between figures of Victory and Peace—new sculptures cast by the French artist François-Frédéric Lemot.

Napoleon was in the process of expanding the Louvre, adding a new wing designed by Percier and Fontaine to run parallel to the Grande Galerie and to connect the palace to the Tuileries, on the north side. The two palaces stood at the center of Napoleon's project to reconstruct Paris, a mostly medieval city with a tangle of narrow streets, into a new Rome. Earlier, in 1801, as First Consul, he had commissioned Percier and Fontaine to map out the rue de Rivoli, with its elegant three-story buildings and open arcades—a new street that would set the Louvre and the Tuileries off from the rest of the city.

To reach the Salon Carré, the French emperor and the Austrian princess paraded down the Grande Galerie, which Napoleon now used as a quarter-mile-long aisle. Over the past four years, Percier and Fontaine

had brightened the green hall with skylights, erected red marble columns to break it into nine bays, and extended the wall space by filling in windows that had overlooked the Seine.

Benjamin Zix describes the wedding procession in a long narrow drawing, which had been commissioned by the porcelain factory at Sèvres as a blueprint for a frieze to decorate a vase. More than one hundred courtiers and guests—women in high-waisted dresses and men in frock coats—sweep down the spectacular corridor, cheered on by spectators. Lined up on the wall behind the crowd are some thirty canvases, including Rubens's *Descent from the Cross* from Antwerp, Raphael's *Transfiguration* from Rome, and others by Leonardo, Perugino, and Andrea del Sarto. Denon had told Napoleon in 1803 that the run of pictures at the Louvre would be "a history course in the art of painting," but as a stage set for the royal wedding, these pictures had less to do with education than with the flaunting of cultural assets by a Corsican soldier who dared a dynastic alliance with the Habsburg Empire.

When Napoleon directed Percier and Fontaine to construct a chapel in the Salon Carré, he also told Denon to strip the gallery of its paintings, so that tiers of boxes could be built along the walls for the congregation. For most of the past twelve years, *The Wedding Feast at Cana* had hung in the Salon Carré, and Denon wanted the picture to remain in place. He warned Napoleon that taking the Veronese off the wall and getting it out of the gallery would put the canvas at risk. But Napoleon had no patience for Denon's caution: "He gave the order for the paintings to be removed," Fontaine wrote. Again, Denon explained that moving the Veronese and other old master pictures was likely to damage them. "Ah well!" Napoleon shot back. "The only thing to do is to burn them!"

Benjamin Zix, *Wedding Procession of Napoleon I and Marie-Louise of Austria*, 1810. The paintings along the Grande Galerie include Raphael's *Transfiguration* and others seized by the French in Rome.

At this point, "the difficulties were immediately cleared," Fontaine reported. "The paintings were detached and rolled." Later, Athanase Lavallée would state that the process of dismantling the Veronese had made him fear for the picture's survival: "During the wedding ceremony of Her Highness the Imperial Archduchess of Austria, we wanted to remove this painting, [and] the efforts that we made in this endeavor exposed it to destruction."

On July 1, the Austrians held a celebration of the French alliance that would end in tragedy. That night, Prince Karl Philipp von Schwarzenberg, the Austrian ambassador to France, invited seven hundred guests to a ball at the embassy on rue du Mont-Blanc. Close to midnight, a candle ignited a curtain and the blaze spread. Twenty died in the fire.

20

"This foreboding painting... seems to summon the eye ... from all directions"

The famous painting by Gros can only give a vague idea [of the result]. He at least paints the effect of those streams of blood spread across the snow with dreadful truth.

—Raymond de Montesquiou-Fezensac

In forcing Denon to strip the Salon Carré of its paintings, Napoleon made explicit his assumption that the purpose of the visual arts was to serve his political aims. On August 6, 1805, he explained his art policies to Pierre Daru, the intendant general of the emperor's household: "I must tell you that my intention is to direct the arts especially towards subjects that perpetuate the memory of what has been accomplished in fifteen years." He found it "astonishing" that he had "not been able to obtain that the Gobelins set aside religious scenes and finally put their artists to work on all those actions of all kinds which have distinguished the army and the nation, events which have elevated the throne."

Napoleon also relied on his greatest artists to recast even those actions that had failed to distinguish the army and the nation. In 1807, only a month after the indecisive battle of Eylau, Napoleon instructed Denon to hold a competition to select a painter who would commemorate what Marshal Ney had called a "massacre . . . without any result."

Napoleon too had recoiled at the bloodshed when, the day after the battle, he had ridden across the battlefield. "The country is covered with the dead and wounded," he wrote Josephine. "This is not the beautiful part of war. One suffers, and the soul is oppressed to see so many victims."

Antoine-Jean Gros won the assignment. To turn the picture's subject away from the battle itself, Denon had delivered detailed instructions on what should be described—"the moment when the Emperor, visiting the

battlefield, comes to bring help and consolation impartially to the victims of the fighting."

Napoleon on the Battlefield of Eylau would be Gros's last masterpiece. Napoleon, on a pale brown horse, and his officers, also on horseback, are riding on a snow-covered plain, stretching far into the distance, beneath a band of gray sky. They have come across a group of dead and wounded soldiers, piled upon one another, and partly submerged in the snow. Black smoke rises from fires burning on the horizon, not far from lines of troops and a church with a steeple. But drawing attention from the landscape are dark corpses strewn across the foreground of the canvas, their uniforms and shadowed faces covered with ice.

Napoleon seems to float above the carnage—his arm raised in benediction, a savior, whose boots the Russian soldiers reach up to touch. He is distanced from the nightmare, which is cast with figures whose colossal scale (twice life-sized) characterizes the magnitude of the carnage. On the ground, French doctors and soldiers, in their dark blue uniforms, struggle to help those who are dying. Even the horses pull back, their nostrils flared, their eyes widened by what they see. A strange figure in a tall red hat tries to escape the grasp of the physician who has grabbed his shoulder. Gros conveys the terror on a face whose convulsed expression and bulging eyes verge on caricature, as though the artist felt that to represent the catastrophe of war, which he had experienced in Genoa, naturalism did not go far enough. Later, Eugène Delacroix would describe Gros's canvas as "this foreboding painting, composed of a hundred paintings, [that] seems to summon the eye and the spirit from all directions at the same time."

Gros had exhibited *Napoleon on the Battlefield of Eylau* at the Salon of 1808—in the room where Napoleon would stage his wedding ceremony two years later. Pleased with the picture, the emperor rewarded the artist with the cross of the Legion of Honor. But, in retrospect, Gros's painting of Napoleon in a frozen landscape, with desperate soldiers prostrate in the snow, would come to seem a prophecy. Gros also captured the mood of the nation, which had begun to tire of Napoleon's constant wars. In 1806, Fouché, the police minister, reported on the discontent he witnessed in a town in Brittany, even after the Prussian defeats at Jena and Auerstädt.

"The public spirit is not good," Fouché wrote. "One greets the news of victories coldly, and false rumors are avidly collected. People complain about the war."

In June 1807, four months after the battle of Eylau, Talleyrand warned Napoleon that he had to find ways to avoid warfare. "Wonderful though it [victory] is, I have to admit that it would lose in my eyes more than I can say if your Majesty were to march to new battles and expose himself to new dangers," he wrote. Two months later, Talleyrand resigned as foreign minister.

By the end of 1810, the French alliance with Russia collapsed. The tsar had allowed British ships into the Baltic, refusing to acquiesce to Napoleon's Continental System, which, put in place in November 1806, prohibited "all trade and correspondence with the British Isles" and their colonies. In May 1811, Napoleon ordered the French ambassador to Russia, Armand-Augustin de Caulaincourt, to return to Paris. On June 5, at a five-hour meeting at Saint-Cloud, Caulaincourt tried to persuade the emperor not to attack Russia. But Napoleon was convinced he could defeat the tsar in one or two major battles.

On June 24, 1812, Napoleon crossed the Niemen River with some 235,000 of the 450,000 troops in his main army, and France was again at war. Austria had supplied a force of 50,000 for Napoleon's Russian campaign, but secretly Emperor Francis informed Tsar Alexander that he wanted these soldiers to refrain from battle. Napoleon reached Vilnius on June 28 and remained there for what some would later see as a fatal ten days. He moved on to Vitebsk and by August 15 reached Smolensk. But, already after marching for weeks in scorching heat, and then rain, across Poland and Byelorussia, without enough water or supplies, starvation and typhus had killed a fifth of the army. "Soldiers are without food and horses without oats," wrote Boniface de Castellane, a French aide-de-camp.

Napoleon finally met the Russians at the battle of Borodino, on September 7, forcing them to retreat. The French continued on to Moscow, but most of the city's 275,000 residents had left. "No one in the streets, no one in the houses, no one in the temples. Everything is dead," wrote one French observer. Within hours of the French arrival, Fyodor Rostopchin, Moscow's military governor, ordered agents to set fire to the

city. From the Kremlin, Napoleon watched "the spectacle of a sea and bil-
lows of fire, a sky and clouds of flame." If Napoleon had imagined taking
art from the tsar's collection, built by Catherine the Great, he would have
had to go to Saint Petersburg; however, in anticipation of a French attack,
Alexander had already evacuated the finest pieces from the Hermitage.

Napoleon's catastrophic retreat from Moscow began on October 18.
He would later blame the death toll on the early winter and the record
cold, but he had failed to provision his army to survive. By the end of
October, even the officers had nothing but the meat of their horses to
eat, and sometimes, to keep the animals working as long as possible, they
hacked off flesh when they were still alive.

Napoleon left the army at Smorgony, in Byelorussia, on December 5
and reached Paris on the eighteenth. Of the more than 650,000 soldiers
who eventually made up Napoleon's invading armies, over 500,000 became
casualties (roughly three-quarters of those were deaths). The Russians lost
about 300,000 men. For the remainder of the winter, Napoleon stayed
in the French capital, working to stabilize his empire, but on March 17,
1813, King Frederick William III of Prussia declared war on France.

On June 26, in Dresden, Metternich spent nine hours with Napo-
leon, attempting to negotiate a peace. His demands included that Na-
poleon give up the Duchy of Warsaw, parts of Prussia, and the Hanseatic
port cities. Napoleon refused. By August 11, Metternich announced that
the peace talks had been abandoned and the Austrian emperor switched
to the Allied side. The victory by the Duke of Wellington on June 21,
against Joseph Bonaparte, at the battle of Vitoria, in Spain, less than one
hundred miles from the French border, had convinced Metternich that
Napoleon could be beaten.

By summer's end, the Sixth Coalition (Austria, Prussia, and other
German states, Russia, the United Kingdom, Sweden, and Spain) had
come together to fight the French emperor. At the four-day battle of
Leipzig (the Battle of the Nations) in October 1813, as Metternich had
predicted, the Allies defeated the French and forced Napoleon to retreat.
In Europe's bloodiest battle yet, some five hundred thousand troops suf-
fered one hundred thousand casualties. The Allies had responded to Na-
poleon's style of warfare, enlarging their armies and replacing professional

soldiers and aristocratic officers with draftees—changes that led to battles of increasingly larger scale. "The deliverance of Europe appears to be at hand," George Hamilton-Gordon, the Earl of Aberdeen, British ambassador to Austria, wrote to the foreign secretary, Robert Stewart, Viscount Castlereagh.

Within three months, Allied forces had invaded France—the Prussian army crossing the Rhine near Mainz and the Austrian army marching from Switzerland. On February 6, 1814, Napoleon ordered gold from the treasury piled in carts and driven out of Paris, yet refused Denon's proposal to evacuate paintings from the Louvre. "Paris is not in such straits as the alarmists believe," Napoleon told his brother Joseph. But on March 20 and 21, at Arcis-sur-Aube, only eighty-five miles from the French capital, Prince Karl Philipp von Schwarzenberg's Austrian and Russian troops defeated Napoleon's army. By then, the Duke of Wellington had captured Bordeaux.

21

"The masterpieces of the arts now belong to us"

I put into your consciousness the charge of the stolen works of art that are in Paris, when you negotiate the peace treaty.
—Caroline von Humboldt to Wilhelm von Humboldt,
February 24, 1814

·

On March 31, 1814, Paris fell to the forces of Austria, Prussia, and Russia. That night, Tsar Alexander rode into Paris on a gray horse, followed by the Prussian king Frederick William III, as well as the Prussian field marshal Gebhard von Blücher and the Austrian commander Prince Karl Philipp von Schwarzenberg, who had led the attack on the city. The Austrian foreign minister Klemens von Metternich reached Paris on April 10, ahead of the emperor, Francis I, and Viscount Castlereagh, the British foreign secretary. These victorious leaders would now have to decide the fate of Napoleon's plunder at the Louvre.

At Fontainebleau, angry, bitter, sometimes delusional, as he laid plans to retake Paris, Napoleon had lost the support of even his most loyal commanders, and finally he recognized he had no choice but to surrender to the Allies. On April 6, after fifteen years in power, the French emperor abdicated.

That day, the Senate recalled the Comte de Provence—now Louis XVIII—from England and approved a constitution drafted by the provisional government, headed by Talleyrand, who had been instrumental in persuading the Allied leaders to restore the Bourbons to the French throne. The new French king arrived in Paris on May 2. Already, royalists in Paris had knocked the statue of the French emperor from the top of the column in the Place Vendôme. "The boulevards are full of people," Metternich wrote to his mistress Wilhelmine de Sagan, a twice-divorced

thirty-three-year-old duchess from Silesia: "Dandies, hussars, ladies in masks, cossacks . . . everybody seeming to know everyone else and greeting each other in the friendliest way."

On April 28, the Allies deported Napoleon from France to the island of Elba, nine miles off the coast of Tuscany. At Fontainebleau, he had attempted suicide, swallowing poison that made him sick but failed to kill him. Tsar Alexander agreed to give the island to Napoleon; at first the Austrians and the British condemned the plan, but then accepted it. Metternich predicted the result would be to "bring us back again to the battle-field in less than two years."

Louis XVIII repossessed the rooms abandoned by Napoleon at the Tuileries and renamed the Louvre the Musée Royal. He also made the self-serving assumption that France would maintain possession of the works of art—more than one thousand objects—that Napoleon had seized from Italy, Germany, Austria, and Spain. While the Allies refused to assure the king that he would keep Napoleon's art, they took no formal steps to force him to return it.

The Treaty of Paris, signed on May 30, 1814, dismantled the empire and pulled back the borders of France to where they were in 1792. Austria received Venice. As a consequence, the Venetians would be given no say in the future of their city nor in the future of the art they had lost to Bonaparte. That the treaty omitted mention of the paintings and sculpture Napoleon had delivered to the Louvre reflected the Allies' desire to let the subject lie, fearful that the French king would appear to lack their support. "I am convinced that a restitution [of the art] would do more than anything else in the world to discredit the French Government [with the French]," wrote the Earl of Aberdeen. "The withdrawal from the Netherlands and Antwerp will not be felt so keenly as a national humiliation as would the restitution of these spoils of victory."

On June 4, Louis XVIII addressed the Chamber of Deputies and made the French position clear: "The glory of the French armies remains intact; the monuments to their valor survive, and the masterpieces of the arts now belong to us by rights more enduring than those of victory."

That July, the Duke of Wellington became the British ambassador to

France. Wellington was not a collector, but he understood the emblematic power of art and architecture, and that the collections Napoleon had stolen from his enemies had more than simply monetary worth. He induced the British government to buy, for eight hundred thousand francs, the Hôtel de Charost at 39, rue du Faubourg Saint-Honoré, the residence of Napoleon's sister Pauline Borghese, to house its new embassy. He moved in at the end of August, and he hung Pauline's portrait in his bedroom.

Wellington was born Arthur Wellesley in 1769, to a Protestant family in Dublin, but he based his worldview and identity on his membership in the educated British elite. He had spent three years at Eton, before enrolling at seventeen for a crucial year at the Royal Academy of Equitation, at Angers, 165 miles southwest of Paris. There he became fluent in French and met members of the nobility—individuals he came to admire. The following year, he joined the British army. As yet, he had proved only that he had a talent for music—something he renounced in the summer of 1793, at twenty-four, when he burned his violin. That year, he was promoted to lieutenant colonel. Wellington respected Napoleon as a strategist but condescended to him. He insisted on using the Corsican "Buonaparte" long after Napoleon had dropped the Italian spelling of his name.

Like Napoleon, Wellington focused on detail, logistics, and topography. "All the business of war, and indeed all the business of life, is to endeavor to find out what you don't know by what you do," he wrote. "That's what I call 'guessing what was at the other side of the hill.'" He was also bolstered by a confidence that withstood opposition even from his party, the Tories, and the British press. Already in December 1811, Wellington predicted that his success in Spain would inspire the European powers to bring down the "fraudulent and disgusting tyranny of Buonaparte."

But Wellington's reserve sharply contrasted with the French emperor's expansive style. After the British triumph at Salamanca in July 1812, Wellington only briefly congratulated his troops: "The commander of the forces returns his best thanks to the general officers, officers, and soldiers for their conduct during the action of the 22nd instant."

Wellington's routing of the French in Spain had depended upon a ruthless, relentless, and carefully plotted campaign. On August 1, 1808,

he landed with thirteen thousand British troops in Mondego Bay on the Portuguese coast. In 1810, after defeating Marshal André Masséna at Busaco, Wellington retreated to the lines of Torres Vedras, twenty-nine miles of forts he had built north of Lisbon. He destroyed everything in his path, knowing the French troops who pursued him would find nothing to supply them. "We are marching across a desert. Women and children and old men have all fled," wrote Masséna. "In fact, no guide is to be found anywhere." By May 1811, Wellington had driven the French from Portugal.

Wellington's victories in Spain had delivered up their own spoils of war—165 paintings, with which Joseph Bonaparte (on the Spanish throne since 1808) had absconded from the Palacio Real in Madrid in May 1813. "The baggage of King Joseph, after the battle of Vitoria, fell into my hands, after having been plundered by the soldiers," Wellington wrote to his brother Henry Wellesley, the British ambassador to Spain. "And I found among it an imperial [a type of luggage designed for a coach] containing prints, drawings and pictures." Wellington sent the pictures— including Velázquez's *Waterseller of Seville*—to London. "From the cursory view which I took of them," he told Henry, they "did not appear to me to be anything remarkable." Earlier, he wrote that some of these canvases had even served as tarpaulins to cover baggage. But after a London dealer valued the pictures at forty thousand pounds and Wellington learned that Joseph Bonaparte had looted them from Spain's royal collection, he tried through Count Fernán Núñez, the Spanish ambassador in London, to return them to the Spanish king. Núñez informed Wellington that the king wanted the British general to keep the art: "His majesty, touched by your delicacy, does not wish to deprive you of that which has come into your possession by means as just as they are honorable."

By contrast, even after Napoleon had made Joseph Bonaparte the king of Spain, he failed to obtain masterpieces from the legendary collections of the Spanish kings, who in the sixteenth and seventeenth centuries had been patrons of Titian and Velázquez. The fifty paintings that he demanded Joseph send him in 1808 from Madrid didn't reach Paris until 1813, and then Denon complained, "This collection contains few pictures of the first order." The delay of the shipment and the mediocrity of its contents showed Joseph's reluctance to strip this capital of its finest

works of art. On December 20, 1809, Joseph established a museum of Spanish masters—"Velazquez, Ribera, Murillo, Ribalta, Navarrete, . . . and others"—a gallery that later would become the Prado. Napoleon's frustration at raiding the Spanish collections reflected a still more stubborn impasse—his inability to win the war on the Iberian peninsula.

Wellington would hang his paintings from the Spanish royal collection at Apsley House, his residence at Hyde Park Corner in London. In 1814, the British could afford to be detached from the question of the Louvre. They had lost no art to the French. On the contrary, the Revolution and the Napoleonic Wars had directed a flood tide of paintings toward London, starting in 1792 with the sale of the pictures of the Duc d'Orléans to dealers and collectors in Britain.

The English painter Thomas Lawrence, who knew King George III, rushed to Paris in May 1814, fearing that the Louvre—"the noblest assemblage of the efforts of human genius that was ever presented to the world"—would be broken up. "Had I delayed my journey a day longer, I should have lost the view of some of the finest works of this Gallery," he wrote to his friend Elizabeth Croft from Paris. "A few days will see the whole taken away."

Already, Wilhelm von Humboldt, the Prussian minister of state, had asked Louis XVIII to return the art Napoleon had seized from Berlin and Potsdam, and the king had agreed. But Denon resisted. He carried on as though France's political situation remained unchanged. On July 25, 1814, he put on an "Exhibition of the Primitive Schools" with 123 pictures he had tracked down in Italy in 1811 and 1812, many from Florence. Among them was Cimabue's towering *Madonna and Child in Majesty Surrounded by Angels*, taken from the church of San Francesco in Pisa.

In response to the Prussians' requests, Denon played a duplicitous game; they managed to retrieve few of the pictures they had sought. A group of Spanish nobles would have more success, securing an order for the return of 230 paintings stolen by the French from their private collections.

In September 1814, Metternich raised the issue of the four-hundred-some paintings that Denon had taken from Vienna. The Austrians had managed to keep their finest pictures out of Napoleon's hands, and

Metternich agreed that instead of giving up the Austrian pieces that had been on public display, the French might keep them, if, in exchange, they would send a group of French paintings to Vienna.

Metternich had much else on his mind. In October 1814, the Austrian emperor welcomed the crowned heads of Europe and their ministers to the summit he organized in Vienna to settle the questions of Poland, Saxony, and other territories. The Austrians would spend thirty million florins putting on the Congress of Vienna and the accompanying festivities, which included a Handel oratorio and a Beethoven symphony, performed by seven hundred musicians.

The territorial issues had yet to be resolved when, on February 26, 1815, Napoleon escaped from Elba and, on March 1, landed on the coast of France, near Cannes. The Austrian negotiations with the French over a possible exchange of pictures abruptly ended.

Napoleon reached Paris on March 20 and immediately took steps to reestablish his government. The question of whether the Veronese would go back to Venice had not yet been raised.

22

"We are at last beginning to drag forth from this great cavern of stolen goods the precious objects of Art"

> Our work is about to begin. Tuscany, Milan, and Venice have re-
> taken all that belongs to them. . . . I am burning with impatience
> to see everything packed up and gone.
> —Antonio Canova to a friend in London, September 30, 1815

Y ou will have seen what a breeze Buonaparte has stirred up in France," the Duke of Wellington wrote his brother William on March 24, 1815, from Vienna. "We are all unanimous here, and in the course of about six weeks there will be not fewer than 700,000 men on the French frontier." By then, Britain, Austria, Prussia, and Russia had decided that only in conjunction would they negotiate with Napoleon, and as members of the Seventh Coalition they declared war.

Napoleon was the first to attack—in Belgium—beating the Prussians at Ligny on June 16. But only two days later, Wellington defeated Napoleon at Waterloo, ten miles south of Brussels, in one of the bloodiest battles of the period. Napoleon with seventy-two thousand troops took on sixty-eight thousand British, German, and Dutch soldiers, later reinforced by the Prussians, but he had lost his legendary energy and focus and came to the fight poorly prepared. On June 22, Napoleon was forced to abdicate a second time.

On July 7, Wellington entered Paris, and British as well as Prussian troops began patrolling the French capital. Seeking now to avenge "the blood of our soldiers killed and mutilated," the Prussians demanded Bonaparte be "delivered over to us with a view to his execution." The British prime minister, Lord Liverpool, suggested the Allies "deliver him up to the King of France who might try him as a rebel," and "deal with him accordingly." Wellington wanted no part of the Prussian plan, arguing,

"Such an act would hand down our names to history stained by a crime, and posterity would say of us, that we did not deserve to be the conquerors of Napoleon; the more so as such a deed is now quite useless, and can have no object." After some weeks of deliberation, the British cabinet decided that Napoleon would be exiled on Saint Helena, a British island in the South Atlantic, 4,400 miles from France. He left France on July 15 and reached Saint Helena three months later.

With the Allied capture of Paris, Veronese's *Wedding Feast at Cana* and the other plundered works of art in the Louvre were drawn onto the negotiating table. Louis XVIII had asked the Allies to add a clause to the July Third Convention of Paris, which surrendered the French capital, stating that they would leave the museums and libraries intact. But they refused.

In 1815, any sympathy the Allies may have held for the French the year before had evaporated. Since Napoleon's return from Elba, three months of warfare had caused one hundred thousand casualties; altogether during the near quarter-century of France's revolutionary and Napoleonic wars, Europe lost five to six million lives.

The second Treaty of Paris, to be signed in November, would pull France back to its 1790 borders and charge the French an indemnity of seven hundred million francs. Again, the treaty remained silent on the fate of the Louvre's contested collections of art. By not spelling out the terms of restitution in the accord, each nation was left to repossess the art Napoleon had seized from its territory. As Venice was under Austria's rule, if *The Wedding Feast at Cana* was to be returned to San Giorgio Maggiore, Metternich would have to retrieve it.

The Prussians, who had troops in Paris, made the first advance on the museum. On July 7, the Prussian envoy Friedrich von Ribbentrop demanded that Denon turn over the art from Berlin and Potsdam that he had refused to release the year before. Denon again stalled, claiming he could give nothing up without an order from the French king. Denon had consulted Talleyrand, now serving as Louis XVIII's prime minister and foreign minister, who observed the French could not resist "such language applied by force."

On July 9, Ribbentrop wrote Denon again: "I hold you so much

more responsible for this resistance that I will be forced to take the Prussian property with the help of armed force." At nine that evening, the Prussian diplomat issued an ultimatum: If Denon did not comply by noon the next day, Ribbentrop would have him "arrested and conducted to the Prison of Graudentz in western Prussia." But Denon still gave no answer.

At six in the morning, on July 11, half a dozen Prussian soldiers entered the Salon Carré, took Rubens's *Crucifixion of Saint Peter* down from the wall, and carried it to the nearby Gallery of Apollo, which they locked. To the Rubens, the Prussians added fourteen paintings and several busts and bronzes that had come from German collections.

Metternich had reached Paris with the Austrian emperor on July 9, having endured a grueling march with the Austrian army across France. On the thirteenth, he sent an envoy to the Louvre to find out what the Prussians had carried off. But an armed entrance was not the approach Metternich wanted to take. He recoiled at the way Field Marshal Blücher had treated the "beautiful chateau" at Saint-Cloud as "his headquarters." He complained that the Prussian commander "and his aides-de-camp smoke where we had seen the court in full dress." From a wall at Saint-Cloud, Blücher would take Napoleon's copy of David's *Bonaparte Crossing the Alps at Grand-Saint-Bernard* and give the painting to the Prussian king.

Metternich seemed to believe he had the power to retrieve Austria's art if he only asked. He knew Talleyrand well and had turned down the latter's invitation to stay at his *hôtel* on the rue de Rivoli. As "close as it is to the [Austrian] emperor's house, it is, however, still too far," Metternich explained. "You will see me, in any case, plenty, at yours." Metternich ended up in a house on the rue du Faubourg Saint-Honoré, where he had the "whole of the first floor and the view on to the Champs-Élysées, which are transformed into an English camp." Metternich clearly wanted to be on his own. He had had many dealings with Talleyrand, but for the first time he held all the cards.

The first trophy of war that Metternich went after was the most conspicuous. On July 31, the Austrian emperor ordered the horses of Saint Mark's from Venice to be removed from the top of the Arc de Triomphe du Carrousel, in front of the Tuileries. "Austria is to restore to Venice the

Thomas Lawrence, *Klemens Lothar Wenzel, Prince Metternich*, 1815.

horses on the Arc de Triomphe, and the winged Lion [of Saint Mark] on the Esplanade of the Invalides," William Richard Hamilton, Castlereagh's undersecretary for foreign affairs, reported from Paris on August 24 to Henry Bathurst, Britain's secretary of state for war, in London. But Hamilton added that "the great question of the galleries of Florence and the Vatican, as well as other Italian collections . . . has not been *entamée* [raised]."

Indeed, the British had yet to agree to the restitution of the paintings and sculpture Napoleon had seized from Italy. Liverpool, who was in London, wanted to strip the French of "the trophies of [their] victories." But Castlereagh continued to fear that emptying the Louvre would undermine the French public's support for the monarchy. He believed that European security depended not upon France's weakness but upon its strength,

and he wanted France to maintain its place among the European powers, which together would keep the continent in balance.

Handsome and reserved, Castlereagh had been Metternich's most important partner in defeating Napoleon and masterminding a European peace. Born in Dublin in 1769, into the Protestant aristocracy, Castlereagh had served in high British government posts for most of two decades. In Paris, Castlereagh and his wife, Amelia, entertained. There, Lady Edgcumbe observed, the "conquerors and the conquered" mixed. "There . . . were the upright and high-minded minister and the crafty politician; the loyal subject and the cold-blooded regicide," she wrote. The crowd included Tsar Alexander, Metternich, Schwarzenberg, and Blücher, as well as Germaine de Staël and Sir Walter Scott. Castlereagh's focus on achieving a lasting peace failed to win universal approval in London, where critics and enemies claimed he had drawn England too much into the orbit of Europe.

Castlereagh also warned Liverpool not to expect the tsar "to go all your lengths, especially on the subject of the Gallery and the Statues." Already, Alexander had made certain that the paintings stolen by the French from the Elector of Hesse and handed over to Josephine would not go back to Kassel. The tsar bought the Elector's pictures (for 940,000 francs) from Eugène de Beauharnais; Eugène had inherited them from Josephine, who had died the year before.

Britain's prince regent, the future George IV, similarly saw the art in the Louvre as enemy property that Great Britain had a right to possess. "The Prince Regent is desirous of getting some of them [the works] for a Museum or a gallery here [in London]," Liverpool wrote to Castlereagh on August 3. "The men of taste and virtù encourage this idea." The British, he argued, "have a better title to them than the French, if legitimate war gives a title to such objects, and they blame the policy of leaving the trophies of the French victories at Paris, and making that capital in future the center of the arts."

No demands had been made on the French to return the paintings and sculpture Napoleon had taken from Italy when, on August 28, the sculptor Antonio Canova arrived in Paris from Rome as the delegate of Pius VII, charged with repossessing the Vatican's antiquities.

Canova was a shrewd choice. Not only was he the most famous living artist in Europe, and known to the European leaders with whom he would have to negotiate, but also he would be particularly persuasive about returning Rome's ancient statues, as he had based his own neo-classical sculptures upon the art he was assigned to retrieve. In 1796, he had decried Napoleon's plans to loot the Vatican's collection: "If the Devil makes these hundred works leave, Rome will be desolate," the artist then wrote. So closely did Canova's works resemble Roman antiquities that in 1801 Pius VII had acquired the sculptor's *Perseus with the Head of Medusa* to fill the niche in the Belvedere courtyard left empty when the *Apollo Belvedere* had been removed. In this sculpture of a young warrior triumphing

Antonio Canova, *Perseus with the Head of Medusa*, ca. 1800.

over evil, Canova eloquently protested the French thefts. Since 1802, he had focused attention on conserving Rome's artistic heritage as inspector general of antiquities and the fine arts for the Papal States.

Canova had lived and worked in Rome for over three decades, but he was Venetian. He had been born in 1757, in Possagno, a hill town near Asolo in the Republic of Venice, the son of a stone carver and the grandson of a sculptor, and had moved to Venice at the age of fourteen, apprenticed to the sculptor Giuseppe Bernardi. Revealing his talent early on, he was taken up by Venetian collectors, who gave him his early commissions, made certain he received the necessary education in mythology and history, and sent him to Rome. There, he lived in the Palazzo Venezia, the Venetian embassy.

Canova was shy, fiercely independent, a fanatically hard worker, and a Romantic; he liked to put the finish on his marble sculptures by candlelight. From a large workshop in Rome, Canova had long struggled to keep up with the demand for his statues, which he produced for far-flung patrons, including Catherine the Great, who in 1794 had invited him to her court in Saint Petersburg.

In 1802, Napoleon, as First Consul, had wanted Canova to sculpt his portrait and had requested he come to Paris. When Canova told Cardinal Consalvi, the Vatican's secretary of state, that Napoleon's conquest of Venice made it impossible for him to go, the cardinal argued that the artist's refusal might jeopardize the concordat and pressured him to take on Napoleon's commission.

Reluctantly, Canova met with Bonaparte at Fontainebleau in October 1802 and modeled a bust in clay. He narrowed Napoleon's face, lengthened his nose, and abstracted his locks of hair, giving him the handsome features and intelligent expression of a classical hero. Canova and Napoleon had gotten along well enough, but they disagreed about the full-length marble sculpture Canova was to make.

Napoleon wanted an equestrian statue to present him as a soldier in uniform. But Canova was intent on portraying Napoleon as "Mars the Peacemaker," and in the nude. When in 1811 Napoleon saw the colossal statue at the Louvre, he instructed Denon to put it in storage, recognizing that his incarnation as a Roman god was too far from the truth. (For the

Antonio Canova, *Napoleon Bonaparte*, 1803.

sculpture, Canova was paid 120,000 francs, or close to twice what David would get for *The Coronation of Napoleon*.)

In contrast, Canova's sultry stone image of Napoleon's sister Pauline Borghese, portrayed as Venus, reclining half-nude on a chaise longue, would be seen as one of his greatest works. Canova finished Pauline's statue in 1808, a year after Napoleon purchased almost seven hundred antiquities from her husband, Prince Camillo Borghese—a collection amassed by Cardinal Scipione Borghese in the seventeenth century and housed in the Villa Borghese in Rome. For these sculptures, the French emperor paid generously—thirteen million francs, or more than three times the value that Denon and Ennio Quirino Visconti, the Louvre's curator of antiquities, assigned them. Because the French government had purchased the Borghese collection, the question of its return to Rome was not raised.

Canova's charge in 1815 was to convince the Allied leaders that the 1797 Treaty of Tolentino, which had ceded one hundred works of art to the French, was not legally binding. Bonaparte, the Vatican contended, had violated the agreement in 1809 by annexing the Papal States to France and, later, by imprisoning Pius VII at Fontainebleau. Canova had hesitated to take on the task. It was "a very difficult affair and certainly far above my limited capability," he wrote Cardinal Consalvi. However, he relented: "The debts I have to the service of your eminence are so many and the reasons you gave me seem and are so strong that I cannot, nor will I, shy away from any attempt or danger in order to succeed in this undertaking."

That Canova was modest and self-effacing would only increase the effectiveness of his diplomacy, Leopoldo Cicognara, the director of Venice's art academy, argued in 1812: "You are a true power in this world, but you do not know the power you possess, which should enable you to exert a much greater influence. Notwithstanding, you have a glory common to extraordinary influence, namely, that of having made a revolution in the arts, like the one the military powers are making in politics." Canova prepared for the mission in France by having Quatremère de Quincy's *Letters to Miranda*—the 1796 treatise written in protest of Napoleon's seizures of the Roman antiquities—issued in Italian and in French to distribute to the European leaders convened in Paris. Before leaving Rome, he also drafted a will.

On his first day in Paris, Canova called upon Wilhelm von Humboldt. The Prussian diplomat told him that because the Vatican's art had been part of the Treaty of Tolentino, it "could never be returned." Undaunted, Canova turned to the British. Two days after his encounter with Humboldt, he was received by Castlereagh, to whom he handed a letter written by Pius VII, arguing that the Treaty of Tolentino should be annulled. Canova also met with the British undersecretary for foreign affairs, William Richard Hamilton, whom he may have known earlier in Rome.

After speaking with Canova, Hamilton immediately became the sculptor's ally. He told the waffling British leaders they should abandon possible stratagems to acquire Napoleon's looted collections. "We must necessarily give up the idea of procuring for ourselves any of the chefs-d'oeuvres from

the Louvre, by way of purchase from the Pope," Hamilton wrote War Secretary Henry Bathurst on September 6. "It would throw an odium upon our exertions to restore stolen goods."

Five days later, Canova was confident enough in Britain's support to formally ask the ministers plenipotentiary of the Allied sovereigns to return the Vatican's art to Rome.

That Hamilton advocated the restitution of Napoleon's plunder was ironic. "Dark Hamilton," as Lord Byron had called him, had been secretary to Thomas Bruce, the Earl of Elgin, when, as Britain's ambassador to the Ottoman Empire, he had removed almost 250 feet of the Parthenon frieze, as well as fifteen stone panels (metopes), and seventeen pediment statues, and had these pieces shipped from Athens to London. Recently, Hamilton had lobbied the British government to procure the controversial "Elgin marbles." Much of the Parthenon had been destroyed over a century earlier, in 1687, when Venetian forces had fired cannons at the temple, stockpiled with ammunition by the Turks, and the attack had set off an explosion. In 1816, the British Parliament would agree to purchase Elgin's Parthenon sculptures for thirty-five thousand pounds.

On the day Canova made his request to the Allied ministers, Castlereagh asked them to base their policies regarding the Louvre on "the principle of property . . . [as] the surest and only guide to justice." He argued that it would "settle the public mind of Europe" if the king of France acted on "a principle of virtue, conciliation and peace," and divested himself of the Louvre's "ornamented spoils."

Castlereagh's dealings with the French had caused his thinking to evolve. Two months before, the Belgian ambassador had asked the French to give back the art looted from Belgium and the Netherlands, but he had still received "no satisfactory answer." In August, Castlereagh brought the issue before the European powers: "We were all of the opinion that something must be done," he told Liverpool. They discussed whether to distinguish the art Napoleon seized by conquest from the art "*ceded by treaty.*" Castlereagh then decided that Bonaparte's treaties "were not inferior in immorality to his wars": all his acquisitions were plunder.

By September 11, Castlereagh could not see Wellington "doing otherwise than" assisting the "King of the Netherlands to replace in the

Churches of Belgium the pictures of which they were despoiled," and if necessary "to remove [these objects] by force." Castlereagh left the question of the art of Rome and of Venice, as well as "the protection of the Pope and the other Italian princes," to the emperor of Austria. But the emperor "will be very reluctant to use force," the British foreign secretary wrote. "And yet without force I do not believe the thing can be done."

Wellington now asked Talleyrand to advise him on how to wrest the Belgian art from the Louvre in the way least disturbing to the French king. When Talleyrand failed to reply, Wellington told Denon that British "troops would go the next morning [September 20] at twelve o'clock to take possession of the King of the Netherlands' pictures." "The spoliation of the Louvre is begun," Castlereagh wrote on September 21. "The King of the Netherlands is hard at work; Austria begins immediately." Once the Paris public saw the Louvre being dismantled, they began to protest. Crowds "clamor loudly over the removal of the articles of Art," reported the *Courier* in London.

Wellington himself heard these complaints. "The French of all parties are very sore. And they were foolish enough at Madame de Duras's the other night, to resent it to the Duke of Wellington in the most pointed manner," wrote Castlereagh. Wellington immediately responded. In a letter addressed to Castlereagh and published in the *Courier*, he condemned the plundering of art as something "the world had made such gigantic efforts to get rid of . . . and contrary to the practice of civilized warfare." Why, he asked, should "the powers of Europe . . . do injustice to their own subjects" simply "to conciliate" the French?

Wellington rightly understood the political significance of the Louvre's looted art. "The feeling of the people of France upon this subject must be one of national vanity only. It must be a desire to retain these specimens of the arts, not because Paris is the fittest depository for them . . . but because they were obtained by military successes, of which they are the trophies."

He wanted to remind the French that "Europe is too strong for them," and he refused to miss "the opportunity of giving the people of France a great moral lesson." Wellington also sought to differentiate the British

from the French, and himself from Napoleon, "the common enemy of mankind." Wellington wanted the restitution of hundreds of paintings and sculptures to set a precedent; eventually it would.

In 1899, the Hague Convention on the Laws and Customs of War would prohibit the plunder of art and demand that warring nations protect cultural property. Article 56 states that "all seizure of, destruction or willful damage done to institutions . . . historic monuments, works of art and science, is forbidden, and should be made the subject of legal proceedings." The Hague Convention of 1907 would reiterate these principles. Ratified by 101 states, this treaty became accepted as international law.

Wellington's policy toward Napoleon's art spoils infuriated Denon, who blamed William Hamilton. "What is most certain is that M. Hamilton has behaved in this matter like a maniac," Denon wrote the Comte de Pradel, the head of the French king's household, on September 28. "That he is set on the entire destruction of the Museum and that he has got the support of Lord [sic] Wellington in the execution of his project." Would it be the Austrians, who now patrolled the Louvre, who would complete the "violation of this establishment"? Denon demanded. Or "will they leave to the English and the Prussian troops the care to commit this new and final outrage"?

The "final outrage" meant the removal of the art of Italy, to which the Austrians now turned their attention. The month before, on August 5, Metternich had approached Denon about recovering the art the French had confiscated from Vienna, and within two weeks the Comte de Pradel authorized its return. But on September 21, when Joseph Rosa, the curator of Vienna's Belvedere palace, came to the Louvre to "retake these paintings that belonged to the Italian States," Denon refused to see him. "I share the unhappiness for you, Monsieur the director, and for myself as well," Rosa wrote. "But you like me must obey the orders that the sovereigns give." To Denon's opposition, the Austrian response was quick. It came from Field Marshal Schwarzenberg, whose aide-de-camp went to the Louvre on September 23 to demand the "objects of art brought from Venice, Parma, Piacenza, and Florence." Denon claimed he had received no orders to give up these Italian works. But Schwarzenberg ignored him. Three days later, a British painter reported that the two Titians from

Venice—*The Death of Saint Peter Martyr* and *The Martyrdom of Saint Lawrence*—had been taken down.

The French king "bears our operations at the Louvre very quietly," Castlereagh reported to Liverpool on September 25. "The King of the Netherlands is finished. The Emperor of Austria is far advanced and the Pope is going to begin." He summed it up: "The whole [Louvre] will soon disappear."

That same day, in the Place du Carrousel, in front of the Tuileries Palace, Austrian soldiers climbed to the top of the five-story Arc de Triomphe and began the considerable job of removing the horses of Saint Mark's. They were breaking up the stone around the bolts that anchored the metal hooves, when the sound of hammering attracted a crowd. "The Austrians were driven from their work the night before last," Castlereagh wrote Liverpool. To continue, the Austrians brought in troops and also the Paris police, who filled the square and refused to let people approach. "There are crowds of French in all the avenues leading to [the Place du Carrousel] who give vent to their feelings by shouts and execrations," the *Courier* reported on October 3. John Scott, a British painter, observed that "carriages that were to take [the horses] away, were in waiting below, and a tackle of ropes was already affixed to one [of the statues]." It took an entire day to attach the ropes to the four statues and to lower them to the ground. Scott went "with a friend to dine at a *Restaurateur's* near the garden of the Thuilleries [*sic*]. Then, between seven and eight in the evening, heard the rolling of wheels, the clatter of cavalry, and the tramp of infantry," guarding the horses. A few days later, from the pillar in front of the Invalides, soldiers pulled down the Lion of Saint Mark and it fell to the ground, breaking into fourteen pieces. The ancient bronze statue would have to be reassembled in Venice.

Finally, at the end of September, Metternich offered Canova Austria's backing. "Canova was made happy last night by Austria, Prussia and England agreeing to support him in removing the Pope's property," Castlereagh wrote on October 1. "The joint order is issued, and he begins tomorrow."

On October 2, at 7:00 a.m., Canova arrived at the Louvre with a team of workers to begin packing the Vatican collections. Three days later, he reported that they had taken away "many fine paintings," among them

Raphael's *Transfiguration* and *Madonna of Foligno*, as well as Domenichino's *Communion of Saint Jerome*. Over the next few days, "other exquisite pictures came away together" with some of the most famous sculptures: the *Dying Gladiator*, the *Belvedere Torso*, the *Laocoön*, and the *Apollo Belvedere*. "The cause of the Fine Arts is at length safe in port," Canova concluded. "We are at last beginning to drag forth from this great cavern of stolen goods the precious objects of Art taken from Rome."

On October 5, Denon resigned. His anger, bitterness, and humiliation color the "meticulously detailed account" he left about his dealings with the Allies. He saw the history of the Paris museum as a paradox: "Europe had had to be conquered in order to fashion this trophy, Europe had had to join together to destroy it." The French would sometimes continue to hold Denon's point of view. "The Allies have taken eleven hundred fifty pictures," wrote Stendhal in his 1817 *Histoire de la peinture en Italie*. "I hope I may be permitted to observe that we acquired them *by a treaty*, that of Tolentino. . . . On the other hand, the Allies have taken our pictures, *without treaty*."

"The Louvre is truly doleful to look at now," Andrew Robertson, a British painter of miniatures, wrote on October 12. "All the best statues are gone, and half the rest, the place full of dust, ropes, triangles, and pulleys, with boards, rollers, etc." Nevertheless, of the 506 paintings the French had seized in Italy, Denon succeeded in keeping 248 in France. Many of these he had sent from Paris to museums in other French cities. He had split up Mantegna's altarpiece from San Zeno in Verona, hanging the three main panels in the Louvre but giving two of the three smaller predella panels—*The Agony in the Garden* and *The Resurrection*—to the Musée des Beaux-Arts in Tours.

Of the eighteen paintings the French had stolen from Venice, they would return fifteen; they kept Veronese's great *Jupiter Expelling the Vices* and also his *Saint Mark Rewarding the Theological Virtues*. At some point, Denon had installed these pictures from the Doge's Palace on a ceiling at Versailles.

Joseph Rosa had demanded the Venetian pictures from the Louvre on September 25, 1815. The following day, Athanase Lavallée, the Louvre's general secretary, warned Rosa that if the Austrians attempted to transport

Veronese's *Wedding Feast at Cana*, they might well destroy it. Lavallée documented his conversation with Rosa in a memorandum.

> Monsieur Rosa, conservator of the gallery of Vienna, having reclaimed in the name of his Majesty, the Emperor of Austria the great painting of Paul Veronese, I made him observe that the colossal dimensions of this painting [and] that the relining that has been done, have rendered the transport if not impossible, at least very difficult; that when it was carried from Venice, this painting was separated in two above the balustrade, but that today with this painting, having been relined, this same operation has become very dangerous and would undoubtedly lead to the ruin of this canvas, whose dimensions are—20 feet, 6 [French] inches in height, by 30 feet and 2 inches in width.

To replace the Veronese, Lavallée proposed a "gift of several French paintings which are lacking in the collection in Vienna." Beneath Lavallée's statement, the Louvre's antiquities curator Ennio Quirino Visconti wrote: "I testify the truth of these facts and the dangers which are pointed out in the certificate of M. Lavallée." By September 28, Rosa had Lavallée's letter delivered to the Austrian emperor, who was leaving Paris that day.

The next day, Denon conveyed good news to the Comte de Pradel. The Austrian emperor "has authorized the [Mon]sieur Rosa to leave this painting [*The Wedding Feast at Cana*] and to accept in exchange another subject of devotion, to replace it in the refectory of the Benedictines of San Giorgio Maggiore, which this painting had decorated."

Denon sounded matter-of-fact, but he must have felt triumphant. He wanted the Comte de Pradel "to accept with haste such an exchange" and "to authorize me to offer in exchange the painting by [Charles] Le Brun, representing *La Madeleine chez le Pharisien*." To Pradel, but presumably not to the Austrians, Denon spelled out in monetary terms the difference between the two pictures:

> The painting of *Les Noces de Cana* is carried in the estimated inventory of the museum for a sum of one million [francs].
> That of *La Madeleine chez le Pharisien* for . . . thirty thousand francs.

Denon urged Pradel to agree quickly, as though he feared the Austrians would change their minds. He had succeeded in persuading them to accept a minor canvas by Louis XIV's court painter and to give up a masterpiece.

Canova expressed outrage. "The famous Supper by Paolo remains here," he wrote to Cicognara on October 2—the day Rosa signed the receipt for the Le Brun.

> You will hear that the Emperor of Austria wanted my opinion on this point to justify the line of reasoning that they brought to bear on the matter, in order to leave [the Veronese] here, and to make an exchange for it. Their reasons were in essence that the canvas would be cut into pieces, as the only advisable way to transport it without destroying it. I had no fault, nor say in the matter because it had already been resolved, before it was mentioned to me.
>
> P.S. Be aware that when I was told that the Emperor Francis wanted to have my opinion on the proposed exchange for Paolo's Supper, I answered that never would I have betrayed the interests and honor of my country, nor ever approved such an exchange.
>
> It's good for the person who suggested this that I arrived late, when there was no time left. I'm telling this to you so that you know the truth and will tell others.

Epilogue

I n 2020, more than two centuries after Napoleon had expropriated *The Wedding Feast at Cana* from Venice, the painting commanded the end wall of the Salle des États, a dark blue gallery in the Musée du Louvre, rising fifty-two feet and lined with a breathtaking flight of some forty Venetian High Renaissance paintings, each framed in gold. These pictures spoke to France's long love affair with the art of Venice. There were eight Titians, three Tintorettos, and nine Veroneses, including *Jupiter Expelling the Vices*. The gilded frames of these Renaissance paintings gleamed against the midnight blue of the gallery's walls—a blue that verged on black—and set off the rich tones of the Venetian paint.

The Wedding Feast at Cana, in its massive gold frame, was a towering presence in the gallery. The vast canvas faced the *Mona Lisa*, which was installed on a freestanding panel at the center of the room. Leonardo's two-and-a-half-foot-tall portrait emphasized the architectural scale of the Veronese, a canvas 150 times greater in size, and still the largest painting in the Louvre.

Two centuries after arriving in Paris, the magnificent Veronese had rightly held its place close to the historic heart of the Louvre. Doorways on either side of the painting led to the Grande Galerie, the corridor built by Henri IV in which Jacques-Louis David and the Committee of Public Safety had first opened the museum at the Louvre in 1793, during the Terror. Now, along the length of the Grande Galerie ran the Louvre's extraordinary collection of Italian paintings. They began in the Salon Carré, with Giotto's late thirteenth-century *Saint Francis of Assisi Receiving the Stigmata* and Cimabue's *Madonna and Child* (taken from Pisa by Denon in 1811), and extended down the hall with fifteenth-, sixteenth-, and seventeenth-century paintings from Florence, Milan, Parma, Padua,

Bologna, and Rome. Among them were pictures often singled out to illustrate standard art history texts—Uccello's *Battle of San Romano*, Mantegna's *Saint Sebastian*, Raphael's *Portrait of Baldassare Castiglione*, and Leonardo's *Virgin and Child with Saint John the Baptist and an Angel*.

Most of the Venetian paintings had come to the Louvre from the collection of the French kings—their royal provenance stated on wall labels, written in French and also English. The complicated history of *The Wedding Feast of Cana* as a work swept up by Napoleon on his Italian campaign was only touched upon. The wall label gave the artist's name ("Paolo Caliari, called Veronese"), the painting's title, its date (1562–1563), and its origins: "Painted for the Benedictine Monastery of San Giorgio Maggiore in Venice." In smaller print, in French, the label identified the painting simply as a "*Saisie révolutionnaire, 1797*" from "the convent of San Giorgio Maggiore in Venice" that had "entered the Louvre in 1798" and been "exchanged in 1815 with Charles Le Brun's *La Madeleine chez le Pharisien*, today in the Gallerie dell'Accademia in Venice."

But, close by, in two enormous galleries, their walls painted blood-red, an extravagant display of nineteenth-century French canvases documented the Napoleonic history in which the Veronese had played a part. The red gallery to the east laid out the evolution of Jacques-Louis David's art, from his early icon of neoclassical history painting, *The Oath of the Horatii*, to *The Coronation of Napoleon*, his huge group portrait of the imperial court, with the emperor and Josephine at the center of the scene in Notre-Dame. Looking down from the walls were characters from the era: David himself, brilliant and troubled in the 1794 *Self-Portrait*, painted in prison after the fall of Robespierre; the defeated Pius VII, whom Napoleon had pressured into crossing the Alps to crown him in Paris; and Juliette Récamier, the freethinking writer, who reclines on a Pompeian chaise longue in a white "antique" dress, her legs outstretched, her feet defiantly bare.

In the red gallery to the west, Antoine-Jean Gros's tragic accountings of Napoleon's war-dependent reign—*Bonaparte Visiting the Plague-Stricken in Jaffa* and *Napoleon on the Battlefield of Eylau*—appeared along with the violent "machines" by Théodore Géricault and Eugène Delacroix, the Romantics who had followed in Gros's wake—*The Raft of the Medusa*,

Scenes from the Massacres of Chios, *The Death of Sardanapalus*, and *July 28, 1830: Liberty Leading the People*. In these masterpieces, the Louvre made the case that French painters had proved themselves heirs to Veronese and the Venetians, as well as the pioneers of modern art. That argument continued across the Seine, at the Musée d'Orsay, in the realist, impressionist, and postimpressionist canvases of Édouard Manet, Claude Monet, Edgar Degas, Georges Seurat, Vincent van Gogh, and Paul Cézanne—artists whose experiments in form and color paved the way for abstract art.

To the French modernists, *The Wedding Feast at Cana*, with its free-wheeling virtuosic technique and rich tones, continued to stand as a model and an inspiration. In 1820, five years after Napoleon's defeat, Delacroix, then twenty-two, made a full-scale copy of two heads in the Veronese. "I wouldn't miss [the work at the Louvre]. . . . I've paid for a very expensive scaffold," he wrote his sister, Henriette de Verninac.

Later, in the 1850s, Delacroix contrasted *The Wedding Feast at Cana* to Raphael's *Disputation of the Holy Sacrament*—"in which nothing is colder than what seems to pass between the figures"—to explain his fascination with Veronese's canvas. "I see men like me, with varied figures and temperaments, who converse and exchange ideas," he wrote. "The optimistic next to the gloomy, the coquettish [woman] near the indifferent or distracted woman, and lastly, passion and life, things difficult [to incorporate into] a calm and nearly motionless scene."

Delacroix had broken from the neoclassicism of David—the high-minded and moralizing subjects, the sharp-edged contours, the worship of antiquity, the idea that great painting was based on draftsmanship. Delacroix painted dark narratives inspired by literature (Dante, Sir Walter Scott, Lord Byron), the Bible, and contemporary events, and he threw himself into the study of color. "The first merit of a painting is to be a feast for the eye," he declared in 1863.

When, toward the end of the nineteenth century, Vincent van Gogh followed Delacroix, he also looked back to Veronese as he worked out his radical approach to color. He believed that *The Wedding Feast at Cana* proved his conviction that "instead of starting from colors in nature," painters should "start from the colors on [their] palette[s]." Writing about the Renaissance painting to his brother Theo in October 1885, he

observed: "COLOR EXPRESSES SOMETHING IN ITSELF. . . . What looks beautiful, really beautiful—is also right." Van Gogh, like Delacroix, never traveled to Italy. What they knew of Veronese they learned from seeing paintings in the Louvre.

In 2020, *The Wedding Feast at Cana* was 457 years old. The French phase of the painting's life had lasted 223 years; the Veronese's time in Paris was now roughly a decade shorter than the period it had spent in Venice.

In 1850, the Comte de Nieuwerkerke, the director general of the French Imperial Museums, made the decision to have the Veronese—split by the Louvre restorers in 1799—put back in one piece. The iron brackets fastening together the two parts of the canvas had begun to break. A fold had "formed along the whole length," Nieuwerkerke explained. "The putty and the paint disguising [the gap between the two canvases] had fallen off." To stop "the progress of . . . these evils," a restorer named Mortemart stitched the two halves together and relined both with "a single canvas, stretched on a single stretcher" made of wood and braced with five horizontal and eight vertical crossbars.

In the two centuries the Veronese had spent in France, wars forced the painting to flee Paris twice. First, on September 3, 1870, during the Franco-Prussian War—the day after Napoleon III surrendered to the Germans—Philippe de Chennevières, France's director of fine arts, had *The Wedding Feast at Cana* (it had been rolled and packed) along with other works from the Louvre transported in seventeen crates to the Brittany coast, where they were stored in the arsenal at Brest. The Veronese returned to the Louvre a year later, and a picture liner unrolled and remounted the canvas. It went back up on the south wall of the Salon Carré, where van Gogh would see it some four years later.

The Veronese left Paris again with the outbreak of World War II. On August 25, 1939, a week before Germany invaded Poland, Jacques Jaujard, the Louvre's director, shut the museum, ostensibly for repairs, and ordered the packing of the art to begin. For two years, Jaujard had laid plans for the possible evacuation of the Louvre's collection. He had scouted castles, churches, and monasteries across France that might work as storehouses and had about two thousand crates constructed. A photograph shows *The Wedding Feast at Cana* leaning up against a gallery wall

and four Louvre staff members attaching sheets of fabric to the front of the picture, to protect the paint before the canvas was rolled.

With the declaration of war on September 3, Jaujard, fearful of air attacks, ordered the most valuable works to leave the Louvre immediately. But the Veronese had already gone. On August 28, curators slipped the painting out of the museum. Wrapped on a cylinder, inside a crate, the canvas had been loaded onto a truck used by the Comédie Française to carry sets and driven south 110 miles to the Château de Chambord, a four-hundred-room castle, built in the sixteenth century by Francis I. "The towers, the turrets, the cupolas, the gables, the lanterns, the chimneys," Henry James had observed in 1884, "look more like the spires of a city than the salient points of a single building."

Over the next four years, as the Germans occupied France, the French would move the Veronese at least five times—to escape bombing and to keep the painting out of Nazi hands. Even packed, the painting was difficult to maneuver. "For *The Wedding Feast at Cana*, by Veronese, a painting rolled, in a very heavy crate, we were always worried," wrote Lucie Mazauric, a Louvre archivist on the team that accompanied the museum's pictures. Only three months after arriving at Chambord, the Veronese and other works were sent north to the Château de Louvigny, near Le Mans, one of eleven Loire valley châteaux between which the Louvre paintings and sculptures were divided.

On May 10, 1940, Germany attacked Belgium and Holland, in an assault led by armored vehicles and Luftwaffe air raids. On June 14, the Germans entered Paris. By then, Jaujard had transferred the Veronese 375 miles south to the Abbey of Loc-Dieu, a twelfth-century Cistercian monastery, near Villefranche de Rouergue. Three thousand paintings (including David's *Coronation of Napoleon*, Gros's *Bonaparte Visiting the Plague-Stricken in Jaffa*, and the *Mona Lisa*) would make the hazardous journey from the Loire valley châteaux to Loc-Dieu. Jaujard had managed to evacuate the Louvre pictures from northern France, which the June 22 armistice that the French signed with the Germans established as German-occupied territory, to the "free zone" in the south, which would be under Marshal Philippe Pétain and his collaborationist French government, headquartered in Vichy.

The abbey was damp, and its rooms were small. Sometimes the curators laid the paintings out on the lawn to air. At one point, Loc-Dieu's relative proximity to Italy stirred fears among the French that the Italians—who on June 10 had declared war on Britain and France—might try to retrieve the famous Veronese. On July 22, Louis Hautecoeur, the secretary general of fine arts in Vichy, ordered Mazauric to return to Chambord—in the German zone—and search the Louvre's archives, which had been stored there, for the 1815 agreement with Austria that had allowed the French to keep the Veronese masterpiece in exchange for the Charles Le Brun. At Chambord, Mazauric spent two days and nights copying the treaties or accords by which Napoleon formalized his art confiscations from Italy.

The French had reason to fear that their enemies would want to repatriate paintings and sculpture they believed were theirs. In 1939, the Germans had made clear their designs on art that had been seized from their territory, when two art historians published the *Memorandum and Lists of Art Looted by the French in the Rhineland in 1794*. Once Hitler defeated France, Joseph Goebbels, the Nazi propaganda minister, ordered Otto Kümmel, the director of the Berlin museums, to expand those lists to include "works of art and valuable objects which since 1500 have been transferred to foreign ownership, either without our consent or by questionable legal transactions." Kümmel's list eventually ran to more than three hundred pages.

Beyond the issue of repatriation, Hitler executed an art-looting project on a scale that outstripped Napoleon's. By June 1939, he had laid plans to build a museum in Linz, Austria, a town where he had spent some of his childhood; by the end of the war, he amassed some eight thousand pictures. At the same time, Reichsmarschall Hermann Göring stocked his eight residences with a collection estimated to contain as many as two thousand works of art.

The Nazis attempted to mask their art plundering with the pretense of the Wehrmacht's art protection office—the Kunstschutz, established in World War I. In Paris, the Kunstschutz was directed by Count Franz Wolff-Metternich, an architectural historian and a descendant of Klemens von Metternich, who took his job more seriously than the Nazi authorities

would have wished. Metternich promised Jaujard that Germany would guard the national collections that he had deposited in the various châteaux in France. In August 1940, Metternich actually prevented Otto Abetz, the German ambassador to France, and Otto Kümmel from shifting some of the Louvre collections at Chambord to Paris, ignoring their claim that the works they wanted were "in danger of being damaged."

But Metternich failed to stop the Nazis' wholesale theft of art owned by Jewish collectors and dealers—first by Abetz, who stole some 1,500 paintings, and then by Alfred Rosenberg, whose Einsatzstab Reichsleiter Rosenberg (ERR, the Special Staff of Reichsleiter Rosenberg) Hitler decreed "entitled to transport to Germany cultural goods which appear valuable to him and to safeguard them there." Rosenberg would supervise the confiscation of more than 21,000 works of art from Jewish collections in France, including Vermeer's *Astronomer*, one of 3,978 objects seized from the Rothschilds. Informed by Hitler in 1941 that the ERR was free to take what it wanted, Metternich met with Göring, holding, as he put it, "some faint hope it might be possible to save something of the objects and principles of Art Protection, and possibly to add a word or two about the scruples which might be felt over the treatment of Jewish artistic property." But, in front of the Reichsmarschall, Metternich claimed he "was roughly cut short and dismissed."

After only three months at Loc-Dieu, on September 20, 1940, the Louvre paintings were transferred again. This time they traveled forty miles southwest, to a massive seventeenth-century redbrick building with square turrets and a large courtyard on the Tarn River, in Montauban, built as the residence of the bishops of Montauban. Since the mid-nineteenth century, the château had housed a collection of paintings and drawings by Jean-Auguste-Dominique Ingres, who had left them to his native city.

In November 1942, in response to the Allied invasion of North Africa, Hitler ordered the German army to occupy all of France. Soon after, from the windows of the Montauban château, the French curators observed German troops crossing bridges over the Tarn. Immediately they acted to remove the Louvre pictures from the city. The Veronese seems to have first been driven to the Château de Loubéjac, about five miles

north of Montauban, and then moved north again, in March 1943, to the Château de Montal, a handsome Renaissance structure built by Jeanne de Balsac, a widow who commissioned it in 1519. High up on the walls of the courtyard, she placed an extraordinary line of busts of members of the Montal family, including herself and her son Robert de Montal. He was killed in Milan during Francis I's Italian campaign, while the castle was under construction.

On February 13, 1946, nine months after the German surrender, the Veronese returned from the Château de Montal to the Louvre. At some point during the six and a half years spent in a crate, the canvas had suffered damage in an accident: according to a condition report, restorers had applied substantial amounts of putty, on the left-hand side, to disguise the injuries.

In the aftermath of World War II, a strongly worded prohibition of "theft, pillage or misappropriation of, and any acts of vandalism directed against, cultural property" became international law with the 1954 Hague Convention. This treaty also banned the requisitioning of "movable cultural property situated in the territory of another High Contracting Party." The treaty's first protocol required the return of cultural property taken illegally from occupied territories. As of 2019, 133 states had ratified the 1954 convention.

In 1949, *The Wedding Feast at Cana* again went on view at the Louvre—this time in the Salle des Sept Cheminées. Three black-and-white photographs show some of the steps involved in hanging the picture. In the first, the Veronese lies facedown on the floor, with ropes running from the stretcher's top edge to pulleys set close to the ceiling. In the second, the painting stands upright, propped against the wall. In the third, the canvas is framed and hung, suspended by five cables from a metal bar above it. Two years later, on September 18, 1951, conservators took down the painting, removed the canvas from the stretcher, then rolled it and transported it to the Salle des États, where they unrolled it, nailed it again to the stretcher, and set it back into its frame. By late November, they had installed *The Wedding Feast of Cana* on the gallery's south wall.

In the Salle des États, the Veronese would remain. In 1989, when a team of six began a project to conserve the painting, they carried out the work inside a glass enclosure constructed around the picture. Three years later, an extraordinary catalogue, *Les Noces de Cana de Véronèse: une oeuvre et sa restauration*, edited by the Louvre curator Jean Habert, explained what the conservators had learned in the course of the painting's restoration. A huge radiograph they had made, composed of 135 films, each five feet tall, revealed the way Veronese had freely reworked certain figures in the process of painting, and also the damage to the paint and the linen beneath it caused by ripping the canvas off the nails attaching it to the wooden stretcher on San Giorgio Maggiore's wall. An analysis of minuscule samples of paint allowed the conservators to identify Veronese's pigments. The catalogue also explored the picture's iconography and documented its history, as well as the artists who had copied it, from the sixteenth-century Federico Zuccaro to Paul Cézanne, who around 1867 drew certain figures, including the servant bent over the jug, into which he pours the wine.

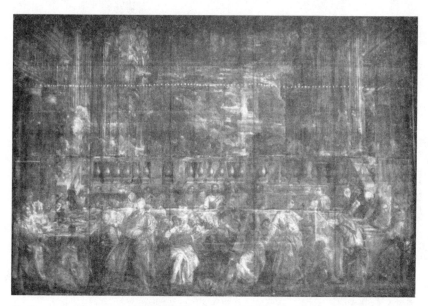

Radiograph of Veronese's "Wedding Feast at Cana," 1992. The radiograph shows a line of holes running horizontally across the canvas and damage along the top rail of the balustrade.

A four-year renovation completed in 2005 stripped the Salle des États of decorative detail and turned it into a modern space with sandstone-colored walls. Before the construction began, *The Wedding Feast at Cana* was transported out of the gallery—a process that required dismantling part of the north wall. When the painting returned to the Salle des États, it was reinstalled on the south wall. There, in a sleight of hand, the painting in its gilded frame appears to be hanging but, in fact, is cantilevered from a metal scaffolding into a rectangular opening cut out of the wall.

The supporting framework is hidden in a narrow room, wedged between the Salle des États and the Grande Galerie. The dimly lit space offers a disarming, backstage view of the Veronese, revealing its centuries of age and the twenty-first-century engineering employed to exhibit the Renaissance painting.

In 2019, the walls of the Salle des États were repainted a deep blue and the Louvre's curators rehung the Venetian paintings. That year, more than nine million people visited the Louvre, and most headed directly to the Salle des États to look at the *Mona Lisa*. The presence of Leonardo's famous portrait jammed the gallery with a capacity crowd, even in winter months. It robbed the Veronese and the room's other pictures of attention and made them difficult, if not impossible, to see.

In stark contrast, San Giorgio Maggiore's refectory, from which the French had seized the Veronese more than two centuries before, could be visited virtually alone. The beautiful light-filled Renaissance room designed by Palladio had been restored, after suffering destruction at the hands of occupying powers, starting with Napoleon. In 1806, the French had shuttered the Benedictine convent and turned the refectory and other buildings into army barracks. Throughout the nineteenth century, the abbey continued to serve as a military base. Alterations and additions disfigured the architecture, and the refectory's Palladian interior was demolished. In the 1850s, the Austrians had torn up the floor and broken the space into two new levels. They turned the top floor into a makeshift theater for troops; on the ground floor, they installed a sawmill and carpentry shop. By the 1920s, San Giorgio Maggiore was in ruins.

The monastery remained abandoned until 1951, when the Venice industrialist Vittorio Cini acquired it. He restored the buildings, including

Palladio's refectory and the library designed in the seventeenth century by Baldassare Longhena. Cini established a cultural and scholarly foundation at San Giorgio Maggiore, in honor of his son Giorgio, who had been killed in a plane crash, and carrying on the tradition of the Benedictine monastery, which had been renowned as a center of learning. In 2006, the Cini Foundation commissioned the Madrid firm Factum Arte to make a full-scale digital reproduction of *The Wedding Feast at Cana*, which was printed on canvas and installed on the wall of the refectory where Veronese had painted the original.

Throughout the twentieth century, the Veronese was still acknowledged to be a transcendent work of Renaissance art, its greatness unquestioned by succeeding generations of art historians and commentators, who recognized the picture's aesthetic force, its significance in the history of Western art, the ways in which it had called forth Veronese's powers of invention, and its particular appeal to the eye and the intellect. The Veronese feast held people's gaze with the beauty of its palette, and with the structural and narrative complexity played out on a heroic scale. Despite the triumph of abstract art, Veronese's ability to conjure flesh-and-blood figures moving about in space and the texture of embroidered silk and the light playing over it with no more than brushstrokes of paint seemed no less miraculous. To the modern question "What is art?," asked in 1913 by Marcel Duchamp's *Bicycle Wheel* and often after, the Veronese still delivered a decisive answer.

The chance to see *The Wedding Feast at Cana* to some degree in the way Veronese imagined it would be seen in Palladio's refectory is to encounter it in the evening, when the Louvre is officially closed and emptied of the public it was designed to serve. Then the Grande Galerie reveals itself to be a spectacular corridor illuminated with barrel-vaulted skylights and lined with more than two hundred paintings. As the light fades outside and the room darkens, the Grande Galerie becomes the sort of space that art museums were once intended to be and that most of the Louvre galleries still are—secular houses of worship—devoted to the contemplation of paintings and sculpture.

In the evening, in the Salle des États, Veronese's *Wedding Feast at Cana* may appear as it did to Marco Boschini in Venice in 1660, when

he wrote: "This is not Painting, this is magic." Or the way that in 1671 it struck Giacomo Barri, who, in *The Painter's Voyage of Italy*, called the picture "a wonder of the world." He added: "And whosoever comes to Venice and departs without a sight of this Picture may be said to have seen nothing." One could say the same of Paris, once the French acquired the painting and unveiled it at the Louvre. There in the 1840s, the Veronese convinced the British critic John Ruskin of "the entire superiority of Painting to Literature as a test, expression, and record of human intellect." He went back many times. It was, he wrote in 1854, "always . . . as if an archangel had come down into the room and were working before my eyes."

The archangel was Veronese, painting at a time when artists carried out commissions and patrons chose their subjects. He was answering to the Benedictine abbot, whose decision to have him depict the miracle of Jesus changing water into wine gave the artist a subject that he handled with such brilliance that the canvas became a metaphor for the chance painters take to transform and to transfix experience, to shape life into art.

Notes

Abbreviations Used in the Notes

AN Archives Nationales (Paris)
ASV Archivio di Stato di Venezia

Introduction: "One of the greatest [paintings] ever made with a brush"

3 *"will cover it completely"*: Jean Habert, "La commande et la réalisation," in *Les Noces de Cana de Véronèse: une oeuvre et sa restauration*, ed. Jean Habert and Nathalie Volle (Paris: Réunion des Musées Nationaux, 1992), 43.

5 *looking straight out*: Frederick Ilchman observes, "Jesus is depicted . . . head on, like an icon." Frederick Ilchman, "The Death of Christ," in *Paolo Veronese: A Master and His Workshop in Renaissance Venice*, ed. Virginia Brilliant and Frederick Ilchman (Sarasota: John and Mable Ringling Museum of Art; London: Scala, 2012), 193.

5 *eight feet, like wainscoting*: Habert, "La commande," 36–37.

6 *"praised with eternal fame"*: Richard Cocke, *Paolo Veronese: Piety and Display in an Age of Religious Reform* (Aldershot, Eng.: Ashgate, 2001), 173.

6 *"greatest ever made with a brush"*: Denis Ton, "An Appraisal of the Critical Fortune of Veronese's *Wedding at Cana*," in *The Miracle of Cana: The Originality of Re-Production*, ed. Pasquale Gagliardi (Caselle di Sommacampagna, It.: Cierre Edizioni, 2011), 27.

6 *"amazes the whole universe"*: Marco Boschini, *Le ricche minere delle pittura veneziana*, in *Italian and Spanish Art, 1600–1750: Sources and Documents*, ed. Robert Enggass and Jonathan Brown (Evanston, Ill.: Northwestern University Press, 1999), 55.

6 *"not painting, it is magic"*: Marco Boschini, "La carta del navegar pitoresco," in Xavier F. Salomon, *Veronese* (London: National Gallery Company, 2014), 111.

6 *"variety of costumes, and invention"*: Giorgio Vasari, Raffaele Borghini, and Carlo Ridolfi, *Lives of Veronese*, ed. Xavier F. Salomon (London: Pallas Athene, 2009), 29.

6 *"And just because he was not Florentine"*: Salomon, *Veronese*, 23.

6 *individuals to introduce them*: Ton, "Appraisal," 33.

6 *the French*: Ibid., 27–33.

6 *"triumph of painting itself"*: Roger de Piles, *Abrégé de la vie des peintres, avec des réflexions sur leurs ouvrages* (Paris: Jacques Estienne, 1715), 273. The French translations were done by Patrick Errington.

7 *a stateroom at Versailles*: See Sylvie Béguin, *"The Feast in the House of Simon," Veronese: History and Restoration of a Masterpiece*, trans. Barbara Mellor (Paris: Alain de Gourcuff Éditeur, 1997).

7 *"most beautiful pieces in the world"*: Jean Le Rond d'Alembert and Denis Diderot, *Encyclopédie* (Paris: Briasson, 1755), 5:333.

8 *"loves glory and praise"*: Piero Del Negro, "The Republic of Venice Meets Napoleon," in *L'Europa scopre Napoleone, 1793–1804*, ed. Vittorio Douglas Scotti (Alessandria: Edizioni dell'Orso, 1999), 1:88.

8 *"for I am the Revolution"*: Andrew Roberts, *Napoleon: A Life* (New York: Penguin, 2015), 341.

8 *let loose the Terror*: Steven Englund, *Napoleon: A Political Life* (Cambridge, Mass.: Harvard University Press, 2004), 69.

9 *"worthy of entering"*: "Circulaire au Directoire," 24 Floréal IV [May 13, 1796], in *Correspondance des directeurs de l'Académie de France à Rome*, vol. 16, *1791–1797*, ed. Anatole de Montaiglon and Jules Guiffrey (Paris: Jean Schemit, 1907), 414.

1. "Send me a list of the pictures, statues, *cabinets* and curiosities"

11 *"brilliance of the arts and sciences"*: Wayne Hanley, *The Genesis of Napoleonic Propaganda, 1796–1799* (New York: Columbia University Press, 2002), 123.

11 *"Modena and Bologna"*: Andrew Roberts, *Napoleon: A Life* (New York: Penguin, 2015), 87.

12 *forty-nine thousand troops*: Ibid., 83.

12 *"the lava it has held back"*: Philip Dwyer, *Napoleon: The Path to Power, 1769–1799* (New Haven: Yale University Press, 2008), 168.

12 *"will leave their marks on history"*: J. M. Thompson, *Napoleon Bonaparte* (1952; repr., Oxford: Basil Blackwell, 1990), 63.

12 *"We do not march, we fly"*: Robert Asprey, *The Reign of Napoleon Bonaparte* (New York: Basic Books, 2002), 134.

13 *the French king's situation was of "common interest"*: Simon Schama, *Citizens: A Chronicle of the French Revolution* (New York: Random House, 1989), 590.

13 *"as did the mass of the Swiss"*: Adam Zamoyski, *Napoleon: A Life* (New York: Basic Books, 2018), 60.

13 *"recover their liberty"*: Dwyer, *Napoleon*, 148.

14 *"carry the war into Bavaria"*: Ibid., 209.

14 *"which may be useful to us"*: Roberts, *Napoleon*, 87.

14 *"needs of the moment?"*: Dwyer, *Napoleon*, 181–82.

14 *"there can be no victory"*: Felix Markham, *Napoleon* (New York: Signet Classics, 2010), 28.

14 *wheat, clothes, and shoes*: Roberts, *Napoleon*, 79.

14 *1,500 suffered by France*: Ibid., 84.

14 *eight thousand bottles*: Thompson, *Napoleon Bonaparte*, 68.

14 *"the force of the new"*: Steven Englund, *Napoleon: A Political Life* (Cambridge, Mass.: Harvard University Press, 2004), 100.

15 *"cold, polished and laconic"*: Roberts, *Napoleon*, 86.

15 *"heart remained oppressed"*: Dwyer, *Napoleon*, 208.

15 *to his generals*: Thompson, *Napoleon Bonaparte*, 62.

15 *eight hundred pieces of correspondence*: Roberts, *Napoleon*, 79.

15 *left five dead*: Dwyer, *Napoleon*, 246.

15 *"to take to send to Paris"*: Marie-Louise Blumer, "La commission pour la re-cherche des objets de sciences et arts en Italie (1796–1797)," in *La Révolution française* 87 (Paris: Éditions Rieder, 1934), 69.

16 *"those that are still to come"*: Ibid.

16 *"the French Republic"*: Andrew McClellan, *Inventing the Louvre: Art, Politics, and the Origins of the Modern Museum in Eighteenth-Century Paris* (Berkeley: University of California Press, 1999), 116.

16 *"the visit you will make"*: Édouard Pommier, "La saisie des oeuvres d'art," *Revue du Souvenir Napoléonien* 408 (1996), 30–43, Napoleon.org.

17 *"most brilliant conquest"*: Martin Rosenberg, "Raphael's *Transfiguration* and Napoleon's Cultural Politics," *Eighteenth-Century Studies* 19, no. 2 (Winter 1985–1986): 182.

17 *"Everywhere inhabitants flee"*: Dwyer, *Napoleon*, 201.

17 *"victory did the rest"*: Thompson, *Napoleon Bonaparte*, 63.

17 *"several have been already"*: Dwyer, *Napoleon*, 203.

17 *"residing in the duchy"*: Giuseppe Bertini, "Art Works from the Duchy of Parma and Piacenza Transported to Paris During the Napoleonic Time and Their Restitution," in *Napoleon's Legacy: The Rise of National Museums in Europe, 1794–1830*, ed. Ellinoor Bergvelt et al. (Berlin: G and H Verlag, 2009), 79n30.

18 *"choice of the General-in-Chief"*: Ibid.

18 *"offered a million to buy it back"*: Bonaparte to the Directory, May 18, 1796, in ibid., 75n10.

18 *"[paintings] in Italy"*: Charles-Nicolas Cochin, *Voyage d'Italie* (Paris: Ch. Ant. Jombert, 1758), I:65.

18 *one square foot*: Gerald Reitlinger, *The Economics of Taste: The Rise and Fall of the Picture Market, 1760–1960* (New York: Holt, Rinehart and Winston, 1961), 6.

19 *the duke would spend*: Bertini, "Art Works from the Duchy of Parma," 77.

20 *"the rest is nothing"*: Dwyer, *Napoleon*, 150.

20 *"as three is to one"*: Englund, *Napoleon*, 105.

20 *paintings chosen for the Louvre*: Hanley, *Genesis*, 116n20.

20 *"adorn the national museum"*: Blumer, "La commission," 1:80n2.

20 *"prize of treasures which it contains"*: Charles Delacroix to Bonaparte, May 17, 1796, in *Correspondance des directeurs de l'Académie de France à Rome*, vol. 16, *1791–1797*, ed. Anatole de Montaiglon and Jules Guiffrey (Paris: Jean Schemit, 1907), 16:418.

2. Venice need not "fear that the French Armies would not fully respect its neutrality"

21 *"where the money flows"*: Patricia Fortini Brown, "Where the Money Flows," in Frederick Ilchman, *Titian, Tintoretto, Veronese: Rivals in Renaissance Venice* (Boston: Museum of Fine Arts, 2009), 41.

21 *"felt by this [Piedmont] court"*: Philip Dwyer, *Napoleon: The Path to Power, 1769–1799* (New Haven: Yale University Press, 2008), 199.

21 *"the bare necessities"*: Piero Del Negro, "The Republic of Venice Meets Napoleon," in *L'Europa scopre Napoleone, 1793–1804*, ed. Vittorio Douglas Scotti (Alessandria: Edizioni dell'Orso, 1999), 1:83.

21 *"puffed up by his victory"*: Ibid., 1:84.

24 *"daring painter in the world"*: Robert Echols and Frederick Ilchman, "Almost a Prophet," in *Tintoretto: Artist of Renaissance Venice*, ed. Robert Echols and Frederick Ilchman (New Haven: Yale University Press, 2018), 17.

25 *"the* colorito *of Titian"*: Carlo Ridolfi, quoted in Robert Echols and Frederick Ilchman, "The Motto on the Wall," in *Tintoretto*, ed. Echols and Ilchman, 85.

26 *various hues and levels of quality*: Louisa C. Matthew, "'Vendecolori a Venezia': The Reconstruction of a Profession," *Burlington Magazine* 144, no. 1196 (2002): 680–86.

27 *Greece, and also from India*: Jean-Paul Rioux, "La matière picturale," in *Les Noces de Cana de Véronèse: une oeuvre et sa restauration*, ed. Jean Habert and Nathalie Volle (Paris: Réunion des Musées Nationaux, 1992), 134–42; Robert Wald, "Materials and Techniques of Painters in Sixteenth-Century Venice," in Ilchman, *Titian, Tintoretto, Veronese*, 79.

27 *Albrecht V of Bavaria*: Xavier F. Salomon, *Veronese* (London: National Gallery Company, 2014), 175–78.

28 *"the one refuge of honorable men"*: David Rosand, *The Myths of Venice: The Figuration of a State* (Chapel Hill: University of North Carolina Press, 2001), 7.

28 *self-sacrificing elite*: Ibid., 2.

29 *"other city that there ever was"*: Pietro Aretino, quoted in J. R. Hale, "Venice and Its Empire," in *The Genius of Venice, 1500–1600*, ed. Jane Martineau and Charles Hope (London: Royal Academy of Arts, 1983), 15.

29 *"more than fifty thousand"*: Arnold von Harff, quoted in "Prologue," in Loren W. Partridge, *The Art of Renaissance Venice 1400–1600* (Berkeley: University of California Press, 2015), xv.

30 *affluence, stability, and strength*: Paul Hills, *Venetian Colour: Marble, Mosaic, Painting and Glass, 1250–1550* (New Haven: Yale University Press, 1999), 4.

30 *"at anchor just by the houses"*: John Julius Norwich, *A History of Venice* (New York: Random House, 1982), 369.

30 *"paw with their feet"*: Patricia Fortini Brown, *Venice and Antiquity: The Venetian Sense of the Past* (New Haven: Yale University Press, 1997), 65.

30 *arch of triumph*: See Marilyn Perry, "Saint Mark's Trophies: Legend, Superstition, and Archaeology in Renaissance Venice," *Journal of the Warburg and Courtauld Institutes* 40 (1977): 28–29.

30 *"all the rest of Italy"*: Peter Humfrey, *Painting in Renaissance Venice* (New Haven: Yale University Press, 1995), 108.

31 *"painted by celebrated artists"* : Patricia Fortini Brown, *Private Lives in Renaissance Venice: Art, Architecture, and the Family* (New Haven: Yale University Press, 2004), 2.

32 *"there has the name of liberty"*: Montesquieu, in Margaret Plant, *Venice: Fragile City, 1797–1997* (New Haven: Yale University Press, 2002), 23.

33 *"fallen into decay"*: Rousseau, in ibid., 22.

33 *twenty-two Veroneses*: Charles Le Brun, *Inventaire Le Brun de 1683: La collection des tableaux de Louis XIV*, ed. Arnauld Brejon de Lavergnée (Paris: Ministère de la Culture et de la Communication/Réunion des Musées Nationaux, 1987).

33 *"none by Sebastiano Ricci"*: *Giambattista Tiepolo, 1696–1770*, ed Keith Christiansen (New York: Metropolitan Museum of Art, 1996), 131.

33 *"comparable to Raphael"*: Pierre Crozat to Michel-Ange de la Chausse, in Rochelle Ziskin, *Sheltering Art: Collecting and Social Identity in Early Eighteenth-Century Paris* (University Park: Pennsylvania State University Press, 2012), 21.

33 *front entrance*: Ibid.; see also Denis Ton, "An Appraisal of the Critical Fortune of Veronese's *Wedding at Cana*," in *The Miracle of Cana: The Originality of Re-Production*, ed. Pasquale Gagliardi (Caselle di Sommacampagna, It.: Cierre Edizioni, 2011), 33.

34 *"Danger is everywhere"*: Norwich, *A History of Venice*, 607.

34 *"such doctrines"*: R. R. Palmer, *The Age of the Democratic Revolution: A Political History of Europe and America, 1760–1800* (Princeton, N.J.: Princeton University Press, 2014), 400.

34 *"as there are Guns"*: Joseph Addison, *Remarks on Several Parts of Italy, &c. in the Years 1701, 1702, 1703* (London: Printed for Jacob Tonson, 1705), 88–89.

35 *"such a disastrous war"*: Del Negro, "The Republic of Venice Meets Napoleon," 86.

35 *"nothing to merit our regard"*: J. M. Thompson, *Napoleon Bonaparte* (1952; repr., Oxford: Blackwell, 1990), 71.

3. "Master Paolo will . . . not spare any expense for the finest ultramarine"

36 *"used by all the experts"*: Contract between Veronese and San Giorgio Maggiore for *The Wedding Feast at Cana*, June 6, 1562, Archivio di Stato di Venezia, San Giorgio Maggiore, busta 21, processo no. 10, in *Les Noces de Cana de Véronèse: une oeuvre et sa restauration*, ed. Jean Habert and Nathalie Volle (Paris: Réunion des Musées Nationaux, 1992), 43. The Italian translations were done by Iris Carulli.

37 *close to four feet, wide*: The width is 1.17 meters (3.84 feet) except for the lowest strip, which is 0.86 meters (2.82 feet). The Veronese's present dimensions are 6.765 by 9.940 meters (22.19 by 32.61 feet): see Nathalie Volle, "La restauration," in *Les Noces de Cana*, ed. Habert and Volle, 157.

37 *more than sixty-three pounds*: The linen weighed 426.6 grams per square meter. The painting measures 67.29 square meters, or 724.30 square feet. Ibid.

37 *construct a stretcher*: "Stretcher" is the modern term used for the wooden frames on which canvases are mounted; these expandable frames were developed in the eighteenth century. In sixteenth-century Venice, canvases were mounted on wooden frames, with fixed corners, today referred to as "strainers."

38 *"him when he requests it"*: Veronese contract, in *Les Noces de Cana*, ed. Habert and Volle, 43.

39 *"you welcomed me"*: Diana Gisolfi, *Paolo Veronese and the Practice of Painting in Late Renaissance Venice* (New Haven: Yale University Press, 2017), 115.

39 *the sky in ultramarine*: Gisolfi observes that in the sky Veronese applied some lead white and smalt under the ultramarine (ibid., 118).

39 Mars and Venus United by Love: Dorothy Mahon et al., "Technical Study of Three Allegorical Paintings by Paolo Veronese: *The Choice Between Virtue and Vice, Wisdom and Strength*, and *Mars and Venus United by Love*," *Metropolitan Museum Studies in Art, Science, and Technology* 1 (2010): 102.

40 *Scuola Grande di San Rocco*: Stefania Mason, "Tintoretto the Venetian," in *Tintoretto: Artist of Renaissance Venice*, ed. Robert Echols and Frederick Ilchman (New Haven: Yale University Press, 2018), 56.

40 *more than 4 square feet*: Rembrandt Duits, "*Abiti gravi, abiti stravaganti*: Veronese's Creative Approach to Drapery," in *Paolo Veronese: A Master and His Workshop in Renaissance Venice*, ed. Virginia Brilliant and Frederick Ilchman (Sarasota: John and Mable Ringling Museum of Art; London: Scala, 2012), 65.

40 *3 ducats a square ell*: Ibid.

40 *"in the wrong place"*: Ridolfi, in Xavier F. Salomon, *Veronese* (London: National Gallery Company, 2014), 78.

41 *"majestic architecture"*: Boschini, in ibid.

42 *"he obtained praise"*: Ridolfi, in ibid., 35.

42 *"as if they were his own sons"*: Vasari, in ibid., 40.

42 *"noblest buildings in Rome"*: Giorgio Vasari, Raffaele Borghini, and Carlo Ridolfi, *Lives of Veronese*, ed. Xavier F. Salomon (London: Pallas Athene, 2009), 43.

42 *"our Champ de Mars"*: D. A. Bingham, ed., *A Selection from the Letters and Dispatches of the First Napoleon* (London: Chapman and Hall, 1884), 1:92.

44 *carrying on other projects*: David Rosand, "Paolo Caliari: A Veronese Painter Triumphant in Venice," in *Paolo Veronese: A Master and His Workshop*, ed. Brilliant and Ilchman, 19–21.

44 *Barbaro's villa at Maser*: Salomon, *Veronese*, 115. Salomon calls *The Wedding Feast at Cana* "the religious counterpart of the Maser frescoes and the most spectacular and impressive of Veronese's refectory scenes."

45 *harmony with the cosmos above*: Inge Jackson Reist, *"Divine Love* and Veronese's Frescoes at the Villa Barbaro," *The Art Bulletin* 67, no. 4 (1985): 614–35.

45 *his first feast*, The Feast in the House of Simon: Santi Nazaro e Celso's Veronese feast is in the Galleria Sabauda, Turin.

45 *"alive and natural"*: Salomon, *Veronese*, 71.

46 *"and sat in the most honored place"*: Giuseppe Pavanello, "Più vino per la festa," in *The Miracle of Cana: The Originality of the Re-Production*, ed. Pasquale Gagliardi (Caselle di Sommacampagna, It.: Cierre Edizioni, 2011), 15–16.

46 *Palladio's room*: See Kate H. Hanson, "The Language of the Banquet: Reconsidering Paolo Veronese's Wedding at Cana," *InVisible Culture* 14 (Winter 2010): 32. Hanson writes, "While Veronese's work offered a marked contrast to the simple lines of the room, the actual and illusionistic architectural elements created the impression that the painting was in fact an extension of the space of the refectory." The refectory was about ninety-eight feet long and thirty-four feet wide; the ceiling was forty-three feet high.

47 *on the double bass*: Marco Boschini, *Le ricche minere della pittura veneziana*, in *Italian and Spanish Art, 1600–1750: Sources and Documents*, ed. Robert Enggass and Jonathan Brown (Evanston, Ill.: Northwestern University Press, 1999), 55.

47 *Veronese put his own portrait*: Rosand, "Paolo Caliari," 25.

48 *"mine hour is not yet come"*: Ibid., 26.

49 *"painter of beautiful things"*: Boschini, in Duits, *"Abiti gravi, abiti stravaganti,"* 59. Duits writes, "It has earned the painter a reputation of being 'decorative' and his paintings of lacking the seriousness of high drama." Duits also quotes Terisio Pignatti, who says that "Paolo remains fundamentally a great decorator" (ibid., 61).

49 *the visual splendor*: Inge Reist, "Classical Tradition: Mythology and Allegory," in *Paolo Veronese: A Master and His Workshop*, ed. Brilliant and Ilchman, 105. Reist

writes, "It is regrettable, then, that Paolo's exceptional artistic gifts and technical facility have too often drawn attention away from the remarkable intellectual depth of his work, a depth that arguably makes him more attuned to the thinking of his humanist patrons than either of his great Venetian rivals, Titian and Tintoretto."

49 *"clothes of different shapes"*: Duits, *"Abiti gravi, abiti stravaganti,"* 61–62.

50 *another* Feast: Veronese's *Feast in the House of Simon* that was painted for San Sebastiano is in the Pinacoteca di Brera, Milan; the *Feast in the House of Simon* painted for Santa Maria dei Servi is at the Château de Versailles. In 1572, Veronese painted *The Feast of St. Gregory the Great* in the Basilica of Monte Berico, in Vicenza.

50 *"furnishings worthy of any knight"*: Ridolfi, in Salomon, *Veronese*, 37.

51 *Giovanni Trevisan*: Ibid., 17.

51 *"books, [and] polygamy"*: Ibid., 20.

51 *"I paint and compose figures"*: Robert Klein and Henri Zerner, eds., *Italian Art, 1500–1600: Sources and Documents* (Evanston, Ill.: Northwestern University Press, 1966), 129.

51 *Venetian painters' guild*: David Rosand, *Painting in Sixteenth-Century Venice: Titian, Veronese, Tintoretto*, rev. ed. (Cambridge: Cambridge University Press, 1997), 6–7.

52 *"other Suppers"*: Klein and Zerner, *Italian Art*, 130.

52 *"the jesters take"*: Ibid., 131. See also Hugh Honour and John Fleming, "Veronese's Interrogation by the Inquisition," in *The Visual Arts: A History*, 5th ed. (New York: Harry N. Abrams, 1999), 501.

52 *"liberties of almost any kind"*: Salomon, *Veronese*, 17.

53 *"with little reverence"*: Klein and Zerner, *Italian Art*, 132.

53 *"improve and change his painting"*: Ibid.

53 "FECIT D[OMINVS]": Luke (5:29), in Salomon, *Veronese*, 20.

53 *"forty years of my life"*: Benedetto Caliari, January 11, 1591, in ibid., 36.

4. "He is rich in plans"

54 *"in a straightforward manner"*: Piero Del Negro, "The Republic of Venice Meets Napoleon," in *L'Europa scopre Napoleone, 1793–1804*, ed. Vittorio Douglas Scotti (Alessandria: Edizioni dell'Orso, 1999), 1:89.

55 *"looking sickly and frail"*: Steven Englund, *Napoleon: A Political Life* (Cambridge, Mass.: Harvard University Press, 2004), 149.

56 *"revealed a flame-like spirit"*: J. M. Thompson, *Napoleon Bonaparte* (1952; repr., Oxford: Blackwell, 1990), 70.

56 *"great activity and great courage"*: Englund, *Napoleon*, 70.

56 *trivial and important*: Andrew Roberts, *Napoleon: A Life* (New York: Penguin, 2015), 210.

56 *"logarithms of thirty or forty numbers"*: Ibid., 11.

57 *"all present in these new men"*: Del Negro, "The Republic of Venice Meets Napoleon," 1:88–89.

57 *"a pure eighteenth-century rationalist"*: R. R. Palmer, Joel Colton, and Lloyd Kramer, *A History of the Modern World* (New York: McGraw-Hill, 2007), 391.

57 *"what makes his politics"*: Englund, *Napoleon*, 268.

57 *"and often without bread"*: Philip Dwyer, *Napoleon: The Path to Power, 1769–1799* (New Haven: Yale University Press, 2008), 254.

58 *"himself by his steady work"*: Thompson, *Napoleon Bonaparte*, 8.

58 *"in a thousand circumstances"*: Roberts, *Napoleon*, 11.

58 *"the order of the day"*: Dwyer, *Napoleon*, 153.

58 *"an officer of transcendent merit"*: Englund, *Napoleon*, 67.

58 *he was detained*: Dwyer, *Napoleon*, 154–55.

59 *church of Saint Roch*: Roberts, *Napoleon*, 66.

59 *"or he will promote himself"*: Englund, *Napoleon*, 98.

59 *"they had a real leader"*: Thompson, *Napoleon Bonaparte*, 61–62.

61 *"brains of the priests"*: Roberts, *Napoleon*, 69.

61 *exceed those of Marie-Antoinette*: Roberts, *Napoleon*, 542; Philip Dwyer, *Citizen Emperor* (New Haven: Yale University Press, 2013), 320.

61 *"brilliantly without it"*: Roberts, *Napoleon*, 71.

62 *"what is her due"*: Thompson, *Napoleon Bonaparte*, 51.

5. "This museum must demonstrate the nation's great riches"

63 *"regime over the regime of old"*: Armand-Guy Kersaint, *Discours sur les monuments publics, prononcé au conseil du département de Paris, le 15 décembre 1791* (Paris: L'Imprimerie de P. Didot l'Aîné, 1792), 40.

64 *"There is urgency"*: Andrew McClellan, *Inventing the Louvre: Art, Politics, and the Origins of the Modern Museum in Eighteenth-Century Paris* (Berkeley: University of California Press, 1999), 91.

65 *"most remarkable part of the palace"*: Thomas Crow, *Painters and Public Life in Eighteenth-Century Paris* (New Haven: Yale University Press, 1985), 41.

65 *nineteen Veroneses*: Xavier F. Salomon, "The Regent's Collection of Venetian Paintings," in *The Orléans Collection*, ed. Vanessa I. Schmid and Julia I. Armstrong-Totten (New Orleans: New Orleans Museum of Art/D. Giles Limited, 2018), 117, 119, 122.

65 *"the Carracci . . . face to face"*: William Hazlitt, "On the Pleasure of Painting," in *Table Talk; or Original Essays* (London: J. M. Dent, c. 1908), 14.

66 *delivered to the "Old Louvre"*: "Catalogue des 125 tableaux enlevés de la surintendance de Versailles et transportés à Paris au Vieux-Louvre, par ordre de M. Roland, Ministre de l'Intérieur, les 17 et 18 septembre 1792," in Alexandre

Tuetey and Jean Guiffrey, *La commission du muséum et la création du Musée du Louvre* (Paris, 1910), 3–20.

66 *"spoils of a murdered monarch"*: Edward Hyde, Earl of Clarendon, *The History of the Rebellion and Civil Wars in England* (Oxford: Clarendon, 1807), 3:399.

67 *"illustrations of the French Republic"*: McClellan, *Inventing the Louvre*, 91–92.

67 *"an imposing school"*: Ibid., 91.

68 *"the last refuge of all aristocracies"*: William Vaughan and Helen Weston, "Introduction," in *David's The Death of Marat*, ed. William Vaughan and Helen Weston (Cambridge: Cambridge University Press, 2000), 13.

68 *"severity, rigor and discipline of Sparta"*: Warren E. Roberts, *Jacques-Louis David: Revolutionary Artist* (Chapel Hill: University of North Carolina Press, 1992), 26.

68 *"need careful handling"*: Jean-Baptiste-Marie Pierre to Joseph-Marie Vien, September 20, 1779, in Anita Brookner, *Jacques-Louis David* (London: Chatto and Windus, 1980), 53.

68 *"less of a hothead"*: Sophie Monnoret, *David and Neo-Classicism*, trans. Chris Miller and Peter Snowdon (Paris: Finest SA/Éditions Pierre Terrail, 1999), 69.

69 *"your glory that I wish to promote"*: Ibid., 96.

69 *"the crimes of an epoch"*: Vaughan and Weston, "Introduction," 18.

69 *"Marat can challenge Apollo"*: Charles Baudelaire, "The Museum of Classics at the Bazar Bonne-Nouvelle," in *Art in Paris 1845–1862*, trans. and ed. Jonathan Mayne (London: Phaidon, 1965), 35.

70 *"not that of savages and barbarians"*: McClellan, *Inventing the Louvre*, 94.

6. "Draw as much as you can from Venetian territory"

71 *"public tranquility will not be compromised"*: Francesco Battagia and Nicolò I Andrea Erizzo to the Venetian Senate, June 5, 1796, in Piero Del Negro, "The Republic of Venice Meets Napoleon," in *L'Europa scopre Napoleone, 1793–1804*, ed. Vittorio Douglas Scotti (Alessandria: Edizioni dell'Orso, 1999), 1:91.

72 *"will spare them any damage"*: Zan Battista Contarini to the Venetian Senate, Crema, May 11–12, 1796, in ibid., 84.

72 *"kindness shown him"*: Ibid., 85.

72 *"Yes, I am very tired"*: John Julius Norwich, *A History of Venice* (New York: Random House, 1982), 611.

72 *constructed in art and literature*: Philip Dwyer, *Napoleon: The Path to Power, 1769–1799* (New Haven: Yale University Press, 2008), 221.

73 *"Caesar and Alexander had a successor"*: Stendhal, *The Charterhouse of Parma*, trans. Richard Howard (New York: Modern Library, 2000), 3.

73 *chosen by the general in chief*: Dwyer, *Napoleon*, 225.

73 *"flag flies over all of Lombardy"*: D. A. Bingham, ed., *A Selection from the Letters and Dispatches of the First Napoleon* (London: Chapman and Hall, 1884), 86.

73 *"those by Michelangelo"*: Napoleon Bonaparte, *Letters and Documents of Napoleon*, ed. John Eldred Howard (New York: Oxford University Press, 1961), 1:120.

73 *"his gallery or his states"*: Marie-Louise Blumer, "La commission pour la recherche des objets de sciences et arts en Italie (1796–1797)," in *La Révolution française* 87 (Paris: Éditions Rieder, 1934), 68.

74 *"at the choice of the commissioners"*: Ibid.

74 *"possibly preventing greater evils"*: Zuanne Vincenti Foscarini to the Venetian Senate, June 1, 1796, in Del Negro, "The Republic of Venice Meets Napoleon," 1:86.

75 *"plundered Houses and violated Churches"*: Francesco Lippomano to Alvise Querini, May 18, 1796, in Francesco Lippomano, *Lettere familiari ad Alvise Querini negli anni 1795–1797*, ed. Giandomenico Ferri Cataldi (Rome: GEDI Gruppo Editoriale, 2010), 98.

75 *"require attention and counsel"*: Lippomano to Querini, May 28, 1796, in ibid., 102.

75 *"oppressed and sacrificed"*: Lippomano to Querini, May 28, 1796, in Del Negro, "The Republic of Venice Meets Napoleon," 1:87.

75 *"map of the Venetian states"*: Napoleon Bonaparte to Jean-Baptiste Lallement, May 17, 1796, in Napoleon Bonaparte, *The Bonaparte Letters and Despatches* (London: Saunders and Otley, 1846), 1:106.

75 *"carry out its orders"*: Norwich, *A History of Venice*, 612.

75 *"free will of the soldiers"*: Nicolò Foscarini to the Venetian Senate, Verona, May 24 and 26, 1797, in Del Negro, "The Republic of Venice Meets Napoleon," 1:87.

75–76 their *"violent ways"*: Foscarini to Bonaparte, May 24, 1796, in ibid.

76 that they *expel them*: Del Negro, "The Republic of Venice Meets Napoleon," 1:89.

76 *"with which to oppose"*: Giovanni Francesco Avesani and Leonardo Salimbeni, May 27, 1796, in ibid.

76 *"seized the town"*: Bonaparte to the Directory, June 4, 1796, in Norwich, *A History of Venice*, 614.

76 *"property will be respected"*: Bonaparte, May 29, 1796, in J. M. Thompson, *Napoleon Bonaparte* (1952; repr., Oxford: Blackwell, 1990), 78.

76 *"Venice as an enemy"*: Giacomo Giusti to the Venetian Senate, in Del Negro, "The Republic of Venice Meets Napoleon," 1:90.

76 *"appeased the French general"*: Giacomo Giusti to the Venetian Senate, in Cristoforo Tentori, ed., *Raccolta cronologico-ragionata di documenti inediti che formano la storia diplomatica della rivoluzione e caduta della Repubblica di Venezia: Corredata di critiche osservazioni* (Florence, 1800), 93.

77 *"the greatest contempt"*: Lippomano to Querini, June 1, 1796, in Del Negro, "The Republic of Venice Meets Napoleon," 1:90.

77 *"planted in some city"*: Lippomano to Querini, June 2, 1796, in Lippomano, *Lettere familiari*, 104–5. For liberty trees, see Lynn Hunt, *Politics, Culture, and Class in*

the French Revolution (Berkeley: University of California Press, 1984. Reprint, 2004), 59.

77 *1.7 million silver ducats*: John Hinckley, *An Accurate Account of the Fall of the Republic of Venice, and of the Circumstances Attending That Event* (London: Hatchard, 1804), 70.

77 *"the favorable moment"*: Norwich, *A History of Venice*, 614.

77 *"paying for nothing"*: Margaret Plant, *Venice: Fragile City, 1797–1997* (New Haven: Yale University Press, 2002), 26.

7. "The Pope will deliver . . . one hundred paintings, busts, vases or statues"

78 *"he wants to decorate his triumphs"*: *Le Moniteur universel*, June 6, 1796, in Marie-Louise Blumer, "La commission pour la recherche des objets de sciences et arts en Italie (1796–1797), in *La Révolution française* 87 (Paris: Éditions Rieder, 1934), 63–64.

78 *twenty-one million francs*: Philip Dwyer, *Napoleon: The Path to Power, 1769–1799* (New Haven: Yale University Press, 2008), 234–35.

78 *"aforementioned commissioners"*: Blumer, "La commission," 84.

80 *"place them in his garden"*: Francis Haskell and Nicholas Penny, *Taste and the Antique: The Lure of Classical Sculpture, 1500–1900* (New Haven: Yale University Press, 1981), 10.

81 *"the imitation of the ancients"*: Lorenz Eitner, ed., *Neoclassicism and Romanticism, 1750–1850* (Englewood Cliffs, N.J.: Prentice-Hall, 1970), 1:11; Johann Joachim Winckelmann, *Johann Joachim Winckelmann on Art, Architecture, and Archaeology*, trans. David Carter (Rochester: Camden House, 2013), 32.

81 *"almost a new Rome"*: Haskell and Penny, *Taste and the Antique*, 5.

81 *"everything of beauty in Italy"*: Ibid., 37.

81 *"busts from antiquity"*: Ibid., 37.

82 *"in exchange for the monuments"*: François Cacault to Charles Delacroix, July 1, 1796, in *Correspondance des directeurs de l'Académie de France à Rome*, vol. 16, *1791–1797*, ed. Anatole de Montaiglon and Jules Guiffrey (Paris: Jean Schemit, 1907), 423.

82 *"extended at their feet"*: Haskell and Penny, *Taste and the Antique*, 73.

82 *"could be made in Paris"*: Cacault to Delacroix, July 2, 1796, in Montaiglon and Guiffrey, eds., *Correspondance des directeurs*, 16:425.

83 *"the [Belvedere] Torso"*: Joseph-Jérôme Lalande, *Voyage en Italie, fait dans les années 1765 et 1766*, 2nd ed. (Paris: Veuve Desaint, 1786), 3:192. Lalande's book was first published in 1769 as *Voyage d'un François en Italie, fait dans les années 1765 et 1766*.

83 *despised ancien régime*: Haskell and Penny, *Taste and the Antique*, 109. They write, "The plunder chosen implied a tribute to consecrated taste." See also

Andrew McClellan, *Inventing the Louvre: Art, Politics, and the Origins of the Modern Museum in Eighteenth-Century Paris* (Berkeley: University of California Press, 1999), 119.

83 *"admiration of the entire world"*: McClellan, *Inventing the Louvre*, 132; Angelo Petracchi and Serafino Casella to Charles Delacroix, July 25, 1796, in Montaiglon and Guiffrey, eds., *Correspondance des directeurs*, 16:430–31.

83 *"to collect your passport"*: "Circulaire du Directoire," May 13, 1796, in ibid., 414.

84 *"Politics are at war"*: Joseph Banks to Jacques-Julien de Labillardière, June 9, 1796, in Elise Lipkowitz, "Seized Natural-History Collections and the Redefinition of Scientific Cosmopolitanism in the Era of the French Revolution," *British Journal for the History of Science* 47 (2014): 15.

84 *"near vandalism"*: Directory to Napoleon Bonaparte, May 31, 1796, in Édouard Pommier, "La saisie des oeuvres d'art," *Revue du Souvenir Napoléonien* 408 (1996), 30–43, Napoleon.org.

84 *"been our stumbling block"*: Blumer, "La commission," 72.

85 *"love for science"*: Auger, "Nécrologie," *Annales de la littérature étrangère*, vol. 9 (1822), in Maurice Crosland, *The Society of Arcueil: A View of French Science at the Time of Napoleon I* (Cambridge, Mass.: Harvard University Press, 1967), 101.

86 *commissioned by Lavoisier*: For David's painting, see Katherine Baetjer, *French Paintings in the Metropolitan Museum of Art from the Early Eighteenth Century Through the Revolution* (New York: Metropolitan Museum of Art, 2018), 317–24.

88 *"protect science"*: Bonaparte to the Directory, October 18, 1797, in Napoleon Bonaparte, *Letters and Documents of Napoleon*, ed. John Eldred Howard (New York: Oxford University Press, 1961), 206.

89 *"in the highest degree"*: Banks to William Price, August 4, 1796, in Lipkowitz, "Seized Natural-History Collections," 39.

90 *"Total 110"*: Bonaparte to the Directory, July 2, 1796, in Napoléon Bonaparte, *Correspondance générale*, vol. 1, *Apprentissages, 1784–1797*, ed. Thierry Lentz (Paris: Fayard, 2004), 483–84.

90 *in the Vatican museum*: Cacault to Azara, August 5, 1796, in de Montaiglon and Guiffrey, eds., *Correspondance des directeurs*, 16:447–49.

90 *"as well as Beautiful"*: Jonathan Richardson, *An Account of Some of the Statues, Bas-reliefs, Drawings and Pictures in Italy* (London: J. Knapton, 1722), 276.

91 *"to do our duty"*: Gaspard Monge to Catherine Huart, August 3, 1796, in Nicole Dhombres, "Gaspard Monge, membre de l'Institut et commissaire des sciences et des arts en Italie: Regard sur une correspondance (June 1796–October 1797)," in Jean-Paul Barbe and Roland Bernecker, *Les intellectuels européens face à la campagne d'Italie (1796–1798)* (Münster: Nodus Publikationen, 1999), 119.

91 *Boulanger was escorted back*: "Mémoire de Boulanger" and "Mémoire de Gaulle," August 8, 1796, in de Montaiglon and Guiffrey, eds., *Correspondance des directeurs*, 16:450–52.

91 *"nothing" to help:* Cacault to Delacroix, August 11, 1796, in ibid., 16:454.

91 *the most famous statues*: Cacault to Delacroix, August 15, 1796, in ibid., 16:462–67.

91 *"divine" work*: Giorgio Vasari, *The Lives of the Most Excellent Painters, Sculptors, and Architects*, ed. Philip Jacks, trans. Gaston du C. de Vere (New York: Modern Library, 2006), 291.

92 *Raphael was gracious*: For the French view of Raphael, see Martin Rosenberg, "Raphael's *Transfiguration* and Napoleon's Cultural Politics," *Eighteenth-Century Studies* 19, no. 2 (Winter 1985–1986): 180–205.

92 *"closest to these inimitable models"*: Ibid., 188.

92 *"taken off their pedestals"*: Commissaires du Gouvernement à la Recherche des objets de sciences et arts, to Delacroix, August 25, 1796, in Montaiglon and Guiffrey, eds., *Correspondance des directeurs*, 16:470.

92 *"a packet of French gazettes"*: Monge to Huart, September 8, 1796, in Dhombres, "Gaspard Monge," 122.

93 *"masterpieces of painting and sculpture"*: "Petition Presented by Artists to the Executive Members of the Directory," in Antoine Quatremère de Quincy, *Letters to Miranda and Canova: On the Abduction of Antiquities from Rome and Athens*, intro. Dominique Poulot, trans. Chris Miller and David Gilks (Los Angeles: Getty Research Institute, 2012), 101.

93 *"the true museum"*: Haskell and Penny, *Taste and the Antique*, 110.

93 *"armistice will be carried out"*: Monge to Huart, September 8, 1796, in Dhombres, "Gaspard Monge," 122.

93 *"in force everywhere"*: Bonaparte to the Directory, June 21, 1796, in Bonaparte, *Correspondance générale*, 1:462–63.

93 *"or lie in hospital"*: Adam Zamoyski, *Napoleon: A Life* (New York: Basic Books, 2018), 145.

93 *On August 21*: John Julius Norwich, *A History of Venice* (New York: Random House, 1982), 615.

94 *had been "suspended"*: Cacault to Delacroix, September 24, 1796, in Montaiglon and Guiffrey, eds., *Correspondance des directeurs*, 16:478.

8. "I'm on a path a thousand times more glorious"

95 *"the new one"*: Antoine-Jean Gros to Madeleine-Cécile Durand, November 23, 1792, in David O'Brien, *After the Revolution: Antoine-Jean Gros, Painting and Propaganda Under Napoleon* (University Park: Pennsylvania State University Press, 2006), 43.

95 *"excited this desire"*: Ibid., 32.

95 *signified his republican politics*: Alan Wintermute, ed., *1789: French Art During the Revolution* (New York: Colnaghi, 1989), 216–17.

97 *"turn the pages of your Plutarch"*: Kenneth Clark, *The Romantic Rebellion: Romantic Versus Classic Art* (New York: Harper and Row, 1973), 21.

97 *"without financial resources"*: O'Brien, *After the Revolution*, 24.

97 *"volatile, impressionable"*: Thomas Crow, *Emulation: David, Drouais, and Girodet in the Art of Revolutionary France* (New Haven: Yale University Press; Los Angeles: Getty Research Institute, 1995), 193.

97 *"David has made himself detestable"*: Ibid., 194.

99 *"I am, a painter/errand boy"*: Gros to Durand, May 16, 1796, in O'Brien, *After the Revolution*, 30.

99 *"Genoa a few months ago"*: Gros to Durand, August 8, 1796, in Philippe Bordes, "A-J Gros en Italie (1793–1800): Lettres, une allégorie révolutionnaire et un portrait," *Bulletin de la Société de l'histoire de l'art français* (1978): 241.

99 *getting him back to Paris*: O'Brien, *After the Revolution*, 36, writes: "Gros recognized that a portrait of the hero whose stunning military success in Italy had seized all Europe's attention could establish his reputation at the Salon. . . . Gros recognized that Bonaparte at Arcole was a subject full of the drama and significance found in history paintings."

99 *"is very, very unhappy"*: Andrew Roberts, *Napoleon: A Life* (New York: Penguin, 2015), 124.

100 *"Bonaparte more or less was"*: O'Brien, *After the Revolution*, 32.

100 *"You are a pupil of David?"*: Gros to Durand, December 6, 1796, in J. B. Delestre, *Gros: Sa vie et ses ouvrages* (Paris: J. Renouard, 1867), 34.

100 *"sent to you"*: Philippe Bordes, *Jacques-Louis David: Empire to Exile* (New Haven: Yale University Press, 2005), 75.

100 *"its form"*: Delestre, *Gros*, 34; Philip Dwyer, *Napoleon: The Path to Power, 1769–1799* (New Haven: Yale University Press, 2008), 5.

100 *"see the head almost done"*: Delestre, *Gros*, 34–35.

101 *"cold and severe"*: Dwyer, *Napoleon*, 5.

101 *enemies of France*: O'Brien, *After the Revolution*, 32–34. "The sketch for the portrait is much more famous that the portrait itself, and perhaps justly so when we consider its stunning and, for the period, completely unexpected painterly flourish that conveys so well the drama and energy of the subject."

102 *"to be a history painting"*: Ibid., 36.

102 *five thousand francs*: Laura Angelucci, *Inventaire général des dessins. École française. Antoine Jean Gros (1771–1835)* (Paris: Musée du Louvre, 2019), 264.

102 *additional engravings*: O'Brien, *After the Revolution*, 246n83.

102 *"Austrians fought so well"*: Dwyer, *Napoleon*, 3.

102 *"attempt the crossing again"*: O'Brien, *After the Revolution*, 34.

102 *"I had ever dared to hope for"*: Gros to Durand, December 6, 1796, in Crow, *Emulation*, 238.

102 *"more about our destinations"*: Gros to Durand, January 9, 1797, Fondation Custodia, Collection Frits Lugt, Paris, France, inv. no. 1991-A, 506.

103 *"as quickly as possible"*: Treaty of Tolentino, February 19, 1797, in *Correspondance des directeurs de l'Académie de France à Rome*, vol. 16, *1791–1797*, ed. Anatole de Montaiglon and Jules Guiffrey (Paris: Jean Schemit, 1907), 498.

103 *"objects in Turin and Naples"*: Napoleon Bonaparte to the Directory, February 19, 1797, in Dwyer, *Napoleon*, 237.

103 *"to see everything before I leave"*: Gros to Durand, March 31, 1797, in O'Brien, *After the Revolution*, 38.

103 *"we can only overcome with time"*: Commissaires du Gouvernement to Charles Delacroix, April 17, 1797, in *Correspondance des directeurs de l'Académie de France à Rome*, vol. 17, *1797–1804*, ed. Anatole de Montaiglon and Jules Guiffrey (Paris: Jean Schemit, 1908), 1.

104 Belvedere Torso: "Composition du Deuxième Convoi des Monuments des Arts Sortis de Rome," May 9, 1797, in de Montaiglon and Guiffrey, eds., *Correspondance des directeurs*, 17:8–9.

104 *"with such masterpieces"*: O'Brien, *After the Revolution*, 38.

105 *and had reached Livorno*: François Cacault to Delacroix, July 15, 1797, in de Montaiglon and Guiffrey, eds., *Correspondance des directeurs*, 17:63.

105 *"overcome the republican escort"*: Charles-Godefroy Redon de Belleville to Charles-Maurice de Talleyrand-Périgord, August 11, 1797, in ibid., 17:83.

9. "The Republic of Venice will surrender . . . twenty paintings"

106 *"an existence of near 1400 years"*: David Laven, "The Fall of Venice: Witnessed, Imagined, Narrated," *Acta Histriae* 19/3 (2011): 346.

106 *side with the French Republic*: George B. McClellan, *Venice and Bonaparte* (Princeton, N.J.: Princeton University Press, 1931), 167.

106 *"to a sorrowful humanity?"*: Philip Dwyer, *Napoleon: The Path to Power, 1769–1799* (New Haven: Yale University Press, 2008), 283–84.

107 *"war is declared"*: John Julius Norwich, *A History of Venice* (New York: Random House, 1982), 619.

107 *"punishments that they won't forget"*: Andrew Roberts, *Napoleon: A Life* (New York: Penguin, 2015), 139.

107 *"the city or to individuals"*: Marie-Louise Blumer, "La commission pour la recherche des objets de sciences et arts en Italie (1796–1797)," in *La Révolution française* 87 (Paris: Éditions Rieder, 1934), 142.

108 *"no more bitter enemies"*: Dwyer, *Napoleon*, 293.

108 *"Attila to the state of Venice"*: Norwich, *A History of Venice*, 625.

108 *"direct the police of Venice"*: Ibid., 626.

108 *"has to be publicly condemned"*: Dwyer, *Napoleon*, 295.

109 *"a favor from you"*: McClellan, *Venice and Bonaparte*, 227–28.

109 *"the face of the map"*: Dwyer, *Napoleon*, 295.

109 establish a new democracy: McClellan, *Venice and Bonaparte*, 230.

109 *"beloved inhabitants"*: Norwich, *A History of Venice*, 630.

109 *"Vote! Vote!"*: Ibid., 631.

110 *French troops entered Venice*: Margaret Plant, *Venice: Fragile City, 1797–1997* (New Haven: Yale University Press, 2002), 26.

110 *"five hundred manuscripts"*: Napoléon Bonaparte, *Correspondance de Napoléon Ier publiée par l'ordre de l'empereur Napoléon III* (Paris: Plon, 1858–1870), 3:51.

10. "In the Church of St. George . . . *The Wedding Feast at Cana*"

111 *"Titian in Santa Maria Maggiore"*: Pietro Edwards to Comitato di Salute Pubblica della Municipalità Provvisoria Veneziana, ca. August 24, 1797, Miscellanea Atti Diplomatici e privati (908–1860), b. 73, n. 2148, ASV.

111 *"choice of the paintings and manuscripts"*: Jean-Baptiste Lallement to Gouvernement Provisoire de Venise, June 19, 1797, Municipalità Provvisoria (1797–1798), b. 181, ASV.

111 *"introduced into France"*: C. L. Berthollet and A. B. Berthollet, *Elements of the Art of Dyeing; With a Description of the Art of Bleaching by Oxymuriatic Acid*, 2nd ed. (London: Thomas Tegg, 1824), 1:23.

113 *"no airs and many graces"*: Sir Humphry Davy, in Maurice P. Crosland, *The Society of Arcueil, a View of French Science at the Time of Napoleon I* (Cambridge, Mass.: Harvard University Press, 1967), 101.

113 *"the distractions available in Venice"*: Paolo Preto, "Un 'uomo nuovo' dell'età napoleonica: Vincenzo Dandolo politico e imprenditore agricolo," *Rivista Storica Italiana* 94, no. 1 (1982): 47.

114 *"the day of regeneration"*: Margaret Plant, *Venice: Fragile City, 1797–1997* (New Haven: Yale University Press, 2002), 27.

114 could place *"the objects"*: Vincenzo Dandolo to Deputazione agli Alloggi, June 18, 1797, Municipalità Provvisoria (1797–1798), b. 181, ASV.

115 *Edwards to meet Berthollet*: Edwards to Comitato di Salute Pubblica, ca. August 24, 1797, Miscellanea Atti Diplomatici e privati (908–1860), b. 73, c. 2148, ASV.

115 *"M. Edoas"*: Joseph-Jérôme Lalande, *Voyage d'un français en Italie, fait dans les années 1765 et 1766*, 2nd ed. (Paris: Veuve Desaint, 1786), 8:385–86.

115 *"state of our depot in Livorno"*: Commissaires du Gouvernement to Charles Delacroix, July 8, 1797, in *Correspondance des directeurs de l'Académie de France à Rome*, vol. 17, *1797–1804*, ed. Anatole de Montaiglon and Jules Guiffrey (Paris: Jean Schemit, 1908), 49.

115 *"ceded to the Republic of France"*: Lallement to Comité de salut public, July 29, 1797, Municipalità Provvisoria (1797–1798), b. 181, ASV.

115 *list of sixteen paintings*: Claude Berthollet, Jean-Simon Berthélemy, and Jacques-Pierre Tinet, "Liste des tableaux qui doivent être livrés à la République française, en vertu du traité conclu entre le général en chef de l'Armée d'Italie et le gouvernement de Venise," ca. August 6, 1797, Demanio, Buste Edwards (1797–1819), b. 1, ASV.

115 *"Palazzo Grimani di San Luca"*: Commissaires du Gouvernement Français pour la recherche des objets des Sciences et Arts en Italie to Lallement, August 6, 1797, F17/1275/B-C in F/17/1275 (a) "Commission des Arts-Registre d'en-registrement des Procès verbaux d'arts. Et suite de la correspondance; lettres; ordres; états ordonnancés," AN.

115 *request on to the Venetians*: Lallement to La Municipalité Provisoire de Venise, August 8, 1797, Municipalità Provvisoria (1797–1798), b. 181, ASV.

116 *some 759 pictures*: Giovanni O'Kelly Edwards and Pietro Edwards, "On the Restoration of the Royal Paintings of Venice (1812 and 1833)," in *Issues in the Conservation of Paintings*, ed. David Bomford and Mark Leonard (Los Angeles: Getty Conservation Institute, 2004), 48.

116 *damage to Venice's pictures*: Elizabeth Darrow, "Pietro Edwards: The Restorer as 'Philosophe,'" *Burlington Magazine* 159 (2017): 310.

116 *"gift of a Titian or a Paolo [Veronese]"*: Elizabeth Darrow, "Pietro Edwards and the Restoration of the Public Pictures of Venice, 1778–1819: Necessity Introduced These Arts" (PhD diss., University of Washington, 2000), 53.

117 *effects of color had "seduced everyone"*: Ibid., 92–93.

117 *"Treaty concerning the Arts"*: Commissaires du Gouvernement to Edwards, August 26, 1797, Demanio, Buste Edwards (179–1819), b. 1, ASV.

118 *"glazing, finishing and harmonizing"*: Johann Wolfgang Goethe, *Goethe's Travels in Italy: Together with His Second Residence in Rome and Fragments on Italy* (London: George Bell and Sons, 1885), 576.

118 *"no more view painters of quality"*: Francis Haskell, "Francesco Guardi as Vedutista and Some of His Patrons," *Journal of the Warburg and Courtauld Institutes* 23, no. 3–4 (July–December 1960): 257.

118 *"our national greatness and genius"*: Edwards to Comitato di Salute Pubblica, ca. August 24, 1797, Miscellanea Atti Diplomatici e privati (908–1860), b. 73, c. 2148, ASV.

118 *"caused me great pain"*: Ibid.

118 *Tinet, and by Berthollet*: Berthollet, Berthélemy, and Tinet, "Liste des tableaux," ca. August 6, 1797, Demanio, Buste Edwards (1797–1819), b. 1, ASV.

118 *in a free-flowing hand*: "Nota dei quadri che debbono essere consegnati alla Repubblica Francese in virtù del trattato concluso tra il generale, et capo

dell'Armata d'Italia, ed il governo di Venezia," ca. August 6, 1797, Demanio, f. Edwards, f. I (1797), ASV.

120 *"done so under protest"*: Edwards to Comitato di Salute Pubblica, ca. August 24, 1797, Miscellanea Atti Diplomatici e privati (908–1860), b. 73, c. 2148. ASV.

122 *"as the bended knee"*: Henry James, *Italian Hours*, ed. John Auchard (New York: Penguin, 1992), 27.

123 *letter to the Venetian Committee*: Edwards to Comitato di Salute Pubblica, ca. August 24, 1797, Miscellanea Atti Diplomatici e privati (908–1860), b. 73, c. 2148, ASV.

125 *"painting in danger"*: Edwards to Comitato di Salute Pubblica, ca. August 24, 1797, Miscellanea Atti Diplomatici e privati (908–1860), b. 73, c. 2148, ASV. See also Commissaires du Gouvernement to Edwards, August 26, 1797, Demanio, Buste Edwards (1797–1819), b. 1, ASV.

125 *"was not in good condition either"*: Edwards to Comitato di Salute Pubblica, ca. August 24, 1797, Miscellanea Atti Diplomatici e privati (908–1860), b. 73, c. 2148, ASV.

125 *documenting the papal visit*: The Guardi painting of the refectory in Santi Giovanni e Paolo is *Pope Pius VI Descending the Throne to Take Leave of the Doge in the Hall of SS. Giovanni e Paolo*, 1782, in the Cleveland Museum of Art. See George A. Simonson, "Guardi's Pictures of the Papal Benediction in Venice, 1782," in *Burlington Magazine* 36, no. 203 (1920): 93–94.

126 *"by the horses"*: Commission des Arts to Général en Chef, August 4, 1797, F/17/1275/B-/C in F/17/1275 (a) "Commission des Arts-Registre d'enregistrement des Procès verbaux d'arts. Et suite de la correspondance; lettres; ordres; états ordonnancés, 267," AN.

126 *"have other means"*: Ibid.

126 *"twenty in the terms of the treaty"*: Commissaires du Gouvernement to Edwards, August 26, 1797, Demanio, Buste Edwards (1797–1819), b. 1, ASV.

126 *"representing a sacrifice"*: Commissaires du Gouvernement to la Municipalité, August 21, 1797, F/17/1275/B-C, in F/17/1275 (a) "Commission des Arts-Registre d'enregistrement des Procès verbaux d'arts. Et suite de la correspondance; lettres; ordres; états ordonnancés, 285," AN.

127 *the Venetians had approved the list*: Lallement to Comité de salut public, August 30, 1797, Municipalità Provvisoria (1797–1798), b. 181, ASV.

127 *"about fifteen days"*: Edwards to Commissione delle Ricerche Francesi, June 29, 1797, and Edwards, "Con ordine del Deputato, agl'alloggiamenti Militari," ca. August 24, 1797, both in Demanio, Buste Edwards (1797–1819), b. 1, ASV.

127 *"where they will be relocated"*: Edwards, "Con ordine del Deputato," ca. August 23, 1797, Demanio, Buste Edwards (1797–1819), b. 1, ASV.

127 *"and the move completed"*: Pietro Edwards, "Memoria confusa, dal memoriale pro-
dotto alla municipalità," August 23, 1797, Demanio, Buste Edwards (1797–1819),
b. 1, ASV.

11. "We . . . have received from Citizen Pietro Edwards"

128 *"around the containers"*: Pietro Edwards to Comitato di Salute Pubblica,
ca. August 24, 1797, Miscellanea Atti Diplomatici e privati (908–1860), b. 73,
c. 2148, ASV.

128 *"artificial floor"*: Nathalie Volle, "Les déplacements et les restaurations suc-
cessives," in *Les Noces de Cana de Véronèse: une oeuvre et sa restauration*, ed.
Jean Habert and Nathalie Volle (Paris: Réunion des Musées Nationaux,
1992), 91.

129 *tore through the fabric*: Lola Faillant-Dumas, "La plus grande radiographie réa-
lisée au Louvre," in ibid., 110.

129 *iron nails had been driven*: Ibid., 110.

129 *touches of putty and paint*: Dorothy Mahon and Dianne Modestini offered the
hypothesis that the rows of nails on *The Wedding Feast at Cana* had been placed
there sometime after the painting was completed.

129 *"this painting over to you"*: Gloria Tranquilli, "Venti capolavori in cambio per
la libertà: Pietro Edwards, 'Cittadino amoroso,' partecipa fra orgoglio di patria
e tormenti dell'anima all'adempimento del Trattato di Milano," in *Arte nelle
Venezie: Scritti di amici per Sandro Sponza*, ed. Chiara Ceschi, Pierluigi Fantelli,
and Francesca Flores d'Arcais (Saonara: Il Prato, 2007), 185.

129 *"have caused further flaking"*: Une autre liste des tableaux choisis à Venise, Septem-
ber 30, 1797, in Volle, "Les déplacements," 92.

130 *"reprimands at this crew"*: Edwards to Comitato di Salute Pubblica, ca. August
24, 1797, Miscellanea Atti Diplomatici e privati (908–1860), b. 73, c. 2148.
ASV. See also Emanuela Zucchetta, "La Chiesa di San Zaccaria: La pala di
San Zaccaria," in *Bellini a Venezia: Sette opere indagate nel loro contesto*, ed. Gi-
anluca Poldi and Giovanni Carlo Federico Villa (Milan: Silvana, 2008), 169.

130 *"weigh[ed] about three thousand pounds"*: Edwards to Comitato di Salute Pub-
blica, ca. August 24, 1797, Miscellanea Atti Diplomatici e privati (908–1860),
b. 73, c. 2148, ASV.

130 *"the passage over water"*: Ibid.

132 *"wrapped and encased"*: Ibid.

132 *they sent this list*: Commissionaires du Gouvernement à la recherche des objets
de Sciences et des Arts, to Charles-Maurice de Talleyrand-Périgord, Septem-
ber 14, 1797, F/17/1275 (a), "Commission des Arts-Registre d'enregistrement
des Procès verbaux d'arts. Et suite de la correspondance; lettres; ordres; états
ordonnancés, 302," AN.

132 *order in which they had been rolled*: Commissionaires du Gouvernement (Ber-
thollet, Tinet, Berthélemy), Procès verbal, September 11, 1797, and Talleyrand,
Ministre des Relations extérieures, to Ministre de l'Intérieur, September 30,
1797, both in F/17/1275 (a), "Commission des Arts-Registre d'enregistrement
des Procès verbaux d'arts. Et suite de la correspondance; lettres; ordres; états
ordonnancés, 302," AN.

133 *"its surface touches nothing"*: Marie-Louise Blumer, "Le transport en France des
objets d'art cédés par le Traité de Tolentino," *Revue des Études Italiennes* 1, no.
1 (January–March 1936), 17–18.

133 *"Republic of France, the following"*: Commissaires du Gouvernement to Ed-
wards, September 14, 1797, Miscellanea Atti Diplomatici e privati (908–1816),
b. 73, c. 2148, ASV.

133 *"detached and delivered"*: Edwards, "Nota dei pezzi di pittura, et scultura,"
September 14, 1797, Miscellanea Atti Diplomatici e privati, b. 73, c. 2148,
ASV.

134 *"feel remorse and envy"*: Edwards to Comitato di Salute Pubblica, ca. Au-
gust 24, 1797, Miscellanea Atti Diplomatici e privati, b. 73, c. 2148, ASV.

134 *"harvested in Italy"*: *Liste des principaux objets de science et d'art recueillis en Italie
par les commissaires du gouvernement français*, Venice, 1 complémentaire, V.

134 *selection of ancient manuscripts*: Napoleon Bonaparte to Louis-Alexandre
Berthier, August 16, 1797, in Napoléon Bonaparte, *Correspondance générale*,
vol. 1, *Apprentissages, 1784–1797*, ed. Thierry Lentz (Paris: Fayard, 2004), 1117;
Bonaparte to the Directory, September 13, 1797, in ibid., 1:1169

134 *"accompany distinguished talent"*: Bonaparte to the Directory, September 13,
1797, in Wayne Hanley, *The Genesis of Napoleonic Propaganda, 1796–1799* (New
York: Columbia University Press, 2005), 118.

134 *tribute to his conquests*: Philip Dwyer, *Napoleon: The Path to Power, 1769–1799*
(New Haven: Yale University Press, 2008), 345.

135 *"pure and great giant of glory"*: Ibid., 322.

135 *"real goal was to attract it"*: Ibid., 323.

135 *"be in our possession"*: Bonaparte to Berthier, December 12, 1797, *Correspon-
dance de Napoléon 1er publiée par l'ordre de l'empereur Napoléon III* (Paris: Plon,
1859), 3:458.

12. "The most secure way would be to send them on a frigate, with 32 cannons"

137 *"suffer even minimum damage"*: Gaspard Monge, Jacques-Pierre Tinet, Jean-
Guillaume Moitte, and Jean-Simon Berthélemy to the Directory, July 1, 1797,
in Gaspard Monge, *Dall'Italia (1796–1798)*, ed. Sandro Cardinali and Luigi
Pepe (Palermo: Sellerio, 1993), 243–44.

137 *"ship adequate for the transport"*: Commission des Arts to Jean-Baptitste Lal-lement, September 15, 1797, 304, and Commission des Arts to Napoleon Bonaparte, September 18, 1797, 314, both in F/17/1275/B-/C, F/17/1275 (a), in-folio, ouvrage relié: "Commission des Arts-Registre d'enregistrement des Procès verbaux d'arts. Et suite de la correspondance; lettres; orders; états ordon-nancés," AN.

138 *"other ordinary accidents"*: Georges de Virenque, "Les chefs-d'oeuvre de l'art Italien à Paris, en 1796," *Revue Bleue*, 4th ser., 3 (1895): 561–62.

138 *"the first good weather"*: Ibid., 562.

138 *"blamed by the entire world"*: Moitte, Tinet, Monge, and Berthélemy to Charles Delacroix, May 5, 1797, in Monge, *Dall'Italia*, 230.

139 *On July 15, 1798*: For the voyage, see Marie-Louise Blumer, "Le transport en France des objets d'art cédés par le Traité de Tolentino," *Revue des Études Italiennes* 1, no. 1 (January–March 1936): 17–18.

139 *"province of the French Republic"*: Steven Englund, *Napoleon: A Political Life* (Cambridge, Mass.: Harvard University Press, 2004), 125.

139 *the study of ancient Egypt*: Ibid., 127–28.

139 *across the French capital*: See Patricia Mainardi, "Assuring the Empire of the Future: The 1798 Fête de la Liberté," *Art Journal* 48, no. 2 (1989): 155–163.

139 *"It is all in Paris"*: Ibid., 155.

139 *"like crates of soap?"*: Ibid., 157.

140 *"not change again"*: *Fêtes de la liberté et entrée triomphale des objets de sciences et d'arts recueillis en Italie* (Paris: L'Imprimerie de la République, 1798), 7; Andrew Mc-Clellan, *Inventing the Louvre: Art, Politics, and the Origins of the Modern Museum in Eighteenth-Century Paris* (Berkeley: University of California Press, 1999), 123. Mainardi, "Assuring the Empire," 155, writes: "The art [of Rome] did embody a double authority, both cultural and political; through the agency of these objects both Romes were symbolically relocated in Paris."

140 *"Here are your masters!"*: Mainardi, "Assuring the Empire," 158–59.

141 "in a free land": Ibid., 158.

141 *"embellishes their palettes"*: *Fêtes de la liberté*, 8.

141 *to the parade at all*: Blumer, "Le transport," 21n1.

141 *any right to Italy's art*: Bénédicte Savoy writes: "Indeed the theft of artworks and looting of libraries are not just illegal acts, they also inflict emotional wounds that heal only with great difficulty or not at all." Savoy, "Plunder, Restitution, Emotion and the Weight of Archives: An Historical Approach," in *Echoes of Exile: Moscow Archives and the Arts in Paris, 1933–1945*, ed. Ines Rotermund-Rynard (Boston: De Gruyter, 2015), 32.

141 *"hatred and revenge"*: Ibid., 32–33.

13. "The seam . . . will be unstitched"

142 "The Communion of Saint Jerome?": *Notice des principaux tableaux recueillis en Italie, par les commissaires du gouvernement français: Seconde partie [November 8, 1798]* (Paris: L'Imprimerie des Sciences et Arts, 1798), ii–iii.

143 *eighty-six paintings*: Francis Haskell, *The Ephemeral Museum: Old Master Paintings and the Rise of the Art Exhibition* (New Haven: Yale University Press, 2000), 33.

143 *"render them for true connoisseurs"*: *Notice des principaux tableaux recueillis dans la Lombardie, par les commissaires du gouvernement français [February 6, 1798]* (Paris: L'Imprimerie des Sciences et Arts, 1798), iii.

143 *endangered works of art*: See Martin Rosenberg, "Raphael's *Transfiguration* and Napoleon's Cultural Politics," *Eighteenth-Century Studies* 19, no. 2 (Winter 1985–1986): 193. About a report on Raphael's *Transfiguration*, Rosenberg writes, "This report thus supported two fictions: that the former owners were not fit to keep such a masterpiece, and that its transportation to France, rather than imposing unnecessary danger of destruction, was an act of preservation."

143 *"not as much as many claim"*: Andrew McClellan, *Inventing the Louvre: Art, Politics, and the Origins of the Modern Museum in Eighteenth-Century Paris* (Berkeley: University of California Press, 1999), 254n40.

144 *They named five pictures*: *Notice des principaux tableaux recueillis en Italie, par les commissaires du gouvernement français: Seconde partie [November 8, 1798]* (Paris: L'Imprimerie des Sciences et Arts, 1798), vi.

144 *"To the Army of Italy"*: McClellan, *Inventing the Louvre*, 121.

144 *"problem of consolidating the support"*: Procès-verbaux du Musée central des Arts, PV1 BB 4, 72, November 28, 1798, Archives du Louvre, in Nathalie Volle, "Les déplacements et les restaurations successives," in *Les Noces de Cana de Véronèse: une oeuvre et sa restauration*, ed. Jean Habert and Nathalie Volle (Paris: Réunion des Musées Nationaux, 1992), 93.

145 *"stretcher will be constructed in two parts"*: Ibid.; see also Faillant-Dumas, "La plus grande radiographie réalisée au Louvre," in *Les Noces de Cana*, ed. Habert and Volle, 110. What remains unexplained are paint losses in a horizontal band of semicircular abrasions above the balustrade. Faillant-Dumas hypothesizes that when the top part of the painting was rolled on a cylinder, the edge was folded, causing the canvas to crease.

145 *"painting on canvas in two parts"*: Volle, "Les déplacements," 94.

145 *"Citizen Hacquin" in charge*: Ibid., 93.

146 *"1 franc per [square] foot"*: Ibid.

146 *"four and five times"*: Ibid.

146 *"putty and old repainting"*: Ibid.

146 *"parts of the canvas"*: Ibid., 94.

14. "The Revolution . . . is finished"

147 *"end the Revolution"*: Philip Dwyer, *Napoleon: The Path to Power, 1769–1799* (New Haven: Yale University Press, 2008), 455.

147 *"leading political priorities"*: David A. Bell, *Napoleon: A Concise Biography* (Oxford: Oxford University Press, 2015), 44.

147 *"It is finished"*: Andrew Roberts, *Napoleon: A Life* (New York: Penguin, 2015), 234.

148 *naval defeat*: Ibid., 396–99.

148 *"presentiment of happiness"*: Ibid., 449–50.

148 *"debasement and misery"*: Ibid., 512.

148 *"man of one faction"*: Philip Dwyer, *Citizen Emperor* (New Haven: Yale University Press, 2013), 9.

148 *"feared by its enemies"*: Steven Englund, *Napoleon: A Political Life* (Cambridge, Mass.: Harvard University Press, 2004), 173.

148 *to only four*: Dwyer, *Citizen Emperor*, 15–16.

149 *government to complete the work*: Andrew McClellan, *Inventing the Louvre: Art, Politics, and the Origins of the Modern Museum in Eighteenth-Century Paris* (Berkeley: University of California Press, 1999), 152.

149 *"like a thunderbolt"*: Englund, *Napoleon*, 174.

149 *"retold again and again"*: Dwyer, *Citizen Emperor*, 52–53.

149 *"triumph than public satisfaction"*: Ibid., 46.

149 *"satisfy our hero [Bonaparte]"*: Mariano Luis de Urquijo, to Ignacio Muzquiz, August 11, 1800, in Philippe Bordes, *Jacques-Louis David: Empire to Exile* (New Haven: Yale University Press, 2005), 85.

150 *David shows the name* BONAPARTE: Dorothy Johnson writes, "The entire composition may be understood, in fact, as a type of 'real' allegory—the event, the individual, and the group he leads that are celebrated in the painting transcend the specificity of the historic setting to embody abstract qualities and political ideals." Johnson, *Jacques-Louis David: Art in Metamorphosis* (Princeton, N.J.: Princeton University Press, 1993), 179.

150 *"the exception of the tricolor sash"*: José Nicolás de Azara to Bernardo Iriarte, in Bordes, *David*, 85.

150 *"features to capture an ideal"*: Ibid., 82.

151 *then tripled*: Dwyer, *Citizen Emperor*, 67.

151 *"What a start to the century"*: Ibid.

151 *"you must be its master"*: Roberts, *Napoleon*, 271.

151 *"great majority of French citizens"*: Ibid., 273.

151 *signed the Peace of Amiens*: Ibid., 294; Dwyer, *Citizen Emperor*, 69.

151 *"mind could have desired for her"*: Dwyer, *Citizen Emperor*, 73.

152 *"and, therefore, war"*: David A. Bell, *The First Total War: Napoleon's Europe and the Birth of Warfare as We Know It* (Boston: Houghton Mifflin, 2007), 233.

153 *"blocks on the sands of France"*: Englund, *Napoleon*, 178.

153 *much of which still stands*: See Roberts, *Napoleon*, 275–79.

15. "You enter a gallery—*such* a gallery. But *such* a gallery!!!"

154 *"desert at a watering place."* Stephen Weston, *The Praise of Paris: or a Sketch of the French Capital; in Extracts of Letters from France* (London: C. and R. Baldwin, 1803), 6.

154 *"the Marriage of Cana"*: Abraham Raimbach and Michael Thomson Scott Raimbach, *Memoirs and Recollections of the Late Abraham Raimbach, Esq., Engraver . . . Including a Memoir of Sir David Wilkie, R.A.* (London: Frederick Shobert, 1843), 47.

154 *"is a heavenly illumination"*: Francis Haskell, *The Ephemeral Museum: Old Master Paintings and the Rise of the Art Exhibition* (New Haven: Yale University Press, 2000), 35.

154 *The French unveiled the Veronese*: *Notice des grands tableaux de Paul Véronèse, Rubens, Le Brun, Louis Carrache* (Paris: L'Imprimerie des Sciences et Arts, 1801).

154 *to French power*: Andrew McClellan, *Inventing the Louvre: Art, Politics, and the Origins of the Modern Museum in Eighteenth-Century Paris* (Berkeley: University of California Press, 1999), 7.

155 *artist's professional fortune*: David O'Brien, *After the Revolution: Antoine-Jean Gros, Painting and Propaganda Under Napoleon* (University Park: Pennsylvania State University Press, 2006), 4–6.

156 *"the Tuileries, finished"*: Ann Sutherland Harris, *Seventeenth-Century Art and Architecture* (London: Lawrence King, 2005), 244.

158 *twenty-three Guercinos*: *Notice des tableaux des écoles française et flamande, exposés dans la grande galerie, dont l'ouverture a eu lieu le 28 Germinal an VII; et des tableaux des écoles de Lombardie et de Bologne* (Paris: L'Imprimerie des Sciences et Arts, 1801).

158 *an end wall at whose center*: See Daniela Gallo, "The Galerie des Antiques of the Musée Napoléon: A New Perception of Ancient Sculpture?," in *Napoleon's Legacy: The Rise of National Museums in Europe, 1794–1830*, ed. Ellinoor Bergvelt et al. (Berlin: G and H Verlag, 2009), 111–23.

159 *"fifteen hundred antique sculptures"*: Cecil Gould, *Trophy of Conquest: The Musée Napoléon and the Creation of the Louvre* (London: Faber and Faber, 1965), 75–76.

159 *and his plundered art*: Steven Englund, *Napoleon: A Political Life* (Cambridge, Mass.: Harvard University Press, 2004), 304.

160 *"built during their lives"*: Hugh Honour and John Fleming, *The Visual Arts: A History*, 5th ed. (New York: Harry N. Abrams, 1999), 611.

160 *downplayed his wealth*: Philip Dwyer, *Citizen Emperor* (New Haven: Yale University Press, 2013), 24.

160 *"seniority that it lacked"*: Ibid., 26.

160 *"in our time in most courts"*: Englund, *Napoleon*, 203.

161 *"progress of their master"*: Ibid., 489n89.

161 *"man giving orders"*: J. M. Thompson, *Napoleon Bonaparte* (1952; repr., Oxford: Blackwell, 1990), 193.

161 *"surpassing the magnificence of this"*: Mary Berry, *Extracts from the Journals and Correspondence of Miss Berry*, ed. Lady Theresa Lewis (London: Longmans, Green, 1866), 2:164.

161 *"you can imagine our regret"*: Gabriel Vauthier, "Denon et le gouvernement des arts sous le Consulat," *Annales historiques de la Révolution française* 4, no. 3 (May–June 1911): 341.

161 *"we must be indebted"*: Ibid., 341–42.

162 *the Comte de Mirabeau*: Andrew Roberts, *Napoleon: A Life* (New York: Penguin, 2015), 247.

162 *plundered paintings and sculpture*: Andrew McClellan, *Inventing the Louvre: Art, Politics, and the Origins of the Modern Museum in Eighteenth-Century Paris* (Berkeley: University of California Press, 1999). He writes, "The eyes of Europe were on the Louvre," 132.

164 *"of the public taste"*: J.C.F. Schiller, *The German Novelists: Tales Selected from Ancient and Modern Authors in That Language*, ed. Thomas Roscoe (London: H. Colburn, 1826), 3:246.

164 *"seized by immobility"*: François-Émmanuel Toulongeon, *Manuel du Muséum français* (Paris: Treuttel et Würtz, 1806), 9:17.

164 *"over this immense surface"*: Joseph Lavallée [and A. C. Caraffe], *Galerie du Musée Napoléon* (Paris: Filhol, 1813), 9: "Les Noces de Cana," 2–4.

165 *as First Consul*: See Bénédicte Savoy, "Looting of Art: The Museum as a Place of Legitimisation," in *War-Booty: A Common Europe Cultural Heritage*, ed. Sofia Nestor (Stockholm: Livrustkammaren, 2009), 11–21. Savoy writes, "The instant and international public success of the Musée Napoléon (the Louvre) filled with looted art treasures, convinced scholars, artists and art lovers the world over during the first decade of the 19th century, causing even the bitterest adversaries of the French policy of annexation to tone down their protests" (15). And Martin Rosenberg notes, "By confiscating the cultural legacy of significant past eras and commissioning works of art which created a personal mythology likening him to great historical leaders, Napoleon attempted to legitimize his rule." Rosenberg, "Raphael's

Transfiguration and Napoleon's Cultural Politics," *Eighteenth-Century Studies* 19, no. 2 (Winter 1985–1986): 181.

165 *ten thousand visitors*: Dwyer, *Citizen Emperor*, 76.

165 *"naked and desolate"*: Weston, *The Praise of Paris*, 4.

165 *"a thousand new ones"*: Berry, *Extracts*, 133–34.

166 *means of transit in their power*: Raimbach, *Memoirs*, 46, 38.

166 *revolutionary calendar*: Berry, *Extracts*, 133.

166 *"a week's journey"*: Weston, *The Praise of Paris*, 6.

166 *"We didn't have enough eyes"*: James J. Sheehan, *Museums in the German Art World: From the End of the Old Regime to the Rise of Modernism* (Oxford: Oxford University Press, 2000), 52.

166 *"glutton at a feast"*: McClellan, *Inventing the Louvre*, 198.

167 *"by the paintings and antiquities"*: Friedrich Schlegel to August Wilhelm Schlegel, September 16, 1802, in Bénédicte Savoy, "'Une ample moisson de superbes choses': Les missions de Vivant Denon en Allemagne et en Autriche, 1806–1809," in *Dominique-Vivant Denon: L'oeil de Napoléon*, ed. Pierre Rosenberg (Paris: Réunion des Musées Nationaux, 1999), 171.

167 *"victory monument"*: Sheehan, *Museums in the German Art World*, 51.

167 *"they are but stone!"*: Friedrich Schiller, *Sämtliche Werke*, ed. Albert Meier (Munich: Hanser, 2004), 1:213.

167 *"is the only one suitable"*: "Lettre de Denon au Premier Consul," in Geneviève Bresc-Bautier, "Dominique-Vivant Denon: premier directeur du Louvre," in *Dominique-Vivant Denon*, ed. Rosenberg, 145.

16. "The transparency of air . . . place[s] Gros beside Tintoretto and Paul Veronese"

168 *"event of the century for all the arts"*: Steven Englund, *Napoleon: A Political Life* (Cambridge, Mass.: Harvard University Press, 2004), 304.

168 *"describing it to me himself"*: David O'Brien, *After the Revolution: Antoine-Jean Gros, Painting and Propaganda Under Napoleon* (University Park: Pennsylvania State University Press, 2006), 84.

169 *"immediately for their departure"*: Philip Dwyer, *Citizen Emperor* (New Haven: Yale University Press, 2013), 113.

169 *"Caesar or nothing"*: Ibid., 124.

169 *"sustained by glory"*: Englund, *Napoleon*, 228.

170 *"hideous corpse of a soldier"*: Philip Dwyer, *Napoleon: The Path to Power* (New Haven: Yale University Press, 2008), 424.

170 as *"a fever"*: Darcy Grimaldo Grigsby, "Rumor, Contagion, and Colonization in Gros's *Plague-Stricken of Jaffa* (1804)," *Representations* 51 (Summer 1995): 7.

170 *"moral courage"*: Dwyer, *Napoleon*, 424.

170 *"taken on board ship"*: Andrew Roberts, *Napoleon: A Life* (New York: Penguin, 2015), 198.

170 *doses of laudanum*: Ibid.; Dwyer, *Napoleon*, 434.

171 *before he returned to Paris*: O'Brien, *After the Revolution*, 48–49.

171 *miraculous cure of their touch*: Ibid., 104.

171 *He spells out the cost of war*: Dwyer, *Citizen Emperor*, 153.

171–72 *"to hang above Gros's picture"*: Ibid., 152.

172 *"the restorer of France"*: Ibid., 109.

172 *"stupor, despondency, fury, desire"*: Grigsby, "Rumor, Contagion, and Colonization," 22.

172 *"productions of the Venetian school"*: Dominique-Vivant Denon to Napoleon Bonaparte, September 19, 1804, in *Vivant Denon: Directeur des musées sous le Consulat et l'Empire; Correspondance, 1802–1815*, Marie-Anne Dupuy, Isabelle le Masne de Chermont, and Elaine Williamson, eds. (Paris: Réunion des Musées Nationaux, Paris, 1999). See Denon [AN 22] at Napoleonica.org.

17. "This beautiful work reminds us of the picture by Paul Veronese"

173 *"glory to the modern school"*: Philippe Bordes, *Jacques-Louis David: Empire to Exile* (New Haven: Yale University Press, 2005), 51.

174 *"seem so natural and true"*: Ibid., 59.

174 *"33 feet long and 18 high"*: Jacques-Louis David, *Account of the Celebrated Picture of the Coronation of Napoleon* (London: G. Schulze, 1822), 4. See also Bordes, *David*, 50: "The sheer size of the canvas was a primary show of his superiority to Veronese, whose *Marriage at Cana* (Musée du Louvre), confiscated in Venice, was heralded as the largest picture in the Musée Napoléon."

174 *to the Vatican*: Philip Dwyer, *Citizen Emperor* (New Haven: Yale University Press, 2013), 156.

175 *kept the pontiff waiting*: Ibid., 162.

175 *"laurel leaves made of gold"*: Bordes, *David*, 95.

175 *"sanctioned and sanctified"*: Steven Englund, *Napoleon: A Political Life* (Cambridge, Mass.: Harvard University Press, 2004), 266.

175 *"one walks in this picture"*: Bordes, *David*, 49.

176 *"participant in Napoleon's coronation"*: Dorothy Johnson, *Jacques-Louis David: Art in Metamorphosis* (Princeton, N.J.: Princeton University Press, 1993), 200.

176 "no effect, no perspective": "Arlequin au Muséum," in Jacques-Louis David, *Le Peintre Louis David, Souvenirs et documents inédits*, ed. J. L. Jules David (Paris: Victor Havard, 1880), 441, 443.

176 *"empty space to the eye"*: Bordes, *David*, 59.

177 *"I hope it will be a prophecy"*: Andrew Roberts, *Napoleon: A Life* (New York: Penguin, 2015), 361.

177 *established the Principality*: Dwyer, *Citizen Emperor*, 186.

177 *"Buonaparte family"*: Leo Tolstoy, *War and Peace*, trans. Richard Pevear and Larissa Volokhonsky (New York: Vintage, 2008), 3. See also Roberts, *Napoleon*, 361.

18. "I succeeded . . . in packing most of the pieces of small size and great value"

178 *"all such arrangements"*: James J. Sheehan, *Museums in the German Art World: From the End of the Old Regime to the Rise of Modernism* (Oxford: Oxford University Press, 2000), 52.

178 *"small size and great value"*: Johann Friederich Emperius, "Über die Wegführung und Zurückkunft der Braunschweigischen Kunst-und Bücherschätze," *Braunschweigisches Magazin*, January 6, 1816, 9–10. The German translations were done by Jonathan Larson. For Napoleon's seizing of art from Germany and Austria, see these works, all by Bénédicte Savoy: *Patrimoine annexé: Les biens culturels saisis par la France en Allemagne autour de 1800* (Paris: Éditions de la Maison des sciences de l'homme, 2003); "'Une ample moisson de superbes choses': Les missions en Allemagne et en Autriche, 1806–1809," in *Dominique-Vivant Denon: L'oeil de Napoléon*, ed. Pierre Rosenberg (Paris: Réunion des Musées Nationaux, 1999), 170–81; and "Looting of Art: The Museum as a Place of Legitimization," in *War-Booty: A Common European Cultural Heritage*, ed. Sofia Nestor (Stockholm: Livrustkammaren, 2009), 11–21. See also Bénédicte Savoy and Yann Potin, eds., *Napoleon und Europa: Traum und Trauma* (Munich: Prestel, 2010).

178 *the "eye" of Napoleon*: Johann Christian von Mannlich, *Histoire de ma vie: Mémoires de Johann Christian von Mannlich, 1741–1822*, ed. Karl Heinz Bender and Hermann Kleber (Trier, Ger.: Spee Verlag, 1993), 2:520. See also Savoy, "'Une ample moisson,'" 170.

179 *"had ever been assembled"*: Emperius, "Über die Wegführung," 15–16. See also Savoy, "'Une ample moisson,'" 170.

179 *"very few things"*: Savoy, "'Une ample moisson,'" 170.

179 *some sixty paintings*: Ibid., 178.

179 *"very desirable to me"*: Emperius, "Über die Wegführung," 15–16.

180 *"a France of hegemonic influence"*: Savoy, "'Une ample moisson,'" 181.

180 *Denon had reinvented himself*: See Andrew McClellan, *Inventing the Louvre: Art, Politics, and the Origins of the Modern Museum in Eighteenth-Century Paris* (Berkeley: University of California Press, 1999), 140.

180 *"paint your history"*: Dominique-Vivant Denon to Napoleon Bonaparte, February 28, 1805, in David O'Brien, *After the Revolution: Antoine-Jean Gros, Painting and Propaganda Under Napoleon* (University Park: Pennsylvania State University Press, 2006), 93.

180 *"to be seen by everyone"*: Pierre Fontaine, February 5, 1804, in Geneviève Bresc-Bautier, "Dominique-Vivant Denon, premier directeur du Louvre," in *Dominique-Vivant Denon*, ed. Rosenberg, 132.

180 *"we must simply have patience"*: Fontaine, April 14, 1808, in ibid.

181 *"nightly labors and plentiful works"*: Philippe Bordes, *Jacques-Louis David: Empire to Exile* (New Haven: Yale University Press, 2005), 43.

181 *no more than twelve thousand francs*: O'Brien, *After the Revolution*, 120.

181 *twenty miles outside the city*: For the Kassel picture gallery, see Tristan Weddigen, "The Picture Galleries of Dresden, Düsseldorf, and Kassel," in *The First Modern Museums of Art: The Birth of an Institution in 18th- and Early-19th-Century Europe*, ed. Carole Paul (Los Angeles: J. Paul Getty Museum, 2012), 158–59. See also Dorothy Mackay Quynn, "The Art Confiscations of the Napoleonic Wars," *American Historical Review* 50, no. 3 (1945): 444; Cecil Gould, *Trophy of Conquest: The Musée Napoléon and the Creation of the Louvre* (London: Faber and Faber, 1965), 93.

181 *299 paintings for the Louvre*: Quynn, "The Art Confiscations," 444.

181 *"had hoped for from Germany"*: Dominique-Vivant Denon [to Athanase Lavallée], January 29, 1807, A.M.N., Z4 1807, AN. See also Savoy, "'Une ample moisson,'" 170.

181 *"we absolutely lacked"*: Denon, January 29, 1807, A.M.N., Z4 1807, AN.

182 *"grinding skulls and members"*: Steven Englund, *Napoleon: A Political Life* (Cambridge, Mass.: Harvard University Press, 2004), 291.

182 *twelve thousand wounded for the Russians*: Philip Dwyer, *Citizen Emperor* (New Haven: Yale University Press, 2013), 241.

182 *"And without any result"*: O'Brien, *After the Revolution*, 158.

183 *shot toward 75 percent*: Dwyer, *Citizen Emperor*, 250–51.

183 *250 cases of Germany's art*: Savoy, "'Une ample moisson,'" 175.

184 *The show's title detailed*: Statues, bustes, bas-reliefs, bronzes, et autres antiquités, peintures, dessins, et objets curieux, conquis par la Grande Armée, dans les années 1806 et 1807; dont l'exposition a eu lieu le 14 octobre 1807, premier anniversaire de la bataille d'Iéna (Paris: Dubray Imprimeur du Musée Napoléon, 1807).

184 *"sight of the old masterpiece"*: Savoy, "Looting of Art," 19.

184 *Germany with Denon:* Savoy, "'Une ample moisson,'" 179.

184 *"elevated to icon status"*: Savoy, "Looting of Art," 19.

184 *"my own resurrection"*: Ibid.

185 *a sixteenth-century church*: Margaret Plant, *Venice: Fragile City, 1797–1997* (New Haven: Yale University Press, 2002), 56–57, 66.

185 *assigned Pietro Edwards to catalogue*: Nora Gietz, "Tracing Paintings in Napoleonic Italy: Archival Records and the Spatial and Contextual Displacement of Artworks," *Artl@s Bulletin* 4, no. 2 (2016): article 6.

185 *"He wants everything"*: Dwyer, *Citizen Emperor*, 304.

186 *to maintain the collection*: Natalia Gustavson, "Retracing the Restoration History of Viennese Paintings in the Musée Napoléon (1809–1815)," *CeROArt*, 2012, para. 3 (and n. 4; https://ceroart.revues.org/2325). The three cities were Peterwardein, Grosswardein, and Temesvár (modern-day Petrovaradin, Serbia; Oradea, Romania; and Timosoara, Romania, respectively). See also A. Hoppe-Harnoncourt, "Geschichte der Restaurierung an der k. k. Gemäldegalerie. 1. Teil: 1772 bis 1828," in *Jahrbuch des Kunsthistorischen Museums*, ed. W. Seipel, vol. 94 (Vienna: Anton Schroll, 2001), 135–206.

186 *"him at his [Denon's] disposal"*: Wilhelm Treue, *Art Plunder: The Fate of Works of Art in War, Revolution and Peace* (London: Methuen, 1960), 167.

186 *some four hundred of Vienna's paintings*: Gustavson, "Retracing the Restoration History," para. 3–4.

186 *Titian, Palma Vecchio, Fra Bartolomeo, and Giorgione*: Paul Wescher, *Kunstraub unter Napoleon* (Berlin: Mann, 1976), 117–18.

186 *"easy to fix it in Paris"*: Savoy, "'Une ample moisson,'" 177.

187 *"with thin blades"*: Füger, in ibid., 178.

187 *"I have crushed them"*: Andrew Roberts, *Napoleon: A Life* (New York: Penguin, 2015), 526.

187 *reparations of 200 million francs*: Dwyer, *Citizen Emperor*, 316.

187 *"the capital of the world"*: David A. Bell, *Napoleon: A Concise Biography* (Oxford: Oxford University Press, 2015), 70.

19. "The only thing to do is to burn them!"

188 *"encouragement of the arts"*: Philippe Bordes, *Jacques-Louis David: Empire to Exile* (New Haven: Yale University Press, 2005), 41.

188 *on clothes alone*: Andrew Roberts, *Napoleon: A Life* (New York: Penguin, 2015), 537.

189 *"triumphant French system"*: Ibid., 533.

189 *He had dominion over*: Philip Dwyer, *Citizen Emperor* (New Haven: Yale University Press, 2013), 352.

189 *"with the chess figures"*: Henry A. Kissinger, *A World Restored: Metternich, Castlereagh and the Problems of Peace, 1812–22* (London: Weidenfeld and Nicolson, 1957), 25–26.

189 *"considered itself the people"*: Clemens Wenzel Lothar Metternich, *Memoirs of Prince Metternich, 1773–1815*, ed. Richard Metternich, trans. Mrs. Alexander Napier (New York: Charles Scribner's Sons, 1880), 1:4–5.

189 *"a well-bred nobleman"*: Laure Junot, Duchesse d'Abrantès, *Memoirs of the Duchess d'Abrantès (Madame Junot)* (London: H. Colburn and R. Bentley, 1835), 7:159.

189 *"calculator par excellence"*: Kissinger, *A World Restored*, 12.

189 *"poor princess he chooses"*: Roberts, *Napoleon*, 539.

189 *"good of the state"*: Anatole France, *On Life and Letters*, trans. A. W. Evans (London: John Lane, 1911), 228.

191 *caused by his wars*: About the wedding, Martin Rosenberg writes, "Nothing more clearly exemplified the role of the *Musée Napoléon* as a trophy of conquest, symbolizing Napoleon's military brilliance and linking him to the great cultural epochs of the past" ("Raphael's *Transfiguration* and Napoleon's Cultural Politics, *Eighteenth-Century Studies* 19, no. 2 [Winter 1985–1986]: 196).

192 *"a history course in the art of painting"*: Andrew McClellan, *Inventing the Louvre: Art, Politics, and the Origins of the Modern Museum in Eighteenth-Century Paris* (Berkeley: University of California Press, 1999), 140.

192 *"paintings to be removed"*: Pierre-François-Léonard Fontaine, *Journal 1799–1853* (Paris: École Nationale Supérieure des Beaux-Arts/Institut Français d'Architecture/Société de l'histoire d l'art français, 1987), 1: March 14, 1810.

192 *"is to burn them!"*: Louis-François-Joseph de Bausset, *Mémoires anecdotiques sur l'intérieur du palais et sur quelques événemens de l'empire, depuis 1805 jusqu'au 1816* (Paris: A. Levavasseur, 1827–1829), 4:204–5.

193 *"detached and rolled"*: Fontaine, *Journal*, 1: March 14, 1810.

193 *"it to destruction"*: Athanase Lavallée, "Note . . . proposant l'échange des Noces de Cana contre La Madeleine chez le Pharisien, et reçu du tableau de Le Brun par Rosa," September 26, 1815, in Nathalie Volle, "Les déplacements et les restaurations successives," *Les Noces de Cana de Véronèse: une oeuvre et sa restauration*, ed. Jean Habert and Nathalie Volle (Paris: Réunion des Musées Nationaux, 1992), 95–96.

20. "This foreboding painting . . . seems to summon the eye . . . from all directions"

194 *"snow with dreadful truth"*: David O'Brien, "Propaganda and the Republic of the Arts in Antoine-Jean Gros's *Napoléon Visiting the Battlefield of Eylau the Morning After the Battle*," *French Historical Studies* 26, no. 2 (2003): 290.

194 *"have elevated the throne"*: Philippe Bordes, *Jacques-Louis David: Empire to Exile* (New Haven: Yale University Press, 2005), 41.

194 *"without any result"*: David O'Brien, *After the Revolution: Antoine-Jean Gros, Painting and Propaganda Under Napoleon* (University Park: Pennsylvania State University Press, 2006), 158.

194 *"so many victims"*: Ibid.

195 *"victims of the fighting"*: Ibid., 161.

195 *covered with ice*: O'Brien observes, "In places the paint become a simulacrum of the depicted object: the . . . white glaze on a face has the texture of real frost" (O'Brien, "Propaganda and the Republic," 297). See also Christopher Prendergast, *Napoleon and History Painting: Antoine-Jean Gros's "La Bataille d'Eylau"* (Oxford: Oxford University Press, 1997).

195 *"all directions at the same time"*: Eugène Delacroix, "Peintres et sculpteurs modernes, III, Gros," *Revue des Deux Mondes*, September 1, 1848, 663.

196 *"People complain about the war"*: Joseph Fouché to Napoleon Bonaparte, November 29, 1806, in O'Brien, *After the Revolution*, 161.

196 *"expose himself to new dangers"*: Philip Dwyer, *Citizen Emperor* (New Haven: Yale University Press, 2013), 245.

196 *"correspondence with the British Isles"*: Andrew Roberts, *Napoleon: A Life* (New York: Penguin, 2015), 427.

196 *not to attack Russia*: Dwyer, *Citizen Emperor*, 357.

196 *again at war*: Ibid., 370.

196 *"horses without oats"*: Roberts, *Napoleon*, 587.

196 *"Everything is dead"*: Dwyer, *Citizen Emperor*, 388–89.

197 *"a sky and clouds of flame"*: David A. Bell, *The First Total War: Napoleon's Europe and the Birth of Warfare as We Know It* (Boston: Houghton Mifflin, 2007), 259.

197 *provision his army to survive*: Roberts, *Napoleon*, 646.

197 *were deaths*: David A. Bell, *Napoleon: A Concise Biography* (Oxford: Oxford University Press, 2015), 88.

197 *300,000 men*: Roberts, *Napoleon*, 425.

197 *and the Hanseatic port cities*: Dwyer, *Citizen Emperor*, 449; Roberts, *Napoleon*, 659.

198 *"to be at hand"*: Dwyer, *Citizen Emperor*, 461.

198 *"as the alarmists believe"*: Roberts, *Napoleon*, 698.

21. "The masterpieces of the arts now belong to us"

199 *"negotiate the peace treaty"*: Bénédicte Savoy, "'Le naufrage de toute une époque': Regards allemands sur les restitutions de 1814–1815," in *Dominique-Vivant Denon: L'oeil de Napoléon*, ed. Pierre Rosenberg (Paris: Réunion des Musées Nationaux, 1999), 259.

200 *"in the friendliest way"*: Desmond Seward, *Metternich: The First European* (London: Thistle Publishing, 2015), 105.

200 *"to the battle-field in less than two years"*: Clemens Wenzel Lothar Metternich, *Memoirs of Prince Metternich, 1773–1815*, ed. Richard Metternich, trans. Mrs. Alexander Napier (New York: Charles Scribner's Sons, 1880), 1:152.

200 *"these spoils of victory"*: Wayne Sandholz, *Prohibiting Plunder: How Norms Change* (New York: Oxford University Press, 2007), 58.

200 *"those of victory"*: Gary Tinterow and Geneviève Lacambre, *Manet/Velázquez: The French Taste for Spanish Painting* (New York: Metropolitan Museum of Art; New Haven: Yale University Press, 2003), 27.

201 *eight hundred thousand francs*: Andrew Roberts, *Napoleon and Wellington* (London: Weidenfeld and Nicolson, 2001), 145.

201 *Italian spelling of his name*: Ibid., 75.

201 "*the other side of the hill*": Ibid., 47.

201 "*tyranny of Buonaparte*": Duke of Wellington to William Bentinck, December 24, 1811, in ibid., 84.

201 "*action of the 22nd instant*": Ibid., 90.

202 "*to be found anywhere*": André Masséna to Louis-Alexandre Berthier, September 15, 1810, in ibid., 87.

202 "*drawings and pictures*": C. M. Kauffmann and Susan Jenkins, *Catalogue of Paintings in the Wellington Museum, Apsley House* (London: English Heritage/Paul Holberton Publishing, 2009), 11.

202 "*to be anything remarkable*": Margaret M. Miles, *Art as Plunder: The Ancient Origins of Debate About Cultural Property* (New York: Cambridge University Press, 2008), 346.

202 "*just as they are honorable*": Kauffmann and Jenkins, *Catalogue of Paintings in the Wellington Museum*, 12.

202 "*pictures of the first order*": Deborah L. Roldán, "Chronology," in *Manet/Velázquez*, ed. Tinterow and Lacambre, 364.

203 *become the Prado*: Ibid., 359.

203 "*the whole taken away*": Thomas Lawrence, *The Life and Correspondence of Sir Thomas Lawrence*, ed. D. E. Williams (London: H. Colburn and R. Bentley, 1831), 1:338–39.

203 *managed to retrieve*: Savoy, "'Le naufrage de toute une époque,'" 261.

203 *return of 230 paintings*: Roldán, "Chronology," 364.

204 *French paintings to Vienna*: Ferdinand Boyer, "Metternich et la restitution par la France des oeuvres d'art de l'étranger (1814–1815)," *Revue d'Histoire Diplomatique* 84 (1970): 67.

204 *seven hundred musicians*: John Bew, *Castlereagh* (New York: Oxford University Press, 2012), 373.

22. "We are at last beginning to drag forth from this great cavern of stolen goods the precious objects of Art"

205 "*everything packed up and gone*": Martin Glinzer, ed., "Canova: Letters to a Friend in London (1815)," in *Translocations: Anthology; A Collection of Commented Source Texts on Relocations of Cultural Assets Since Antiquity*, 2018; https://translanth.hypotheses.org/ueber/canova.

205 "*the French frontier*": Andrew Roberts, *Napoleon and Wellington* (London: Weidenfeld and Nicolson), 166.

205 *came to the fight poorly prepared*: Philip Dwyer, *Citizen Emperor* (New Haven: Yale University Press, 2013), 546–48.

205 "*view to his execution*": General Count von Gneisenau to Major-General von Müffling, in Roberts, *Napoleon and Wellington*, 222.

205 *"deal with him accordingly"*: Ibid., 225.

206 *"and can have no object"*: Philipp von Müffling quoting Duke of Wellington, in ibid., 222.

206 *five to six million lives*: Andrew Roberts, *Napoleon: A Life* (New York: Penguin, 2015), 777; Roberts, *Napoleon and Wellington*, 228.

206 *contested collections of art*: Viscount Castlereagh to Lord Liverpool, July 24, 1815, in Robert Stewart, Viscount Castlereagh, *Correspondence, Despatches and Other Papers of Viscount Castlereagh*, ed. Charles Vane (London: John Murray, 1853), 10:435.

206 *without an order from the French king*: Dominique-Vivant Denon to Duc de Richelieu, July 8, 1815, in Charles Saunier, *Les conquêtes artistiques de la révolution et de l'empire* (Paris: Librairie Renouard, 1902), 102.

206 *"such language applied by force"*: Charles-Maurice de Talleyrand-Périgord to Denon, July 9, 1815, in Eugène Müntz, "Les invasions de 1814–1815 et la spoliation de nos musées," *La Nouvelle Revue* 115, no. 2 (1897), 194.

207 *"the help of armed force"*: Friedrich von Ribbentrop to Denon, July 9, 1815, in Saunier, *Les conquêtes artistiques*, 103–4.

207 *"Graudentz in western Prussia"*: Ribbentrop to Denon, July 9, 1815 (9:00 p.m.), in ibid., 105.

207 *several busts and bronzes*: Müntz, "Les invasions," 197–98.

207 *"seen the court in full dress"*: Klemens von Metternich to his daughter Mary, July 13, 1815, in Clemens Wenzel Lothar Metternich, *Memoirs of Prince Metternich, 1773–1815*, ed. Richard Metternich, trans. Mrs. Alexander Napier (New York: Charles Scribner's Sons, 1880), 1:724.

207 *"plenty, at yours"*: Ferdinand Boyer, "Metternich et la restitution par la France des oeuvres d'art de l'étranger (1814–1815)," *Revue d'Histoire Diplomatique* 84 (1970): 68.

207 *"transformed into an English camp"*: Metternich to his daughter Mary, July 13, 1815, in Metternich, *Memoirs*, 610.

208 *"has not been* entamée *[raised]"*: William Richards Hamilton to Henry Bathurst, August 24, 1815, Historical Manuscripts Commission, *Report on the Manuscripts of Earl Bathurst*, Cirencester Park (London, 1923), 375.

208 *"the trophies of [their] victories"*: Liverpool to Castlereagh, in Dorothy Mackay Quynn, "The Art Confiscations of the Napoleonic Wars," *American Historical Review* 50, no. 3 (1945): 447.

209 *"cold-blooded regicide"*: John Bew, *Castlereagh* (New York: Oxford University Press, 2012), 403.

209 *"the Gallery and the Statues"*: Castlereagh to Liverpool, July 24, 1815, in Castlereagh, *Correspondence*, 10:435.

209 *Josephine, who had died the year before*: Saunier, *Les conquêtes artistiques*, 78–80; Quynn, "The Art Confiscations," 460.

209 *"in future the center of the arts"*: Liverpool to Castlereagh, August 3, 1815, in Castlereagh, *Correspondence*, 10:453.

210 *"Rome will be desolate"*: Antonio Canova to Giannantonio Selva, 1796, in Christopher M. S. Johns, *Antonio Canova and the Politics of Patronage in Revolutionary and Napoleonic Europe* (Berkeley: University of California Press, 1988), 71.

211 *take on Napoleon's commission*: Christopher M. S. Johns, "Portrait Mythology: Antonio Canova's Portraits of the Bonapartes," *Eighteenth-Century Studies* 28, no. 1 (1994): 121.

211 *too far from the truth*: For Napoleon's response to Canova's statue, see ibid., 125.

212 *thirteen million francs*: Valérie Huet, "Napoleon I: A New Augustus?," in *Roman Presences: Receptions of Rome in European Culture, 1789–1945*, ed. Catherine Edwards (Cambridge: Cambridge University Press, 1999), 62.

213 *"to succeed in this undertaking"*: Canova to Ercole Consalvi, August 10, 1815, in Franca Zuccoli, "Le ripercussioni del Trattato di Tolentino sull'attività diplomatica di Antonio Canova nel 1815, per il recupero delle opere d'arte," in *Ideologie e patrimonio storico-culturale nell'età rivoluzionaria e napoleonica* (Rome: Ministero per i beni e le attività culturali/Ufficio centrale per i beni archivistici, 2000), 616.

213 *"are making in politics"*: Leopoldo Cicognara to Canova, September 19, 1812, in Johns, *Antonio Canova*, 7.

213 *"could never be returned"*: Müntz, "Les invasions," 205.

214 *"restore stolen goods"*: Quynn, "The Art Confiscations," 448–49.

214 *Vatican's art to Rome*: Katharine Eustace, "Questa Scabrosa Missione: Canova in Paris and London in 1815," in *Canova: Ideal Heads*, ed. Katharine Eustace (Oxford: Oxford University Press, 1997), 13.

214 *shipped from Athens to London*: Mary Beard, *The Parthenon*, rev. ed. (Cambridge, Mass.: Harvard University Press, 2010), 12.

214 *set off an explosion*: Ibid., 76–81.

214 *"virtue, conciliation and peace"*: Castlereagh to the Allied Ministers, Paris, September 11, 1815, Annual Register (London: Rivingtons, 1815), 604.

214 *"no satisfactory answer"*: Duke of Wellington to Castlereagh, September 23, 1815, in Cecil Gould, "Appendix," in *Trophy of Conquest: The Musée Napoléon and the Creation of the Louvre* (London: Faber and Faber, 1965), 132.

214 *"in immorality to his wars"*: Castlereagh to Liverpool, August 17, 1815, in Castlereagh, *Correspondence*, 10:491.

215 *"the other Italian princes"*: Castlereagh to Liverpool, September 11, 1815, in ibid., 11:13–14.

215 *disturbing to the French king*: Wellington to Castlereagh, September 23, 1815, in Gould, "Appendix," 132.

215 *"King of the Netherlands' pictures"*: Ibid.

215 *"Austria begins immediately"*: Castlereagh to Liverpool, September 21, 1815, in Arthur Wellesley, Duke of Wellington, *Supplementary Despatches and Memoranda of Field Marshal Arthur, Duke of Wellington, K.G.*, ed. A. R. Wellesley (London: J. Murray, 1858–1872), 11:167.

215 *"the removal of the articles of Art"*: Quynn, "The Art Confiscations," 446. The article in the *Courier* was dated October 15, 1815.

215 *"most pointed manner"*: Castlereagh to Liverpool, September 21, 1815, in Wellesley, *Supplementary Despatches*, 11:167.

215 *"to conciliate" the French?*: Wellington to Castlereagh, September 23, 1815, in Gould, "Appendix," 134.

215 *"they are the trophies"*: Ibid.

216 *"common enemy of mankind"*: Ibid., 135.

216 *"subject of legal proceedings"*: Convention (II) with Respect to the Laws and Customs of War on Land and Its Annex: Regulations Concerning the Laws and Customs of War on Land," The Hague, July 29, 1899, International Committee of the Red Cross; Ihl-databases.icrc.org.

216 *"the execution of his project"*: Johns, *Antonio Canova*, 177.

216 *"this new and final outrage"*: Denon to Comte de Pradel, September 28, 1815, in Saunier, *Les conquêtes artistiques*, 135.

216 *the Comte de Pradel authorized*: Quynn, "The Art Confiscations," 451; Denon to Pradel, August 5, 1815 (no. 3493), and August 16, 1815 (no. 3496), both in Denon, *Correspondance Administrative de Vivant Denon*, available at Napoleonica.org.

216 *"to the Italian States"*: Joseph Rosa to Denon, September 21, 1815, in Saunier, *Les conquêtes artistiques*, 131.

216 *"orders that the sovereigns give"*: Ibid.

216 *"Venice, Parma, Piacenza, and Florence"*: Denon to Pradel, September 23, 1815, in ibid., 133.

216 *the two Titians*: Emily Robertson, ed., *Letters and Papers of Andrew Robertson, Miniature Painter* (London: Eyre and Spottiswoode, 1895), 254.

217 *"The whole [Louvre] will soon disappear"*: Castlereagh to Liverpool, September 25, 1815, in Castlereagh, *Correspondence*, 11:32.

217 *"work the night before last"*: Castlereagh to Liverpool, October 1, 1815, in Quynn, "The Art Confiscations," 452.

217 *"shouts and execrations"*: Ibid., 453.

217 *"to one [of the statues]"*: John Scott, *Paris Revisited, in 1815, by Way of Brussels* (London: Longman, 1816), 348.

217 *"the tramp of infantry"*: Ibid., 352.

217 *"he begins tomorrow"*: Castlereagh to Liverpool, October 1, 1815, in Castlereagh, *Correspondence*, 11:39.

218 *"objects of Art taken from Rome"*: Quynn, "The Art Confiscations," 455–56.

218 *"to join together to destroy it"*: Bénédicte Savoy, "Looting of Art: The Museum as a Place of Legitimization," in *War-Booty: A Common European Cultural Heritage*, ed. Sofia Nestor (Stockholm: Livrustkammaren, 2009), 20.

218 *"taken our pictures,* without treaty": Quynn, "The Art Confiscations," 459.

218 *"with boards, rollers, etc."*: Robertson, *Letters and Papers*, 265.

218 *succeeded in keeping 248 in France*: Andrew McClellan, "For and Against the Universal Museum in the Age of Napoleon," *Napoleon's Legacy: The Rise of National Museums in Europe, 1794–1830*, ed. Ellinoor Bergvelt et al. (Berlin: G and H Verlag, 2009), 97.

219 *"by 30 feet and 2 inches in width"*: Athanase Lavallée, "Note . . . proposant l'échange des Noces de Cana contre La Madeleine chez le Pharisien, et reçu du tableau de Le Brun par Rosa," September 26, 1815, in Natalie Volle, "Les déplacements et les restaurations successives," in *Les Noces de Cana de Véronèse: une oeuvre et sa restauration*, ed. Jean Habert and Nathalie Volle (Paris: Réunion des Musées Nationaux, 1992), 95–96.

219 *"which this painting had decorated"*: Denon to Comte de Pradel, September 29, 1815, in ibid., 96.

219 *"for . . . thirty thousand francs"*: Ibid.

220 *"the truth and will tell others"*: Canova to Cicognara, October 2, 1815, in *Un'amicizia di Antonio Canova: Lettere di lui al conte Leopoldo Cicognara raccolte e pubblicate*, ed. Vittorio Malamani (Città di Castello: S. Lapi, 1890), 59–60.

Epilogue

223 *"very expensive scaffold"*: Eugène Delacroix to Henriette de Verninac, May 30, 1820, in Asher Miller, "The Act of Looking in Delacroix's Early Narrative Paintings," in Sébastien Allard and Côme Fabre, *Delacroix* (New York: Metropolitan Museum of Art, 2018), 225.

223 *"nearly motionless scene"*: Michèle Hannoosh argues that he is referring to *The Wedding Feast at Cana*. See Eugène Delacroix, "Cahier Autobiographique," *Journal*, vol. 2, *1853–1863*, ed. Michèle Hannoosh (Paris: Librairie José Corti, 2009), 1732 (entry of January 25, 1853).

223 *"a feast for the eye"*: Michèle Hanoosh, "'Painting His Thoughts on Paper': Delacroix and His Journal," in Allard and Fabre, *Delacroix*, 239.

224 *"also right"*: Vincent van Gogh to Theo van Gogh, Nuenen, on or about October 28, 1885, in Leo Jansen, Hans Luijten, Nienke Bakker, eds., *Vincent Van Gogh: The Letters* (Amsterdam: Van Gogh Museum; The Hague: Huygens Institute; London: Thames & Hudson, 2009), 3:303.

224 *"on a single stretcher"*: Comte de Nieuwerkerke, October 26, 1854, in Nathalie Volle, "Les déplacements et les restaurations successives," in *Les Noces de Cana*

de Véronèse: une oeuvre et sa restauration, ed. Jean Habert and Nathalie Volle (Paris: Réunion des Musées Nationaux, 1992), 100. See also Nathalie Volle, "La restauration," in ibid., 157.

224 *remounted the canvas*: Volle, "Les déplacements," 101–2.

224 *crates constructed*: Lynn H. Nicholas, *The Rape of Europa: The Fate of Europe's Treasures in the Third Reich and the Second World War* (New York: Alfred A. Knopf, 1994), 51.

225 *leave the Louvre immediately*: Ibid., 54.

225 *out of the museum*: Volle, "Les déplacements," 103.

225 *"points of a single building"*: Henry James, *A Little Tour of France* (New York: AMS Press, 1900), 46.

225 *move the Veronese at least five times*: The five châteaux were Chambord, the Château de Louvigny, the Abbey of Loc-Dieu, Montauban, Loubéjac, and then a sixth, the Château de Montal, according to a card in the files of the Paintings Department in the Louvre. However, Rose Vallant, *Le front de l'art* (Paris: Plon, 1961), 9, writes that *The Wedding Feast at Cana* and other large paintings went to Cherreperrine, in Orne.

225 *"we were always worried"*: Lucie Mazauric, *Ma vie de châteaux* (Paris: Perrin, 1967), 117.

225 *were divided*: Nicholas, *The Rape of Europa*, 87.

225 *hazardous journey from the Loire valley*: Ibid., 89.

226 *formalized his art confiscations from Italy*: Mazauric, *Ma vie de châteaux*, 103–9.

226 *"questionable legal transactions"*: Nicholas, *The Rape of Europa*, 121.

226 *two thousand works of art*: Jonathan Petropoulos, *Art as Politics in the Third Reich* (Chapel Hill: University of North Carolina Press, 1996), 15.

226 *the Kunstschutz, established in World War I*: Nicholas, *The Rape of Europa*, 119–20.

227 *"in danger of being damaged"*: Ibid., 123.

227 *"safeguard them there"*: Ibid., 125.

227 *seized from the Rothschilds*: Petropoulos, *Art as Politics*, 131.

227 *"cut short and dismissed"*: Noah Charney, *Stealing the Mystic Lamb: The True Story of the World's Most Coveted Masterpiece* (New York: Public Affairs, 2010), 206–7.

227 *bridges over the Tarn*: Nicholas, *The Rape of Europa*, 286–87.

228 *the Veronese returned*: Card, "Véronèse, *Les Noces de Cana*" file, Département des Peintures, Musée du Louvre.

228 *suffered damage in an accident*: Condition report, "Véronèse, *Les Noces de Cana*" file, Département des Peintures, Musée du Louvre.

228 *By late November*: Volle, "Les déplacements," 103–7.

229 *San Giorgio Maggiore's wall*: Lola Faillant-Dumas, "La plus grande radiographie réalisée au Louvre," in ibid., 110–29.

229 *Veronese's pigments*: Jean-Paul Rioux, "La matière picturale," in ibid., 130–54.

229 *pours the wine*: Andreas Priever and Marie-Claude Chaudonneret, "Les Copies, de Zuccaro à Cézanne," in ibid., 298–323. For Cézanne and the Veronese, see Mary Tompkins Lewis, "A Mellow Rekindling of Earlier Fires: Still Life and Metamorphosis, Early to Late Cézanne," in *Cézanne: Metamorphoses*, ed. Alexander Eiling (Munich: Prestel, 2017), 106–17.

232 *"to have seen nothing"*: Giacomo Barri, *The Painter's Voyage of Italy*, trans. William Lodge (London, 1679), 94.

232 *"human intellect"*: John Ruskin, *The Diaries of John Ruskin*, vol. 2, *1848–1873*, ed. Joan Evans and J. H. Whitehouse (Oxford: Clarendon, 1958), 437.

232 *"working before my eyes"*: John Ruskin to Lady Trevelyan, September 24, 1854, in *The Works of John Ruskin*, ed. E. T. Cook and Alexander Wedderburn (London: George Allen, 1909), 36:176.

Selected Bibliography

Abrantès, Laure Junot, Duchesse d'. *Memoirs of the Duchess d'Abrantès (Madame Junot)*. 8 vols. London: H. Colburn and R. Bentley, 1835.

Ackerman, James S. *Palladio*. Baltimore: Penguin, 1966.

Addison, Joseph. *Remarks on Several Parts of Italy, &c. in the Years 1701, 1702, 1703*. London: Jacob Tonson, 1705.

Alberti, Annibale. "Pietro Edwards e le opere d'arte tolte da Napoleone a Venezia." *Nuova Antologia: rivista di lettere, scienze ed arti* 326, no. 1313 (Novembre–Dicembre 1926): 325–38.

Allard, Sébastien, and Côme Fabre. *Delacroix*. New York: Metropolitan Museum of Art, 2018.

Alpers, Svetlana, and Michael Baxandall. *Tiepolo and the Pictorial Intelligence*. New Haven: Yale University Press, 1994.

Angelucci, Laura. *Inventaire général des dessins. École française. Antoine Jean Gros (1771–1835)*. Paris: Musée du Louvre, 2019.

Antonello, Elio. "Bonaparte and the Astronomers of Brera Observatory." https://arxiv.org/pdf/1405.6841.pdf, accessed December 20, 2019.

Appiah, Kwame Anthony. *Cosmopolitanism: Ethics in a World of Strangers*. New York: W. W. Norton, 2006.

Arlequin au Muséum, ou Critique en vaudeville des tableaux du Salon. Paris: Delaunay, 1808.

Asprey, Robert. *The Reign of Napoleon Bonaparte*. New York: Basic Books, 2002.

Augusti, Ruggeri A. "Le requisizioni napoleoniche a Venezia e la costituzione della pinacoteca di Brera e delle Gallerie dell'Accademia." In *Venezia Napoleonica* (conference proceedings), 91–103. Venice: Centro Tedesco di Studi Veneziani, 2001.

Bailey, Colin B. *Patriotic Taste: Collecting Modern Art in Pre-Revolutionary Paris*. New Haven: Yale University Press, 2002.

Baudelaire, Charles. *Art in Paris, 1845–1862*. Translated and edited by Jonathan Mayne. London: Phaidon, 1965.

de Bausset, Louis-François-Joseph. *Mémoires anecdotiques sur l'intérieur du palais et sur quelques évenemens de l'Empire, depuis 1805 jusqu'au 1816*. vol. 4. Paris: A. Levavasseur, 1827–1829.

Beard, Mary. *The Parthenon*. Rev. ed. Cambridge, Mass.: Harvard University Press, 2010.

Béguin, Sylvie. *"The Feast in the House of Simon," Veronese: History and Restoration of a Masterpiece*. Translated by Barbara Mellor. Paris: Alain de Gourcuff Éditeur, 1997.

———. "Le goût pour Véronèse en France," introduction to *Tout l'oeuvre peint de Véronèse*, edited by Remigio Marini, 5–9. Paris: Flammarion, 1970.

Bell, David A. *The First Total War: Napoleon's Europe and the Birth of Warfare as We Know It*. Boston: Houghton Mifflin, 2007.

———. *Napoleon: A Concise Biography*. Oxford: Oxford University Press, 2015.

Beltramini, Guido, and Antonio Padoan, eds. *Andrea Palladio: The Complete Illustrated Works*. New York: Universe, 2001.

Bergvelt, Ellinoor, D. J. Meijers, L. Tibbe, and E. van Wezel, eds. *Napoleon's Legacy: The Rise of National Museums in Europe, 1794–1830*. Berlin: G and H Verlag, 2009.

Berry, Mary. *Extracts from the Journals and Correspondence of Miss Berry*. Edited by Lady Theresa Lewis. 3 vols. London: Longmans, Green, 1865.

Bew, John. *Castlereagh*. New York: Oxford University Press, 2012.

Bingham, D. A., ed. *A Selection from the Letters and Dispatches of the First Napoleon*. London: Chapman and Hall, 1884.

Bisson, Massimo. "Il Convento." In *La Basilica dei Santi Giovanni e Paolo: Pantheon della Serenissima*, edited by Giuseppe Pavanello, 469–80. Venice: Marcianum Press/Fondazione Giorgio Cini, 2012.

Black, Jeremy. *Italy and the Grand Tour*. New Haven: Yale University Press, 2003.

Blumer, Marie-Louise. "La commission pour la recherche des objets de sciences et arts en Italie (1796–1797)." In *La Révolution française* 87. Paris: Éditions Rieder, 1934: 62–88, 124–50, 222–59.

———. *La mission de Denon en Italie (1811)*. Paris: Éditions G. Ficker, 1934.

———. "Le transport en France des objets d'art cédés par le Traité de Tolentino." *Revue des Études italiennes* 1, no. 1 (January–March 1936): 11–23.

Boime, Albert. *Art in an Age of Bonapartism, 1800–1815*. 1990. Reprint, Chicago: University of Chicago Press, 1993.

Bonaparte, Napoleon. *The Bonaparte Letters and Despatches*. 2 vols. London: Saunders and Otley, 1846.

———. *Correspondance de Napoléon Ier publiée par l'ordre de l'empereur Napoléon III*. 32 vols. Paris: Plon, 1858–1870

———. *Correspondance générale*. Edited by Thierry Lentz. 15 vols. Paris: Fayard, 2004–2018.

———. *Letters and Documents of Napoleon*. Edited by John Eldred Howard. New York: Oxford University Press, 1961.

Bonnet, Jean-Claude, ed. *L'Empire des muses: Napoléon, les arts et les lettres*. Paris: Belin, 2004.

Bordes, Philippe. "A-J Gros en Italie (1793–1800): Lettres, une allégorie révolutionnaire et un portrait." *Bulletin de la Société de l'histoire de l'art français* (1978): 221–49.

———. *Jacques-Louis David: Empire to Exile*. New Haven: Yale University Press, 2005.

Borean, Linda. "Paolo Veronese nel collezionismo veneziano del settecento." In *I colori della seduzione*, edited by Linda Borean and William L. Barcham, 63–81. Udine: Filacorda, 2012.

Boyer, Ferdinand. "Metternich et la restitution par la France des oeuvres d'art de l'étranger (1814–1815)." *Revue d'histoire diplomatique* 84 (1970): 65–79.

Brejon de Lavergnée, Arnauld. *L'inventaire Le Brun de 1683: La collection des tableaux de Louis XIV*. Paris: Réunion des Musées Nationaux, 1987.

Bresc-Bautier, Geneviève, and Guillaume Fonkenell, eds. *Histoire du Louvre*. 3 vols. Paris: Louvre éditions: Fayard, 2016.

Brilliant, Virginia, and Frederick Ilchman, eds. *Paolo Veronese: A Master and His Workshop in Renaissance Venice*. Sarasota: John and Mable Ringling Museum of Art; London: Scala, 2012.

Brookner, Anita. *Jacques-Louis David*. London: Chatto and Windus, 1980.

Brown, David Alan, and Sylvia Ferino-Pagden. *Bellini, Giorgione, Titian, and the Renaissance of Venetian Painting*. Washington, D.C.: National Gallery of Art, 2006.

Brown, Patricia Fortini. *Art and Life in Renaissance Venice*. Upper Saddle River, N.J.: Prentice Hall, 1997.

———. *Private Lives in Renaissance Venice: Art, Architecture, and the Family*. New Haven: Yale University Press, 2004.

———. *Venice and Antiquity: The Venetian Sense of the Past*. New Haven: Yale University Press, 1997.

———. "Veronese's Patrons." In *Studies in Venetian Art and Conservation*, 78–83. New York: Save Venice, Inc., 2009.

Bruce, Evangeline. *Napoleon and Josephine: An Improbable Marriage*. 1995. Reprint, New York: Kensington, 1996.

Burleigh, Nina. *Mirage: Napoleon's Scientists and the Unveiling of Egypt*. New York: Harper Perennial, 2007.

Carrithers, David W., Michael A. Mosher, and Paul Anthony Rahe, eds. *Montesquieu's Science of Politics: Essays on the Spirit of Laws*. Lanham, Md.: Rowman and Littlefield, 2001.

"Catalogue des 125 tableaux enlevés de la surintendance de Versailles et transportés à Paris au Vieux-Louvre, par ordre de M. Roland, Ministre de l'Intérieur, les 17 et 18 septembre 1792." In Alexandre Tuetey and Jean Guiffrey, *La commission du Muséum et la création du Musée du Louvre (1792–1983)*, 3–20. Paris, 1910.

Chambers, David, Brian Pullan, and Jennifer Fletcher, eds. *Venice: A Documentary History, 1450–1630*. Oxford: Blackwell, 1992.

Charney, Noah. *Stealing the Mystic Lamb: The True Story of the World's Most Coveted Masterpiece*. New York: Public Affairs, 2010.

Chevallier, Bernard, and Marc Walter. *Empire Style: Authentic Decor*. London: Thames and Hudson, 2008.

Christiansen, Keith, ed. *Giambattista Tiepolo, 1696–1770*. New York: Metropolitan Museum of Art, 1996.

Cicogna, Emmanuele Antonio. *Delle inscrizioni veneziane*. 6 vols. Bologna: Forni, 1969–70.

Clark, Kenneth. *The Romantic Rebellion: Romantic Versus Classic Art*. New York: Harper and Row, 1973.

Clark, T. J. *Heaven on Earth: Painting and the Life to Come*. London: Thames and Hudson, 2018.

Claudon, Francis, and Bernard Bailly, eds. *Vivant Denon: Colloque de Chalon-sur-Saône, le 24 mai 2003*. Chalon-sur-Saône: Université pour Tous de Bourgogne, 2003.

Cochin, Charles-Nicolas. *Voyage d'Italie*. Paris: Ch. Ant. Jombert, 1758.

Cocke, Richard. "The Development of Veronese's Critical Reputation." *Arte Venetia* 34 (1980): 96–111.

———. *Paolo Veronese: Piety and Display in an Age of Religious Reform*. Aldershot, Eng.: Ashgate, 2001.

Collavizza, Isabella, "'Fra poco vedremo i nostri Cavalli [. . .] tornare a Venezia': Note di cronaca sul rientro della quadriga marciana (1815–1817)." *Engramma*, no. 111 (November 2013); http://www.engramma.it/eOS/index.php?id_articolo=1455.

Connelly, James L. "The Grand Gallery of the Louvre and the Museum Project: Architectural Problems," *Journal of the Society of Architectural Historians* 31 (May 1972): 120–32.

"Convention (II) with Respect to the Laws and Customs of War on Land and Its Annex: Regulations Concerning the Laws and Customs of War on Land." The Hague, July 29, 1899. International Committee of the Red Cross; ihl-databases.icrc.org.

Cooper, Tracy E. *Palladio's Venice: Architecture and Society in a Renaissance Republic*. New Haven: Yale University Press, 2005.

———. "Un Modo per 'la Riforma Cattolica'?: La scelta di Paolo Veronese per il refettorio di San Giorgio Maggiore." In *Crisi e rinnovamenti nell'autunno del Rinascimento a Venezia*, edited by Vittore Branca and Carlo Ossola, 271–92. Florence: Olschki, 1991.

Cordier, Sylvain, ed. *Napoleon: The Imperial Household*. Montreal: Museum of Fine Arts, 2018.

Crosland, Maurice P. *The Society of Arcueil: A View of French Science at the Time of Napoleon I*. Cambridge, Mass.: Harvard University Press, 1967.

Crouzet-Pavan, Elisabeth. *Venice Triumphant: The Horizons of a Myth*. Translated by Lydia G. Cochrane. Baltimore: Johns Hopkins University Press, 2002.

Crow, Thomas. *Emulation: David, Drouais, and Girodet in the Art of Revolutionary France*. Yale University Press, in association with Getty Research Institute, Los Angeles. Copyright 1995. Revised version, 2006; reprinted, 2008.

———. *Painters and Public Life in Eighteenth-Century Paris*. New Haven: Yale University Press, 1985.

———. *Restoration: The Fall of Napoleon in the Course of European Art, 1812–1820*. Princeton, N.J.: Princeton University Press, 2018.

Cuno, James. *Who Owns Antiquity? Museums and the Battle over Ancient Heritage*. Princeton, N.J.: Princeton University Press, 2003.

Darrow, Elizabeth. "Pietro Edwards and the Restoration of the Public Pictures of Venice, 1778–1819: Necessity Introduced These Arts." PhD diss., University of Washington, 2000.

———. "Pietro Edwards: The Restorer as 'Philosophe.'" *Burlington Magazine* 159 (2017): 308–17.

David, Jacques-Louis. *Account of the Celebrated Picture of the Coronation of Napoleon*. London: G. Schulze, 1822.

———. *Le peintre Louis David: Souvenirs et documents inédits*. Edited by J. L. Jules David. Paris: Victor Havard, 1880.

Delestre, J. B. *Gros: Sa vie et ses ouvrages*. Paris: J. Renouard, 1867.

Del Negro, Piero. "L'Accademia di Belle Arti di Venezia dalle origini al 1806." In *L'Accademia di Belle Arti di Venezia: Il Settecento*, edited by Giuseppe Pavanello, Ilaria Mariani, and Giovanni B. Piazzetta, vol. 1, 1–31. Crocetta del Montello: Antiga, 2015.

———. "The Republic of Venice Meets Napoleon." In *L'Europa scopre Napoleone, 1793–1804*, edited by Vittorio Douglas Scotti, vol. 1, 81–91. Alessandria: Edizioni dell'Orso, 1999.

Dhombres, Nicole. "Gaspard Monge, membre de l'Institut et commissaire des sciences et des arts en Italie: Regard sur une correspondance (juin 1796–octobre 1797)." In Jean-Paul Barbe and Roland Bernecker, *Les intellectuels européens face à la campagne d'Italie (1796–1798)*, 115–26. Münster: Nodus Publikationen, 1999.

Di Giorgi, Carmen. "Arte di conquista: Le requisizioni napoleoniche." *Art e dossier* 19, no. 204 (2004): 31–35.

Duncan, Carol. *Civilizing Rituals: Inside Public Art Museums*. London: Routledge, 1995.

Dupuy, Marie-Anne, Isabelle Le Masne de Chermont, and Elaine Williamson, eds. *Vivant Denon: Directeur des musées sous le Consulat et l'Empire; Correspondance, 1802–1815*. 2 vols. Paris: Réunion des Musées Nationaux, 1999.

Dursteler, Eric R. *A Companion to Venetian History, 1400–1797*. Leiden: Brill, 2013.

Dwyer, Philip. *Citizen Emperor*. New Haven: Yale University Press, 2013.

———. *Napoleon: The Path to Power, 1769–1799*. New Haven: Yale University Press, 2008.

Echols, Robert, and Frederick Ilchman, eds. *Tintoretto: Artist of Renaissance Venice.* New Haven: Yale University Press, 2018.

Edwards, Giovanni O'Kelly, and Pietro Edwards. "On the Restoration of the Royal Paintings of Venice (1812 and 1833)." In *Issues in the Conservation of Paintings,* edited by David Bomford and Mark Leonard, 46–58. Los Angeles: Getty Conservation Institute, 2004.

Eiling, Alexander, ed. *Cézanne: Metamorphoses.* Munich: Prestel, 2017.

Eitner, Lorenz. *An Outline of 19th Century European Painting: From David Through Cézanne.* New York: Icon/HarperCollins, 1992.

———, ed. *Neoclassicism and Romanticism, 1750–1850.* 2 vols. Englewood Cliffs, N.J.: Prentice-Hall, 1970.

Englund, Steven. *Napoleon: A Political Life.* Cambridge, Mass.: Harvard University Press, 2004.

Étienne, Noémie. *The Restoration of Paintings in Paris, 1750–1815: Practice, Discourse, Materiality.* Los Angeles: Getty Conservation Institute, 2017.

Eustace, Katharine, ed. *Canova: Ideal Heads.* Oxford: Ashmolean Museum, 1997.

Fehl, Philipp P. *Decorum and Wit: The Poetry of Venetian Painting.* Vienna: IRSA, 1992.

———. "Veronese and the Inquisition: A Study of the Subject Matter of the So-Called 'Feast in the House of Levi.'" *Gazette des Beaux-Arts* 58 (1961): 325–54.

———. "Veronese's Decorum: Notes on the Marriage at Cana." In *Art, the Ape of Nature: Studies in Honour of H. W. Janson,* edited by Moshe Barasch and Lucy Freeman Sandler, 341–65. New York: Harry N. Abrams, 1981.

Ferraro, Joanne M. *Venice: History of the Floating City.* Cambridge: Cambridge University Press, 2012.

Fêtes de la liberté et entrée triomphale des objets de sciences et d'arts recueillis en Italie. Paris: L'Imprimerie de la République, 1798.

Fontaine, Pierre-François-Léonard. *Journal 1799–1853.* 2 vols. Paris: École Nationale Supérieure des Beaux-Arts/Institut français d'architecture/Société de l'Histoire de l'Art Français, 1987.

Foscolo, Ugo. *Last Letters of Jacopo Ortis; and, Of Tombs.* Translated by J. G. Nichols. London: Hesperus, 2002.

France, Anatole. *On Life and Letters.* Translated by A. W. Evans. London: John Lane, 1911.

Francis, Sir Philip. *Memoirs of Sir Philip Francis.* London: Longmans, Green, 1867.

Gagliardi, Pasquale, ed. *The Miracle of Cana: The Originality of the Re-Production.* Caselle di Sommacampagna, It.: Cierre Edizioni, 2011.

Galassi, C. *Il Tesoro perduto: Le requisizioni napoleoniche a Perugia e la fortuna della 'scuola' umbra in Francia tra 1797 e 1815.* Perugia: Volumnia, 2004.

Gardner, James. *The Louvre: The Many Lives of the World's Most Famous Museum.* New York: Grove Atlantic, 2020.

Garric, Jean-Philippe, ed. *Charles Percier: Architecture and Design in an Age of Revolutions*. New Haven: Yale University Press, 2017.

Gietz, Nora. "Tracing Paintings in Napoleonic Italy: Archival Records and the Spatial and Contextual Displacement of Artworks." *Artl@s Bulletin* 4, no. 2 (2016): article 6.

Gilbert, C. "Last Suppers and Their Refectories." In *The Pursuit of Holiness in Late Medieval and Renaissance Religion*, edited by Charles Trinkaus and Heiko A. Oberman, 371–402. Leiden: Brill, 1974.

Gilks, David. "Art and Politics During the 'First' Directory: Artists' Petitions and the Quarrel over the Confiscation of Works of Art from Italy in 1796." *French History* 26, no. 1 (March 2012): 53–78.

———. "Attitudes to the Displacement of Cultural Property in the Wars of the French Revolution and Napoleon." *Historical Journal* 56 (2013): 113–43.

Gisolfi, Diana. *Paolo Veronese and the Practice of Painting in Late Renaissance Venice*. New Haven: Yale University Press, 2017.

———. "Paolo Veronese e i Benedettini della congregazione cassinese: Un caso di committenza nel cinquecento." *Arte Veneta* 61 (2004): 206–11.

Glinzer, Martin, ed. "Canova: Letters to a Friend in London (1815)." In *Translocations: Anthology; A Collection of Commented Source Texts on Relocations of Cultural Assets Since Antiquity*, 2018; https://translanth.hypotheses.org/ueber/canova.

Goethe, Johann Wolfgang. *Goethe's Travels in Italy: Together with His Second Residence in Rome and Fragments on Italy*. London: George Bell and Sons, 1885.

Gould, Cecil. *Trophy of Conquest: The Musée Napoléon and the Creation of the Louvre*. London: Faber and Faber, 1965.

Grasselli, Margaret Morgan, and Yuriko Jackall. *Hubert Robert*. Washington, D.C.: National Gallery of Art, 2016.

[Greatheed, Bertie.] *A Tour in France, 1802*. London: J. Barfield, 1808.

Grigsby, Darcy Grimaldo. "Rumor, Contagion, and Colonization in Gros's *Plague-Stricken of Jaffa* (1804)." *Representations* 51 (Summer 1995): 1–46.

Gustavson, Natalia. "Retracing the Restoration History of Viennese Paintings in the Musée Napoléon (1809–1815)." *CeROArt*, 2012; http://doi.org/10.4000/ceroart.2325.

Habert, Jean, and Nathalie Volle, eds. *Les Noces de Cana de Véronèse: une oeuvre et sa restauration*. Musée du Louvre, Paris, 16 novembre 1992–29 mars 1993. Paris: Réunion des Musées Nationaux, 1992.

Hanley, Wayne. *The Genesis of Napoleonic Propaganda, 1796–1799*. New York: Columbia University Press, 2005.

Hanson, Kate H. "The Language of the Banquet: Reconsidering Paolo Veronese's *Wedding at Cana*." *InVisible Culture* 14 (Winter 2010).

Harris, Ann Sutherland. *Seventeenth-Century Art and Architecture*. London: Lawrence King, 2005.

Haskell, Francis. *The Ephemeral Museum: Old Master Paintings and the Rise of the Art Exhibition*. New Haven: Yale University Press, 2000.

———. "Francesco Guardi as Vedutista and Some of His Patrons." *Journal of the Warburg and Courtauld Institutes* 23, no. 3–4 (July–December 1960): 256–76.

———, and Nicholas Penny. *Taste and the Antique: The Lure of Classical Sculpture, 1500–1900*. New Haven: Yale University Press, 1981.

Hazlitt, William. "On the Pleasure of Painting." In *Table Talk; or Original Essays*. London: J. M. Dent, c. 1908.

Hills, Paul. *Venetian Colour: Marble, Mosaic, Painting and Glass, 1250–1550*. New Haven: Yale University Press, 1999.

Hinckley, John. *An Accurate Account of the Fall of the Republic of Venice, and of the Circumstances Attending That Event*. London: Hatchard, 1804.

Hitchens, Christopher. *The Parthenon Marbles: The Case for Reunification*. 1997. Reprint, London: Verso, 2008.

Hoeniger, Cathleen. "The Art Requisitions by the French Under Napoléon and the Detachment of Frescoes in Rome, with an Emphasis on Raphael." *CeROArt*, 2012; https://doi.org/10.4000/ceroart.2367.

Honour, Hugh, and John Fleming. *The Visual Arts: A History*. 5th ed. New York: Harry N. Abrams, 1999.

Hope, Charles. *Veronese and the Venetian Tradition of Allegory*. Oxford: Oxford University Press, 1985.

Huet, Valerie. "Napoleon I: A New Augustus?" In *Roman Presences: Receptions of Rome in European Culture, 1789–1945*, edited by Catherine Edwards, 53–69. Cambridge: Cambridge University Press, 1999.

Humfrey, Peter. *Painting in Renaissance Venice*. New Haven: Yale University Press, 1995.

———, T. Clifford, A. Weston-Lewis, and M. Bury, eds. *The Age of Titian: Venetian Renaissance Art from Scottish Collections*. Edinburgh: National Galleries of Scotland, 2004.

Hunt, Lynn. *Politics, Culture, and Class in the French Revolution*. 1964. Reprint, Berkeley: University of California Press, 1984.

———, and Jack R. Censer. *The French Revolution and Napoleon: Crucible of the Modern World*. London: Bloomsbury Academic, 2017.

Hyde, Edward, Earl of Clarendon. *The History of the Rebellion and Civil Wars in England*. 3 vols. Oxford: Clarendon, 1807.

Ideologie e patrimonio storico-culturale nell'età rivoluzionaria e napoleonica: A proposito del trattato di Tolentino. Rome: Ministero per i beni e le attività culturali/Ufficio centrale per i beni archivistici, 2000.

Idzerda, Stanley J. "Iconoclasm During the French Revolution." *American Historical Review* 60, no. 1 (1954): 13–26.

Ilchman, Frederick. "Jacopo Tintoretto in Process: The Making of a Venetian Master, 1540–1560." PhD diss., Columbia University, 2014; https://academiccommons .columbia.edu/doi/10.7916/D8T151TW.

Ilchman, Frederick, et al. *Titian, Tintoretto, Veronese: Rivals in Renaissance Venice.* Boston: Museum of Fine Arts, 2009.

James, Henry. *Italian Hours.* Edited by John Auchard. New York: Penguin, 1992.

———. *A Little Tour of France.* New York: AMS Press, 1900.

Johns, Christopher M. S. *Antonio Canova and the Politics of Patronage in Revolutionary and Napoleonic Europe.* Berkeley: University of California Press, 1988.

———. "Portrait Mythology: Antonio Canova's Portraits of the Bonapartes." *Eighteenth-Century Studies* 28, no. 1 (1994): 115–29.

Johnson, Dorothy. *Jacques-Louis David: Art in Metamorphosis.* Princeton, N.J.: Princeton University Press, 1993.

———, ed. *Jacques-Louis David: New Perspectives.* Newark: University of Delaware Press, 2006.

Jones, Colin. *The Cambridge Illustrated History of France.* Cambridge: Cambridge University Press, 1994.

Kauffmann, C. M., and Susan Jenkins. *Catalogue of Paintings in the Wellington Museum, Apsley House.* London: English Heritage/Paul Holberton Publishing, 2009.

Kennedy, Emmet. *A Cultural History of the French Revolution.* New Haven: Yale University Press, 1989.

Kersaint, Armand-Guy. *Discours sur les monuments publics, prononcé au conseil du département de Paris, le 15 décembre 1791.* Paris: L'Imprimerie de P. Didot l'Aîné, 1792.

Kissinger, Henry A. *A World Restored: Metternich, Castlereagh and the Problems of Peace, 1812–22.* London: Weidenfeld and Nicolson, 1957.

Klein, Robert, and Henri Zerner, eds., *Italian Art, 1500–1600: Sources and Documents.* Evanston, Ill.: Northwestern University Press, 1966.

Lalande, Joseph-Jérôme. *Voyage d'un français en Italie, fait dans les années 1765 et 1766.* 2nd ed. 9 vols. Paris: Veuve Desaint, 1786.

Laveissière, Sylvain, ed. *Napoléon et le Louvre.* Paris: Fayard, 2004.

Laven, David. "The Fall of Venice: Witnessed, Imagined, Narrated." *Acta Histriae* 19/3 (2011): 241–58.

Lawrence, Thomas. *The Life and Correspondence of Sir Thomas Lawrence.* Edited by D. E. Williams. 2 vols. London: H. Colburn and R. Bentley, 1831.

Levey, Michael. *Rococo to Revolution: Major Trends in Eighteenth-Century Painting.* New York: Frederick A. Praeger, 1966.

Lipkowitz, Elise. "Seized Natural-History Collections and the Redefinition of Scientific Cosmopolitanism in the Era of the French Revolution." *British Journal for the History of Science* 47 (2014): 15–41.

Lippomano, Francesco. *Lettere familiari ad Alvise Querini negli anni, 1795–1797.* Edited by Giandomenico Ferri Cataldi. Rome: GEDI Gruppo Editoriale, 2010.

Lubliner-Mattatia, Sabine. "Monge et les objets d'art d'Italie." *Bulletin de la Sabix* 41 (2007): 92–110.

Mahon, Dorothy, Silvia A. Centeno, Mark T. Wypyski, Xavier F. Salomon, and Andrea Bayer. "Technical Study of Three Allegorical Paintings by Paolo Veronese: *The Choice Between Virtue and Vice, Wisdom and Strength,* and *Mars and Venus United by Love.*" *Metropolitan Museum Studies in Art, Science, and Technology* 1 (2010): 83–108.

Mainardi, Patricia. "Assuring the Empire of the Future: The 1798 Fête de la Liberté." *Art Journal* 48, no. 2 (1989): 155–63.

Malamani, Vittorio, ed. *Un'amicizia di Antonio Canova: Lettere di lui al conte Leopoldo Cicognara raccolte e pubblicate.* Città di Castello: S. Lapi, 1890.

Mannlich, Johann Christian von. *Histoire de ma vie: Mémoires de Johann Christian von Mannlich, 1741–1822.* Edited by Karl Heinz Bender and Hermann Kleber. Trier, Ger.: Spee Verlag, 1993.

Markham, Felix. *Napoleon.* New York: Signet Classics, 2010.

Martineau, Jane, and Charles Hope, eds. *The Genius of Venice, 1500–1600.* London: Royal Academy of Arts, 1983.

Matthew, Louisa C. "'Vendecolori a Venezia': The Reconstruction of a Profession." *Burlington Magazine* 144, no. 1196 (2002): 680–86.

Mazauric, Lucie. *Le Louvre en voyage, 1939–1945.* Paris: Plon, 1978.

———. *Ma vie de châteaux.* Paris: Perrin, 1967.

Mazzocca, Ferdinando, Paola Marini, and Roberto De Feo, eds. *Canova, Hayez, Cicognara: L'ultima gloria di Venezia.* Venice: Marsilio/Electa, 2017.

McClellan, Andrew. *Inventing the Louvre: Art, Politics, and the Origins of the Modern Museum in Eighteenth-Century Paris.* Berkeley: University of California Press, 1999.

———, ed. *Art and Its Publics: Museum Studies at the Millennium.* Malden, Mass.: Blackwell, 2003.

McClellan, George B. *Venice and Bonaparte.* Princeton, N.J.: Princeton University Press, 1931.

Metternich, Clemens Wenzel Lothar. *Memoirs of Prince Metternich, 1773–1815.* Edited by Richard Metternich. Translated by Mrs. Alexander Napier. 5 vols. New York: Charles Scribner's Sons, 1880.

Miles, Margaret M. *Art as Plunder: The Ancient Origins of Debate About Cultural Property.* New York: Cambridge University Press, 2008.

Monge, Gaspard. *Dall'Italia (1796–1798).* Edited by Sandro Cardinali and Luigi Pepe. Palermo: Sellerio, 1993.

Monnoret, Sophie. *David and Neo-Classicism.* Translated by Chris Miller and Peter Snowdon. Paris: Finest SA/Éditions Pierre Terrail, 1999.

de Montaiglon, Anatole, and Jules Guiffrey, eds. *Correspondance des directeurs de l'Académie de France à Rome*. Vol. 16, *1791–1797*. Paris: Jean Schemit, 1907.

———. *Correspondance des directeurs de l'Académie de France à Rome*. Vol. 17, *1797–1804*. Paris: Jean Schemit, 1908.

Müntz, Eugène. "Les invasions de 1814–1815 et la spoliation de nos musées." *La Nouvelle revue* 115, no. 1 (1897): 703–16; and 115, no. 2, 193–207, 420–39.

Neher, Gabriele, and Rupert Shepherd, eds. *Revaluing Renaissance Art*. Aldershot, Eng.: Ashgate, 2000.

Nepi Scirè, Giovanna. "Il 'Convito in Casa di Levi' di Paolo Veronese, vicende e restauri," *Il restauro del Convito in Casa di Levi di Paolo Veronese*. Venezia: Ministero per i Beni Culturali e Ambientali, 1984, 13–42.

———. *Treasures of Venetian Painting: The Gallerie dell'Accademia*. Venice: Arsenale Editrice, 1991.

———, ed. *Paolo Veronese: restauri: 1 giugno–30 settembre*. Venice: Ministero per i Beni Culturali e Ambientali, 1988.

Nestor, Sofia, ed. *War-Booty: A Common European Cultural Heritage*. Stockholm: Livrustkammaren, 2009.

Nicholas, Lynn H. *The Rape of Europa: The Fate of Europe's Treasures in the Third Reich and the Second World War*. New York: Alfred A. Knopf, 1994.

Norwich, John Julius. *A History of Venice*. New York: Random House, 1982.

Notice de plusieurs précieux tableaux, recueillis à Venise, Florence, Turin et Foligno. Paris: L'Imprimerie des Sciences et Arts, 1802.

Notice des grands tableaux de Paul Véronèse, Rubens, Le Brun, Louis Carrache. Paris: L'Imprimerie des Sciences et Arts, 1801.

Notice des principaux tableaux recueillis dans la Lombardie, par les commissaires du gouvernement français. Paris: L'Imprimerie des Sciences et Arts, 1798.

Notice des principaux tableaux recueillis en Italie, par les commissaires du gouvernement français: Seconde partie. Paris: L'Imprimerie des Sciences et Arts, 1798.

Notice des principaux tableaux recueillis en Italie, par les commissaires du gouvernement français: Troisième partie. Paris: L'Imprimerie des Sciences et Arts, 1800.

Notice des tableaux des écoles française et flamande, exposés dans la grande Galerie dont l'ouverture a eu lieu le 28 Germinal an VII; et des tableaux des écoles de Lombardie et de Bologne. Paris: L'Imprimerie des Science et Arts, 1801.

Notice des tableaux, dont plusieurs ont été recueillis à Parme et à Venise. Paris: L'Imprimerie des Sciences et Arts, 1805.

O'Brien, David. *After the Revolution: Antoine-Jean Gros, Painting and Propaganda Under Napoleon*. University Park: Pennsylvania State University Press, 2006.

———. "Propaganda and the Republic of the Arts in Antoine-Jean Gros's *Napoleon Visiting the Battlefield of Eylau the Morning After the Battle*." *French Historical Studies* 26, no. 2 (2003): 290–314.

Palmer, R. R. *The Age of the Democratic Revolution: A Political History of Europe and America, 1760–1800*. Princeton, N.J.: Princeton University Press, 2014.

——, Joel Colton, and Lloyd Kramer. *A History of the Modern World*. New York: McGraw-Hill, 2007.

Pancaldi, Giuliano. *Volta: Science and Culture in the Age of Enlightenment*. Princeton, N.J.: Princeton University Press, 2003.

Partridge, Loren W. *The Art of Renaissance Venice, 1400–1600*. Berkeley: University of California Press, 2015.

Paul, Carole, ed. *The First Modern Museums of Art: The Birth of an Institution in 18th- and Early-19th-Century Europe*. Los Angeles: J. Paul Getty Museum, 2012.

Pederzani, Ivana. *I Dandolo: dall'Italia dei lumi al Risorgimento*. Milan: F. Angeli, 2014.

Penny, N. *National Gallery Catalogues: The Sixteenth-Century Italian Paintings*. Vol. 2, *Venice, 1540–1600*. London: National Gallery, 2008.

——, A. Roy, and M. Spring. "Veronese's Paintings in the National Gallery: Technique and Materials; Part II." *National Gallery Technical Bulletin* 17 (1996): 32–55.

Perry, Marilyn, "Saint Mark's Trophies: Legend, Superstition, and Archaeology in Renassiance Venice." *Journal of the Warburg and Courtauld Institutes* 40 (1977): 27–49.

Petropoulos, Jonathan. *Art as Politics in the Third Reich*. Chapel Hill: University of North Carolina Press, 1996.

——. *The Faustian Bargain: The Art World in Nazi Germany*. New York: Oxford University Press, 2000.

Pignatti, Terisio, and Filippo Pedrocco. *Veronese*. 2 vols. Milan: Electa, 1995.

Plant, Margaret. *Venice: Fragile City, 1797–1997*. New Haven: Yale University Press, 2002.

Pomian, Krzystof. *Collectors and Curiosities: Paris and Venice, 1500–1800*. Cambridge: Polity, 1990.

Pommereul, François-René-Jean de. *Campagne du Général Buonaparte en Italie pendant les années IVe et Ve de la République française*. Paris: Plassan, 1797.

Pommier, Édouard. "Idéologie et musée à l'époque de la Révolution." In *Les images de la Révolution française*, edited by Michel Vovelle, 57–78. Paris: Publications de la Sorbonne, 1988.

——. *L'art de la liberté: Doctrines et débats de la Révolution française*. Paris: Gallimard, 1991.

——. "La saisie des oeuvres d'art." *Revue du Souvenir Napoléonien* 408 (1996): 30–43.

——. "L'invention du monument aux grands hommes (XVIIIe siècle)." In *Entretiens de la Garenne Lemot: Le culte des grands hommes au XVIIIe siècle; Actes du Colloque 3 au 5 octobre 1996*, 8–23. Nantes: Institut Universitaire de France, 1998.

Porterfield, Todd, and Susan L. Siegfried. *Staging Empire: Napoleon, Ingres, and David*. University Park: Pennsylvania State University Press, 2006.

Potts, Alex. *Flesh and the Ideal: Winckelmann and the Origins of Art History*. New Haven: Yale University Press, 1994.

Poulot, Dominique. *Musée, nation, patrimoine, 1789–1815*. Paris: Gallimard, 1997.

———. "Museums and Museologies." Translated by Matthew Rampley. In *Art History and Visual Studies in Europe: Transnational Discourses and National Frameworks*, edited by Matthew Rampley, Thierry Lenain, Hubert Locher, Andrea Pinott, Charlotte Schoell-Glass, and Kitty Zijlmans, 197–215. Leiden: Brill, 2012.

———. "Provenance and Value: The Reception of Ancien Régime Works of Art Under the French Revolution." In *Provenance: An Alternate History of Art*, edited by Gail Feigenbaum and Inge Reist, 61–84. Los Angeles: Getty Research Institute, 2013.

Prendergast, Christopher. *Napoleon and History Painting: Antoine-Jean Gros's "La Bataille d'Eylau."* Oxford: Oxford University Press, 1997.

Preto, Paolo. "Un 'uomo nuovo' dell'età napoleonica: Vincenzo Dandolo politico e imprenditore agricolo." *Rivista Storica Italiana* 94, no. 1 (1982): 44–97.

Quatremère de Quincy, Antoine. *Letters to Miranda and Canova: On the Abduction of Antiquities from Rome and Athens*. Introduction by Dominique Poulot. Translated by Chris Miller and David Gilks. Los Angeles: Getty Research Institute, 2012.

Quynn, Dorothy Mackay. "The Art Confiscations of the Napoleonic Wars." *American Historical Review* 50, no. 3 (1945): 437–60.

Raimbach, Abraham, and Michael Thomson Scott Raimbach. *Memoirs and Recollections of the Late Abraham Raimbach, Esq., Engraver . . . Including a Memoir of Sir David Wilkie, R.A.* London: Frederick Shobert, 1843.

Razzall, Rosie, and Lucy Whitaker. *Canaletto: The Art of Venice*. London: Royal Collection Trust, 2017.

Reist, Inge Jackson. "*Divine Love* and Veronese's Frescoes at the Villa Barbaro." *The Art Bulletin* 67, no. 4 (1985): 614–35.

Reitlinger, Gerald. *The Economics of Taste: The Rise and Fall of the Picture Market, 1760–1960*. New York: Holt, Rinehart and Winston, 1961.

Richardson, Jonathan. *An Account of Some of the Statues, Bas-reliefs, Drawings and Pictures in Italy*. London: J. Knapton, 1722.

Roberts, Andrew. *Napoleon: A Life*. New York: Penguin, 2015.

———. *Napoleon and Wellington*. London: Weidenfeld and Nicolson, 2001.

Roberts, Warren E. *Jacques-Louis David: Revolutionary Artist*. Chapel Hill: University of North Carolina Press, 1992.

Robertson, Emily. *Letters and Papers of Andrew Robertson, Miniature Painter*. London: Eyre and Spottiswoode, 1895.

Rosand, David. *The Myths of Venice: The Figuration of a State*. Chapel Hill: University of North Carolina Press, 2001.

———. *Painting in Sixteenth-Century Venice: Titian, Veronese, Tintoretto*. Rev. ed. Cambridge: Cambridge University Press, 1997.

———. "Theater and Structure in the Art of Paolo Veronese." *The Art Bulletin* 55, no. 2 (1973): 217–39.

Rosenberg, Martin. "Raphael's *Transfiguration* and Napoleon's Cultural Politics." *Eighteenth-Century Studies* 19, no. 2 (Winter 1985–1986): 180–205.

Rosenberg, Pierre. ed. *Dominique-Vivant Denon: L'oeil de Napoléon*. Paris: Musée du Louvre, 20 octobre 1999–17 janvier 2000. Paris: Réunion des Musées Nationaux, 1999.

Rosenblum, Robert. *Transformations in Late Eighteenth Century Art*. Princeton, N.J.: Princeton University Press, 1967.

Rowland, Ingrid, and Noah Charney. *The Collector of Lives: Giorgio Vasari and the Invention of Art*. New York: W. W. Norton, 2017.

Ruskin, John. *The Diaries of John Ruskin*. Edited by Joan Evans and J. H. Whitehouse. 3 vols. Oxford: Clarendon, 1956–1959.

———. *The Works of John Ruskin*. Edited by E. T. Cook and Alexander Wedderburn. 39 vols. London: George Allen, 1903–1912.

Salomon, Xavier F. "Review of *La Cena in Casa di Levi di Paolo Veronese: Il processo riaperto* by Maria Elena Massimi." *Burlington Magazine* 154 (2012): 581–83.

———. "Review of *Tiepolo and Veronese* Exhibition." *Burlington Magazine* 155 (2013): 287–89.

———. *Veronese*. London: National Gallery Company, 2014.

———. *Veronese's Allegories: Virtue, Love, and Exploration in Renaissance Venice*. New York: Frick Collection, 2006.

———, ed. *Paolo Veronese: The Petrobelli Altarpiece*. Milan: Silvana, 2009.

Sandholz, Wayne. *Prohibiting Plunder: How Norms Change*. New York: Oxford University Press, 2007.

Saunier, Charles. *Les conquêtes artistiques de la Révolution et de l'Empire*. Paris: Librairie Renouard, 1902.

Savoy, Bénédicte. *Patrimoine annexé: Les biens culturels saisis par la France en Allemagne autour de 1800*. Paris: Éditions de la Maison des sciences de l'homme, 2003.

———. "Plunder, Restitution, Emotion and the Weight of Archives: An Historical Approach." In *Echoes of Exile: Moscow Archives and the Arts in Paris, 1933–1945*, edited by Ines Rotermund-Rynard, 27–44. Boston: De Gruyter, 2015.

———. "'Une ample moisson de superbes choses': Les missions en Allemagne et en Autriche 1806–1809." In *Dominique-Vivant Denon: L'oeil de Napoléon*, edited by Pierre Rosenberg, 170–81. Paris: Musée du Louvre, 1999.

Savoy, Bénédicte, and Yann Potin, eds. *Napoleon und Europa: Traum und Trauma*. Munich: Prestel, 2010.

Schama, Simon. *Citizens: A Chronicle of the French Revolution*. New York: Random House, 1989.

Schmid, Vanessa I., and Julia I. Armstrong-Totten, eds. *The Orléans Collection*. New Orleans: New Orleans Museum of Art/D. Giles Limited, 2018.

Scott, John. *Paris Revisited, in 1815, by Way of Brussels*. London: Longman, 1816.

Seward, Desmond. *Metternich: The First European*. London: Thistle Publishing, 2015.

Sheehan, James J. *Museums in the German Art World: From the End of the Old Regime to the Rise of Modernism*. Oxford: Oxford University Press, 2000.

Siegfried, Susan L. *The Art of Louis-Léopold Boilly: Modern Life in Napoleonic France*. New Haven: Yale University Press, 1995.

Simonson, George A. "Guardi's Pictures of the Papal Benediction in Venice, 1782." *Burlington Magazine* 36, no. 203 (1920): 93–94.

Spiegel, Régis. *Dominique-Vivant Denon et Benjamin Zix: Témoins et acteurs de l'épopée napoléonienne*. Paris: Harmattan, 2000.

Spieth, Darius A. *Revolutionary Paris and the Market for Netherlandish Art*. Leiden: Brill, 2018.

Statues, bustes, bas-reliefs, bronzes, et autres antiquités, peintures, dessins, et objets curieux, conquis par la Grande Armée, dans les années 1806 et 1807. Paris: Dubray Imprimeur du Musée Napoléon, 1807.

Stendhal. *The Charterhouse of Parma*. Translated by Richard Howard. New York: The Modern Library, 2003.

———. *Histoire de la peinture en Italie*. Paris, 1868.

Stewart, Robert, Viscount Castlereagh. *Correspondence, Despatches and Other Papers of Viscount Castlereagh*. Vols. 10, 11 and 12. Edited by Charles Vane. London: John Murray, 1853.

Stuffmann, M. "Les Tableaux de la collection de Pierre Crozat: Historique et destinée d'un ensemble célèbre établi en partant d'un inventaire après décès inédit, 30 mai 1740." *Gazette des Beaux-Arts* 72 (1968): 11–143.

Supplément à la notice des tableaux des trois écoles exposés dans la grande galerie du Musée Napoléon. Paris: L'Imprimerie des Sciences et Arts, 1804.

Tentori, Cristoforo, ed. *Raccolta cronologico-ragionata di documenti inediti che formano la storia diplomatica della rivoluzione e caduta della Repubblica di Venezia: Corredata da critiche osservazioni*. Florence, 1800.

Thompson, J. M. *Napoleon Bonaparte*. 1952. Reprint, Oxford: Blackwell, 1990.

Tinterow, Gary, and Geneviève Lacambre. *Manet/Velázquez: The French Taste for Spanish Painting*. New York: Metropolitan Museum of Art; New Haven: Yale University Press, 2003.

Tolstoy, Leo. *War and Peace*. Translated by Richard Pevear and Larissa Volokhonsky. New York: Vintage, 2008.

Ton, Denis. "Appendix: Anthology." In *The Miracle of Cana: The Originality of the Re-Production*, edited by Pasquale Gagliardi, 46–69. Caselle di Sommacampagna, It.: Cierre Edizioni, 2011.

———. "An Appraisal of the Critical Fortune of Veronese's *Wedding at Cana*." In *The Miracle of Cana: The Originality of the Re-Production*, edited by Pasquale Gagliardi, 27–45. Caselle di Sommacampagna, It.: Cierre Edizioni, 2011.

Toulongeon, François-Émmanuel. *Manuel du Muséum français*. Vol. 9. Paris: Treuttel et Würtz, 1806.

Tranquilli, Gloria. "Venti capolavori in cambio per la libertà: Pietro Edwards, 'Cittadino amoroso,' partecipa fra orgoglio di patria e tormenti dell'anima all'adempimento del trattato di Milano." In *Arte nelle Venezie: Scritti di amici per Sandro Sponza*, edited by Chiara Ceschi, Pierluigi Fantelli, and Francesca Flores d'Arcais, 179–90. Saonara: Il Prato, 2007.

Treue, Wilhelm. *Art Plunder: The Fate of Works of Art in War, Revolution and Peace*. London: Methuen, 1960.

Trevor-Roper, Hugh. *The Plunder of the Arts in the Seventeenth Century*. London: Thames and Hudson, 1970.

Tuetey, Alexandre, and Jean Guiffrey. *La commission du Muséum et la création du Musée du Louvre (1792–1793)*. Paris, 1910.

Uglow, Jenny. *In These Times: Living in Britain Through Napoleon's Wars, 1793–1815*. New York: Farrar, Straus and Giroux, 2014.

Valland, Rose. *Le front de l'art: défense des collections françaises, 1939–1945*. Paris: Réunion des Musées Nationaux, 1997.

Van Gogh, Vincent. *Van Gogh: The Letters*. Vol. 3. Edited by Leo Jansen, Hans Luijten, Nienke Bakker. Amsterdam: Van Gogh Museum; The Hague: Huygens Institute; London: Thames & Hudson, 2009.

Van Nimmen, Jane, "Friedrich Schlegel's Response to Raphael in Paris." In *The Documented Image: Visions in Art History*, edited by Gabriel P. Weisberg, Laurinda S. Dixon, and Antje Bultmann Lemke, 319–33. Syracuse, N.Y.: Syracuse University Press, 1987.

Vasari, Giorgio, Raffaele Borghini, and Carlo Ridolfi. *Lives of Veronese*. Edited by Xavier F. Salomon. London: Pallas Athene, 2009.

Vaughan, William, and Helen Weston, eds. *David's The Death of Marat*. Cambridge: Cambridge University Press, 2000.

Vauthier, Gabriel. "Denon et le gouvernement des arts sous le Consulat." *Annales historiques de la Révolution française* 4, no. 3 (May–June 1911): 337–65.

de Virenque, Georges. "Les chefs-d'oeuvre de l'art italien à Paris, en 1796." *Revue Bleue*, 4th ser., 3 (1895): 561–63.

Wardropper, Ian, and Thomas F. Rowlands. "Antonio Canova and Quatremère de Quincy: The Gift of Friendship." *Art Institute of Chicago Museum Studies* 15, no. 1 (1989): 38–46, 85–86.

Watson, Peter. *Wisdom and Strength: The Biography of a Renaissance Masterpiece*. New York: Doubleday, 1989.

Wescher, Paul. *Kunstraub unter Napoleon.* Berlin: Mann, 1976.

Wellesley, Arthur, Duke of Wellington. *Supplementary Despatches and Memoranda of Field Marshal Arthur, Duke of Wellington, K.G.* Edited by Arthur Richard Wellesley. 15 vols. London: J. Murray, 1858–1872.

Weston, Stephen. *The Praise of Paris: or a Sketch of the French Capital; in Extracts of Letters from France.* London: C. and R. Baldwin, 1803.

Wilson-Smith, Timothy. *Napoleon and His Artists.* London: Constable, 1996.

Wilton-Ely, John, and Valerie Wilton-Ely, trans. *The Horses of San Marco.* Milan: Olivetti, 1979.

Winckelmann, Johann Joachim. *Johann Joachim Winckelmann on Art, Architecture, and Archaeology.* Translated by David Carter. Rochester: Camden House, 2013.

Winfield, Rif, and Stephen S. Roberts. *French Warships in the Age of Sail, 1786–1861: Design, Construction, Careers and Fates.* Barnsley, Eng.: Seaforth, 2015.

Wintermute, Alan, ed. *1789: French Art During the Revolution.* New York: Colnaghi, 1989.

Zamoyski, Adam. *Napoleon: A Life.* New York: Basic Books, 2018.

Zanetti, Anton Maria. *Della pittura veneziana e delle opere pubbliche de' veneziani maestri.* 5 vols. Venice, 1771.

Ziskin, Rochelle. *Sheltering Art: Collecting and Social Identity in Early Eighteenth-Century Paris.* University Park: Pennsylvania State University Press, 2012.

Zorzi, Alvise. *Napoleone a Venezia.* Milan: Mondadori, 2010.

———. *Venezia austriaca, 1798–1866.* Bari: Laterza, 1985.

———. *Venezia scomparsa.* Milan: Electa, 1972.

Zucchetta, Emanuela. "La Chiesa di San Zaccaria: La pala di San Zaccaria." In *Bellini a Venezia: Sette opere indagate nel loro contesto,* edited by Gianluca Poldi and Giovanni Carlo Federico Villa, 157–62. Milan: Silvana, 2008.

Acknowledgments

To the many individuals who contributed to the writing of this book, I am tremendously grateful.

First, I would like to thank Jonathan Galassi for his enthusiasm from the start for a book about Napoleon's Italian art thefts, his support as the book progressed, and, above all, his friendship.

At the Louvre, Vincent Delieuvin gave me the extraordinary chance to stand in front of *The Wedding Feast at Cana* in the evening when the museum was closed and the galleries were empty. He also graciously answered countless questions.

For reading the entire manuscript and giving so generously of their formidable knowledge to improve it, I am thankful to David Bell, Lynn Hunt, and Svetlana Alpers, whose seminar at Berkeley on seventeenth-century Dutch art started me off. To Philippe Bordes, Piero Del Negro, Frederick Ilchman, Elise Lipkowitz, Asher Miller, David O'Brien, Inge Reist, and Xavier Salomon, who each read parts of the manuscript and sharpened it, I also owe my great thanks.

To the John Simon Guggenheim Memorial Foundation for the support it gave to this book, I am deeply indebted. In particular, I thank André Bernard.

To understand Veronese's process when painting *The Wedding Feast at Cana* in San Giorgio Maggiore's refectory and then what may have happened when the French rolled up the canvas and sent it to Paris, I relied on Dorothy Mahon and Dianne Modestini, both in New York. Each spent hours, in their light-filled conservation studios, explaining the various issues involved in conserving sixteenth-century paintings. Matthew Hayes, also in New York, answered many conservation questions, as did Alice Panhard and Ludovic Roudet, in Paris, and Natalia Gustavson, in Vienna.

My thanks go especially to Iris Carulli, in Rome, who has been a great friend since seventh grade. She did the Italian translations and helped navigate Venice's Archivio di Stato, where we went through boxes of documents, which she translated on the spot. In Venice, we also followed the footsteps of the chemist Claude Berthollet, when in 1797 he traversed the city to choose paintings for the Louvre. At Columbia University, and then at the University of St. Andrews, Patrick Errington responded to French translation questions at all hours of the day and night. For the German translations I turned to Jonathan Larson. Anne Pfitzer also kindly answered French questions.

In Venice, Isabella Collavizza undertook critical advance work and found essential documents at the Archivio di Stato and the Archivio dell'Accademia di Belle Arti. In Paris, Iris Bernadac tracked down documents in the Archives nationales (France) and in archives at the Louvre; her research was a model of thoroughness and elegance.

Others contributed significantly to the research: Laura Angelucci, Tracy Cooper, Elizabeth Darrow, Christopher Johns, Dorothy Johnson, Andrée Hayum, Mary Lewis, Andrew McClellan, Dan-el Padilla Peralta, Martin Sonnabend, and Ian Wardropper; in Venice, Roberta Battaglia and Massimo Bisson (who accompanied me to what had been the convent of Santi Giovanni e Paolo and is now a hospital), as well as Alesandro Martori and Francesca Salatin, at the Fondazione Giorgio Cini; in Paris, Jean Habert and Thierry Lentz. For their research, I also thank Sarah Harty, Mallory Hope, Laura Itzkowitz, and (on photographs) Laurie Platt Winfrey. I very much appreciate that early on Lynn Nicolas encouraged me to write about Napoleon's art thefts, and that Suzanne Freeman read early drafts of several chapters.

Sameen Gauhar vigilantly fact-checked the manuscript; Trent Duffy expertly and thoughtfully copyedited it.

For access to documents, I am indebted to the archivists at the Archivio di Stato in Venice, and at the Archives nationales (France), as well as at the Services d'études et de documentation at the Musée du Louvre, and at the Fondation Custodia in Paris. The staff of the Centre de recherche et de restauration des musées de France showed me the radiograph of the Veronese, and members of the Louvre's Département des peintures explained the Veronese files.

My thanks go also to the librarians at the Frick Art Reference Library and at the Metropolitan Museum of Art's Thomas J. Watson Library, where Ken Soehner gave me stack privileges, and especially at the New York Public Library, where they supplied so many books as well as a desk and a shelf in the Frederick Lewis Allen Room.

For their friendship and support, I would like to thank Susan Galassi, Joan Gardiner, Emily Rafferty, Penelope Saltzman, and Charlotte Winton, as well as, in Paris, Laure de Gramont and Diane Johnson. Again, for friendship, I am profoundly grateful to Trinita Logue, who gave the manuscript a thoughtful reading, and to Lily Tuck, who generously read the manuscript and read it again, and whose ideas made it better.

Always, I am thankful to Melanie Jackson, the most excellent of literary agents and a wonderful friend, on whose wise counsel I depend. Ileene Smith, at Farrar, Straus and Giroux, brought her insightful, masterful editing and steadfast support to the book. Also at FSG, great appreciation goes to Scott Auerbach, Jackson Howard, Ian Van Wye, Jonathan Woollen, Eva Gabrielsen, who designed a beautiful cover, and Abby Kagan, who designed a beautiful book.

Finally, I would like to thank Matthew Motley and Claire Fowler, and William Motley and Katherine Gribble. And once again, how to express my thanks to Warren Motley, who read the manuscript so many times?

Index

Page numbers in *italics* refer to illustrations.

Illustration Credits

Illustration Insert

Paolo Veronese, *The Wedding Feast at Cana*, 1563. Oil on canvas, 677 × 994 cm (266⁹⁄₁₆ × 391⁵⁄₁₆ in.). Musée du Louvre, Paris, INV 142. © RMN-Grand Palais/ Art Resource, NY.

Canaletto (Giovanni Antonio Canal), *San Giorgio Maggiore: From the Bacino di San Marco*, 1726–1730. Oil on canvas, 46.3 × 63.2 cm (18¼ × 24⅞ in.). Museum of Fine Arts, Boston, bequest of William A. Coolidge. © Museum of Fine Arts, Boston.

Paolo Veronese, *The Wedding Feast at Cana* (detail), 1563. Oil on canvas, 677 × 994 cm. Musée du Louvre, Paris, INV 142. © RMN-Grand Palais/Art Resource, NY.

Antoine-Jean Gros, *Bonaparte on the Bridge of Arcola, November 17, 1796*, 1796–1797. Oil on canvas, 130 × 94 cm (51¼ × 37 in.). Château de Versailles et de Trianon, MV6314. © RMN-Grand Palais/Art Resource, NY.

Paolo Veronese, *The Feast in the House of Levi*, 1573. Oil on canvas, 555 × 1280 cm (218 × 503 in.). Gallerie dell'Accademia, Venice. © Scala/Art Resource, NY.

Francesco Guardi, *Pope Pius VI Descending the Throne to Take Leave of the Doge in the Hall of SS. Giovanni e Paolo, 1782*, ca. 1783. Oil on canvas, 51.4 × 68.8 cm (20¼ × 27¹⁄₁₆ in.). The Cleveland Museum of Art. © Cleveland Museum of Art, gift of the Hanna Fund 1949.

Giovanni Bellini, *Madonna and Child Enthroned with Saints Peter, Catherine of Alexandria, Lucy, and Jerome*, 1505. Oil on wood, 500 × 235 cm. San Zaccaria, Venice. © Scala/Art Resource, NY.

Raphael, *The Transfiguration*, 1520. Oil on wood, 410 × 279 cm (161 × 109 in.). The Vatican Museums, Pinacoteca. © Scala/Art Resource, NY.

Jacques-Louis David, *Bonaparte Crossing the Alps at Grand-Saint-Bernard*, 1801. Oil on canvas, 259 × 221 cm. Châteaux de Malmaison et Bois-Préau, Reuil-Malmaison, France, MM.49.7.1. © RMN-Grand Palais/Art Resource, NY.

Hubert Robert, *Grande Galerie of the Louvre*, 1801–1805. Oil on canvas, 37 × 46 cm. Musée du Louvre, Paris, RF 1964-34. © RMN-Grand Palais/Art Resource, NY.

Antoine-Jean Gros, *Bonaparte Visiting the Plague-Stricken in Jaffa*, 1804. Oil on canvas, 523 × 712 cm. Musée du Louvre, Paris. © Scala/Art Resource, NY.

Jacques-Louis David, *The Coronation of the Emperor Napoleon and Josephine at Notre-Dame on December 2, 1804*, 1807. Oil on canvas, 621 × 979 cm. Musée du Louvre, Paris, INV 3699. © RMN-Grand Palais/Art Resource, NY.

Antoine-Jean Gros, *Napoleon on the Battlefield of Eylau*, 1808. Oil on canvas, 581 × 784 cm. Musée du Louvre, Paris. © Scala/Art Resource, NY.

In the Text

page 19 Attributed to Charles Meynier, *The Correggio Madonna of Saint Jerome Is Taken from the Academy of Parma and Delivered to the French Commissioners (May 1796)*, ca. 1802–1814. Black ink, 17.8 × 32.4 cm. Musée du Louvre, Paris, RF 2949. © RMN-Grand Palais/Art Resource, NY.

page 24 Titian (Tiziano Vecellio), *The Assumption of the Virgin*, 1518. Oil on panel, 690 × 360 cm. Santa Maria Gloriosa dei Frari, Venice. © CameraphotoArte, Venice/Art Resource, NY.

page 25 Tintoretto (Jacopo Robusti), *The Miracle of the Slave*, 1548. Oil on canvas, 415 × 541 cm. Gallerie dell'Accademia, Venice. © Scala/Ministero per i beni e le attività culturali/Art Resource, NY.

page 38 Contract between the monastery of San Giorgio Maggiore and Paolo Veronese, June 6, 1562, Archivio di Stato di Venezia, San Giorgio Maggiore, B. 21 Proc. 10. © Published by permission of the Ministero per i beni e le attività culturali e per il turismo—Archivio di Stato di Venezia, n. 1/2020.

page 44 Veronese, *Hunter*, ca. 1560. Fresco. Villa Barbaro, Maser. © Scala/Art Resource, NY.

page 47 Vincenzo Maria Coronelli, *The Refectory of San Giorgio Maggiore*, from *Singolarita di Venezia*, 1709. Engraving, 32.8 × 38.5 cm (12¹⁵⁄₁₆ × 15³⁄₁₆ in.). Museo Correr, Venice. © Photo Archive—Fondazione Musei Civici di Venezia.

page 55 Antoine-Jean Gros, *Bust Portrait of Bonaparte*, 1796–1797. Pen/brush drawing, gray ink and wash, 21.5 × 16.5 cm. Musée du Louvre, Paris, RF 28. © RMN-Grand Palais/Art Resource, NY.

page 60 Pierre-Paul Prud'hon, *Empress Josephine*, 1805. Oil on canvas, 244 × 179 cm. Musée du Louvre, Paris. © RMN-Grand-Palais/Art Resource, NY.

page 64 Jean Marot, *West Façade of the Cour Carrée of the Louvre*, from *Architecture de Marot: Le Grand Marot* (set A), seventeenth century. Engraving, 46.6 × 30.6 cm (18⅜ × 12¹⁄₁₆ in.). The Metropolitan Museum of Art, Rogers Fund, 1952 (52.519.185). Image © The Metropolitan Museum of Art; image source: Art Resource, NY.

page 70 Jacques-Louis David, *The Death of Marat*, 1793. Oil on canvas, 165 × 128 cm. Musée d'Art Ancien, Brussels. © Erich Lessing/Art Resource, NY.

page 79 Vincenzo Feoli; intermediary draughtsman Francesco Miccinelli, *Right Side of the Portico in the Courtyard of the Museo Pio Clementino*, from *Veduta generale in prospettiva del cortile nel Museo Pio Clementino*, ca. 1790–1827. Etching and engraving: 57.7 × 90.2 cm (22¹¹⁄₁₆ × 35½ in.). The Metropolitan Museum of Art, Gift of Estate of Ogden Codman, 1951 (51.644.537). Image © The Metropolitan Museum of Art; image source: Art Resource, NY.

page 87 Jacques-Louis David, *Antoine Laurent Lavoisier and Marie Anne Pierrette Paulze Lavoisier*, 1788. Oil on canvas, 259.7 × 194.6 cm (102¼ × 76⅝ in.). The Metropolitan Museum of Art, Purchase, Mr. and Mrs. Charles Wrightsman Gift, in honor of Everett Fahy, 1977 (1977.10). Image © The Metropolitan Museum of Art; image source: Art Resource, NY.

page 96 François Gérard, *Antoine-Jean Gros*, ca. 1790. Oil on canvas, 61 × 50 cm. © Musée des Augustins, Toulouse.

page 98 Jacques-Louis David, *Self-Portrait*, 1794. Oil on canvas, 81 × 64 cm. Musée du Louvre, Paris, INV 3705. © RMN-Grand Palais/Art Resource, NY.

page 104 Antoine-Jean Gros, *Scene of a Convoy in a Landscape of Hills*, 1797. Album 3-folio 84 drawn on the back; pen drawing, black ink, graphite, 22 × 16.8 cm. Musée du Louvre, Paris, RF 54925,121 (folio 84 verso). © RMN-Grand Palais/Art Resource, NY.

page 112 François Seraphin Delpech, after Nicolas-Eustache Maurin, *Claude Berthollet*, 1832. Lithograph from *Iconographie des Contemporains . . . 1789–1829*, vol. 1, 19. Library of Congress, Prints and Photographs.

page 114 Letter from the Committee of Public Safety of the Provisional Municipality of Venice to the Delegation in charge of housing, signed Dandolo, 30 Pratile V (June 18, 1797). Archivio di Stato di Venezia, Municipalita Provvisoria (1797–1798), b. 181. © Published by permission of the Ministero per i beni e le attività culturali e per il turismo—Archivio di Stato di Venezia, n. 1/2020.

page 119 "List of Paintings that must be removed to the French Republic, according to the Treaty Concluded Between the General in Chief of the Army of Italy and the Government of Venice," signed Berthélemy, Tinet, Berthollet. Archivio di Stato di Venezia, Municipalità Provvisoria (1797–1798), b. 181. © Published by permission of the Ministero per i beni e le attività culturali e per il turismo—Archivio di Stato di Venezia, n. 1/2020.

page 131 Canaletto (Giovanni Antonio Canal), *San Giorgio Maggiore*, 1735–1740. Pen and ink, 26.8 × 37.7 cm. Queen's Gallery, Buckingham Palace. Royal Collection Trust/© Her Majesty Queen Elizabeth II 2019.

page 136 Jean Duplessis-Bertaux, after Carle Vernet, *The Entrance of the French into Venice, Floréal, Year 5*, 1799–1805. Engraving, 31 × 47 cm. Département des estampes et de la photographie, Bibliothèque nationale de France, Paris.

page 140 Pierre-Gabriel Berthault, *Triumphal Procession of the Monuments of the Sciences and the Arts, 9 and 10 Thermidor, Year 6 of the Republic* [July 27, 1798], 1798. Engraving, 24 × 29 cm. Département des estampes et de la photographie, Collection complète des Tableaux historiques de la Révolution française. Collection de Vinck, 6935. Bibliothèque nationale de France, Paris.

page 152 Pierre-Paul Prud'hon, *Charles-Maurice de Talleyrand-Périgord, Prince de Bénévent*, 1817. Oil on canvas, 215.9 × 141.9 cm (85 × 55⅞ in.). The Metropolitan Museum of Art, Purchase, Mrs. Charles Wrightsman Gift, in memory of Jacqueline Bouvier Kennedy Onassis, 1994 (1994.19). Image © The Metropolitan Museum of Art; image source: Art Resource, NY.

page 157 Israel Silvestre, *Tuileries Palace of Catherine de Médicis, Built in 1564, Augmented in 1600 by Henry IV Who Made the Gardens*, 1649–1651. Etching, 10.8 × 14.6 cm (4¼ × 5¾ in.). The Metropolitan Museum of Art, Bequest of Phyllis Massar, 2011 (2012.136. 565.1). Image © The Metropolitan Museum of Art.

page 157 Pierre-Alexandre Aveline, after Jean-Michel Chevotet, *Façade of the Grande Galerie of the Louvre on the Side of the River*, 1628. Lithograph, 57.3 × 140 cm. Salle des Estampes, Musée Carnavalet, Paris. © Musée Carnavalet, Paris/ Agence Roger-Viollet.

page 182 Benjamin Zix, *M. Denon Supervising the Removal of Paintings from the Picture Gallery, in Kassel*, 1807. Pen and wash, 25.7 × 21.6 cm. Département des estampes et de la photographie, Bibliothèque nationale de France, Paris.

page 183 Benjamin Zix, *Arrival at the Louvre of Works Seized from Berlin*, 1808. Pen and brown ink, brown wash, 26.3 × 44.6 cm. Musée du Louvre, Paris, RF 6061. © RMN-Grand Palais/Art Resource, NY.

page 190 Louis Charles Auguste Couder, *Napoleon I Visiting the Louvre, Accompanied by the Architects Charles Percier and Pierre Fontaine*, 1833. Oil on canvas, 177 × 135 cm. Musée du Louvre, Paris. © RMN-Grand Palais/Art Resource, NY.

page 192 Benjamin Zix, *Wedding Procession of Napoleon I and Marie-Louise of Austria*, 1810. Watercolor, graphite, pen, and black ink, 18 × 84 cm. Musée du Louvre, Paris, Mp-4 1832.25. © RMN-Grand Palais/Art Resource, NY.

page 208 Thomas Lawrence, *Klemens Lothar Wenzel, Prince Metternich*, 1815. Oil on canvas, 131.2 × 105 cm. Waterloo Gallery, Windsor Castle. Royal Collection Trust. © Her Majesty Queen Elizabeth II 2019.

page 210 Antonio Canova, *Perseus with the Head of Medusa*, ca. 1800. Marble, 235 × 190 × 110 cm. Museo Pio Clementino, Rome. © Scala/Art Resource, NY.

page 212 Antonio Canova, *Napoleon Bonaparte,* 1803. Marble, 65 × 44 cm. Galleria d'Arte Moderna, Palazzo Pitti, Florence. © Alinari/Art Resource, NY.

page 229 *Radiograph of Veronese's "Wedding Feast at Cana,"* 1992. Centre de Recherche et de Restauration des Musées de France, Paris. © C2RMF/Joël Requilé.

A Note About the Author

Cynthia Saltzman is the author of *Portrait of Dr. Gachet: The Story of a Van Gogh Masterpiece, Money, Politics, Collectors, Greed, and Loss* and *Old Masters, New World: America's Raid on Europe's Great Pictures*. A former reporter for *The Wall Street Journal*, she is the recipient of a fellowship from the Guggenheim Foundation and has degrees in art history from Harvard and the University of California, Berkeley. She lives in Brooklyn, New York.